DATE DUE

DEC - 5 1995	
DEC 8 1998	
BRODART	Cat. No. 23-221

Whistler:
Prosaic Views, Poetic Vision

Works on Paper from
The University of Michigan Museum of Art

Carole McNamara and John Siewert

Thames and Hudson
The University of Michigan Museum of Art

Front Cover

The Traghetto, No. 2
from the "Twelve Etchings," or the "First Venice Set"
1879-80
Etching, printed in dark brown ink on laid paper
K. 191 v/vi
Bequest of Margaret Watson Parker, 1954/1.377

Back Cover

The Traghetto, No. 1
1879-80
Etching, printed in warm black ink on laid Japan paper
K. 190 ii/iii
Bequest of Margaret Watson Parker, 1954/1.376

Copyright © 1994 by the Regents
of the University of Michigan

First published in paperback in the United
States of America in 1994 by Thames and
Hudson, Inc., 500 Fifth Avenue, New York,
New York 10110

Library of Congress Catalog Card Number:
93-61541
ISBN 0-500-27761-3

The exhibition has been made possible with
the assistance of Ford Motor Company; the
National Endowment for the Arts, a Federal
Agency; the Horace H. Rackham School of
Graduate Studies and the Office of the Vice
President for Research of the University of
Michigan; and Precision Photographics, Inc.

Designed by Beth Keillor Hay

Edited by Leslie Stainton

Photography by Patrick Young

Editorial and production assistance by
Antonia Kramer, Lori Mott, Carrie St. John

Typesetting by Doug Hagley, Kolossos Printing
in Ann Arbor, Michigan

Printed and bound by Signet Printing Company
in Detroit, Michigan

This catalogue is published in connection with
the exhibition *Whistler: Prosaic Views, Poetic
Vision. Works on Paper from the University
of Michigan Museum of Art* presented at the
University of Michigan Museum of Art from
March 26 through May 22, 1994.

Albright-Knox Art Gallery
Buffalo, New York
September 9 - October 30, 1994

Sterling and Francine Clark Art Institute
Williamstown, Massachusetts
March 4 - April 16, 1995

Nelson-Atkins Museum of Art
Kansas City, Missouri
November 12, 1995 - January 5, 1996

Georgia Museum of Art
University of Georgia
Athens, Georgia
February 3 - March 24, 1996

Table of Contents

In 1899 art critic Frederick Wedmore wrote of the work of James Whistler, "It has been given to this master . . . to see common things with a poetic eye." This exhibition celebrates the continuing appeal of Whistler's subtle and elegant vision as well as the generosity of one of the Museum of Art's great patrons, Margaret Watson Parker.

When in 1936 Mrs. Parker donated 679 objects from her collection to the University of Michigan Museum of Art, Museum Director Jean Paul Slusser characterized the gift as "the most important bequest of art objects to come into the University's possession." Today, more than fifty years later, Slusser's words still hold true.

The Parker Bequest of Asian ceramics, lacquer and sculpture, Japanese prints, and Pewabic Pottery forms the foundation of the Museum's holdings in each of these areas. The heart of the Parker Collection, however, is a magnificent group of works by James McNeill Whistler. In a stroke Mrs. Parker established the University of Michigan as a center for the study of Whistler and his work. In the years since, the Museum has systematically added to this collection, expanding its range and depth. Selected works from our holdings are often shown here in Ann Arbor and are in great demand for inclusion in Whistler exhibitions around the world. This publication and the exhibition associated with it, however, mark the first time that the Museum's Whistler collection has been presented comprehensively, as well as the first time that full and detailed information on this great resource and on the woman who formed it has been made widely available to scholars, students, and the general public.

The Museum is grateful to Carole McNamara and John Siewert for their skilled and dedicated work in compiling the catalogue, and to the National Endowment for the Arts for its support of this publication. Additional crucial aid was provided by the Horace H. Rackham School of Graduate Studies and the Office of the Vice President for Research of the University of Michigan. We are especially grateful to Ford Motor Company for its generous support of this catalogue and the accompanying exhibition.

We invite you to join with us in the enjoyment and celebration both of Whistler's exquisite graphic works and of Margaret Watson Parker's generosity and collecting genius.

William J. Hennessey
Director

Acknowledgments

Through the donation in 1936 of a substantial gift of Asian works of art and a rich selection of works by the painter James McNeill Whistler, the University of Michigan Museum of Art formed the nucleus of two important facets of the permanent collection. Margaret Watson Parker's donation of an early seascape painting, three drawings, and over one hundred prints by this major American artist has made Michigan's collection one of the finest groups of Whistler's work in this country. The Museum of Art, in celebration of the twenty-fifth anniversary of the Friends of the Museum, has chosen for exhibition some of the outstanding impressions in the collection of Whistler's etchings and lithographs. In the process we have enjoyed the opportunity of presenting these prints and contributing some new scholarship to the already formidable work of previous curators and scholars, to whom we express our appreciation.

The work of many people contributes to the success of any exhibition, and we are indebted to many of our colleagues on the staff and at other institutions. Two people, however, deserve special thanks for their support in seeing this exhibition and publication to completion. First, we would like to thank our director, William J. Hennessey. Enthusiastic about this exhibition from its inception, he has worked long and hard to provide the exhibition curators with the precious time and resources to realize the catalogue. We would also like to extend special appreciation to Nesta R. Spink, former curator of Western Art at the Museum of Art. In addition to her well-earned reputation as a Whistler scholar and her familiarity with this particular group of objects, she has been repeatedly willing to take valuable time away from her own research to meet with us concerning fine points of scholarship in this field. We have benefited from her continuing interest in the museum's collections, and in particular its holdings in Whistler's prints.

Of our colleagues at the museum, special recognition goes to Leslie Stainton for her skillful and patient editing of the catalogue text, and to Antonia Kramer for additional assistance in proofing copy. Beth Hay was responsible for the handsome design of the catalogue and graphics of the exhibition. Her vision was a critical contribution to the success of both the catalogue and the exhibition itself. Patrick Young, photographer, and Lori Mott, associate registrar, helped with compiling all of the visual materials in the catalogue. For contributing their expertise to the success of the exhibition thanks go also to Leslie Austin, Janet Torno, Mark Nielsen, Kevin Canze, Kirsten Neelands, Carolyn Simpson, Carrie St. John, Melonee Ranzinger, Nan Plummer, Kelly Miller, and Adam Blitz.

We would like to thank museums both in this country and in Great Britain for their generous access to resources in their collections. Carole McNamara would like to extend her appreciation to the staffs of the print rooms of the New York Public Library, the Metropolitan Museum of Art, and the Detroit Institute of Arts. Additional thanks go to her husband, Dennis, and children, David and Andrew, for the many months of support and understanding throughout the project. Many of the major research volumes on Whistler are in the University of Michigan Library. The staff of the Special Collections Library, in particular Kathleen Dow, assisted this project immensely by allowing us special access to these resource books throughout the researching and writing of the catalogue. The catalogue received generous support from Ford Motor Company; the National Endowment for the Arts, a Federal agency; and the Horace H. Rackham School of Graduate Studies and the Office of the Vice President for Research of the University of Michigan. Precision Photographics, Inc. provided further catalogue assistance in production of the photographs. Our thanks also go to Professor Robert Getscher for his reading of the manuscript. In addition to the individuals gratefully acknowledged at the end of his introductory essay, John Siewert owes many thanks to David Cole of the Freer Gallery of Art for his assistance with the Freer print collection; to Nigel Thorp, Director of the Centre for Whistler Studies, Glasgow University Library; and to the University Court of the University of Glasgow for granting permission to quote from Whistler's correspondence.

Whistler's reputation as an outstanding printmaker as well as a painter was established by the many awards which he received during his lifetime. It has been rewarding for us to have the opportunity to research these prints and drawings and work closely with them over a period of time. With this catalogue and the accompanying exhibition, we are pleased to observe the twenty-fifth anniversary of the Friends of the Museum of Art.

Carole McNamara
John Siewert
Exhibition Curators

Sponsor's Note

Ford Motor Company is pleased to have this opportunity to join with the University of Michigan Museum of Art in presenting this exhibition of the works on paper of James McNeill Whistler. In addition to the exhibition itself, our support assures a wide variety of educational programs and outreach into the community.

For Ford, support of the arts is an integral part of our commitment to having a positive impact on the quality of life in the communities we operate in, and beyond. We are proud to help fulfill that commitment by assisting in bringing the artistry of James McNeill Whistler to people here in southeastern Michigan, and across the United States.

Alex Trotman
Chairman and Chief Executive Officer
Ford Motor Company

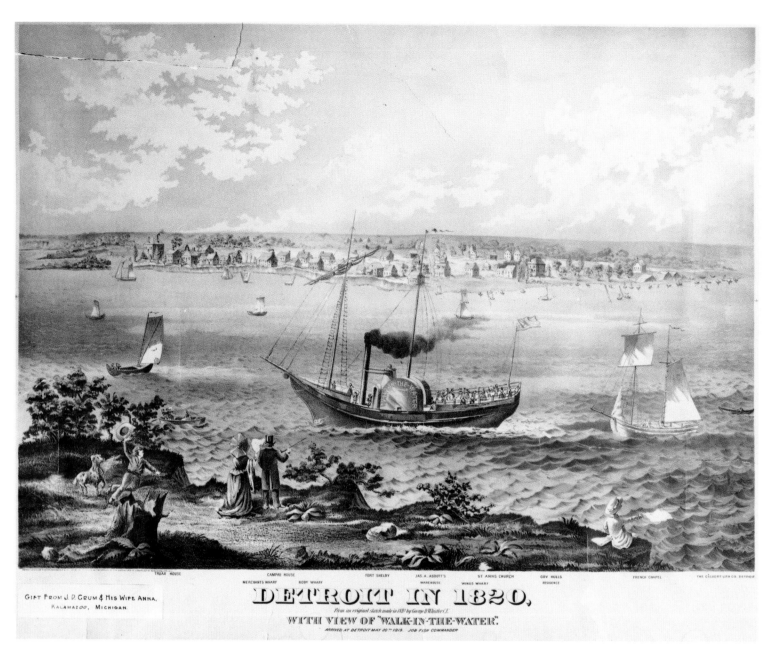

1 George Washington Whistler (after),
Detroit in 1820, 1870s(?), color lithograph,
Transportation History Collection, Special
Collections Library, University of Michigan

Whistler and Michigan
The Artist, Mr. Freer, and Miss Watson

by John Siewert

James McNeill Whistler (1834-1903) never included Detroit among the various sites he creatively claimed as his birthplace. Yet if Whistler chose not to put his cradle anywhere in the Great Lakes region, as he did regularly in places as disparate as Baltimore and St. Petersburg, Russia, the city of Detroit still assumed a particular significance in his personal history at two widely separated moments. The initial factors linking Michigan and Whistler began to take shape some thirty years before his birth, during Detroit's own infancy. The artist's grandfather, Captain John Whistler (ca. 1760?-1829) of the First United States Infantry, was assigned in the early 1800s to Fort Lernoult, which stood at the present-day intersection of Shelby and West Fort Streets in downtown Detroit. After several years' duty divided between Fort Lernoult and Fort Wayne, Indiana, Capt. Whistler was ordered to assist with the construction of fortifications at the head of Lake Michigan. In 1803 he took his large family to the hastily built Fort Dearborn, now known as Chicago.[1]

The captain's years in Detroit, however, had set in motion a union that would ensure the Whistlers' continued association with the city, for while he served there his daughter Sarah (1786-1874) met James Abbott (1776-1858), the son of a Detroit fur trader. They were married in November 1803, in what history records as the first wedding ceremony to take place in the new city of Chicago.[2] The newlyweds returned to Abbott's Michigan home where they seem to have established themselves as prominent citizens. In addition to his activities as a merchant carrying on his father's business, James held positions of authority as postmaster, associate judge of the District Court of Huron and Detroit, and inspector of customs.

In 1820 Sarah's brother George visited the couple. Following in the military footsteps of his father, the captain, George Washington Whistler (1800-49), had graduated from West Point the previous year. Now a lieutenant in the United States Army, he was assigned to topographical duty, an appointment that may in part have prompted his travels to Detroit. While he was there he applied his draughtsman's talents to recording the young city as it appeared from Canada, a representation later reproduced as a three-color lithograph (fig. 1). In the center of the look-alike buildings that line the shore in this view of "Detroit in 1820," neatly labeled in the lithograph's legend, stands James Abbott's warehouse.[3] George Washington Whistler must have continued to enjoy good relations with his brother-in-law over the following decades. When a son was born in 1834 to George and his second wife, Anna Mathilda McNeill (1804-81), he was named after his great-uncle, the businessman and civic leader, and christened James Abbott Whistler.

Although he later avoided the use of "Abbott" in all but the most formal and legal of circumstances, preferring instead his mother's maiden name, James McNeill Whistler would come to have more than just a nominal connection to the city of Detroit. In 1890, the year the artist published an instantly infamous book called *The Gentle Art of Making Enemies*, Charles Lang Freer (1854-1919), a Detroit industrialist, became Whistler's friend. In London on business, Freer presented his card at Whistler's door on 4 March, seeking an audience with the expatriate painter who by that time had lived in Chelsea for nearly thirty years. At this first meeting the visitor from Detroit affected a naiveté he assuredly did not possess, claiming that he had heard Whistler once made an etching, and that he would now like to see it. In fact, Freer's considerable collection of prints already included close to one hundred of the artist's etchings, which he began acquiring in 1887.[4] Whether he was amused by his transatlantic caller's attitude, or whether he even then sensed in Freer a sympathetic spirit, Whistler admitted him to his studio, where the two men enjoyed a visit Freer recounted several weeks later to *The Detroit Free Press*.[5] Their friendship marked the beginning of a new phase in Freer's art collecting. From that point, he obtained many of Whistler's prints and a number of important paintings directly from the artist.

2 Charles Lang Freer, platinum print by Alvin Langdon Coburn, 1909, Charles Lang Freer Papers, Freer Gallery of Art Archives, Smithsonian Institution, Washington, D.C.

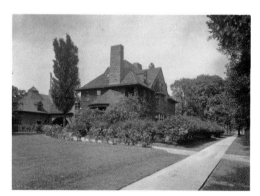

3 Freer's house at 33 East Ferry Avenue, Detroit, platinum print, 1904, Charles Lang Freer Papers, Freer Gallery of Art Archives, Smithsonian Institution, Washington, D.C.

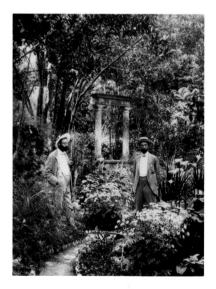

4 Thomas S. Jerome, left, and Freer, right, in the garden of the Villa Castello, Capri, photograph, 1901, Charles Lang Freer Papers, Freer Gallery of Art Archives, Smithsonian Institution, Washington, D.C.

In the 1890s Charles Freer (fig. 2) was well on his way to accumulating as much of a fortune as he would require from the manufacture of railroad cars. He and his partner, Frank J. Hecker, purchased several regional railroads and in 1892 consolidated their competition in the Michigan-Peninsular Car Company. During that year Freer moved into a new home in Detroit he had built just off Woodward Avenue, on East Ferry. Hecker's own residence stood next door, a palatial structure modeled after a French château.[6] Freer's house (fig. 3) made a less ostentatious statement with a comparatively modest, shingle-style design that belied the careful, refined craftsmanship of its every detail, all orchestrated by Freer himself.[7]

Charles Freer was characteristically active in 1892. In addition to acquiring a new address he bought his first Whistler oil painting, a scene of kimono-clad models posed before a prospect of the River Thames in London, called *Variations in Flesh Colour and Green: The Balcony* (1864-70, Freer Gallery of Art, Washington, D.C.). In the same year, he purchased his first examples of Japanese art, the very sort of images that had inspired Whistler to paint *The Balcony*.[8] This initial foray into the acquisition of Asian art would have far-reaching ramifications for Freer and his collecting. When he later shared his new enthusiasm with Whistler during their second meeting in 1894, the artist informed his friend of his own passion for the arts of Asia. He confided in Freer his belief that the Japanese prints, screens, porcelain, and other art objects available in the West were only intimations of far richer and more ancient cultures. He encouraged the man from Detroit to travel to Japan and especially to China, lands Whistler himself would never see but which he believed held the key to unlocking a vast and venerable visual tradition.[9] Freer promised he would do so, and in 1894 he embarked upon the first of four trips to the Far East.[10]

By 1899 Freer was poised to retire from his business at the age of forty-five determined, with his friend's help, to assemble "a fine collection of Whistlers," as the artist said — "perhaps," he added, "*the* collection."[11] Freer spent his early retirement continuing to learn about and to acquire the arts of Asia and the works of select American painters, and he cultivated a circle of cultured, educated friends. One of these, Thomas Spencer Jerome (1864-1914), University of Michigan alumnus, Detroit attorney, and avid student of classical civilization, left Michigan for Italy in the year of Freer's retirement to take up the post of Consular Agent in Sorrento and then on the island of Capri. In 1900 the two friends bought a villa on Capri, where Freer could escape the dull Detroit winters (fig. 4).[12]

Although his own education ended in the seventh grade, Freer had a deep respect for scholars at the University near Detroit in Ann Arbor, and he established a regular, informed correspondence with academics such as Francis W. Kelsey, Professor of Latin Language and Literature from 1889 until his death in 1927. In 1904, when the University of Michigan awarded Freer an honorary Master of Arts degree, he wrote to President James B. Angell to express his "high appreciation." To a fellow collector he admitted that the honor, "having been conferred without my knowledge or desire, appeals to me more than it otherwise possibly could."[13]

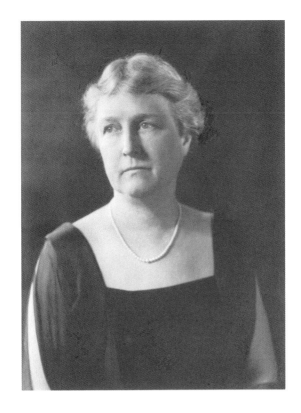

6 Margaret Watson Parker, photograph, University of Michigan Museum of Art files

His increasingly active acquisition of art brought Freer into further contact with like-minded individuals. He seems to have had a particularly high regard for Charles J. Morse (1852-1911), a civil engineer from Evanston, Illinois. Morse represented a firm that constructed the Manufacturer's Building for the World's Columbian Exposition, held in Chicago in 1893. The exotic world cultures on display at the Exposition stimulated his interest in East Asia, and he temporarily retired from his business in 1897 to travel to Japan, where he began his study and his collection of Asian art.[14] His preoccupation overlapped with Freer's own growing attention to his Far Eastern collections, and the two men met sometime soon after the turn of the century.

Freer was generous with praise and appreciation when he believed it was warranted. He commended Morse to the attention of dealers and other collectors of Asian art, describing Morse's holdings as "the most perfect collection of Japanese colour prints owned in America, outside of the Boston Museum."[15] Freer's own interest in these works on paper had diminished by 1905, when he disposed of them in order, he said, to concentrate on acquiring "specimens of ancient paintings."[16] Morse, however, continued to add to his print collection to the point where he was able to offer selections from it to others. In November 1900, he sold seven Japanese woodblock prints (see fig. 5) to a fellow resident of Evanston, a woman named Margaret Watson.[17]

Margaret Selkirk Watson (fig. 6) was born 22 July 1867 in Vermont, the third daughter of George R. Watson and Julia Dickinson. Her father, a banker and real estate broker who established the Bank of Montreal in Chicago, moved the family to Evanston by the time Margaret was in high school.[18] In 1883, at the age of 16, she entered Northwestern University in Evanston, enrolling in the Latin and Scientific Course. She spent her junior year in the Philosophical Course, but did not complete her degree.[19] Little else is known of her early years, yet it is clear from subsequent events that she possessed a taste for art and the means to acquire it. Purchase records preserved at the University of Michigan Museum of Art indicate that by 1894 she owned several Whistler etchings, including *Little Venice* (cat. no. 33) and *The Palaces* (cat. no. 38). She apparently bought a handful of additional Whistler prints over the next several years, a fairly unexceptional beginning to a collecting career that would soon take on a higher profile.

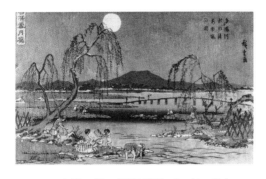

5 Hiroshige (1797-1858), *Catching Fish by Moonlight on the Tama River*, color woodblock print, University of Michigan Museum of Art, Bequest of Margaret Watson Parker, through Dr. Walter R. Parker, 1948/1.137

As her acquisitions of Japanese prints attest, Watson knew Charles Morse at least by 1900. These purchases and her contact with Morse, coupled with the interest she had already established in Whistler prints, ensured that it was only a matter of time before she would meet Charles Lang Freer. It seems likely that Morse introduced her to Freer late in 1904, when the Detroit collector was in Evanston.[20] The following month Freer anticipated hosting Morse in his home at 33 East Ferry Avenue, writing that he hoped his friend would bring Mrs. Morse and Miss Watson as well.[21] The Evanston contingent arrived in Detroit on 20 January 1905 and stayed for four days.[22]

While she was at Freer's house Watson surely would have admired the decorative pictures especially commissioned for the interiors, paintings by Thomas Wilmer Dewing (1851-1938), Dwight William Tryon (1849-1925), and Abbott Handerson Thayer (1849-1921), whose works, like Whistler's, Freer believed embodied the "highest ideals of American art."[23] Shortly after their visit, Freer wrote to Thomas Dewing about his Evanston friends, telling the painter that Miss Watson "already has a few very beautiful prints, lithographs and paintings." He added that they had discussed the possibility of her purchasing a "fine Dewing," and asked the artist to keep her in mind. "I have no doubt she would like to own the 'Girl with Lute'," he wrote, referring to a recent acquisition of his own, "but I cannot let her have it."[24]

Watson apparently did not follow up on her intention to buy a Dewing painting. In February 1905, however, she was seriously considering acquiring *Twilight* (fig. 7), a landscape Tryon had recently completed. "The responsibility of advising any one to buy an object of art is a matter from which I think we all naturally shrink," Freer noted, "and I hope that when you see the canvas you will not let my slight connection with the matter influence you in the slightest. Your own unerring taste should be the real influencing power."[25] Within a matter of days, Watson bought the painting, for Freer congratulated her on her purchase in a letter sent later in February, offering his opinion that the picture "equals in many ways the best one dozen landscapes ever painted in America," and expressing his delight "that it belongs to our little circle."[26]

Dissatisfied with her new acquisition's frame, which Tryon had designed, Watson replaced it with a thinner surround that warped and brought the wood panel into contact with its glazing. A small section of paint loosened, and Freer wrote the artist to ask if he might repair the damage. Tryon did so but, understandably, he requested that Freer advise Watson to return the painting to its original frame.[27] She remained firm in her decision, however, a conviction Freer applauded. "Unless one's own personality appears especially in one's own home," he observed, "what is the use of having a personality. . . . So it seems to me that you are doing a wise thing in this as well as in so many other details of your collecting."[28]

While she acquainted herself with Freer's favorite American painters, Watson continued to develop her taste for art from lands farther flung. At the very time she was pondering the Tryon painting, she purchased an example of Rakka ware, a piece of pottery with iridescent turquoise glazes produced in Syria during the 12th or 13th century (fig. 8). Watson acquired the ceramic chalice from the Parisian dealer Siegfried Bing, for the transaction's receipt, dated 27 February 1905, was made out to her by Marie Nordlinger (Museum files). Nordlinger, from Manchester, England, began as an enamelist in Bing's art nouveau workshop and eventually acted as his sales agent.[29] She spent significant time with Freer himself, one of Bing's most important American clients, staying at 33 East Ferry for two weeks in April 1905, and then again for three months in 1906 when she assisted Freer in cataloguing his collection.[30] Her cousin, Reynaldo Hahn, was a close friend of Marcel Proust, and around 1902-05 she helped the writer translate passages of John Ruskin's difficult English prose into French. In a letter to Marie written in 1905, Proust added his best wishes to "le magicien wisthlérien," the Whistlerian magician of Detroit who brought so much happiness to her work.[31]

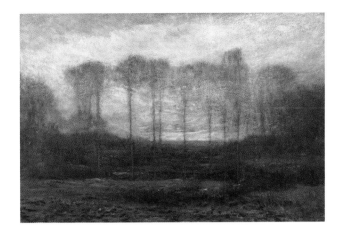

7 Dwight William Tryon (1849-1925), *Twilight*, 1905, oil on panel, University of Michigan Museum of Art, Bequest of Margaret Watson Parker, 1955/1.87

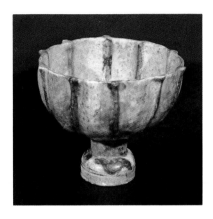

8 Syrian, Rakka ware chalice, 12th-13th century, ceramic with blue, turquoise, and black glazes, University of Michigan Museum of Art, Bequest of Margaret Watson Parker, through Dr. Walter R. Parker, 1948/1.116

Freer was delighted to know a collector as understanding and eager as Margaret Watson. "Yes, as you truly say," he wrote to Morse, "the Whistlers, the Tryon and the Rakka vase are strong influences and if Miss Watson continues to exercise her keen discernment and sympathetic appreciation, she will be a strong competitor of all American collectors. More strength to her! I sincerely believe," he concluded, "that with such objects in her possession she can never add to her group an unimportant thing."[32] That high opinion of Watson's perspicacious collecting was corroborated by dealers such as Marcel Bing, who carried on his father's business after Siegfried's death in 1905. Early the next year the younger Bing sent her a catalogue and price list for the upcoming sale of East Asian art previously in the collection of Jean Garié, a Parisian lawyer and connoisseur.[33] Although she apparently bought nothing from the sale, Bing's concern that she should be well-informed about it suggests that she was quickly becoming known to the important purveyors of art objects.

Watson met Freer around the time he was beginning negotiations with the Regents of the Smithsonian Institution, to whom he had recently offered his art collections.[34] An "expert committee" of Regents, which included President Angell of the University of Michigan, had only recently completed its visit to Detroit to view Freer's treasures when he wrote again to Watson. He approved her purchase of the Rakka chalice which, he thought, would harmonize nicely with her "wonderful Tryon." And he offered to send a letter introducing her to Gustav Mayer of Obach & Co. in London, the principal supplier of his Whistler prints since the artist's death in 1903. He added that his collection of Whistlers was nearly complete, and that she should fear no competition from him.[35] Several days later Freer did inform Mayer that Watson, "a lady of very refined tastes," would be calling. "I would add for your information," he said, "that Miss Watson is likely to be very particular in the quality of prints she buys. I do not think that she expects to attempt to make anything like a complete collection of Mr. Whistler's etchings and she will be attracted only by the finest plates in the best states and condition."[36]

Freer made his offer of an introduction in advance of a trip to England Watson was planning for the summer of 1905. A small notebook she kept records her presence in London during July and August and lists the titles of Whistler prints she studied at the British Museum and at Obach & Co. (Museum files). Freer visited London for part of the summer as well, making a pilgrimage to Whistler's grave in Chiswick on 20 July and no doubt reserving time to look over prints with Margaret Watson. Before the summer of 1905 Freer had frequently handled Watson's transactions with Obach for her, paying money to her account and receiving reimbursement from her later.[37] She established more personal relations with Gustav Mayer on her visit to London and dealt more directly with his firm thereafter. Freer also interceded on her behalf with Rosalind Birnie Philip, Whistler's sister-in-law and executrix. A page in Birnie Philip's detailed ledger book lists six Whistler lithographs set aside for Freer to forward to Charles Morse and Margaret Watson (see cat. nos. 77 and 79).[38]

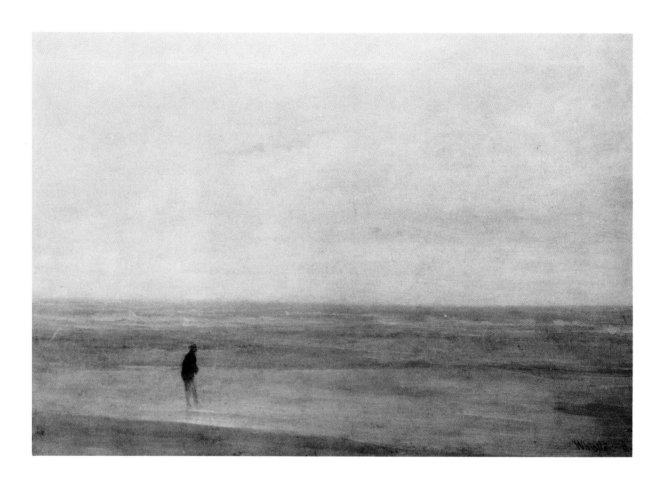

9 James McNeill Whistler (1834-1903), *Sea and Rain*, 1865, oil on canvas, University of Michigan Museum of Art, Bequest of Margaret Watson Parker, 1955/1.89

In 1906 Watson purchased her only Whistler oil painting, a seascape from 1865 entitled *Sea and Rain* (fig. 9). That same year several major collections of Whistler prints came onto the art market, and she was well placed with Freer's influence to take full advantage of the offerings. The Royal Library at Windsor sold its Whistler etchings through Obach & Co. in 1906, and the great collection assembled by H.S. Theobald, a London lawyer, was made available through Colnaghi in 1906 and Knoedler in New York the following year. Margaret Watson added to her own holdings by purchasing selectively from each of these stocks. Freer continued to keep her informed of other such opportunities, as he had done from the earliest moments of their friendship.[39] Freer seems to have taken great satisfaction in his role as adviser and facilitator, watching as another collector amassed a number of fine Whistler prints. For the most part, as he had assured his friend earlier, his own purchasing in that area was largely complete, and he was now more concerned with culling his artistic possessions for the Smithsonian. "Tell Miss Watson, when you see her," he wrote to Charles Morse, "that the weeding of the Whistler etchings is finished and the accepted proofs number six hundred and ten impressions. It is pleasurable to feel that each impression has particular charm and positive reason for being kept in the Collection."[40]

Freer traveled extensively during 1906-07, making his second tour of Asia. He spent a pleasant portion of his time in Japan at Sannotanni, a villa overlooking Yokohama Bay belonging to a Japanese banker, silk merchant, and art collector.[41] On 30 April 1907 he met Mr. and Mrs. Charles Morse and Margaret Watson in Yokohama by prior arrangement, and returned with them to Sannotanni. The party traveled together to Tokyo, and the Morses and Watson continued from there to Kyoto, where they were once again joined by Freer on 13 June.[42]

After 1907 Margaret Watson abruptly distanced herself from Charles Freer, and certain events that transpired during her adventurous journey to Japan appear to have contributed to the beginning of the end of their close relations. While the American circle toured Japan Freer was duped into visiting a temple by art dealers posing as priests.[43] "Many suspicious things happened," he recorded, "and the game is pretty clear now. Shocking!!! . . . Extraordinary lies on all sides—but very exciting."[44] Watson, however, was apparently offended by something Freer said about the situation. Writing to Newman Montross, a New York art dealer who had sold Watson her Tryon painting, Freer observed that he had not heard from her since their time together in Japan. "And I fancy she took a strong dislike to my attitude toward certain of the Japanese," he added, "as she has been very cool ever since."[45] Earlier in the same letter he alluded to another, more material reason for this changed behavior, informing Montross that Watson's married name was now "Mrs. Doctor Walter R. Parker."

Margaret Watson and Walter Parker (1865-1955) married on 28 December 1907. Two years earlier Dr. Parker (fig. 10), a graduate of the University of Michigan and a noted specialist in diseases of the eye, had been appointed Professor of Ophthalmology at his *alma mater*. The Parkers lived in Detroit, where the doctor had been practicing privately, and they eventually resided at 1 Woodland Place in Grosse Pointe (fig. 11). Despite their closer proximity, contact between the two collectors assumed the decidedly more formal and distant tones Freer detected in the immediate aftermath of the trip to Japan. Watson was never a prolific letter writer. "I have to prod her a good deal about answering letters etc," Charles Morse confided to Freer, "especially with you who is [*sic*] so prompt."[46] But not even habitual tardiness as a correspondent accounts for the change after 1907 in the formerly cordial relations between Watson and Freer.

Freer made one last effort. Gustav Mayer wrote late in 1908 to inform him that Obach & Co. had recently acquired a small but choice private collection of Whistler drawings and watercolors.[47] Freer generously sent word of the imminent sale to Margaret Watson Parker, who replied in a short note that she could not possibly consider purchasing what were sure to be expensive works (see discussion under cat. no. 23). After this unpromising exchange, direct communication between the two appears to have come to an end.

Charles Freer's concern to engage the aesthetic sensibilities of others extended beyond cultivating the friendship of collectors such as Margaret Watson. And his desire to broaden the American public's exposure to what he believed were transcendent, timeless artistic standards hardly diminished with his decision to place his collections in the care of the Smithsonian Institution, which formally accepted his gift in 1906.[48] He also undertook other projects closer to home. In 1909 he sponsored a lecture delivered at the Detroit Museum of Art by the eminent art critic Charles H. Caffin (1854-1918), who spoke about Whistler.[49] Caffin accompanied his remarks with projected autochromes of Whistler's works made from paintings and pastels in Freer's collection, lantern slides taken by the American photographer Alvin Langdon Coburn (1882-1966), using the recently perfected Lumière process.[50] The lecture was attended by a "fashionable and enthusiastic audience," *The Free Press* reported: "As Whistler's nocturnes were thrown on the screen, one by one, their luminosity scarcely suffering in a single instance, they excited spontaneous bursts of applause."[51]

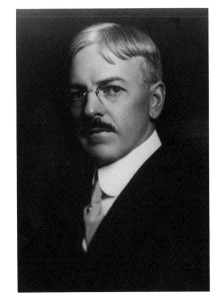

10 Dr. Walter R. Parker, ca. 1915, photograph, Bentley Historical Library, University of Michigan

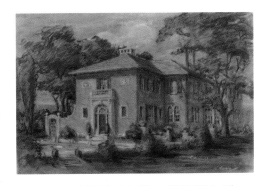

11 Adelaide Cole Chase (1868-1944), *The Parkers' House*, n.d., pastel on tan paper, University of Michigan Museum of Art, Bequest of Margaret Watson Parker, 1954/1.214

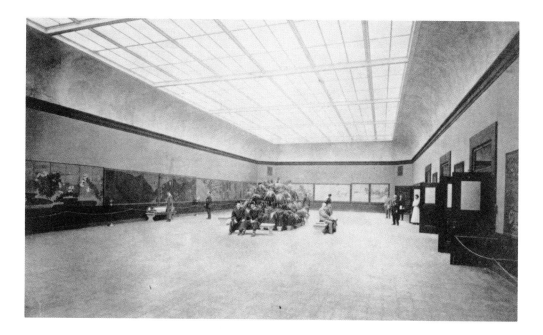

12 Main Gallery, "Exhibition of Oriental and American Art," 1910, photograph, University of Michigan Museum of Art files

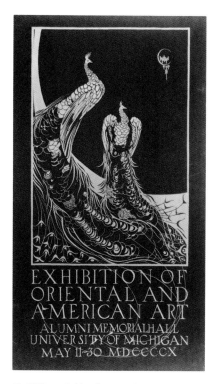

13 William Caldwell Titcomb (1882-1963), Poster for "Exhibition of Oriental and American Art," 1910, stenciled gold ink on black paper, University of Michigan Museum of Art, Gift of The Ann Arbor Art Association, in memory of Ruby S. Churchill, 1972/2.28

The following year a generous selection from Freer's Asian holdings and a number of his paintings by American artists made up the majority of an exhibition that opened the newly completed Alumni Memorial Hall on the campus of the University of Michigan, the structure that is today the University's Museum of Art. The building, constructed to commemorate Michigan alumni who gave their lives in the Spanish-American War, was formally dedicated on 11 May 1910.

In conjunction with the dedication ceremonies, the Alumni Memorial Committee and the Ann Arbor Art Association organized an "Exhibition of Oriental and American Art," to which Freer lent all of the Asian works displayed. The Main Gallery walls were lined with a magnificent representation from his collection of Japanese screens (fig. 12), and he provided examples of lacquer ware and ceramics as well. Freer also lent ten American paintings, including works by his favorite quartet of Dewing, Tryon, Thayer, and Whistler. Among the other contributors to the American component of the exhibition were Freer's former business partner, Frank Hecker, and the art dealer Newman Montross.[52] "Ann Arbor will be the center of art for three weeks," a local newspaper proclaimed, "and the memory of it will last for years."[53] William Caldwell Titcomb, Professor in the University of Michigan School of Architecture, designed the exhibition's poster (fig. 13). Its motif of peacocks may have been intended to evoke Whistler's renowned Peacock Room, which Freer had purchased for his Detroit collection in 1904. In a larger sense the paired birds, their plumage prominently arrayed, captured the exotic effect of two artistic traditions brought together in Ann Arbor under the ideal of universal beauty.[54]

Given her keen interest in Whistler's work and the arts of Asia, and her ties to both Detroit and Ann Arbor, it is easy to imagine that Margaret Watson Parker attended the Caffin lecture and enjoyed the art exhibition at some point during its three-week installation at Alumni Memorial Hall. Although she had no further contact with Freer, she continued to add to her personal holdings of Asian and American art. Her collecting activities also embraced the European paintings and graphics that her formerly close friend largely declined to buy. In 1916, for example, Mrs. Parker returned six of her Whistler etchings to Knoedler for credit to be placed toward her purchase of a picture entitled *Hide-and-Seek* (fig. 14), by the Belgian painter Alfred Stevens (Museum files). Along with paintings and prints, she amassed a sizable number of small sculptures by the American *animalier* Edward Kemeys (1843-1907), best known for the large-scale pair of lions that grace the entrance to the Art Institute of Chicago. On a rather more prosaic level, Mrs. Parker commissioned Kemeys to sculpt a bronze of her pet collie, Tuck.[55]

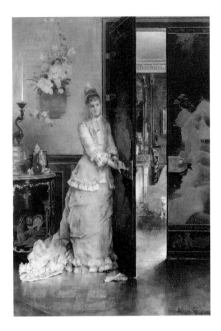

14 Alfred Stevens (1823-1906), *Hide-and-Seek (Cache-Cache)*, ca. 1878, oil on panel, University of Michigan Museum of Art, Bequest of Margaret Watson Parker, 1955/1.85

A fervent supporter of Detroit arts and artists, Watson Parker also assembled a considerable collection of Pewabic pottery (fig. 15), ceramics with distinctive glazes, which Freer had collected from the time Mary Chase Perry Stratton founded her Detroit firm in 1903. Like Freer, Mrs. Parker encouraged others to enjoy her aesthetic possessions; in 1915 she lent Japanese and Whistler prints, along with Chinese brocades, to the Detroit Society of Arts and Crafts.[56] And she maintained a steady enthusiasm for the art of Whistler. One of the final additions to her print collection proved to be among her most important purchases: a rare, complete edition of Whistler's "French Set" etchings (see discussion under cat. no. 2), acquired in 1932.

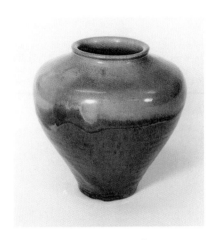

15 Mary Chase Stratton, Pewabic vase, 1925, stoneware with iridescent turquoise glaze, University of Michigan Museum of Art, Transfer from the College of Architecture and Design, 1972/2.187

Margaret Watson Parker died suddenly on 30 May 1936 while she and Dr. Parker were vacationing in Hot Springs, Virginia. Her will stipulated that the University of Michigan was to receive her art collections, which were transferred from Grosse Pointe to Ann Arbor in several installments.[57] Dr. Parker retained control over these artistic properties until his death in 1955, when the remainder of the estate was settled. The Parker collection, totalling 679 works, has been called "the most important bequest of art objects ever to come into the University's possession."[58] In addition to the collection itself, Dr. Parker left half of his personal estate to the University, establishing a fund in his wife's name for the Museum's acquisition of Asian art.

Perhaps the Parkers' gift of art to a prominent public institution was inspired, in some measure and after the passage of many years, by the example and the memory of Charles Lang Freer. Freer died in 1919 but his incomparable collections were made available to the nation as he desired when the Freer Gallery of Art opened in Washington, D.C., in 1923. Margaret Watson Parker's more modest donation constitutes a substantial part of the holdings at the University of Michigan Museum of Art. Her bequest, with its strong emphasis on Whistler prints and Asian art, reflects her brief but productive association with a remarkable fellow collector from Detroit. The collection she left to the Museum of Art and the continuing legacy of the endowment that bears her name remain enduring monuments to a friendship and to her own discerning, intelligent taste.

I am deeply grateful to Linda Merrill, associate curator of American art at the Freer Gallery of Art, for her careful reading of this essay and her constructive comments, for her generous insights into Charles Freer, and for her good counsel about matters Whistlerian and more. Other friends at the Freer Gallery have been extremely helpful as well. I wish to acknowledge the many kindnesses of archivist Colleen Hennessey, and of Lily Kecskes and Kathryn Phillips at the Library. At the University, Carolyn Simpson proved a valuable liaison to Evanston. For repeated assistance with the George Washington Whistler print, I would like to thank James Fox, assistant head, and his dedicated staff in the Special Collections Library, University of Michigan. —JS

1 "Chicago," Whistler later reflected from his home in London, "dear me, what a wonderful place! I really ought to visit it some day—for, you know, my grandfather founded the city and my uncle was the last commander of Fort Dearborn!" (Elizabeth Robins Pennell and Joseph Pennell, *The Life of James McNeill Whistler*, 2 vols. [London: William Heinemann; Philadelphia: J.B. Lippincott, 1908], 1:5).

2 Information about James Abbott is contained in the biography file and a typescript headed "James Abbott Jr. and Sarah Whistler Abbott" in the G.B. Catlin MSS., both in the Burton Historical Collection, Detroit Public Library. Cf. F.W. Coburn, *Whistler and His Birthplace*, ed. Edith W. Burger and Liana De Girolami Cheney (privately printed, 1988), 12, where the marriage is dated 1804.

3 The history of this print deserves further study. The lithograph quite possibly is a composite made from several sources, one of which may, in fact, be a drawing or painting done by G.W. Whistler. The rendering of figures on the near shore and the steamship "Walk-in-the-Water" could be taken from a number of pictures of this, the first such vessel to travel the upper Great Lakes between Buffalo and Detroit; see, for example, John Lee Douglas Mathies, *The Wreck of the Steamer "Walk-in-the Water"* (1821), *American Paintings in the Detroit Institute of Arts*, vol. 1 (New York: Hudson Hills Press, 1991), 288. The painting, not a convincing source for the lithograph but nevertheless representative of a type of imagery that flourished, has since been deaccessioned and is now in the collection of the Detroit Historical Society.
 A related sheet in the William L. Clements Library, University of Michigan, has been cited as the "original" G.W. Whistler painting (Clarence M. Burton to William Van Dyke, 11 June 1920, Michigan Papers, Clements Library). This work appears to have been executed in chalk and gouache and seems more like a free and fairly awkward copy after the lithograph, rather than the inspiration for it.

4 For a thorough overview of Freer's interaction with Whistler, see Linda Merrill, "The Whistler Collection," in Thomas Lawton and Linda Merrill, *Freer: A Legacy of Art* (Washington, D.C.: Freer Gallery of Art, in association with Harry N. Abrams, 1993), 31-57.

5 "A Day With Whistler," *The Detroit Free Press*, Sunday, 30 March 1890, 2.

6 The Hecker house until recently belonged to the Smiley Bros. Music Company; it now houses the law firm of Charfoos & Christensen P.C.

7 See Linda Merrill, "Acquired Taste," in Lawton and Merrill, *Freer*, 13-29; and Thomas Brunk, "The House That Freer Built," *Dichotomy* 3 (Spring 1981): 5-53. The Freer house at 33 East Ferry Avenue is now occupied by the Merrill Palmer Institute, Wayne State University.

8 Howard Mansfield, "Charles Lang Freer," *Parnassus* 7 (October 1935): 16.

9 Agnes E. Meyer, *Charles Lang Freer and His Gallery* (Washington, D.C.: Freer Gallery of Art, 1970), 5.

10 See Thomas Lawton, "The Asian Tours," in Lawton and Merrill, *Freer*, 59-97.

11 Whistler to Freer, 29 July 1899, Freer Gallery of Art Archives (hereafter cited as FGA).

12 Jerome's passion for cultural history inspired him to endow a distinguished lectureship to promote the ideals of historical research and scholarship. The Jerome Lectures continue to be delivered biannually at the University of Michigan and the American Academy in Rome. See *In Pursuit of Antiquity: Thomas Spencer Jerome and the Bay of Naples (1899-1914)*, exh. cat. (Ann Arbor: Kelsey Museum of Archaeology, The University of Michigan, 1983), 2-4.

13 Freer to Angell, 27 June 1904; Freer to Richard A. Canfield, 28 June 1904, Freer Papers/FGA, letterbook 14 (hereafter cited as LB).

14 Charles J. Morse obituary, *The Evanston Index*, 9 December 1911, 2. I am grateful to Mark Burnette, archivist at the Evanston Historical Society, for providing information about Morse.

15 Freer to James Tregaskis, 15 August 1904, Freer Papers/FGA, LB 14.

16 Quoted in Merrill, "The Whistler Collection," in Lawton and Merrill, *Freer*, 57.

17 Receipt from Morse to Watson, dated 16 November 1900, Museum files. Subsequent references to Watson's vouchers and receipts will be given parenthetically in the text. Many of the Japanese prints that came to the Museum in the Margaret Watson (Parker) Bequest are signed "Chas J Morse" on the mount. See, for example, 1948/1.126, 1948/1.131, 1948/1.136, 1948/1.138, and 1948/1.143, all by Hiroshige.

18 Julie [Mrs. J. Munroe] McNulty to Lewis Heath, 21 June 1978, photocopy, Museum files.

19 I wish to thank Patrick M. Quinn, University Archivist; and Peggy Parsons, Acting Director, Northwestern Alumni Association, for providing me with a copy of Margaret Watson's matriculation paper.

20 Freer's Diary, 15-16 November 1904, Freer Papers/FGA.

21 Freer to Morse, 28 December 1904, Freer Papers/FGA, LB 15.

22 Freer's Diary, 20-23 January 1905, Freer Papers/FGA.

23 Freer to William K. Bixby, 7 February 1902, Freer Papers/FGA, LB 9. On the decorative paintings, see Merrill, "Acquired Taste," in Lawton and Merrill, *Freer*, 24-28; and Linda Merrill, *An Ideal Country: Paintings by Dwight William Tryon in the Freer Gallery of Art*, exh. cat. (Washington, D.C.: Freer Gallery of Art, 1990), 54-61.

24 Freer to Dewing, 24 January 1905, Freer Papers/FGA, LB 16. Dewing's *Girl With Lute* is in the collection of the Freer Gallery of Art (05.2). I am grateful to Linda Merrill for drawing my attention to this letter.

25 Freer to Watson, 7 February 1905, Freer Papers/FGA, LB 16.

26 Freer to Watson, 21 February 1905, Freer Papers/FGA, LB 16. In 1906, Watson added a Tryon pastel entitled *Morning* (1955/1.88) to her collection.

27 Freer to Tryon, 9 November 1905; Freer to Watson, 23 December 1905, Freer Papers/FGA, LB 18.

28 Freer to Watson, 16 March 1906, Freer Papers/FGA, LB 19.

29 Gabriel P. Weisberg, *Art Nouveau Bing: Paris Style 1900* (New York: Harry N. Abrams, in association with the Smithsonian Institution Traveling Exhibition Service, 1986), 41.

30 Freer's Diary, 1905, 1906, Freer Papers/FGA.

31 Marcel Proust to Marie Nordlinger, 9/10 February 1905; *Correspondance de Marcel Proust*, ed. Philip Kolb (Paris: Plon, 1979), 5:41. Nordlinger later would marry Rudolf Meyer Riefstahl (1880-1936), a prominent dealer of Asian art and artifacts.

32 Freer to Morse, 8 March 1905, Freer Papers/FGA, LB 16.

33 Marcel Bing to Watson, 5 February 1906, Museum files. See *Collection J. Garié. Objets d'art et peintures du Japon et de la Chine*, Paris, Hôtel Drouot, 5-10 March 1906.

34 See Linda Merrill, "Composing the Collection," in Lawton and Merrill, *Freer*, 183-201.

35 Freer to Watson, 9 March 1905, Freer Papers/FGA, LB 16.

36 Freer to Mayer, 21 March 1905, Freer Papers/FGA, LB 16.

37 See, for example, receipts dated 23 February, 12 March, and 22 December 1905, Freer Papers/FGA.

38 Glasgow University Library, Whistler Collections, NB 1/88.

39 In one of his first letters to her, Freer offered his opinions on the Whistler prints in the collection of Walter S. Carter, a Brooklyn lawyer (Freer to Watson, 21 February 1905, Freer Papers/FGA, LB 16). The Carter collection was sold in 1905 through the American Art Association; see M. Lee Wiehl, *A Cultivated Taste: Whistler and American Print Collectors*, exh. cat. (Middletown, Conn.: Davison Art Center, Wesleyan University, 1983), 13. Margaret Watson declined to purchase from the Carter sale.

40 Freer to Morse, 22 February 1906, Freer Papers/FGA, LB 19. Ultimately, the vast Whistler collection Freer left to the nation included 745 etchings and drypoints, and 196 lithographs.

41 Thomas Lawton, "The Asian Tours," in Lawton and Merrill, *Freer*, 70-72.

42 Freer's Diary, April-June 1907, Freer Papers/FGA.

43 Lawton, "The Asian Tours," in Lawton and Merrill, *Freer*, 73.

44 Freer's Diary, 28 May 1907, Freer Papers/FGA.

45 Freer to Montross, 30 January 1908, Freer Papers/FGA, LB 23.

46 Morse to Freer, 3 March 1907, Freer Papers/FGA.

47 Mayer to Freer, 30 October 1908, Freer Papers/FGA.

48 Freer retained control of his collection until his death, when it was transferred to Washington, D.C.

49 Charles H. Caffin, "The Art of James McNeill Whistler," 23 April 1909, unpublished typescript, Rare Book Collection, Library of the Freer Gallery of Art and Arthur M. Sackler Gallery.

50 Freer's Diary, 1909, Freer Papers/FGA. Coburn and Caffin arrived in Detroit together on 10 February. Caffin left for New York on the 14th, while Coburn continued to photograph at Freer's home until his departure on the 21st. The Lumière process is discussed succinctly in John Wood, *The Art of the Autochrome: The Birth of Color Photography* (Iowa City: University of Iowa Press, 1993), 3-4.

51 "Value of Color Photos Shown. Whistler's Nocturnes Reproduced Before Large Audience at Museum of Art," *The Detroit Free Press*, Saturday, 24 April 1909, 12.

52 See *Exhibition of Oriental and American Art*, exh. cat. (Detroit: J. Bornman & Son, 1910).

53 "On the Eve of the Great Art Exhibition," *The Daily Times News* [Ann Arbor], Wednesday, 11 May 1910, 1.

54 That theme resounded in the local newspaper account of the exhibition: "The great spirit of universal genius, which pervades all times, all arts, which passes from country to country, from century to century, through all great minds of genius, which never dies, traveling through ethereal realms and resting now here, now there—this great spirit of spirits, this unfathomable and unanalyzable manifestation of a divine power is now manifesting itself in American art. Mr. Freer has discovered this spirit especially in one great American master —Whistler" (*ibid.*).

55 Julie [Mrs. J. Munroe] McNulty to Lewis Heath, 21 June 1978, photocopy, Museum files.

56 Susan Hobbs, "Detroit and Its Development in the Arts," in *Artists of Michigan from the Nineteenth Century*, exh. cat. (Muskegon, Mich.: Muskegon Museum of Art, 1987), 87.

57 Most of the Parker Bequest came to the Museum in 1948, 1954, and 1955, the Whistler prints (100 etchings and drypoints, and fifty-seven lithographs) arriving in the latter two years. In 1972, more Pewabic pottery from the Parker collection was transferred to the Museum from the University's College of Architecture and Design (Museum files).

58 Jean Paul Slusser, "The Museum of Art," in *The University of Michigan: An Encyclopedic Survey*, ed. Walter A. Donnelly, part 8 (Ann Arbor: The University of Michigan Press, 1956), 1486. For additional discussion of the collection's scope, see *Margaret Watson Parker: A Collector's Legacy*, exh. cat. (Ann Arbor: University of Michigan Museum of Art, 1982).

James McNeill Whistler
A Chronology

1834
Born in Lowell, Massachusetts, 11 July.

1843
Family moves to St. Petersburg, Russia, where Major G.W. Whistler supervises railroad construction.

1849
Returns to America on death of Major Whistler.

1851
Enters West Point.

1854
Discharged from West Point; works at U.S. Coast Survey (later called U.S. Coast and Geodetic Survey), Washington, D.C., where he learns to etch.

1855
Resigns from position and travels to Paris.

1856
Enters studio of Marc-Gabriel Charles Gleyre, Paris.

1857
Visits "Art Treasures Exhibition," Manchester.

1858
Takes walking tour of northern France, Luxembourg, and the Rhineland, resulting in the "French Set" etchings. Meets Gustave Courbet, Henri Fantin-Latour.

1859
Settles in London, begins the "Thames Set" etchings.

1860
Exhibits *At the Piano* at Royal Academy. Joanna Hiffernan becomes his model and mistress.

1863
Moves to Chelsea. Exhibits *The White Girl* (later entitled *Symphony in White, No. 1*) at Salon des Refusés in Paris. Visits Amsterdam. By now is collecting Japanese art and curios.

1865
Meets Albert Moore. Paints in Normandy with Courbet.

1866
Travels to Valparaiso, Chile.

1867
Shows *Symphony in White, No. 3*, first work exhibited with musical title, at Royal Academy.

1869
First visit to Speke Hall, Liverpool home of his patron, F.R. Leyland.

1871
Paints first Nocturnes of the Thames; paints *Arrangement in Grey and Black: Portrait of the Artist's Mother*. Possibly meets Claude Monet in London. The "Thames Set" published.

1873
Exhibits paintings at Durand-Ruel, Paris. Paints portrait of Thomas Carlyle. Maud Franklin replaces Joanna Hiffernan as mistress and principal model.

1874
First one-man exhibition in London, at Flemish Gallery.

1876
Works on Peacock Room in Leyland's London home, 49 Prince's Gate.

1877
Shows work at first exhibition of Grosvenor Gallery, London. John Ruskin's review of exhibition prompts him to sue for libel. Commissions E.W. Godwin to design the White House, Chelsea.

1878
Begins work in lithography. Awarded one farthing damages in Ruskin trial.

1879
Declares bankruptcy. Leaves for Venice, commissioned by Fine Art Society to make twelve etchings there.

1880
Exhibits the "First Venice Set" at Fine Art Society.

1881
Exhibits Venice pastels at Fine Art Society.

1883
Shows rest of Venice etchings along with other new work at Fine Art Society.

1884
Shows "'Notes'—'Harmonies'—'Nocturnes'" at Dowdeswell.

1885
Delivers "Ten O'Clock" lecture, London.

1886
The "Second Venice Set" published by Dowdeswell. Elected president, Society of British Artists.

1887
Resumes work in lithography. Boussod, Valadon & Co. publish *Notes*, set of six lithographs created in late 1870s. Queen Victoria grants Society of British Artists a royal charter.

1888
Resigns as president of Royal Society of British Artists. Publishes "Ten O'Clock." Meets Stéphane Mallarmé. Marries E.W. Godwin's widow, Beatrix. Honeymoons in France and makes several etchings there.

1889
"'Notes'—'Harmonies'—'Nocturnes'" exhibited at Wunderlich, New York. Spends time in Amsterdam where he paints and etches. Named Chevalier in French Legion of Honor.

1890
Publishes *The Gentle Art of Making Enemies*. Meets Charles Lang Freer of Detroit.

1891
Portrait of mother bought by Musée du Luxembourg, Paris; portrait of Carlyle bought by Glasgow Corporation.

1892
Establishes residence in Paris at 110 rue du Bac. Named Officier in French Legion of Honor.

1893
Joseph Pennell helps print etchings in Paris. Works on color lithographs.

1894
Beatrix Whistler becomes ill.

1895
Works on paintings and prints at Lyme Regis, Dorset.

1896
Beatrix dies. Visits Honfleur, Dieppe, Calais.

1897
Visits Dieppe. The Pennells begin their biographical notes.

1898
Elected president of International Society of Sculptors, Painters, and Gravers. Sets up Académie Carmen in Paris.

1900
Declining health prompts visit at end of year to Tangiers and Corsica.

1901
Visits Dieppe in summer.

1902
Travels in Holland with Charles Freer.

1903
Granted honorary doctor of laws degree from University of Glasgow, but illness prevents him from attending ceremonies. Dies 17 July in London. Pallbearers include Théodore Duret and Charles Freer.

1904
Memorial exhibition held in Boston.

1905
Memorial exhibitions held in London and Paris.

The catalogue sequence is approximately chronological following, in most cases, the dates assigned by Katharine A. Lochnan, *The Etchings of James McNeill Whistler* (1984), and Margaret F. MacDonald, "Whistler's Lithographs" (1988). Etchings and lithographs are given their standard "K." and "W." numbers, referring to E.G. Kennedy, *The Etched Work of Whistler* (1910) and Thomas R. Way, *Mr. Whistler's Lithographs: The Catalogue*, second edition (1905). Dimensions are given in centimeters and inches, height preceding width. Placement of signatures and inscriptions is indicated by the following abbreviations: upper and lower by "u." and "l."; right and left by "r." and "l." Virgules signify that the following words fall on another line.

Former ownership, where known, is designated by numbers referring to Frits Lugt, *Les marques de collections de dessins et d'estampes* (Amsterdam, 1921), and its *Supplément* (The Hague, 1956). Acquisition information for objects from the collection of Margaret Watson Parker is taken from dealers' invoices and receipts in the files of the Museum of Art.

In the entry texts, "YMSM" refers to catalogue numbers for Whistler's oil paintings as established in Andrew McLaren Young et al., *The Paintings of James McNeill Whistler* (1980). Selected works in the collection of the Freer Gallery of Art are mentioned in the text but not illustrated; readers are directed parenthetically to reproductions in David Park Curry, *James McNeill Whistler at the Freer Gallery of Art* (1984). Appendix numbers (app. no.) in the entries signal another work as catalogued in the Appendix, a complete, illustrated checklist of the Museum of Art's holdings of Whistler works on paper. Catalogue numbers (cat. no.) refer to the eighty-three images discussed in entry texts. Full references for works cited in the entry notes by author's last name and short title can be found in the Selected Bibliography.

Entries are signed with the author's initials:
CM — Carole McNamara
JS — John Siewert

Color plate 1
Catalogue number 24

Color plate 2
Catalogue number 23

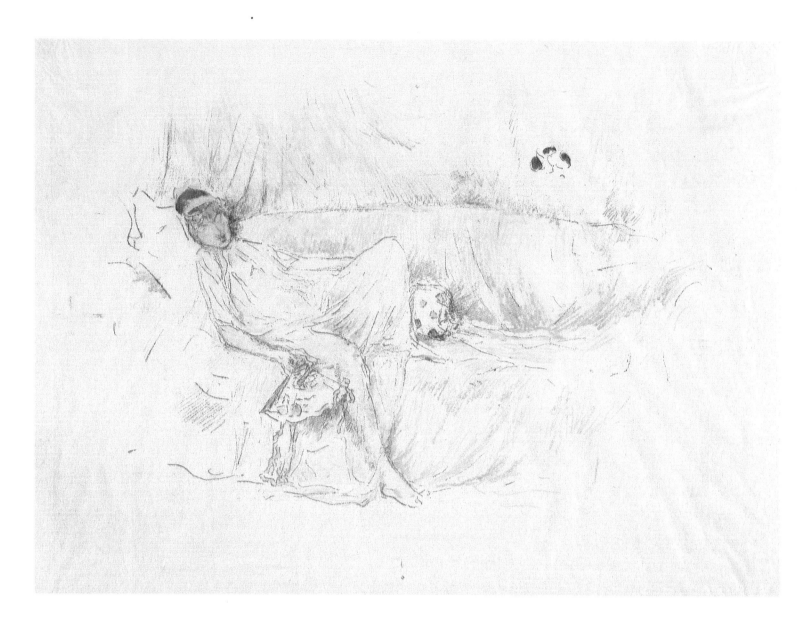

Color plate 3
Catalogue number 63

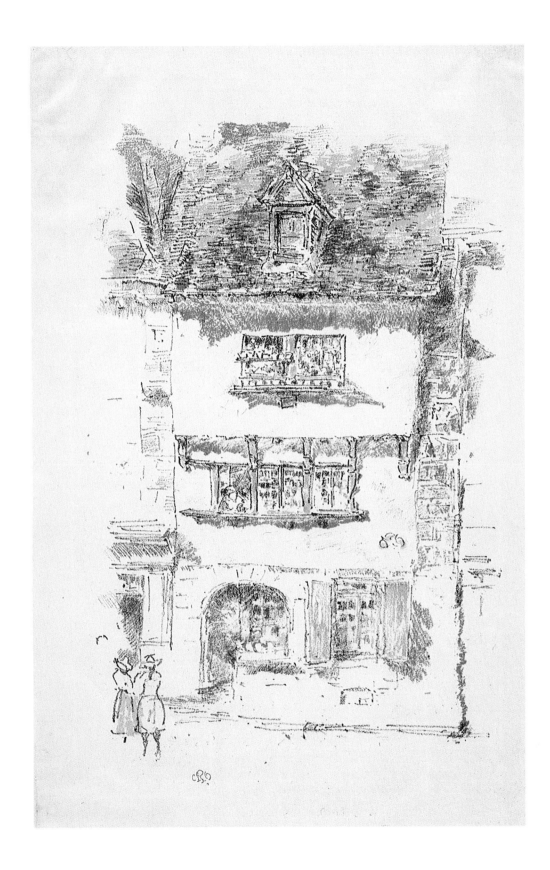

Color plate 4
Catalogue number 72

1 Portrait of Whistler

1859

Etching and drypoint, printed in black ink
on laid paper

K. 54 ii/ii

Plate: 22.4 x 15.1 cm. (8 3/4 x 5 7/8 in.)
Sheet: 29.6 x 22.1 cm. (11 9/16 x 8 5/8 in.)

Signed and dated on the plate, l.r.: Whistler. 1859.
Inscribed in pencil, l.l., and on verso: J.T.K. [in
oval] no. 7
Notation in red ink, l.r.: 363.

Collection: Sir James Thomas Knowles (Lugt 1546)
Purchased from Obach & Co., London, 1907

Bequest of Margaret Watson Parker, 1954/1.341

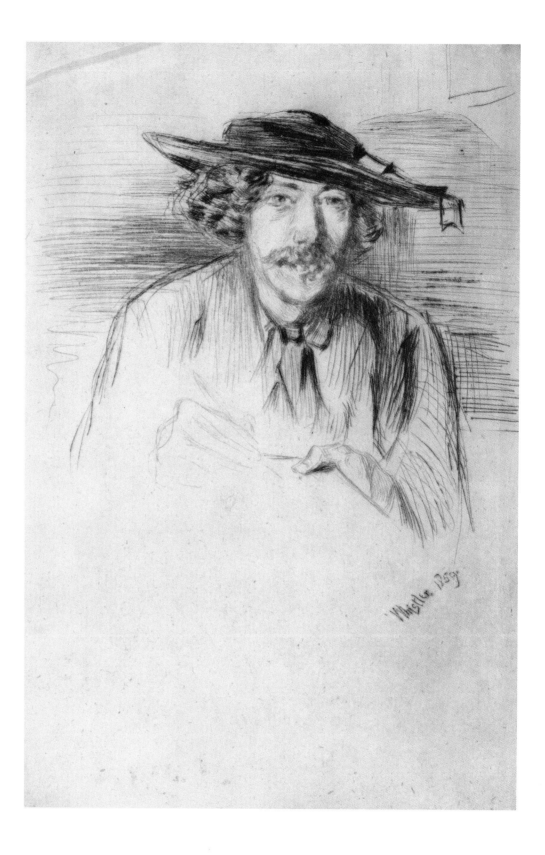

James McNeill Whistler arrived in Paris in the autumn of 1855 to pursue the life of an artist and devoted the next four years to his formal and self-directed studies. At the same time that he was acquiring the elements of an aesthetic education, he was perfecting the persona that would largely define the Victorian public's perception of him for the next several decades. This self-portrait, one of two in the Parker Bequest (see also app. no. 81), marked a period of transition for Whistler, recording aspects of his appearance and personality as his student years were drawing to a close and a newly professionalized phase of his career was about to unfold in London.

Whistler went to Paris determined to live like the fictional heroes of a favorite and well-thumbed book, Henry Murger's *Scenes of Bohemian Life*, published in 1851. A drawing done around 1856, and now in the collection of the Freer Gallery of Art, shows Whistler leading just such an existence in a cramped Latin Quarter garret, surrounded by a picturesque domestic clutter and the accoutrements of his art (repro. Curry, pl. 147). By 1859, however, he had discarded the conspicuous squalor of a bohemian identity in favor of the more dandified character he presents in this etching. He portrays himself scrutinizing his own image, the literal and figurative focal point of which is framed at bottom by the faintly indicated hands that hold his etching needle and copper plate, and by the parallel angle of his distinctive hat above. That hat, "of an American shape not yet well known in Europe," as a fellow student recalled it, had been an emblem of Whistler's original style from his first days in Paris.[1]

Portrait of Whistler works in other, less apparent ways to construct its subject's individuality relative to his social milieu and to artistic tradition. The self-portrait relates to a number of prints Whistler produced at the same time of friends from the Parisian world of arts and letters, including *Astruc, A Literary Man* (K. 53), a portrait of the artist-critic Zacharie Astruc (1835-1907); and a likeness of Just Becquet (1829-1907), a sculptor and amateur cellist (fig. 1a). Katharine Lochnan suggests that Whistler may have meant the energetic drypoint line and "humanist" content of these images to refer to van Dyck's *Iconographia*, an ensemble of bust-length etchings of sitters drawn from the baroque artist's own elite circle.[2] In this context, Whistler's self-depiction could have served notice that he was emerging from student status to claim a position within contemporary ranks of the creative and the cultured.

If Whistler's allusion to van Dyck is subtle, his interest in Rembrandt's prints is clearly evident throughout his graphic work and may well play a part in this particular print. Whistler's biographer, Joseph Pennell, claimed such portraits were evidence that the American artist was "consciously competing with the Dutchman."[3] Indeed, *Portrait of Whistler* might be seen as a loose interpretation of a well-known Rembrandt etching, *Self-Portrait Drawing at a Window* (fig. 1b), in which the Dutch artist shows himself at work, probably on the very print we now view. Here Rembrandt offers an alternative to the icon of the virtuoso artist established in the often flamboyant self-portraiture of a Rubens or a van Dyck, and in his own, more theatrical self-imagery. *Self-Portrait Drawing at a Window* focuses on the essential dignity of the aesthetic enterprise by picturing the artist's quiet engagement in his craft.[4] Whistler's deceptively unassuming etching seems to combine this intimate directness with something of the exuberant execution of a van Dyck.[5] But a clue to his ultimate allegiance to Rembrandt may be contained in the emphasis Whistler has given in this image to his singular headwear, at once an unmistakable element of his personal style and a tip of the hat to a deeply admired Old Master.

JS

1 Thomas Armstrong, *Thomas Armstrong, C.B.: A Memoir 1832-1911*, ed. L.M. Lamont (London: Martin Secker, 1912), 174.
2 Lochnan, *Etchings*, 102-04, 113. Whistler's brother-in-law, Francis Seymour Haden, owned early states of the *Iconographia*, and the artist would have had occasion to study them on his visits to the Haden home.
3 Quoted in Lochnan, *Etchings*, 112.
4 See H. Perry Chapman, *Rembrandt's Self-Portraits: A Study in Seventeenth-Century Identity* (Princeton: Princeton University Press, 1990), 81-84.
5 The references to Rembrandt's print might even extend to what appears to be a window indicated at the upper right in Whistler's etching.

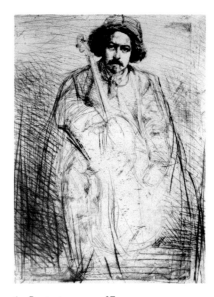

1a *Becquet*, app. no. 27

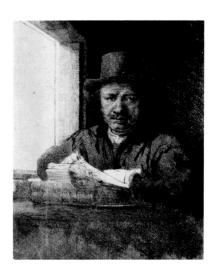

1b Rembrandt, *Self-Portrait Drawing at a Window*, 1648, B. 22 ii/v, etching and drypoint, Trustees of the British Museum, London

2 **The Title to the "French Set"**
from the "Twelve Etchings from Nature,"
or the "French Set"
1858

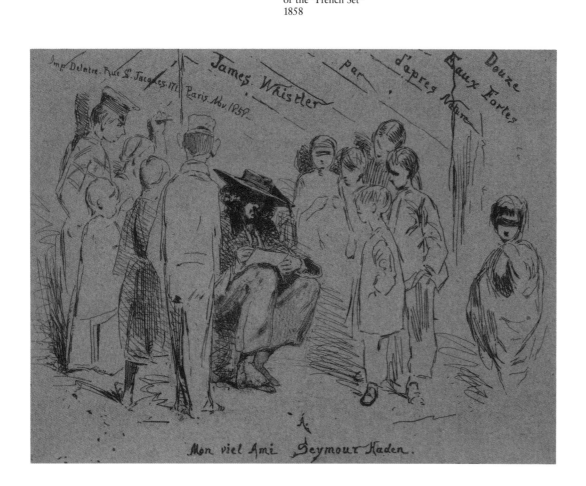

Etching, printed in black ink on blue wove paper

K. 25 (only state)

Plate: 11.2 x 14.7 cm. (4 3/8 x 5 3/4 in.)
Sheet: 35.2 x 53.6 cm. (13 3/4 x 20 7/8 in.)

Inscribed on the plate, at top (right to left):
Douze / Eaux Fortes / d'apres Nature / par /
James Whistler / Imp. Delatre. Rue St. Jacques.
171. Paris. Nov. 1858
Inscribed on the plate, at bottom: Á [*sic*] / Mon
viel Ami Seymour Haden.

Collection: Charles Sydenham Haden (no mark)
Purchased from P. & D. Colnaghi & Co.,
London, 1932

Bequest of Margaret Watson Parker, 1954/1.333

Among the last group of Whistler prints acquired by Margaret Watson Parker was a complete edition of the artist's first published portfolio of etchings, which he had issued in 1858. *Twelve Etchings from Nature (Douze eaux-fortes d'après nature)* introduced the twenty-four-year-old Whistler to his first audience of potential patrons. Commonly referred to as the "French Set," the prints selected for this commercial venture include images executed in London and on a trip through Alsace and the Rhineland, as well as scenes of Parisian life. The ensemble was unified not by a common subject matter, but rather by Whistler's ambition to take his disparate subjects from his immediate experience or, as the inscription on the title page to the set prominently states, from nature. With that inscription, Whistler publicly aligned his work with both the naturalism of his favorite seventeenth-century Dutch art and the progressive tenets of the influential Gustave Courbet.

Whistler spent much of the winter and spring of 1858 in London, recuperating from an illness at the home of his half-sister, Deborah, and her husband, Francis Seymour Haden, a surgeon with a keen interest in collecting and creating prints, the "old friend" to whom Whistler dedicated the "French Set." During his convalescence in the Haden household the artist naturally gravitated to subjects readily at hand, and he etched portraits of his young nephew and niece (app. nos. 3, 14) which he would later incorporate into the "Set." Back in Paris that summer, he pursued his study of the accessible and the ordinary in etchings such as *La Rétameuse* and *La Mère Gérard* (app. nos. 9, 13). In the "French Set," these distinctly urban types play off images of rural landscapes and genre scenes gathered during Whistler's journey from Paris to Germany, upon which he embarked in August with a fellow artist, Ernest Delannoy.[1]

Originally planned to culminate in Rembrandt's Amsterdam, the travelers' itinerary was limited by their finances, which took them only as far as Cologne. Along the way, Whistler sketched the changing countryside and local residents he encountered, at times drawing directly on copper plates he had brought along to produce etchings that became part of his published set. The conviction to take his inspiration from the everyday world, the founding principle of his entire project, is expressed in the imagery as well as the words of the publication's title page. Like cat. no. 1, this is a self-portrait of the artist "in costume" and at work. Here, however, he represents not the solitary act of creation but its social context, the life around him, literally, that is the consistent theme of the "French Set." The youthful throng watching Whistler draw in the open air, sketching the kind of study he would

later use in making his etchings,[2] suggests the much larger audience he hoped to engage by publishing and marketing those prints.

Whistler developed several variations on the theme of the artist bent over his sketchbook (see fig. 2a) before determining the final appearance of his title page. The drawing most closely related to the conclusive design (repro. Curry, pl. 192) actually depicts Ernest Delannoy at the center of attention. When Whistler transferred this sketch to the etching plate, tracing over its pencil lines with a stylus, he put himself and his telltale hat in his friend's place. He also experimented with another version of the composition, which he ultimately rejected. An unpublished etching that exists in a single proof (fig. 2b) shows a more diverse crowd surrounding a seated figure who turns his back to the viewer, hardly a gesture likely to encourage the public's acquaintance with the work of an as yet largely unknown artist.[3]

Whistler returned to Paris in October 1858 and spent the rest of the month working with the printer Auguste Delâtre, a key figure in the mid-nineteenth century etching revival, to prepare the "French Set" for publication. Twenty sets were issued in early November. The title page, like the rest of the edition, was printed on *chine collé*—thin Japan paper trimmed to plate size and both imprinted and mounted onto a larger, heavier sheet when passed through the press—and published as a thirteenth image. Several weeks later, Whistler and Delâtre produced another fifty sets in London, also on *chine collé*. This edition, however, was encased in a blue paper wrapper which bore an impression of the title plate, and it would appear that Margaret Watson Parker later purchased one of the sets issued in London. The set she acquired may, in fact, be something of a hybrid, integrating the "thirteenth sheet" usually associated with the Paris publication (see app. no. 2) with the blue wrapper of the London production.[4] According to a dealer's invoice dated 15 August 1932 (Museum files), Mrs. Parker's set was formerly owned by Seymour Haden's brother, Charles Sydenham Haden.

JS

1 Lochnan, *Etchings*, 25, 28, 33.
2 Many of these drawings are now in the collection of the Freer Gallery of Art (repro. Curry, pls. 156-93).
3 Forty years later, Whistler revisited the subversive idea of the unused title page in a photograph of himself with his back turned, which T.R. Way adapted as the frontispiece to his first catalogue of Whistler's lithographs, published in 1896 (see p. 224 in the present volume).
4 I am grateful to Katharine Lochnan, Curator of Prints and Drawings, the Art Gallery of Ontario, for her help in sorting through these issues.

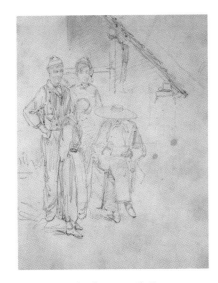

2a *Whistler Sketching*, pencil, Courtesy of the Freer Gallery of Art, Smithsonian Institution, Washington, D.C. (98.207)

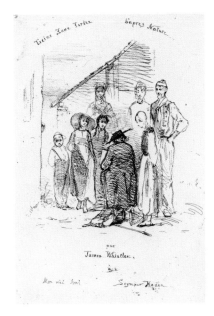

2b *Treize eaux-fortes d'après nature*, K. App. 443, Trustees of the British Museum, London

3 **The Unsafe Tenement**

from the "Twelve Etchings from Nature,"
or the "French Set"
1858

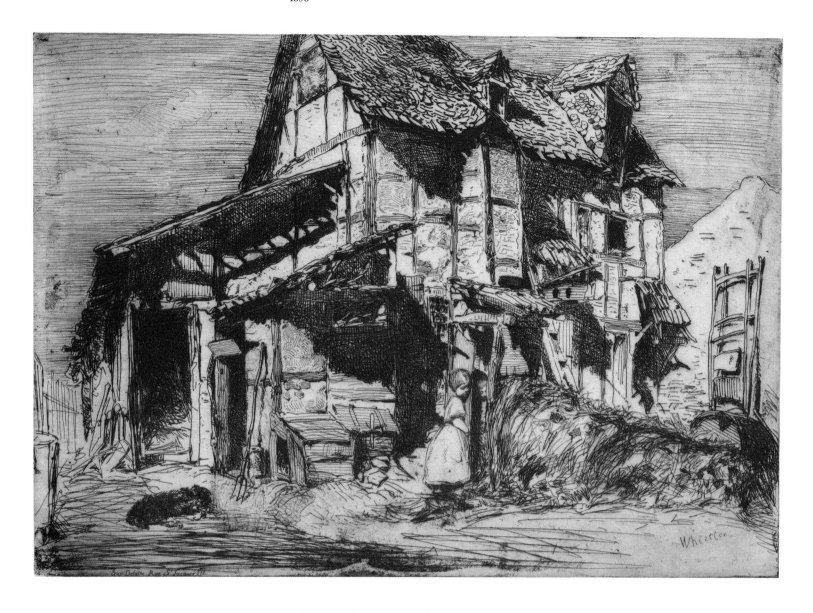

Etching, printed in black ink on Japan paper,
laid down on white wove paper

K. 17 ii/iv

Plate: 15.9 x 22.5 cm. (6 1/4 x 8 7/8 in.)
Sheet: 24.7 x 32.5 cm. (9 3/4 x 12 3/4 in.)

Signed on the plate, l.r.: Whistler
Inscribed on the plate, bottom left: Imp. Delatre.
Rue St. Jacques. 171.

Collection: Charles Sydenham Haden (no mark)
Purchased from P. & D. Colnaghi & Co.,
London, 1932

Bequest of Margaret Watson Parker, 1954/1.324

Whistler's debts both to Dutch prints of the seventeenth century and to contemporary French Realism are evident in *The Unsafe Tenement*. This view of an Alsatian farm, which Whistler would have seen during his journey through France and Germany with Ernest Delannoy in 1858, shows its close affinity to the etchings of Rembrandt and van Ruisdael, and also to the stark naturalism of Charles Emile Jacque.[1]

The artist has filled the plate with this minutely rendered farmhouse, the only figures being the pair of children talking behind a partially open door and the slumbering dog which lies near the stoop. The first state of the print had included a standing figure of a woman at the left, a common device used in prints of this genre to add an element of human warmth and interest. Whistler burnished this figure out and replaced her with a pitchfork, although the form of the woman remains visible. There is a congested, almost trapped, feeling to this print. The plate is covered with tightly spaced lines, even in the sky, and the unrelieved closeness of the building and the chiaroscuro of the deep shadows and half-timbered structure lend it an ominous presence. The protective presence of the woman has been consciously removed, leaving the children unattended and heightening the feeling of abandonment in this claustrophobic and run-down farmhouse.

Significantly, this plate underwent an important transformation before it was published. Another impression of the second state in the Zelman Collection has a notation in Seymour Haden's hand on the margin stating that it was printed *after* the pitchfork was substituted for the woman, but *before* the lines in the sky were removed.[2] The alteration to the sky, as well as some changes in the modeling of the structure itself, seem to have been executed by Haden in the third state. The removal of the horizontal lines in the sky in the third state creates a dramatic change in the image, thus releasing much of its tightly controlled tension.

Despite Whistler's early links with the Realist tradition in mid-nineteenth-century France, the artist soon abandoned his association with Courbet and Jacque, opting to develop his more personal strengths. Fueled in the 1860s by his passion for Japanese prints and ceramics, Whistler's style evolved a delicacy of touch and manner of pictorial composition which reflected his avid interest in things Oriental. Almost a decade later, in a letter to his good friend Henri Fantin-Latour, Whistler lamented his early reliance on Realism during his student days:

Ah my dear Fantin what a frightful education I've given myself—or rather what a terrible lack of education I feel I have had!—With the fine gifts I naturally possess what a fine painter I should be by now! . . . It's that damned Realism which made an immediate *appeal to my vanity as a painter! and mocking tradition cried out loud, with all the confidence of ignorance, "Long live Nature!!" Nature! My dear chap that cry has been a big mistake for me!—Where could you find an apostle more ready to accept so appealing an idea!*

Whistler goes on to say that he wished that he had been a student of Ingres, not because Ingres' style of painting coincided with Whistler's, but because Whistler's education would have been more firmly grounded in the principles of drawing—a lesson he was undertaking on his own at that time:

But I repeat would I had been his pupil! What a master he would have been—How sound a leader he would have been—drawing! My God! Colour—it's truly a vice! Certainly it's probably got the right to be one of the most beautiful of virtues—if directed by a strong hand—well guided by its master drawing . . .[3] During the 1860s and 1870s, Whistler's draftsmanship does acquire greater assurance, and this will be reflected in the crisp and controlled drawing of the "Thames Set" etchings.

CM

1 Katharine Lochnan compares this image to those dilapidated farmhouses which Jacque portrays in his etchings of the same period. Jacque's style and vocabulary of imagery were a result of studying the same seventeenth-century artists' prints that Whistler had seen in Seymour Haden's collection in London. Lochnan, *Etchings*, 38.
2 Fine, *Drawing Near*, 35.
3 Letter to Fantin-Latour, autumn 1867, quoted in Spencer, *Whistler: A Retrospective*, 82-3.

4 **Street at Saverne**

from the "Twelve Etchings from Nature,"
or the "French Set"
1858

Etching, printed in black ink on Japan paper,
laid down on white wove paper

K. 19 iv/v

Plate: 20.7 x 16 cm. (8 1/16 x 6 1/4 in.)
Sheet: 32.7 x 24.8 cm. (12 3/4 x 9 11/16 in.)

Signed on the plate, l.l.: Whistler
Inscribed on the plate, l.r.: Imp. Delatre. Rue St.
Jacques.

Collection: Charles Sydenham Haden (no mark)
Purchased from P. & D. Colnaghi & Co.,
London, 1932

Bequest of Margaret Watson Parker, 1954/1.325

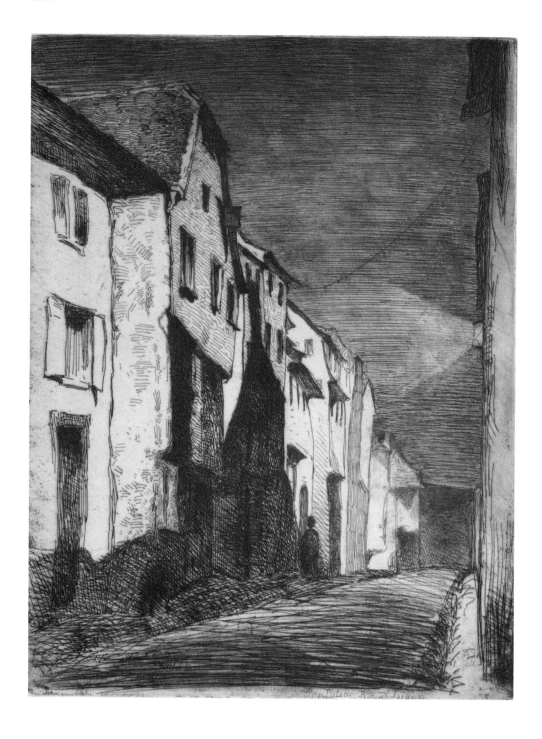

When Whistler and his friend, fellow artist Ernest Delannoy, embarked upon a walking tour through France and Germany during the summer of 1858, they took along with them both sketching materials and copper plates, and the pair spent time making drawings which could be realized into more finished works back in Paris. *Street at Saverne* grew out of this journey, and in it Whistler's employment of preparatory drawings towards the final etching can be traced.

During the tour Whistler executed drawings such as *A Street Scene* (fig. 4a) where he records the lively detail and figures of the towns through which he and Delannoy traveled on their way to Cologne. Whistler took obvious delight in the architecture and inhabitants in this view of an unidentified town. In this pencil drawing he has carefully massed the buildings along the lane with convincing spatial recession. The composition in a sketch of this kind, filled with the immediacy of direct observation, is distilled to broader essential components in a preparatory watercolor for the etching *Street at Saverne* (fig. 4b). In the watercolor of the French town of Saverne, a similar view up a street with closely spaced buildings has been made more compact and monumental. The twisting street and architectural embellishment of the pencil drawing have been replaced in the watercolor by a much straighter view in which the incidentals of figures and architecture have been subordinated to the imposing row of buildings and the lone figure passing at the side. As others have pointed out, the watercolor depicts this Alsatian town in the late afternoon, but when Whistler etched the plate it became, in effect, the first of his series of Nocturnes.[1]

In the etching *Street at Saverne*, Whistler's rich linear technique is used to portray this street in deep shadow against a darkened sky. His use of line to evoke the lonely darkness, coupled with Delâtre's rich printing, have created an image which recalls the nocturnal prints of Rembrandt, as well as realist etchings produced in France by artists such as Charles Meryon. The effects which in *Street at Saverne* are achieved through line will later be achieved in the Venice etchings through the manipulation of plate tone (cat. nos. 37, 46, 47). This impression is from the published edition of the "French Set." The Museum also owns a later impression (app. no. 17) printed by Whistler, after the removal of the printed inscription at the bottom. The inking in this next state is much darker in tonality than the printing in the fourth state and postdates the Venice trip. Mortimer Menpes, an Australian-born artist who assisted Whistler in printing the "First Venice Set," recalled Whistler's response as the artist looked back at his earlier work in the "French Set." "In comparing earlier and later practices, he was looking over some impressions from the French Set when he noted (referring possibly to an impression of *The Kitchen*), 'Well, well, well! Not bad, not bad! But I have learnt something since then, I think Menpes. At that time I struggled to get tone with my etchings in a labored way' which he learned to obtain with plate tone."[2] Whistler's later impression has more emphasis on the lantern, and the final state shares more of the qualities found in the printing of the Venetian etchings.

CM

1 Both Ruth Fine and Katharine Lochnan discuss the relationship of the preparatory drawing to the final etching, noting the transition from late afternoon with its long, cast shadows to the final nocturnal image in the etching; see *Drawing Near*, 36-7; *Etchings*, 43.
2 Menpes, *Whistler As I Knew Him*, 98.

4a *A Street Scene*, 1858, pencil on paper, Courtesy of the Freer Gallery of Art, Smithsonian Institution, Washington, D.C. (98.168)

4b *Street at Saverne*, 1858, watercolor and pencil on paper, Courtesy of the Freer Gallery of Art, Smithsonian Institution, Washington, D.C. (98.147)

5 **La Marchande de Moutarde**

from the "Twelve Etchings from Nature,"
or the "French Set"
1858

Etching, printed in black ink on Japan paper,
laid down on white wove paper

K. 22 ii/v

Plate: 15.7 x 8.9 cm. (6 1/8 x 3 1/2 in.)
Sheet: 32.3 x 24.7 cm. (12 5/8 x 9 5/8 in.)

Signed on the plate, l.l.: Whistler
Inscribed on the plate, bottom left: Imp. Delatre.
Rue St. Jacques. 171.

Collection: Charles Sydenham Haden (no mark)
Purchased from P. & D. Colnaghi & Co.,
London, 1932

Bequest of Margaret Watson Parker, 1954/1.329

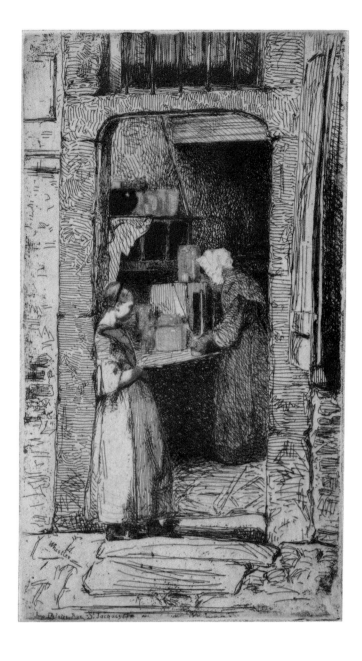

As if isolating a small section of *Street at Saverne* and turning it parallel to the page, *La Marchande de Moutarde* focuses on two figures standing in the doorway of a shop front. A pair of drawings, actually done in Cologne (repro. Curry, pls. 188, 189), provided Whistler with the basis for the print he created upon his return to Paris. Together with two other "French Set" plates produced after his Rhineland journey, *La Vieille aux Loques* (app. nos. 10-12) and *The Kitchen* (cat. no. 6), this etching establishes the motif of a figure framed by the geometric space of doors and windows as a central theme in Whistler's work, one he continued to explore in paintings and prints throughout his career.

Late in life the artist's friend Edgar Degas looked back at the years on either side of 1860 and recalled that he, Henri Fantin-Latour, and Whistler were then "all on the same road, the road from Holland."[1] Indeed, many of Whistler's views "from nature" are mediated by his knowledge of seventeenth-century Dutch art; the spatial order and tranquil mood of *La Marchande de Moutarde* and related compositions point to his early and continuing affection for Dutch paintings, especially by de Hooch and Vermeer, of figures posed in domestic architectural settings. *La Vieille aux Loques* (fig. 5a), in particular, could derive in part from the detail of a woman seated in a doorway in Vermeer's *Little Street* (fig. 5b), a work Whistler may have known from a reproduction or copy. The measured, lucid structure of this picture must have made a lasting impression on him, for much later he acquired a photograph of it.[2] The seemingly casual charm of *La Marchande de Moutarde* is no less clearly constructed, juxtaposing sunlit exterior and darker recesses, as well as youth and age in the figures that assume opposing profiles.

The subjects of *La Vieille aux Loques* (The Old Rag Woman) and *La Marchande de Moutarde* (The Mustard Seller) attest to the other major influence on Whistler's early work, the ideas and imagery of French Realism. These etchings, along with *La Rétameuse* (The Tinsmith) and *La Mère Gérard* (a Parisian flower vendor), draw their content from the world of ragpickers and other working-class denizens of the city streets that Charles Baudelaire commended in his *Salon of 1846* and other essays as the unheroic source for the "heroic" representation of modern life.

After its publication with the "French Set" in 1858, *La Marchande de Moutarde* was shown at the Salon of 1859, Whistler's first successful submission to an official exhibition. The enduring appeal of the print was underscored nearly thirty years later, in 1886, when the periodical *English Etchings* acquired the plate and issued 200 impressions of the etching in its fifth and final state.[3]

JS

1 *Lettres de Degas*, ed. Marcel Guérin (Paris: Editions Grasset, 1945), 256.
2 Nigel Thorp, "Studies in Black and White: Whistler's Photographs in Glasgow University Library," in Fine, ed., *Whistler: A Reexamination*, 90. The photograph is dated 1902.
3 Wedmore, *Whistler's Etchings*, 24; Kennedy, *Etched Work*, 10.

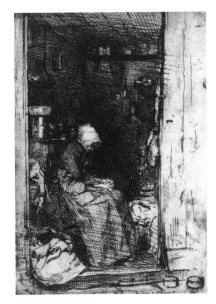

5a *La Vieille aux Loques*, app. no. 10

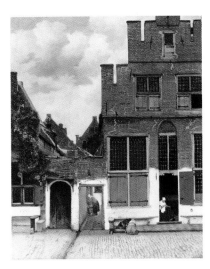

5b Johannes Vermeer, *The Little Street*, ca. 1657-58, oil on canvas, Rijksmuseum, Amsterdam

6 **The Kitchen**

from the "Twelve Etchings from Nature,"
or the "French Set"
1858

Etching, printed in dark brown ink on
laid paper

K. 24 ii/iii

Plate: 22.6 x 15.8 cm. (8 13/16 x 6 3/16 in.)
Sheet: 28.5 x 20.4 cm. (11 1/8 x 7 15/16 in.)

Signed on the plate, l.r.: Whistler
Inscribed on the plate, bottom right: Imp. Delatre.
Rue St. Jacques. 171.
Inscribed in pencil [in Whistler's hand], on the
sheet, l.l.: Seymour
Inscribed in pencil, on verso: S. H.

Collection: Sir Francis Seymour Haden (not in
Lugt in this form)

Bequest of Margaret Watson Parker, 1954/1.331

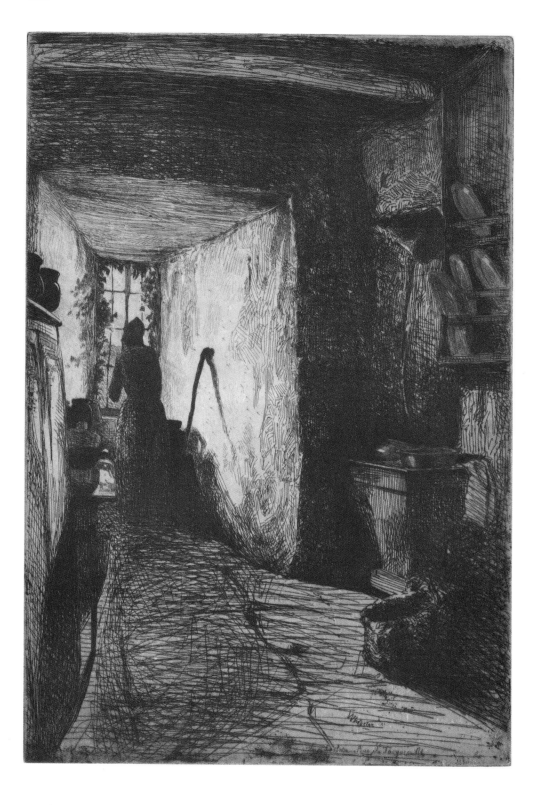

According to P.G. Hamerton, one of the first English art critics to write at length about Whistler's etchings, the artist was "a master of line, but not of chiaroscuro."[1] Another Victorian commentator, however, looked at *The Kitchen* and found in it effects "of light and shade of the kind known as 'Rembrandtish',' " although he preferred to describe the room as "flooded with sunshine, like a chamber of De Hooch's."[2] Whichever Dutch master provided the frame for it, *The Kitchen* was seen by many of Whistler's contemporaries as one of the most ambitious and satisfying of his "French Set" prints, exploiting with dramatic results the interplay of light and dark integral to the etching medium.

Whistler developed *The Kitchen* from an elaborate watercolor he executed at Lutzelbourg, a few miles west of Saverne in Alsatian France (fig. 6a). In both the watercolor and the etching derived from it an interior wall cast into heavy shadow plays off the brightly illuminated nook behind it, where a woman stands, her own dark form set *contre-jour* before a window. This sequence of alternating shade and light accentuates the spatial recession of the room as it progressively narrows to enclose the silhouetted figure. In the watercolor, the floor stones and the shadows thrown upon them retain their discrete legibility. The etching, however, reinterprets those areas of wash in linear terms, and the pattern of abutting stones becomes an insistent outline that follows from the foreground to attain the right contour of the woman, reinforcing the directional impetus of the composition. The figure itself mysteriously seems to emerge from a tenebrous web of crosshatching on the floor.

This proof of *The Kitchen*, like the one published with the complete edition of the "French Set" (app. no. 6), is from the second state of the plate. Whistler apparently considered it an especially fine impression, for the penciled notations on it indicate that he must have presented it to Seymour Haden himself. *The Kitchen* enjoyed a wider popularity as well, and the Fine Art Society of London, which acquired the plate, commissioned Whistler in 1884 to produce fifty additional impressions of the image in its third state.[3] These later proofs were printed with plate tone—ink permitted to remain selectively on the surface of the copper—to achieve the more "painterly" effects Whistler now favored, thus adding another dimension to the etching's inherently graphic contrasts.

JS

1 Hamerton, *Etching and Etchers*, 229.
2 Wedmore, *Whistler's Etchings*, 25-26.
3 Ruth Fine provides evidence to redate these later impressions to 1884, rather than to 1885 as previously believed (*Drawing Near*, 39).

6a *The Kitchen*, watercolor, Courtesy of the Freer Gallery of Art, Smithsonian Institution, Washington, D.C. (98.153)

7 Fumette

from the "Twelve Etchings from Nature,"
or the "French Set"
1858

Etching and drypoint, printed in black ink on
Japan paper, laid down on white wove paper

K. 13 iv/iv

Plate: 16.2 x 10.9 cm. (6 3/8 x 4 1/4 in.)
Sheet: 32.6 x 24.9 cm. (12 3/4 x 9 3/4 in.)

Signed on the plate, l.r. of figure: Whistler
Inscribed on the plate, l.l.: Imp. Delatre. Rue St.
Jacques. 171.

Collection: Charles Sydenham Haden (no mark)
Purchased from P. & D. Colnaghi & Co.,
London, 1932

Bequest of Margaret Watson Parker, 1954/1.320

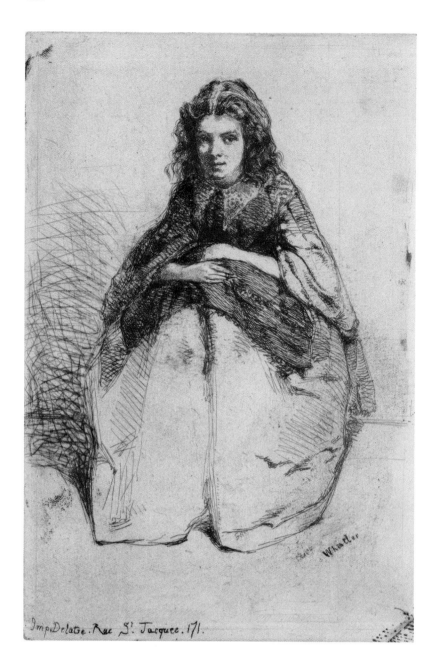

When Whistler came to Paris and entered the *atelier* of Charles Gleyre in June of 1856, he brought with him a style of draftsmanship that had absorbed the lessons learned from Rembrandt. Dark chiaroscuro contrasts created by intricate webs of crosshatching provided Whistler with a rich and descriptive means of recording a scene. Whistler's own wit and facility enabled him to capture the essence of his subject with great economy.

This ability to grasp the essentials of personality and mood is found in his image of his Parisian mistress, Eloise, a *grisette* known as "La Fumette." A milliner, she lived with the artist on the Rue St. Sulpice, according to the Pennells, "together in misery, for two years."[1] She was known for having an explosive temper and the personality of a tigress, and is said to have destroyed the drawings in Whistler's studio in a jealous rage.[2] Her watchful, feline self-possession is admirably captured here, as is the sense that, although contained within the circumscribed outline of her form, she possesses an animal vitality which is barely held in check. Whistler has created a vignette within the work by concentrating his attention on the dark hair framing Fumette's intense, sidelong gaze, and on details of her dress, such as its lace collar, sleeves and apron. The front part of her skirt is left comparatively less developed, and the background is summarily indicated with a few lines. The wary mood of the sitter is revealed in the way the figure, seated on a low step or stoop, hunches forward as though prepared to spring to her feet. Her face is partly obscured by shadow, and her averted gaze contributes to an enigmatic but moving portrait of this tempestuous Parisian.

CM

1 Pennell and Pennell, *Journal*, 91.
2 Pennell and Pennell, *Life* (1911), 39.

8 En Plein Soleil
from the "Twelve Etchings from Nature,"
or the "French Set"
1858

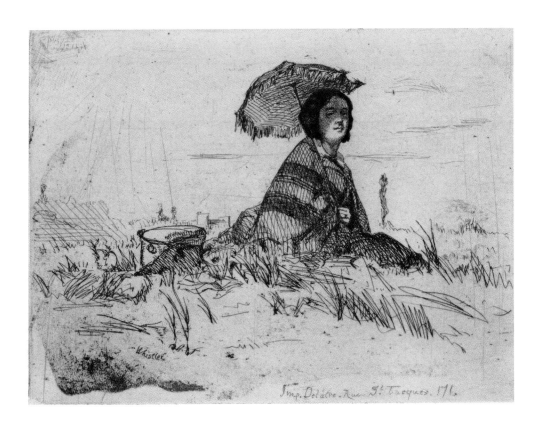

Etching, printed in black ink on Japan paper,
laid down on white wove paper

K. 15 ii/ii

Plate: 10.1 x 13.5 cm. (4 x 5 3/8 in.)
Sheet: 24.8 x 32.4 cm. (9 3/4 x 12 3/4 in.)

Signed on the plate, l.l.: Whistler
Inscribed on the plate, bottom right: Imp. Delatre.
Rue St. Jacques. 171.

Collection: Charles Sydenham Haden (no mark)
Purchased from P. & D. Colnaghi & Co.,
London, 1932

Bequest of Margaret Watson Parker, 1954/1.322

French art of the nineteenth century is celebrated for the practice of executing works directly from the model and, in the case of landscape painting later in the century, for painting out of doors. The Impressionists are given the credit for the transformation from studio creation to *plein air* painting, but there were antecedents in earlier artists such as Boudin and, to a lesser extent, Courbet. Whistler came under the influence of the older Courbet when he studied in Paris; they even traveled to the Normandy coast and painted seascapes together. An example from this period of Whistler's work is the Museum's early seascape *Sea and Rain*. Courbet's works, however, even those set in landscape, were largely finished in the studio. *En Plein Soleil*, on the other hand, typifies this new taste in contemporary French art for the immediacy of a work drawn directly from the subject.

Working from a low vantage point, Whistler has placed the woman on a hillock with a view of a distant town and poplar tree behind her, so that her form becomes an imposing mass on the horizon line. Whistler has created an engaging image of his model, uniting the composition through the use of diagonal hatching lines. Her parasol forms part of this interplay of intersecting lines, thereby merging with her figure. Whistler's quick notational style has allowed him to record specific details of the environment. The bright play of sun and shade upon her face, the veiled half-shadow cast by the parasol, and the wind-whipped fringe and grasses all contribute to the immediacy of the scene and to the artist's developing powers to capture nuances of his subject.

CM

9 **The Wine Glass**
1858

Etching, printed in black ink on laid paper;
watermark: (partial) PRO PATRIA

K. 27 ii/ii

Plate: 8.2 x 5.5 cm. (3 3/16 x 2 1/8 in.)
Sheet: 20.8 x 16.8 cm. (8 1/8 x 6 9/16 in.)

Signed on the plate, l.l.: Whistler

Purchased from C. & J. Goodfriend, New York,
1992

Gift of the Friends of the Museum, 1992/2.4

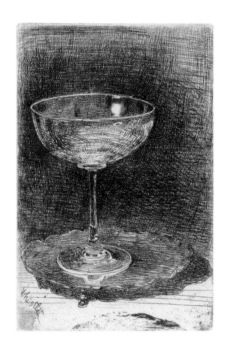

Whistler's early training in etching received a solid technical grounding during his brief involvement in the United States Coast Survey from 1854-55. At the Coast Survey Whistler was trained to make detailed topographical maps, first in the Drawing Division and then in the Engraving Division. His few existing Coast Survey etchings reveal his fluency in the new medium and also suggest how difficult it must have been for him to sustain the concentration and discipline which he lacked as a cadet at West Point. As during his three years at West Point (1851-53), he was remembered at the Coast Survey for his irreverent jokes and truancy; however, he also was clearly a young man with considerable talent in drawing and he quickly mastered the medium of etching.[1] Whistler's early coast elevations reveal how adept he was at etching the assigned coastline, and yet how impossible it was for him to refrain from creating vivid marginalia in the form of doodles (fig. 9a). After a few months Whistler quit the Coast Survey and, armed with his new expertise in printmaking, he went to Paris, stopping en route in London to visit his sister's family and to study once again his brother-in-law's outstanding collection of prints.

Whistler's half-sister, Deborah, had settled in London in 1847, after marrying a prominent surgeon, Francis Seymour Haden. Whistler lived with them shortly after they were married. Seymour Haden was a skilled amateur artist and an avid collector of etchings and engravings. Haden's skill as a draftsman, the availability of a printing press in the upper floor of the Haden's house, and Haden's extensive print collection provided Whistler with a comprehensive overview of the potentials of the etching medium. Among Haden's print collection were works of both contemporary and old master printmakers, including 139 etchings by Rembrandt. Throughout Whistler's career the example of Rembrandt remained a powerful one. In fact, Whistler referred to Rembrandt as "the Master," and his early etching style, like that of his realist contemporaries, was steeped in the naturalism of the Dutch artist. The Haden collection was also strong in the works of Ostade, Hollar, and van Dyck, as well as in modern works by Charles Meryon, Alphonse Legros, and Charles Emile Jacque.

Among Whistler's early etching endeavors executed while staying with the Hadens in 1858 is *The Wine Glass*. Seen on a dark table, the brilliantly lit goblet in this work allowed Whistler to experiment with dramatic contrasts of textures, light and shadow much as Rembrandt had done.[2] The deftness with which Whistler masters the placement and definition of the wine goblet shows how he combined strength of observation with a delicacy for handling this new medium. The manner in which the light passes over the surfaces of the glass demonstrates Whistler's ability to render with great assurance a substance as complicated as reflective glass: the bright rim silhouetted against the dark foil of the background, the gleam of light on the inner surface of the bowl, and the way the edge of the foot of the goblet, like the rim above it, is set in stark opposition to the dark tray on which the glass stands. The composition of light and dark arcs and ovals is enriched by the fine hatching lines that form the dark background, and by the tiny vertical hatching lines in the bowl of the goblet which suggest the texture of the substance itself, including the irregularities of air bubbles embedded in the glass. Whistler has avoided creating a static image by emphasizing the flickering lights and reflective quality of the goblet and by placing the glass slightly to one side of the footed tray. The result is a subtly asymmetrical arrangement upon the copper plate.

CM

9a *Sketches on the Coast Survey Plate*, etching, K. 1, The Metropolitan Museum of Art, Gift of J. Pierpont Morgan, 1917 (17.3.1)

1 Interestingly, although Whistler was discharged from West Point, he retained fond memories of the period he spent in the military academy. He was very proud of his West Point days and was even sentimental about them. He donated a copy of his *Art and Art Critics* to the West Point library with the dedication, "From an old cadet whose pride it is to remember his West Point days" (Pennell and Pennell, *The Art of Whistler* (New York: The Modern Library, 1928), 112).

2 Lochnan compares *The Wine Glass* to Rembrandt's *The Shell*. Both contain brightly lit objects against a dramatically darkened background (Lochnan, *Etchings*, figs. 71 & 72). It could be argued that Whistler was attempting to surpass the older artist by choosing as his subject a material as tricky as glass.

10 Finette

1859

Etching and drypoint, printed in black ink
on laid Japan tissue

K. 58 iii/x

Plate: 29.1 x 20.1 cm. (11 3/8 x 7 13/16 in.)
Sheet: 35.3 x 23.3 cm. (13 3/4 x 9 1/16 in.)

Signed and dated on the plate, l.r.: Whistler. 1859.
Inscribed in pencil, l.l.: Early state. W.—

Collection: H.S. Theobald (no mark)
Purchased from M. Knoedler & Co., New York,
1907

Bequest of Margaret Watson Parker, 1954/1.342

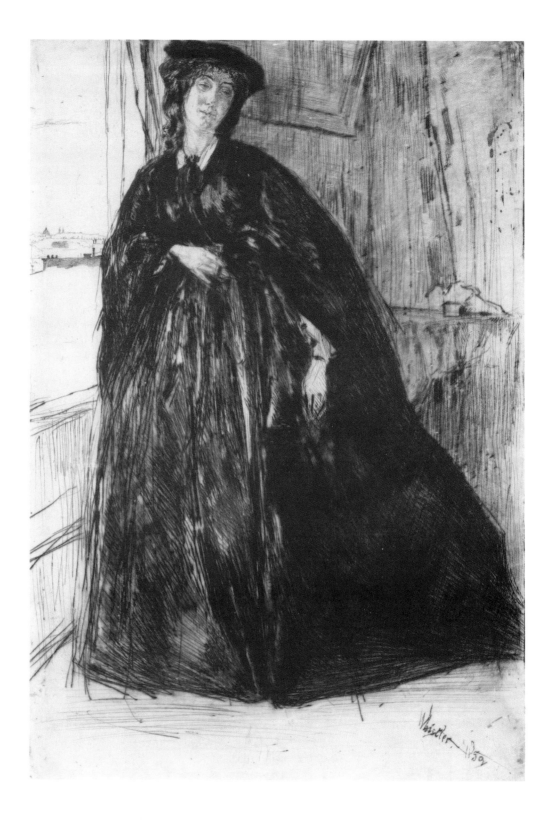

Of Whistler's portraits of his bohemian friends and fellow artists, perhaps none is as imposing as the portrait of Finette, a *cocotte* seen standing in her apartment on the Boulevard Montmartre. She was described by Whistler's friend and critic, Théodore Duret, as "a creole of light character who danced at the Bal Bullier," a dance hall located at 33 avenue de l'Observatoire.[1] This early state shows the face and dark dress largely completed, but the still life on the table is yet to be realized. These objects, including a fan and a mask—the accoutrements of a coquette[2]—will be added in later states, along with the completion of the balustrade and view of Paris out the window (fig. 10a).

Whistler has created an image of spectacular contrasts. Both the nascent landscape and Finette's face are rendered in the most delicate lines as the reflected light falls across the woman's face. In juxtaposition to these delicate passages is the richly drawn drypoint of the dress and hair, the latter framing the features in dark, heavy locks (fig. 10b).[3] Her pose reflects Whistler's admiration for the work of the Flemish painter and etcher Anthony van Dyck, whose works Whistler saw at the Manchester Art Treasures exhibition earlier that year. Finette's commanding figure is drawn from the tradition of aristocratic portraiture, of which van Dyck was an exponent.[4] Whistler must have thought highly of *Finette*. Ralph Thomas noted that "the early states of all of the drypoints, as I have stated elsewhere, are not to be had," and the artist "guarded them jealously."[5]

Finette herself, described by the Pennells as "very elegant," continued to dance after Whistler's association with her ceased. She went to London and danced the cancan at dance halls there, introduced to her audiences as Madame Finette.[6]

CM

1 Duret, *Whistler*, 19.
2 A similar opinion regarding the objects on the table has been recorded by Hilarie Faberman in an unpublished manuscript (Museum files).
3 In *Finette* Whistler was exploring the visual possibilities of a dark fabric as strong light from the window falls across the figure. Whistler himself signals the import of the dress in an impression in the New York Public Library which carries an inscription in Whistler's hand, "Lady in blue dress." Whistler's emphasis on the dress was conveyed through the rich blacks of the drypoint, and this was remarked upon at the time by Ralph Thomas, who described her "velvet dress" (no. 56).
4 Lochnan, *Sources of Whistler's Early Style*, 148.
5 Thomas, *Catalogue*, no. 56.
6 Pennell and Pennell, *Journal*, 91.

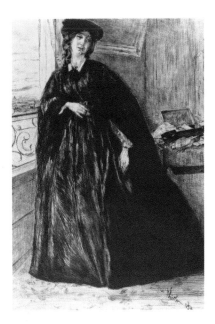

10a *Finette*, K. 58, ix/x, S.P. Avery Collection, Miriam and Ira D. Wallach Division of Art, Prints and Photographs, The New York Public Library, Astor, Lenox and Tilden Foundations

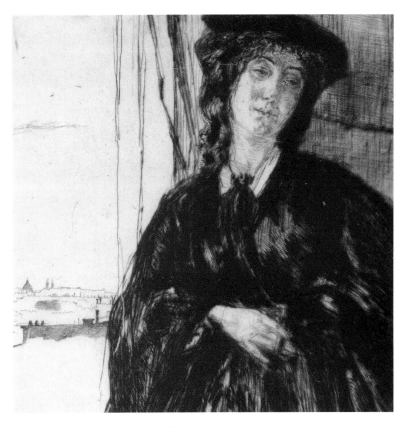

10b *Finette*, K. 58, iii/x, detail (actual size)

11 Arthur Haden

1859

Drypoint, printed in black ink on laid Japan tissue

K. 61 iii/iii

Plate: 22.5 x 15.2 cm. (8 7/8 x 6 in.)
Sheet: 38.2 x 26 cm. (15 x 10 1/4 in.)

Signed and dated on the plate, l.l.: Whistler. 1869.
Inscribed in pencil, lower margin: Portrait of
Arthur Seymour [not in Whistler's hand]

Collection: Sir John Day. (Lugt 526)
Purchased from Obach & Co., London, 1908

Bequest of Margaret Watson Parker, 1954/1.343

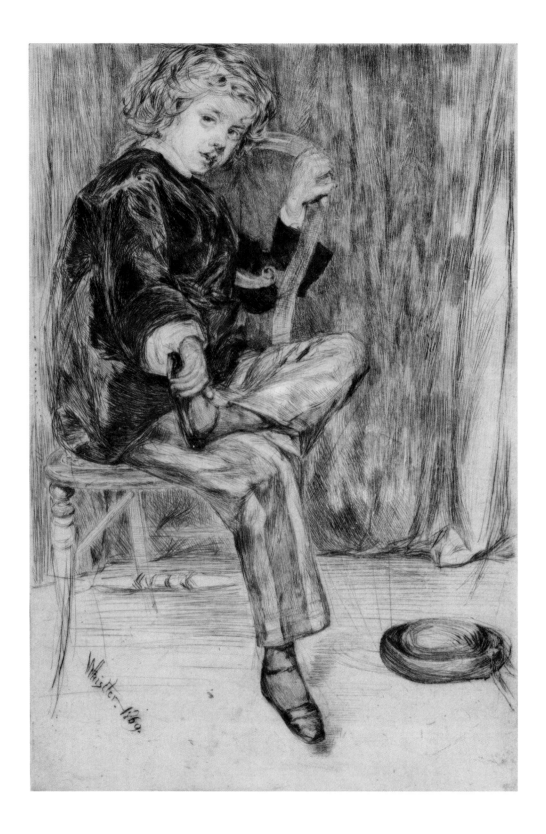

This image of Arthur Haden, seen here sitting sideways in a chair, was possibly conceived as a pendant to the figure of his older sister, *Annie Haden* (cat. no. 12). This portrait, like that of Annie, shows Whistler's interest in, and ability to render, differences in fabric: the carefully pleated pants legs, the loosely arranged curtain, and the shiny patent leather shoes. When composing his portraits, Whistler was always careful to depict the sitter in attire and in an attitude which would have been considered characteristic. The personalities of the artist's nephew and niece are evidenced by their poses: Arthur turns in space, fidgeting, while Annie's more static, standing figure is portrayed at a greater distance from the viewer. Arthur's unabashed engagement is contrasted to Annie's relative withdrawal.

As Whistler's art increased in technical expertise and personal expression, the unspoken tension between the brothers-in-law deepened, fueled by professional jealousy. Seymour Haden, Whistler's early mentor and informal etching teacher, received more public recognition than Whistler, including—eventually—a knighthood. Whistler, who surpassed Haden in both ability and creativity, was stung by the unfavorable comparisons. The final breach came in 1867. James Reeves Traer, Haden's medical partner and a close friend of Whistler's, died suddenly in Paris and was hastily buried there by Haden. Whistler, infuriated by Haden's peremptory disposal of his friend, got into a public argument about the incident with Haden in a Paris café, pushing him through a plate glass window. The men never spoke again. Thus, symbolically and literally, Whistler severed his ties to Haden's influence and began at this time to turn away from Realism, eventually embracing in the 1870s the tenets of Aestheticism and "Art for Art's Sake."

CM

Drypoint, printed in black ink on laid paper

K. 62 iii/iii

Plate: 35.1 x 21.5 cm. (13 13/16 x 8 1/2 in.)
Sheet: 47.1 x 32.9 cm. (18 1/2 x 12 15/16 in.)

Signed and dated on the plate, l.l.: Whistler.
1860. ("6" is in reverse)
Notation in pencil, lower margin [possibly by
Beatrix Whistler]

Collection: Royal Library, Windsor (Lugt 2535)
Purchased from Obach & Co., London, 1906

Bequest of Margaret Watson Parker, 1954/1.344

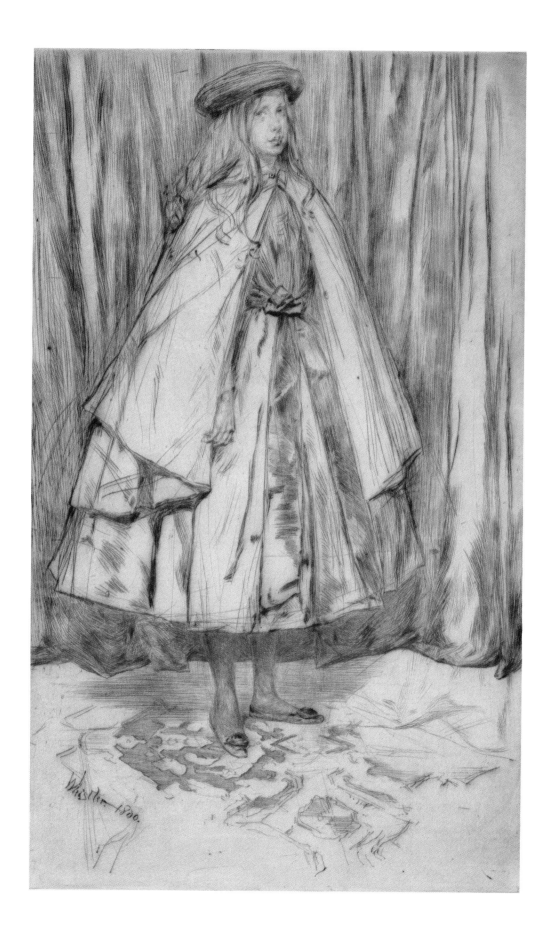

Whistler's affection for his sister and her family is evident in the early works done of the family, both before he studied in Paris and afterwards in the 1860s when he settled in London. Depicted here is Whistler's twelve-year-old niece, Annie Harriet Haden. Posed full-length before a curtain, Annie stands at an angle, gazing at the viewer. Her self-contained form against the curtained backdrop recalls the painted and etched portraits of Velásquez which Whistler had seen and admired at The Art Treasures Exhibition held in Manchester in 1857. From her infancy onward, he frequently used Annie as a subject.[1] One of these portraits of Annie standing became part of the "French Set" and is included in the Museum of Art's complete "French Set" (app. no. 3).

Whistler considered *Annie Haden* one of his finest prints. He told his dealer, Edward Kennedy, that Annie was his best work,[2] and when in 1900 Whistler indicated that he would like to have approximately thirty of his prints included in that year's Exposition Universelle, he told Howard Mansfield that among the selection he would include "the fine full length of Annie Haden (dry point)."[3] It was at this Paris exposition that Whistler took the Grand Prix in etching.

Annie Haden, standing in hat and cape as though to go out, justifies Whistler's high praise. Although derived from aristocratic portraiture, her pose and expression underscore the awkwardness of a young girl and emphasize the shy and melancholy expression of her deep set eyes. Executed entirely in drypoint, *Annie Haden* has both the same pose and the introspective and meditative qualities that will be seen in Whistler's portrait of Joanna Hiffernan exhibited in the Salon des Refusés, *Symphony in White No 1: The White Girl.* (see fig. 18a). The finely balanced cloth textures—the curtain, dress, sash and cape—demonstrate Whistler's ability to suggest the textural differences between fabrics, distinctions captured by the accents of drypoint burr. Yet for all of this technical subtlety, it is the haunting expression of the artist's young niece, framed by her hat and curling locks, that most arrests the viewer.

CM

1 Among works on paper are included an early pencil drawing of Annie as a baby, *Ma Nièce*, at the Hunterian Art Gallery, University of Glasgow, and several etchings, K. 8, K. 10 and K. 30.
2 Getscher, *Stamp*, 27.
3 Lochnan, *Etchings*, 269.

13 The Pool

from the "Sixteen Etchings," or the "Thames Set"
1859

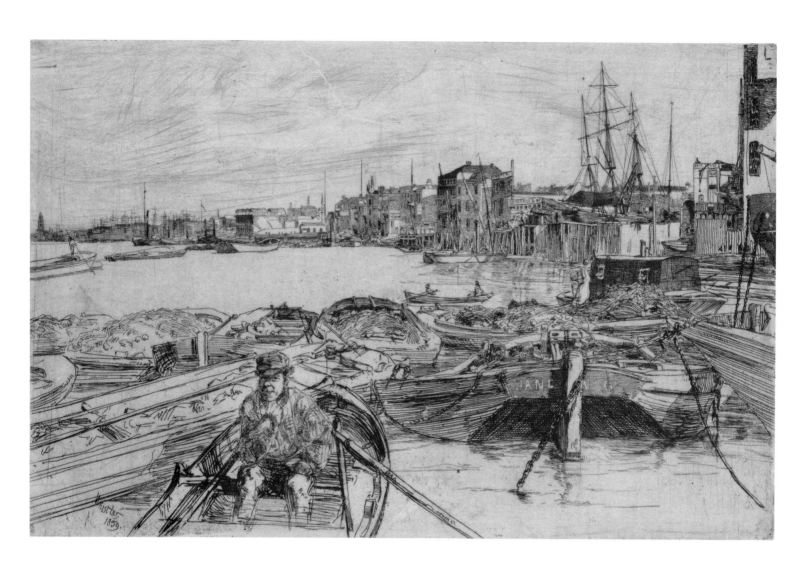

Etching, printed in dark brown ink on laid
Japan tissue

K. 43 undescribed state between iii and iv/iv

Plate: 13.9 x 21.5 cm. (5 7/16 x 8 3/8 in.)
Sheet: 24.5 x 34.2 cm. (9 9/16 x 13 5/16 in.)

Signed and dated on the plate, l.l.: Whistler. /
1859.

Purchased from P. & D. Colnaghi & Co.,
London, 1927

Bequest of Margaret Watson Parker, 1954/1.337

Whistler left Paris in May of 1859 and settled temporarily in London, dividing his time from spring through autumn between the Hadens' comfortable home and the much less refined surroundings of the warehouses and wharves of the London Docks. From early August he lived in Wapping and Rotherhithe, just east of the Tower of London, where he could immerse himself in the commercial ambience of a stretch of the Thames known as the Pool. The river as a place of work and a way of life claimed his artistic attention and provided most of the subjects for a collection of etchings he eventually published as the "Thames Set." Whistler produced eight plates for that project during the two months he spent in the vicinity of the Pool, effectively translating into English the realist concerns of his "French Set."

The Pool exemplifies the approach Whistler took in his Thames etchings of 1859. In the crowded foreground, a conspicuously placed figure directly engages the viewer and provides local color before the strip of space he occupies abruptly gives way to a largely empty middle distance. The etching's descriptive line then resumes in the background with tight, staccato variations on the comparatively longer rhythms established in the foreground's jumble of moored boats. The composition thus separates into three distinctly horizontal zones, the open middle ground activated by isolated elements such as the procession of barges at the far left. The introduction of such passages also contributes to an illusion of depth.[1] That sensation of spatial recession combines with dense, two-dimensional surface patterns—particularly evident in the background buildings—to create a visual amplitude, as well as a subtle tension, appropriate to the representation of the Pool's bustling trade and traffic.

Whistler pulled proofs of his Thames etchings in 1859-60 with Auguste Delâtre, who arrived in London from Paris to assist with the printing. The plates were steel-faced by 1871, when the London publishing house of Ellis and Green issued one hundred sets of *A Series of Sixteen Etchings of Scenes on the Thames and Other Subjects.* Further editions of the "Thames Set" were published in 1879 and 1890, and additional sets probably were printed before the plates were canceled in 1897.[2] A selection of these etchings was shown at a small Paris gallery in 1862, where they were enthusiastically noticed by Baudelaire as evocations of "the profound and intricate poetry of a vast capital."[3] Impressions of *The Pool* itself were exhibited the following year, both in London, at the Royal Academy, and at the Paris Salon.

The formal publication of the "Thames Set" met with a great deal of positive response from English critics who especially approved the artist's ability to find picturesque aspects in a seemingly unpromising subject. As one reviewer put it, the Thames plates captured the essence of an area "where masts and yards score the sky over your head, and fleets of barges darken the mud and muddy water at your feet, and all is pitchy and tarry, and corny and coally, and ancient and fish-like."[4] Such favorable reaction survived even when the rest of Whistler's reputation suffered later in the 1870s and 1880s, and the etched work of "the recorder of 'Billingsgate,' the historian of 'Wapping'" was frequently set in contrast to the aesthetic offenses allegedly perpetrated in his paintings.[5]

Above all, London audiences appreciated *The Pool* and related etchings for their visual documentation of a local scene fast disappearing as the Thames was being reshaped within a developing culture of commerce and industry under the demands of Victorian empire. Writing in 1895, Joseph Pennell looked back at the etchings as valuable souvenirs of sites creatively interpreted. "In the Thames plates," he observed, "it was Mr. Whistler's aim to show the river as it was in 1859, and each of them is a little portrait of a place, a perfect work of art."[6]

JS

1 For a discussion of the pictorial strategies (and the various influences informing them, from Japanese prints to photography) in the Thames etchings, see Lochnan, *Etchings*, 85-100.
2 The complicated publishing history is fully recounted in Katharine Lochnan, "'The Thames from Its Source to the Sea': An Unpublished Portfolio by Whistler and Haden," in Fine, ed., *Whistler: A Reexamination*, 45 (n.61).
3 Charles Baudelaire, *Art in Paris, 1845-62,* trans. and ed. Jonathan Mayne (London: Phaidon, 1965), 220.
4 "A Whistle for Whistler," *Punch* 60 (17 June 1871): 245.
5 Frederick Wedmore, "Mr. Whistler's Theories and Mr. Whistler's Art," *The Nineteenth Century* 6 (August 1879): 334.
6 Joseph Pennell, "Mr. Whistler's Etchings," *The Daily Chronicle* (22 February 1895); rpt. in Frederick Keppel, comp., *Concerning the Etchings of Mr. Whistler* (New York: Keppel, n.d. [1895]), 9.

14 The Lime-burner

from the "Sixteen Etchings," or the "Thames Set"
1859

Etching and drypoint, printed in black ink
on laid Japan tissue

K. 46 ii/iii

Plate: 25.4 x 17.7 cm. (9 3/4 x 7 in.)
Sheet: 29.9 x 21.3 cm. (11 3/4 x 8 3/8 in.)

Signed and dated on the plate, l.r.: Whistler. 1859
Signed lightly on the plate, l.l.: Whistler

Purchased from R.M. Light & Co., Inc.,
Santa Barbara

The Alfred E. Pernt Memorial Fund, in honor
of Dr. of Technical Sciences Max H.J. Pernt and
his wife Anna Pernt (née Mueller), 1986/2.14

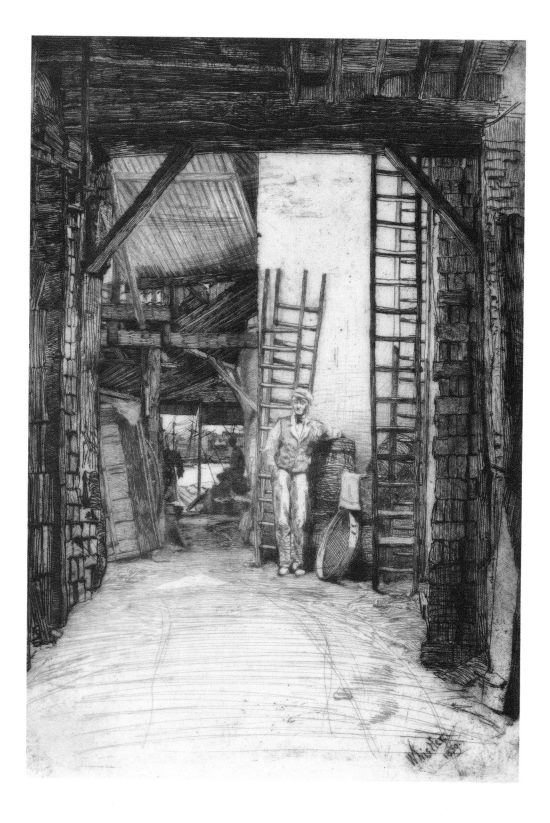

Of the images in the "Thames Set," most include a figure; many are set along the wharves and include a figure of a man seated in a boat in the immediate foreground. Originally exhibited at the Royal Academy in 1860 under the title *W. Jones, Lime-burner, Thames Street*, the etching shows Mr. Jones standing in a warehouse and facing out to the viewer, engaging our attention. Whistler has chosen both a boldly dramatic and highly complex setting. The image is framed on three sides by an intricately hatched framework—literally—of timbers, posts, beams, and ladders. This dark, tunnel-like space is suddenly flooded by light coming from an overhead shaft. In the distance behind Mr. Jones, a figure sits in shadow gazing out toward the ships and wharves beyond the far side of the building. The only other area of bright daylight is the unetched triangular area on the floor. This dramatic alternation of light and dark becomes a *leitmotif* in the print and is picked up in the handling of the ladders. Behind the lime-burner stand two ladders which, like the figure, are brightly lit. As a counterpoint to those are the two ladders to the right of the composition and closer to the viewer. The figure, so beautifully and freely drawn in fine drypoint, stands poised between these two groups of ladders (fig. 14a). Reinforcing the structural composition of the etching is the tight hatching of the woodwork. Throughout the composition there is a closely related play of grids, brickwork and beams. The profound darkness of the interior passageways and labyrinthine profusion of dark beams and angles recall the spatial complexity of Piranesi's *Carceri* etchings.

As an image of a lower class laborer in the disappearing docksides of London, *The Lime-burner* is a realist rendering of a gritty side of contemporary urban life. The dramatic lighting and the precise descriptive line demonstrate how thoroughly Whistler has assimilated the work of Rembrandt. The resulting image has a haunting, vacant quality, in which the enveloping darkness of the warehouse is balanced by the limpid figure of the lime-burner. The Industrial Revolution and its shabby structures have created a new type of prison, as suggested by this figure standing in isolation.

CM

Shown in Ann Arbor only

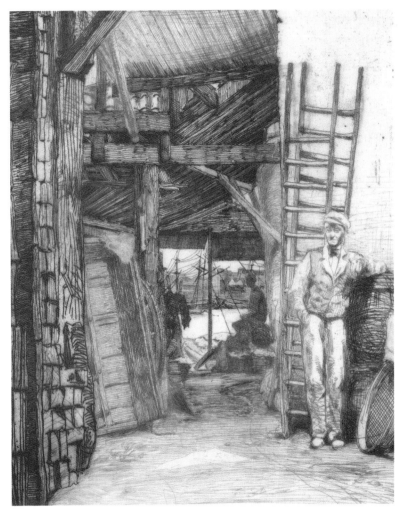

14a *The Lime-burner*, K. 46, ii/iii, detail
(actual size)

15 **The Forge**
from the "Sixteen Etchings," or the "Thames Set"
1861

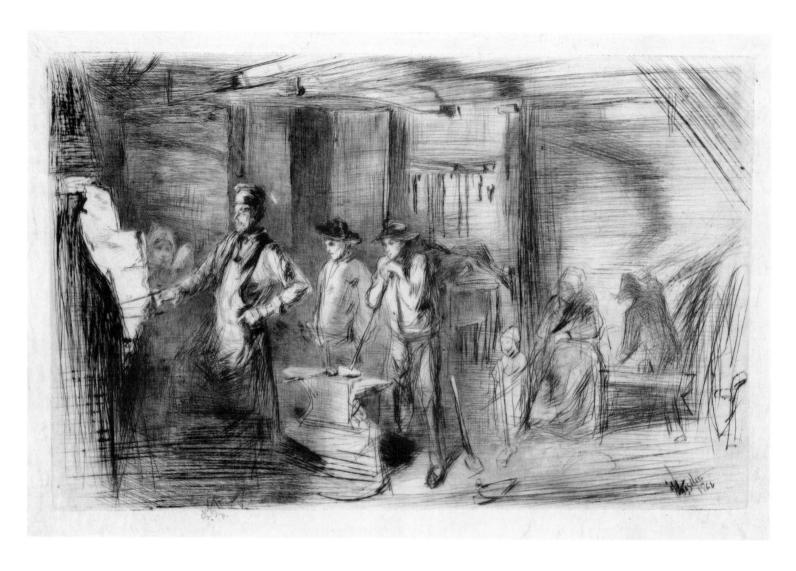

Drypoint, printed in black ink on laid Japan tissue

K. 68 iii/iv

Plate: 19.2 x 30.5 cm. (7 1/2 x 11 7/8 in.)
Sheet: 25.9 x 36.5 cm. (10 1/8 x 14 1/4 in.)

Signed in pencil, l.l. margin: butterfly and imp.
Signed and dated on the plate, l.r.: Whistler. / 1861.

Collections: Howard Mansfield (Lugt 1342);
H.S. Theobald (no mark); B. Bernard McGeorge
(Lugt Suppl. 394)
Purchased from M. Knoedler & Co., New York,
1907

Bequest of Margaret Watson Parker, 1954/1.347

The Forge was the only print from the "Thames Set" to be executed completely in drypoint. According to Whistler, it was also the only image of the set printed entirely by the artist himself. One of two images in the "Thames Set" which is not British, *The Forge* depicts a scene from the Brittany coast in France, at Perros-Guirac. Whistler was fond of the Brittany coast and visited it several times during his life. Returning to France in 1893 to seek treatment for his ailing wife, Beatrix, he produced one of his few color lithographs, *Yellow House, Lannion* (cat. no. 72), in the nearby town of Lannion.

This etching was the first example in Whistler's prints of figures working in front of a forge—a theme to which he repeatedly returned. As a subject the image had dramatic visual possibilities, which are evident in *The Forge* from the "Thames Set." The theme also reflects Whistler's early orientation in Realism and its images of labor. In each of his many prints on the subject, Whistler handles the theme differently. But although an example such as *The Little Forge* (app. no. 55) captures the physical labor of a smith, none of the prints combines the immediacy and vibrancy of the drypoint technique with the ethereal quality of light as this one does, where the master smith's labor is transformed into a conjurer's art.

The Museum's impression of *The Forge* is an especially rich one. The drypoint burr has not yet been eroded by repeated passes through the press, and the rich textural quality of the inking creates spectacular contrasts of light and dark. The smith, positioned between the furnace itself and the anvil, is isolated from his assistants and the figures in the room at the right. The dark mass of the edge of the furnace is juxtaposed against the brightly lit open furnace. The white-hot light illuminates the face of the smith, and his features are captured in fine, delicate lines (fig. 15a). Like the *Lime-burner, The Forge* captures the effect of a figure, itself brightly lit, within a darkened architectural setting. That framework, however, is treated quite differently in the two prints; instead of a series of rectangles and squares arranged parallel to the picture plane as they are in the *Lime-burner*, the architecture and the figures in *The Forge* are set at an angle so that they create a sense of recession into space. In addition, *The Forge* is very freely drawn, as is evidenced by the way the smith's legs disappear into the darkness surrounding the forge, an effect quite different from the precision and clarity of the other images in the "Thames Set."

CM

Shown in Ann Arbor only

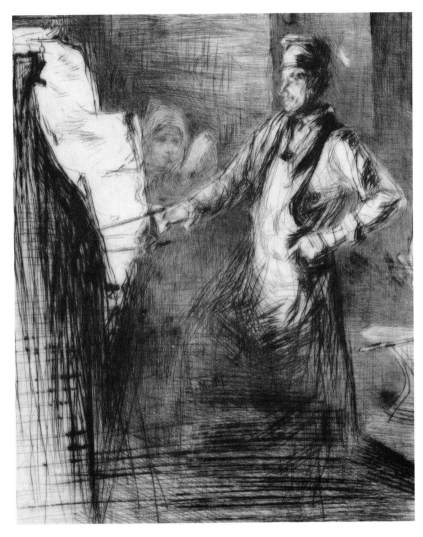

15a *The Forge*, K. 68, iii/iv, detail
(actual size)

16 Rotherhithe

from the "Sixteen Etchings," or the "Thames Set"
1860

Etching and drypoint, printed in black ink
on laid Japan paper

K. 66 iii/iii

Plate: 27.8 x 20.1 cm. (10 13/16 x 7 13/16 in.)
Sheet: 36.8 x 28 cm. (14 3/8 x 10 15/16 in.)

Signed and dated on the plate, l.l.: Whistler. 1860.

Bequest of Margaret Watson Parker, 1954/1.345

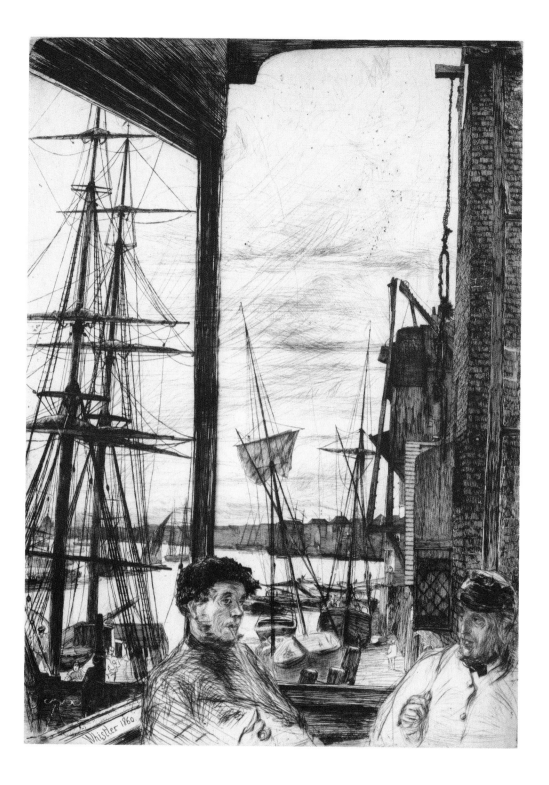

Rotherhithe presents a view from the balcony of The Angel, a tavern in Cherry Gardens on the south bank of the river, looking northwest to the Wapping side and beyond to the dome of St. Paul's at the extreme left. The precise orientation of the scene and its topographical accuracy have been matters of some debate.[1] Beyond dispute, however, is the relatively equal weight Whistler gives in this etching to the Thames setting and the figures placed before it. The two workers represented with individual attention in the foreground of *Rotherhithe* speak to Whistler's desire in the early 1860s to integrate within a single, striking image the genres of portraiture and landscape.

That ambition is most fully expressed in a closely related painting begun in 1860. Whistler conceived of *Wapping* (fig. 16a), a picture that shares the same balcony vantage of the etching, as a modern-life tableau worthy of submission to the Salon or Royal Academy. His mother described the composition to a friend in words that could apply equally to the riverscape etchings: "The Thames & so much of its life, shipping, buildings, steamers, coal heavers, passengers going ashore, all so true to the peculiar tone of London & its river scenes."[2] The artist himself discussed his painting at length in a letter to his friend and colleague Fantin-Latour, calling the work-in-progress a future "masterpiece" and imploring him not to reveal its subject to Courbet.[3] As their correspondence around this time indicates, both Whistler and Fantin-Latour were determined to work "from nature," and each was struggling with the objective to paint in the open air before his chosen motif. Whistler intended *Wapping* largely as a statement of his successful negotiation of that enterprise. *Rotherhithe*, too, must have been executed at least partly *en plein air*, for the long vertical line visible in the etching's sky is said to have been caused by a slip of the etching needle when a falling brick from a nearby warehouse startled Whistler as he was absorbed in his work.[4]

Both *Wapping* and *Rotherhithe* were designed to demonstrate the complexity of the artist's craft. Innumerable hatched lines laid down in parallel patterns describe the different textures in the buildings at the right of the etching, and the intricate rigging of ships' masts must have posed an extreme test of the painter's abilities. Indeed, Whistler wrote Fantin-Latour that the background of *Wapping* was "like an etching" and difficult to handle, suggesting that what he could effectively obtain with a linear technique was a challenge to duplicate in the medium of painting. Whistler reworked his canvas over the course of the early sixties, eventually minimizing the narrative connotations of the young woman's relationship to her male companions, a dynamic that now remains open to interpretation. P.G. Hamerton perceived a comparable kind of ambivalence in the artist's attitude toward the subjects of his early Thames etchings. Unlike the many critics affected by the "portraiture of place" and the artistic empathy it implied, Hamerton decried what he identified as Whistler's indifference to "the common life" he depicted. "The only people for whom he seems to have a sort of liking are the Thames bargemen," Hamerton conceded, perhaps with *Rotherhithe* specifically in mind, "and he has sketched them not unfaithfully, with appropriate costume and short pipes."[5]

Whistler showed his etching at the Royal Academy exhibition of 1862 under the title it bears today, and his painting was accepted by the Academy for display two years later. When the "Thames Set" etchings were published in 1871, as if to complete the connections between the two images, *Rotherhithe* was retitled *Wapping*.

JS

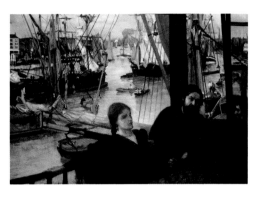

16a *Wapping on Thames*, oil on canvas, John Hay Whitney Collection, ©1993 National Gallery of Art, Washington

1 Margaret MacDonald contends that the image was reversed on the plate so the print would correspond to the actual site (*Graphic Work*, 15), while Robert Getscher argues that a view towards St. Paul's would necessarily take in London Bridge, which is not depicted, and suggests that the dome was inserted to give the scene a recognizably "London" imprint (*Stamp*, 57-58). Katharine Lochnan points out that St. Paul's is visible from the vantage Whistler assumed, although he did not compensate for the reversal of the image (*Etchings*, 116).
2 Anna McNeill Whistler to Mr. [James] Gamble, 10 February 1864, Glasgow University Library, Whistler Collections (hereafter cited as GUL) Whistler W516.
3 Whistler to Fantin-Latour, n.d. [1861], Pennell-Whistler Collection, Library of Congress, Manuscripts Division (hereafter cited as PWC) 1.
4 Duret, *Histoire de Whistler*, 14.
5 Hamerton, *Etching and Etchers*, 229.

Etching and drypoint, printed in dark brown ink
on laid paper; watermark: V I

K. 78 ii/iia

Plate: 22.6 x 15 cm. (8 13/16 x 5 7/8 in.)
Sheet: 32 x 19.4 cm. (12 1/2 x 7 9/16 in.)

Collections: Mortimer Menpes (no mark);
H.S. Theobald (no mark)

Purchased from M. Knoedler & Co., New York,
1907

Bequest of Margaret Watson Parker, 1954/1.349

In quiet contrast to Whistler's often intricately worked plates destined for publication and a relatively wide audience, this portrait etching sets a perceptibly personal tone with a minimum of graphic means. Joanna Hiffernan, a young Irish woman the artist had met by 1860, played prominent roles in Whistler's work and life as his principal model, muse, and mistress for the first six years of the decade. She makes her first important appearance in his art as the sphinx-like central figure in *Wapping* (see fig. 16a). Several years after that picture was begun, she posed for the first in his series of three "White Girls" (see fig. 18a), canvases which established Whistler's reputation as a distinctive painter of the human figure.

The second painting in that sequence, *Symphony in White, No. 2: The Little White Girl* (fig. 17a), most closely matches the mood achieved three years earlier in *Jo's Bent Head*. The model's lowered gaze and profile, similarly inclined in both the painting and the print, register a reverie that is reinforced and multiplied in the mirror and in the exotic *japonaiserie* of the accessories and accoutrements accompanying *The Little White Girl*. In the etching, however, this introspection is sustained entirely through a spare and elegant design that focuses the viewer's attention on the young woman's features. Her head and the brief vertical hatching behind it combine as dark passages that play off the mostly blank space of the lower two-thirds of the page, where only a few marks intrude to indicate the outlines of a garment.[1] The strikingly "empty" composition emphasizes the figure's self-absorption and suggests something of her vulnerability.

In addition to this cleanly wiped proof, the Museum of Art owns two other impressions of *Jo's Bent Head*, both from the Margaret Watson Parker Bequest (app. nos. 37, 39). One of these (fig. 17b) surely dates from the 1880s, when Whistler regularly returned to such earlier efforts and reinterpreted them through "artistic printing," primarily by manipulating the film of ink on the plate in ways he had mastered when printing his atmospheric views of Venice after returning from Italy in 1880. The open structure and the expanse of untouched plate in *Jo's Bent Head* lent itself perfectly to such experimentation with process, in effect giving him a blank canvas upon which to create a later variation on the image of a woman who was by then long since absent from his life.

JS

1 This progressive "fading" of the figure was one of Whistler's favorite devices, employed perhaps most effectively in the *Arrangement in Black and Brown: The Fur Jacket* (YMSM 181; Worcester Art Museum, Mass.). Whistler painted this portrait of Maud Franklin, who succeeded Joanna Hiffernan as his mistress, in 1876. He exhibited the canvas the next year and many times thereafter, clearly considering it to be a completed picture.

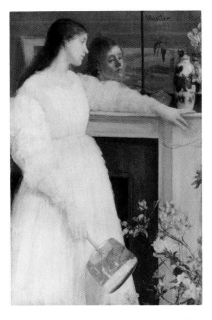

17a *Symphony in White, No. 2: The Little White Girl*, oil on canvas, Tate Gallery, London

17b *Jo's Bent Head*, app. no. 37

18 Weary
1863

Drypoint, printed in warm black ink on laid
Japan tissue, tipped down

K. 92 ii/iii

Plate: 19.7 x 13.1 cm. (7 11/16 x 5 1/8 in.)
Sheet: 27.4 x 19.2 cm. (10 11/16 x 7 1/2 in.)

Signed in pencil, on the sheet, l.r.: Whistler and
butterfly
Signed and dated on the plate, l.l.: Whistler. / 63.
Inscribed in pencil, on the sheet, l.l.: A Lady /
"Weary"
Notation in pencil, on the sheet, u.r.: 71

Purchased from Obach & Co., London, 1907

Bequest of Margaret Watson Parker, 1954/1.353

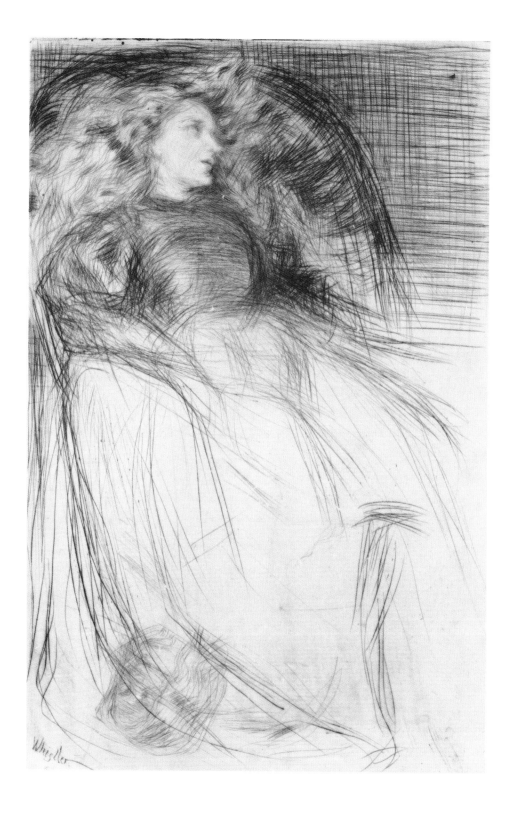

Weary, another drypoint for which Joanna Hiffernan was the model, is often considered one of Whistler's most "Pre-Raphaelite" prints. The Pre-Raphaelite Brotherhood formed in 1848 as a protest by seven young English artists and writers against the Royal Academy's hegemony and the moral and aesthetic degradation the dissidents believed such an official structure perpetuated. Although founded with a clarity of purpose, Pre-Raphaelitism was never a monolithic movement, and the original Brotherhood embraced both the sacral, minutely rendered naturalism of William Holman Hunt (1827-1910) and the dreamy, medievalizing romanticism of Dante Gabriel Rossetti (1828-1882). Whistler met the poet-painter Rossetti in 1862. The following year, the American artist moved to Lindsey Row in Chelsea, where Rossetti was one of his more colorful neighbors.

Rossetti developed a distinctive imagery of feminine languour in his many paintings and drawings of models such as Fanny Cornforth, Jane Morris, and his wife, Elizabeth Siddall. This archetypal woman, reiterated throughout the artist-author's pictorial oeuvre, forms the standard basis for the argument that Rossetti's Pre-Raphaelitism was a source for Whistler's *Weary*.[1] Indeed, with her abundance of copper-colored hair, splayed out in the print against the high-backed chair into which she sinks, Joanna Hiffernan would appear to conform in at least some respects to the physical ideal of the Pre-Raphaelite "stunner." But Whistler here employs the qualities of the drypoint line, at once supple and brittle, to picture in his model's introspection an expression more restrained and fragile than the ample sensuality of Rossetti's voluptuous icons.

A poem, rather than a picture, suggests more intriguing parallels between Rossetti's aesthetic and *Weary*. Rossetti began verses entitled "Jenny" in 1848 and reworked them from 1858 to 1869, a period when Whistler might well have heard the poem read or seen it in manuscript. Katharine Lochnan cites an American newspaper review of a prints exhibition of 1903 in which *Weary* was shown. "Is it true," asks an anonymous critic, "that the original of this beautiful etching is the Jenny of Rossetti's fascinating poem?"[2] The question is phrased in a way that seems to indicate it had been asked before, and that the two works of art had been linked in the past. Rossetti's dramatic monologue presents the musings of a young man who directs his attention to a sleeping prostitute, a figure he addresses and seeks to understand even while he recognizes the futility of that effort: "Yet, Jenny, looking long at you, / The woman almost fades from view" (ll. 276-77). She remains asleep, unknown, other.[3] This theme of woman's evasiveness under male scrutiny is strikingly echoed in

Weary, where the contours of Whistler's model literally "fade from view" in a way that also recalls the progressively diminishing outlines of *Jo's Bent Head* (cat. no. 17). In an effort to inscribe the substance of woman, she literally becomes difficult for the artist and viewer to bring into focus.

Whether or not Rossetti's "Jenny" is an identifiable source in the strictest sense for Whistler's drypoint, both the poem and *Weary* address a similar dynamics of frustrated desire. Rossetti's monologuist sees woman, the object of his contemplation, as "A cipher of man's changeless sum / of lust, past, present, and to come," and as "a riddle" without solution ("Jenny," ll. 278-80). Whistler enshrines Joanna Hiffernan as the essence of feminine enigma in his most extraordinary representation of her, the *Symphony in White, No. 1: The White Girl* (fig. 18a). Among the considerable commentary that accompanied the painting's exhibition in 1863 at the Salon des Refusés was a reading of the picture as an allegory of lost innocence, "that troubling moment when a young woman reflects on the absence of yesterday's virginity"[4] Both monumentally present and disturbingly disengaged, the deliberately ambiguous presentation of *The White Girl*, like that of *Weary*, opens itself up to sexual interpretation.

In a chalk study for *Weary* (fig. 18b) Jo's face and left hand float like disembodied lighter accents against the densely worked backdrop of her dark form. Whistler emphasizes a similar effect in *Weary* itself, juxtaposing a carefully studied face and torso against the structure of a lower body that is here more lightly, loosely rendered than in the drawing to create the figure that "almost fades from view." These elusive, tenuous qualities of the image and its erasure are underlined in the Museum's impression by the thin, transparent paper on which Whistler printed the plate, a use of material means to evoke immaterial properties.

JS

1 See, for example, Alastair Grieve, "Whistler and the Pre-Raphaelites," *Art Quarterly* 34 (Summer 1971): 221. Katharine Lochnan reproduces a Rossetti pencil drawing of Fanny Cornforth, ca. 1862 (*Etchings*, 151).
2 "The Burritt Collection of Etchings," *The Sun* [New York], 22 March 1903, 8; cf. Lochnan, *Etchings*, 149, where the review is called evidence of a "tradition" connecting poem and print.
3 For a brief but penetrating discussion of these aspects of "Jenny," see Jonathan Freedman, *Professions of Taste: Henry James, British Aestheticism, and Commodity Culture* (Stanford: Stanford University Press, 1990), 37-38.
4 Jules-Antoine Castagnary, 1863, quoted in Curry, *Whistler at the Freer*, 41. Whistler showed an impression of *Weary* that same year at the Royal Academy.

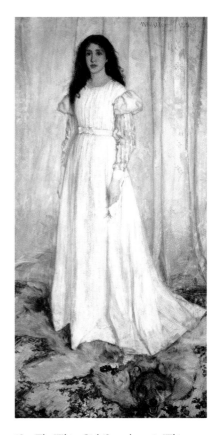

18a *The White Girl (Symphony in White, No. 1)*, oil on canvas, Harris Whittemore Collection, ©1993 National Gallery of Art, Washington

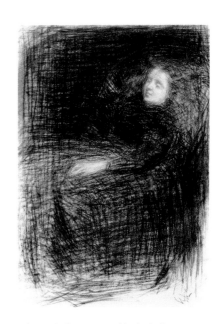

18b *Study for "Weary"*, black chalk, Sterling and Francine Clark Art Institute, Williamstown, Massachusetts

19 **Fanny Leyland**
1873

Drypoint, printed in dark brown ink on laid paper; watermark: Arms of Amsterdam

K. 108 iv/vi

Plate: 19.5 x 13.2 cm. (7 5/8 x 5 1/8 in.)
Sheet: 33.8 x 21.3 cm. (13 3/16 x 8 5/16 in.)

Signed on the plate, center left: butterfly
Inscribed on the plate, u.l.: Fanny Leyland

Collections: unidentified (Lugt Suppl. 2912h);
Royal Library, Windsor (Lugt 2535)
Purchased from Obach & Co., London, 1906

Bequest of Margaret Watson Parker, 1954/1.355

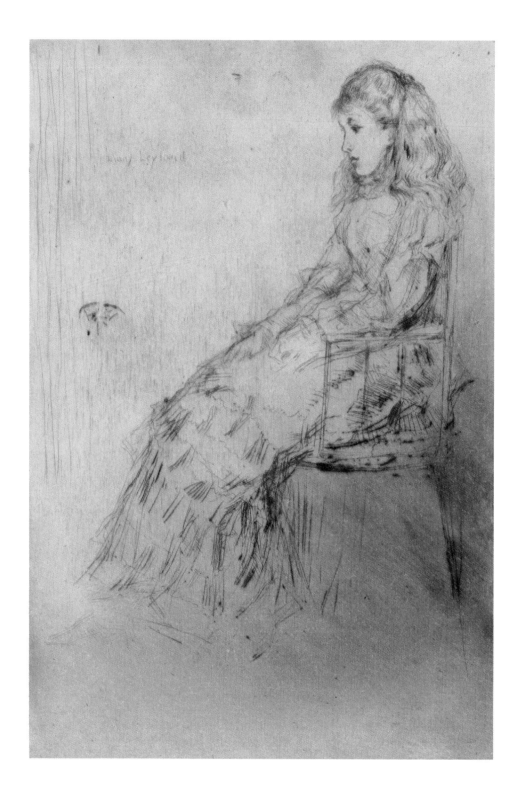

20 Florence Leyland
ca. 1873

Drypoint, printed in dark brown ink on laid paper

K. 110 viii/ix

Plate: 21.4 x 13.8 cm. (8 3/8 x 5 3/8 in.)
Sheet: 32.7 x 20 cm. (12 3/4 x 7 13/16 in.)

Signed in pencil, on the sheet, l.l.: Whistler
Signed on the plate, l.r.: butterfly
Inscribed on the plate, u.r.: "I am Flo"

Collections: J.H. Hutchinson (no mark);
C.W. Dowdeswell (Lugt 690)
Purchased from Obach & Co., London, 1905

Bequest of Margaret Watson Parker, 1954/1.356

In addition to formally conceived sets of etchings produced on his own initiative, Whistler occasionally received requests to create other kinds of works in series, especially portrait ensembles. Such a commission came in the early 1870s from William C. Alexander, a London banker, who asked Whistler to produce pictures of his daughters. Among the works resulting from that undertaking was *Harmony in Grey and Green: Miss Cicely Alexander* (fig. 19/20a), one of Whistler's most appealing full-length portrait paintings. Frederick R. Leyland, a wealthy shipowner from Liverpool and the artist's most important English patron, employed Whistler in a similar project at about the same time, engaging him to paint likenesses of himself, his wife, and his four children.[1] Of that group of canvases, *Arrangement in Black: Portrait of F.R. Leyland* (YMSM 97; Freer Gallery of Art) and *Symphony in Flesh Colour and Pink: Portrait of Mrs. Frances Leyland* (YMSM 106; Frick Collection, New York) are extant. Only one of the children's portrait paintings remains.[2] But the commission gave Whistler ample opportunity during the first half of the seventies to spend time at Speke Hall, the Leylands' Tudor-style home near Liverpool (see app. no. 46). During his visits there, he did complete a large number of pastel studies and several drypoint portraits of the Leyland children.[3]

Fanny Leyland (born 1857) and her younger sister, Florence (born 1859), are depicted in relatively formal poses enlivened by an aura of youthful spirit and grace. Fanny is shown seated in a delicate chair and in the strict profile Whistler most famously employed in his *Arrangement in Grey and Black: Portrait of the Painter's Mother* (YMSM 101; Musée d'Orsay, Paris), a picture begun, like those for the Leyland commission, in the early 1870s. An apparently slight and pensive girl, Fanny is set in contrast to the matter-of fact frontal view of her sister, who stands holding a toy hoop. Whistler seems to have been particularly fond of these prints of the Leyland sisters, for he worked the plates in an extensive number of states (six in the case of Fanny, nine for the portrait of Florence) and made numerous small adjustments, strengthening and retracing the richly linear network that defines the figures and, in the *Florence*, a draped background. Both images were printed with plate tone to suggest shadows that further enhance the velvety softness of the drypoint burr.

Whistler may have exhibited one or both of the Leyland drypoints at his first one-man exhibition, held in 1874 at the Flemish Gallery in London.[4] Among the paintings, prints, drawings, and one decorated screen on display were a number of exhibits listed simply as "Drypoint. Portrait." One prominent English critic characterized that category of works in terms that suggest the Leyland sisters' images of beguiling adolescence were included on the gallery walls. As Sidney Colvin described the gallery installation, "some half a dozen portraits of young girls, done with the drypoint, are exquisite, and show a charm as well as a vividness and address which . . . put them at the head of all Mr. Whistler's engraved work."[5]

JS

1 Pennell and Pennell, *Life* (1908), 1:175.
2 *Portrait of Miss Florence Leyland* (YMSM 107; Portland Art Museum, Maine).
3 For a selection of pastel drawings of Florence Leyland, see MacDonald, *Whistler Pastels*, 41-42, nos. 85-90.
4 On the exhibition in general, see Robin Spencer, "Whistler's First One-Man Exhibition Reconstructed," in *The Documented Image: Visions in Art History*, ed. Gabriel P. Weisberg and Laurinda S. Dixon (Syracuse: Syracuse University Press, 1987), 27-49.
5 Sidney Colvin, "Exhibition of Mr. Whistler's Pictures," *The Academy* 5 (13 June 1874): 673.

19/20a *Harmony in Grey and Green: Miss Cicely Alexander*, oil on canvas, Tate Gallery, London

Drypoint, printed in brown ink on laid paper, trimmed to platemark; watermark: Arms of Amsterdam

K. 155 i/iv

14.9 x 22.5 cm. (5 13/16 x 8 3/4 in.)

Signed in pencil, on tab and on verso: butterfly
Signed on the plate, u.r.: butterfly
Inscribed in pencil [in Whistler's hand], on verso: "Battersea Morn"—1st— / Plate destroyed

Purchased from Obach & Co., London, 1908

Bequest of Margaret Watson Parker, 1954/1.362

From 1863 to 1870 Whistler virtually stopped etching, in part to work on improving the drawing skills he came to believe he had neglected in his previous investigations of *plein-air* realism and his other attempts to embrace a naturalist objectivity. Around 1867, especially, he focused on his studies of the human figure, diligently drawing from the model as part of a self-imposed re-education. At the same time, he kept his eyes upon the sights and sensations of the London river, increasing his acquaintance with its moods in paintings such as *Battersea Reach from Lindsey Houses*, ca. 1864 (YMSM 55; Hunterian Art Gallery, Glasgow), and *Symphony in Grey: Early Morning, Thames*, of 1871 (YMSM 98; Freer Gallery of Art). With the publication and the positive reception of his "Thames Set" etchings in 1871, he returned to making prints with renewed enthusiasm and a readiness to apply both his new-found sense of pictorial structure as well as his tonalist vision to the riverscape motifs that were quickly becoming associated with his name.

Whistler had taken up long-term residence in Chelsea in 1863, and he was to make that part of London his home, with only slight interruptions, for the next thirty years. In *Battersea: Dawn*, he constructs an image of the riverbank opposite Chelsea from an interlace of crosshatched lines to suggest the layers of mist that could envelop the Thames at all times of the day. Faced with the challenge of rendering so ethereal an effect in the obdurate materials of the print medium, he lightened his drypoint line to the faintest of scratches upon the surface of the copper plate.

Reduction is also the keynote for the composition of *Battersea: Dawn*. A few sketched-in boats provide a vestigial foreground interest, but gone now are the overt signs of life, the bargemen and other river workers, portrayed in the "Thames Set" etchings. Instead, a thin strip of the riverbank, interspersed with the slender verticals of factory stacks, seems to float silently between undifferentiated areas of water and sky. The ephemeral aspects of the scene are complemented by the way the plate is produced so that very little ink is caught and held in its tenuous lines. The image thus appears to have been printed with a much paler ink than is actually the case, an effect created from the consonance between the delicate nature of the drypoint technique and the atmospheric moment it captures.

JS

22 **Limehouse**
1878

Lithotint, printed on heavy wove paper

W. 4

Image: 17.3 x 26.6 cm. (6 7/8 x 10 1/2 in.)
Sheet: 19.1 x 27.9 cm. (7 1/2 x 11 in.)

Signed in pencil, l.l.: butterfly
Signed on the stone, l.r.: butterfly

Purchased from Obach & Co., London, 1905

Bequest of Margaret Watson Parker, 1954/1.412

By the 1870s the revival of interest in etching as a vehicle for original work had redeemed it from its reputation as a reproductive medium. About this time Whistler began to experiment with another medium branded as worthy only for reproductive purposes, lithography. Although he produced a number of very beautiful lithographs in the 1870s, Whistler abandoned the medium from this time until around 1890. When Whistler returned to lithography technical developments allowed him a greater freedom and range of possibilities. By the mid-1890s Whistler depended more and more on lithography, and the etchings from that period become comparatively rare. Part of what spurred Whistler's interest in lithography was his close friendship and collaboration with the printers who helped him produce the majority of his work in the medium, Thomas Way and his son, Thomas R. Way.

Limehouse is one of Whistler's earliest works in lithography. The image is produced by drawing with a waxy crayon directly upon a polished limestone block. The block is then inked and printed, the ink adhering to the waxy image created with the lithographic crayon or dilute wash, known as lithotint. In both this print and *The Toilet* (cat. no. 26) Whistler created the image by working on a stone with a prepared ground, creating the blacks by building up the darks with the crayon, and creating the light areas by scraping away the ground so the ink does not adhere. Thomas R. Way described Whistler's drawing of *Limehouse*: "Several stones being made ready, he went to one of his old haunts at Limehouse with my father, and sitting out on a barge made the lithotint of the old wharves and shipping known as 'Limehouse.'"[1]

Closely linked by subject matter to his "Thames Set," this lithograph depicts an entirely different image of the working docksides of London. Robert Getscher records its location as the entrance to the West India Docks, near the point where the commercial area of docks and warehouses ends at Limehouse Reach.[2] The scene consists of a couple standing on a passing barge, while at the right eerie figures are seen tarring a ship. Whereas the "Thames Set" etchings are full of detail and employ a lively, descriptive line, *Limehouse* approaches the same general subject by building up the image with a series of graded tonalities. Way records how problematic it was to create the right balance of tonal contrasts and luminosity: "When first proved, this subject came too heavy and flat, and he repeatedly retouched it until he was satisfied."[3] The careful drawing and scraping used to create *Limehouse* did not allow it to produce a large edition; only about thirty impressions could be taken from the stone before the image began to degrade. Whistler and the Ways had hoped that *Limehouse* would be very popular, but they were disappointed to find that, after advertising the print to a large list of collectors, "the response was less than could be counted upon the fingers of one hand!"[4] *Limehouse* was eventually included as one of six images published by Messrs. Boussard, Valladon & Co. in 1887, presented in a brown paper cover entitled "Notes."

CM

1 Way, *Memories*, 15-16.
2 Getscher, *Stamp*, 60.
3 Way, *Memories*, 16.
4 Way, *Memories*, 16.

23 **Lady With a Fan** (recto, shown)
Standing Woman (verso)
ca. 1871-73

Black and white chalk on brown wove paper

21 x 13 cm. (8 1/4 x 5 1/8 in.)

Signed in chalk, center right: butterfly

Purchased from Obach Co., London, 1905

Bequest of Margaret Watson Parker, 1954/1.266

Color plate 2

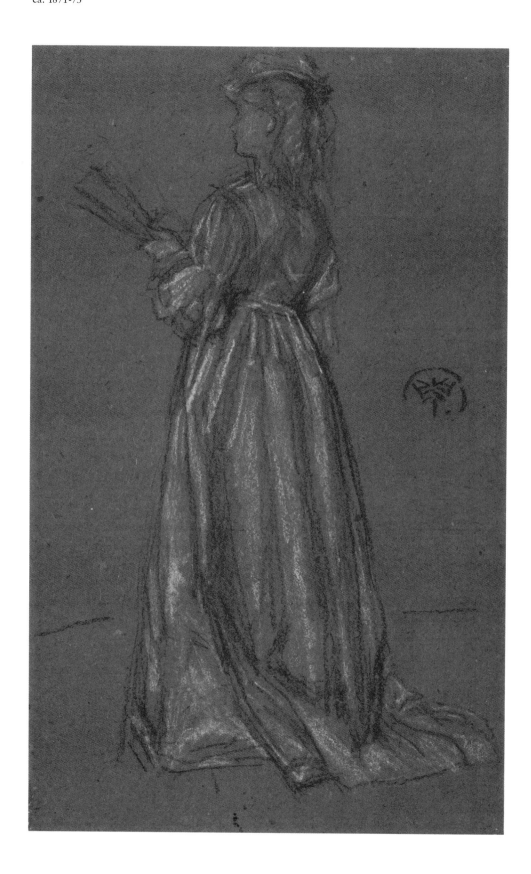

In the single letter from her preserved among Charles Lang Freer's voluminous correspondence and personal papers, Margaret Watson Parker thanks her fellow Detroit collector for calling her attention to a number of Whistler drawings currently on the art market. Mindful, however, that her financial resources were always much more modest than Freer's, Mrs. Parker declined to pursue the matter. "Inasmuch as I cannot possibly add to my collection just now," she wrote, "I think it best not to put the least temptation in my way by even taking a look at the drawings."[1] As it happened, Mrs. Parker acquired relatively little of Whistler's work in any medium during that entire year of 1908. In January she bought one lithograph and six etchings from Obach & Co., including *Steps, Amsterdam* and *The Embroidered Curtain* (cat. nos. 53, 57), for which she paid the rather considerable sums of £180 and £150, respectively (Museum files). By the time she wrote to Freer in November, she had made no further purchases and must have been aware, to her regret, that the drawings he mentioned were beyond her means.

Indeed, Mrs. Parker's bequest included only one drawing by Whistler, which she had acquired three years before receiving the tantalizing news from Charles Freer that more might be obtained. *Lady With a Fan* is one in an ensemble of related figure studies Whistler executed in the early 1870s. Two very similar drawings, now at the Freer Gallery of Art, seem to represent the same young model, once from the angle adopted in the Michigan sheet, and again from the opposite side (repro. Curry, pls. 235, 236). David Curry and Nesta Spink have noted that this group of studies is contemporary with Whistler's sumptuously orchestrated *Symphony in Flesh Colour and Pink*, the portrait of Mrs. Leyland begun in 1871.[2] As both scholars further observe, however, the subject of the Michigan drawing is clearly too young to be identified as Mrs. Leyland herself, and Curry tentatively but plausibly proposes that she might be the Leylands' daughter, Fanny (see cat. no. 19).

Whatever her identity, the model here assumes a stance Whistler often favored in his full-length portraiture of women. In this portrait type, the female figure turns her back to the viewer at the same time that she offers what one French critic, speaking of a similar effect in a Whistler painting from the later seventies, termed a "disdainful profile" [*dédaigneux profil*].[3] That posture recurs throughout the artist's oeuvre and can be found as late as 1900, when he was still at work on *Mother of Pearl and Silver: The Andalusian* (YMSM 378; National Gallery of Art, Washington, D.C.).[4] In each instance, the pose fully reveals the model's dress, giving Whistler an opportunity to study the finery of fashion artistically displayed as if on a mannequin. At the same time, the glimpse of the figure's face affords the viewer the potential, at least, of making contact with the human subject. The result is a composition slightly at odds with itself, an image that engages an audience even as it seems to withdraw from it. At its most fully developed, the back-view portrait type visually embodies the doubled character of Whistler's art, an art founded upon an aesthetic of "harmony" that strives to keep in play a dialectic of opposing tendencies as much as it seeks a resolution of those factors in synthesis. In somewhat embryonic form, the *Lady With a Fan* makes a graphic expression of the deliberately unresolved contradictions at the heart of Whistler's aestheticism.

JS

1 Watson Parker to Freer, 24 November 1908, Charles Lang Freer Papers, Freer Gallery of Art Archives, Smithsonian Institution, Washington, D.C.
2 Curry, *Whistler at the Freer*, 253; Spink and Holmes, "Whistler: The Later Years," no. 76.
3 Gustave Geffroy, *La vie artistique* (Paris: E. Dentu, 1892), 1:274. Geffroy refers to *Arrangement in Brown and Black: Portrait of Miss Rosa Corder*, ca. 1876-78 (YMSM 203; Frick Collection, New York).
4 For further discussion of this Whistlerian portrait type, see Branka Nakanishi, "A Symphony Reexamined: An Unpublished Study for Whistler's Portrait of Mrs. Frances Leyland," *The Art Institute of Chicago Museum Studies* 18 (1992): 156-67.

24 Nocturne: The River at Battersea
1878

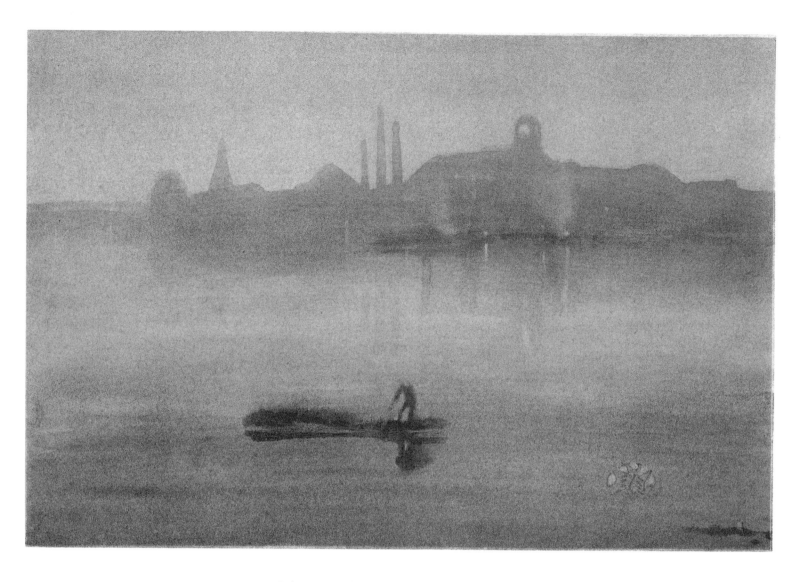

Lithotint, printed on blue-grey laid paper,
laid down on white wove paper

W. 5

Image sheet: 17.2 x 25.8 cm. (6 3/4 x 10 1/8 in.)
Support sheet: 37.9 x 54.7 cm. (14 7/8 x 21 1/2 in.)

Signed in pencil, on the support, l.r.: Whistler
Signed on the stone, l.r.: butterfly
Inscribed in pencil [in T.R. Way's hand], on the
support, l.r.: nocturne no. 5
Inscribed in pencil, on verso, u.l.: Way

Collection: Thomas R. Way (Lugt 2456)
Purchased from Obach & Co., London, 1906

Bequest of Margaret Watson Parker, 1954/1.413

Color plate 1

Throughout the 1870s, Whistler devoted much of his artistic energies to developing his signature visual form, the Nocturne. In thirty-two extant oil paintings he explored the nighttime landscape, especially his own riverside neighborhood of Chelsea and Battersea, familiar terrain made more intriguing by darkness and mist that concealed mundane realities and uncovered the implicitly pictorial possibilities of the urban scene. Over the course of the decade Whistler extended his investigations of the Nocturne subject and style to other media as well, as this atmospheric lithotint eloquently attests. In *Nocturne: The River at Battersea*, broad washes and the cool tonality of blue paper work together to create a painterly print with an expressive understatement comparable to some of the most characteristic Nocturne canvases.

Nocturne depicts a view readily available to Whistler as he looked across the river from his Chelsea home to industrialized Battersea. Ranged along the opposite bank of the Thames (and reversed in the print) is a skyline comprised of the church of St. Mary, at the left, the pyramidal shape of a factory slag heap, and a trio of smoke stacks belonging to the Morgan Company, a manufacturer of crucibles and importer of graphite. To the right stands the company's office building, a tower popularly known as "Mr. Ted Morgan's Folly."[1] The structure plays a prominent role in a number of the Nocturne paintings, its illuminated clock dimly punctuating the surrounding darkness, and it appears as well in *Battersea: Dawn* and *Early Morning* (cat. nos. 21, 27). This Italianate tower may well have been on Whistler's mind when he spoke memorably about the efficacy of nocturnal transformation, the metamorphic moment when "tall chimneys become campanili, and the warehouses are palaces in the night. . . ."[2]

A similar Thames prospect, though cropped to omit "Morgan's Folly," provided Whistler with the composition for a Nocturne painted in the early 1870s (fig. 24a). Even more closely related to the lithotint is another *Nocturne in Blue and Silver* (YMSM 151, private collection) which, like the print, includes the clock tower and a solitary bargeman poling an otherwise quiet river. Whistler probably began this painting in 1872 and possibly exhibited it in 1878, the year he produced his lithographic version of the subject. Clearly, the artist turned to a favorite motif, and one particularly fresh in his memory, when he created *Nocturne: The River at Battersea*, one of his earliest experiments in the medium of lithotint.

Whistler's methods for making his Nocturnes were themselves grounded in memory and repetition. He often took visual notes in charcoal and chalk on brown paper, memoranda of buildings on the riverbanks and lights reflected in the water, that Thomas R. Way recalled as sketches "drawn in the dark, by feeling not by sight. . . ."[3] One such study, drawn in the early 1870s (fig. 24b), articulates the same Battersea silhouette that reappears in the *Nocturne* lithotint, the undifferentiated line of the drawing now thickened into a shadowy shape. In the same way that he repeatedly traced salient appearances on paper, Whistler systematically committed nocturnal images to memory, turning his back on the scene that captured his attention and reciting its essential aspects to a companion who would check the artist's accuracy.[4] These perceptual and conceptual rehearsals furnished the material for studio performance. T.R. Way, who was present at the production of the Battersea lithotint, records Whistler prefacing his work with a remark suggesting that something like a ritual was to follow: "Now, let us see if we can remember a nocturne."[5]

Like *Limehouse* (cat. no. 22), *Nocturne* was executed on a stone prepared with a rectangular area of half-tint. Whistler used this ground as he had the brown paper of his studies, as a middle value upon which he brushed and drew in dark tones and scraped out lighter accents in the river and butterfly signature. Originally proved on a thin Japanese paper, this lithographic Nocturne was subsequently printed on the blue sheets that so successfully underscore and contribute to its evocative qualities. In 1887, nine years after it was drawn, *Nocturne* was one of the six lithographs issued by Boussod, Valadon & Co. under the title *Notes*.

Whistler initially referred to his nighttime landscapes as "moonlights," but responded with delight when a patron suggested "Nocturne," a term from music, as a less naturalistic alternative. The artist particularly appreciated his new title's multivalence, exclaiming over its ability to "so poetically say all I want to say and *no more* than I wish!"[6] That enthusiasm for expression poised between disclosure and reserve informs much of Whistler's art, and it is given an especially effective voice in *Nocturne*'s quiet dialogue of description and subtle dissolution.

JS

1 Richard Bennett, *Battersea Works, 1856-1956* (London: The Morgan Crucible Company Ltd., 1956), 25-26. The tower has been demolished.
2 Whistler, *"Ten O'Clock"*, 15.
3 Way, *Memories*, 14.
4 For detailed eyewitness accounts of Whistler's memory practices, see *ibid.*, 67-68; and Bernhard Sickert, *Whistler* (London: Duckworth; New York: Dutton, n.d. [1908]), 111-12.
5 Way, "Whistler's Lithographs" (1913), 286.
6 Whistler to Frederick R. Leyland, n.d. [November 1872], PWC 6B.

24a *Nocturne in Blue and Silver*, oil on panel, Courtesy of The Fogg Art Museum, Harvard University Art Museums, Bequest of Grenville L. Winthrop

24b *Sketch for Nocturne*, n.d., charcoal with white heightening on brown paper, Munson-Williams-Proctor Institute, Museum of Art, Utica, New York, Edward W. Root Bequest

25 The Guitar Player

1875

Drypoint, printed in black ink on old laid paper; watermark: Arms of Amsterdam

K. 140 ii/v

Plate: 27.5 x 17.5 cm. (10 7/8 x 6 7/8 in.)
Sheet: 32.3 x 19.7 cm. (12 3/4 x 7 3/4 in.)

Signed on the plate, center right: butterfly

Purchased from R.M. Light & Co., Inc., Santa Barbara, 1993

Gift of the Friends of the Museum on the Occasion of their Twenty-fifth Anniversary, 1993/2.4

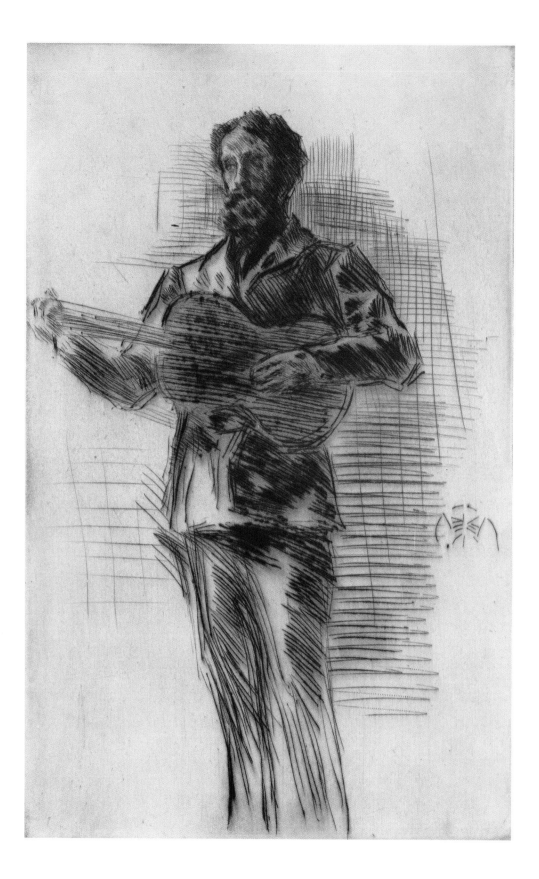

Whistler executed numerous portraits of friends and associates during his early years in Paris and then later after he had settled in London. His Parisian etchings included portraits of his Bohemian artist-friends, such as Drouet and Becquet (app. no. 27). His London etchings tend to be members of his family, such as his portraits of Annie and Arthur Haden (cat. nos. 11, 12) and their little brother, Seymour (app. no. 22), or of his patrons, such as shipping magnate Francis Leyland and his family.

This portrait of Whistler's artist friend Matthew White Ridley is one of the richest of these drypoint portraits. As with many of his painted portraits, his single figure of the artist strumming a guitar is set against an undifferentiated background; except for the hatching behind the figure's contours there is no suggestion as to the setting of the scene. Rich tonalities dominate the image, conveyed by the velvety drypoint burr used to define both the figure and its background. Visual unity in the work is achieved, in part, through the system of parallel diagonal hatching used to describe the figure, and by the contrasting network of vertical and horizontal hatching which the artist employed in the background. It is interesting to note that Whistler, whose early portraits such as *Fumette* (cat. no. 7) and *Finette* (cat. no. 10) used line to capture the features of the sitter, has here employed a different means of describing volume through line. Instead of using firm outline to render the subject, he has in essence used the hatching in a wholly tonal manner. Ridley's features are portrayed in closely spaced diagonal marks rather than in detailed outline. Tonal massings of form and shadow are created as light passes over his face, and his features are given a poetic and evocative presence which a tight linear descriptive method would find difficult to capture.

This impression of *The Guitar Player* was most likely printed before Whistler's trip to Venice in 1879. A post-Venetian impression in the Zelman Collection has more plate tone, and the figure emerges from a greater sense of darkness. In the Museum's impression, the richness of the drypoint is further enhanced by the care with which the artist wiped the ink. In passages of the coat and trousers it is evident that Whistler took great pains to eliminate some of the plate tone in areas of greatest brightness—further indication of the great care that Whistler took in the printing process. As the plate is printed, the tremendous richness of the drypoint will disappear in a work such as this one. This image is therefore uncommon. Its evocative and atmospheric characteristics become central to Whistler's art, as can be observed in his lithographs of the Thames, *Early Morning* (cat. no. 27) and *Limehouse* (cat. no. 22). They will also be expanded upon in the Venice etchings.

CM

26 The Toilet
1878

Lithotint, heightened with black and white crayon, on wove paper

W. 6a

Image: 26 x 16.3 cm. (10 1/4 x 6 1/2 in.)
Sheet: 30 x 20.5 cm. (11 3/4 x 8 1/16 in.)

Signed on the stone, l.l.: butterfly
Notation, in pencil, on mat: Touched proof

Purchased from Obach & Co., London, 1906

Bequest of Margaret Watson Parker, 1954/1.414

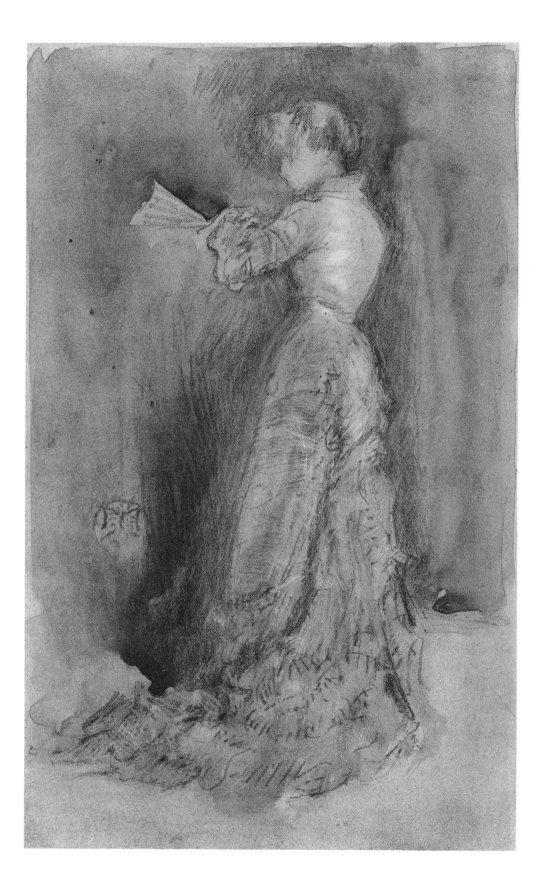

In 1878, Whistler was approached by Theodore Watts-Dunton, the editor of the periodical *Piccadilly*, who hoped to bolster its circulation by issuing lithographic illustrations by Whistler. Watts-Dunton's commission resulted in four lithographs, including *The Toilet* and *Early Morning* (cat. no. 27). For economy's sake the prints were drawn on the same stone using the prepared half-tone of *manière noir*. When the stone was printed, both images printed too dark, so that *Early Morning* became more like a nocturne than a representation of dawn, and *The Toilet* required scraping out of the darks in order to lighten the image. After some modification, *The Toilet* was finally published in *Piccadilly* in July 1878; however, the periodical failed shortly thereafter and ceased publication.

This lithotint of Whistler's mistress, Maud Franklin, is a rare touched proof, an impression of the first state drawn on by the artist to indicate changes that needed to be made to the stone before additional proofs were to be pulled. Similar to his etchings and paintings of the period, Maud is presented here in fashionable dress, half turned from the viewer as she holds a fan. Another work that treats the standing female model can be found in a chalk drawing in the Museum's collection, *Lady with a Fan* (cat. no. 23), although there are important differences. In the drawing the figure appears against an undifferentiated background, while the figure in *The Toilet* emerges from a dark, enveloping background, and the contours of her skirt and bodice are redrawn in white to indicate the slight alterations desired. The dark crayon lines behind the figure, used in much the same way as the bold parallel hatching employed in Whistler's drypoint portraits such as *The Guitar Player* (cat. no. 25), create a strong silhouette as the figure turns in space, emphasizing the smooth back and curve of the model's hip. Whistler's use of lithotint wash augments the backdrop of darkness from which the figure emerges. The resulting image is as rich and enigmatic as Whistler's best portraits of the 1870s.

CM

27 Early Morning
1878

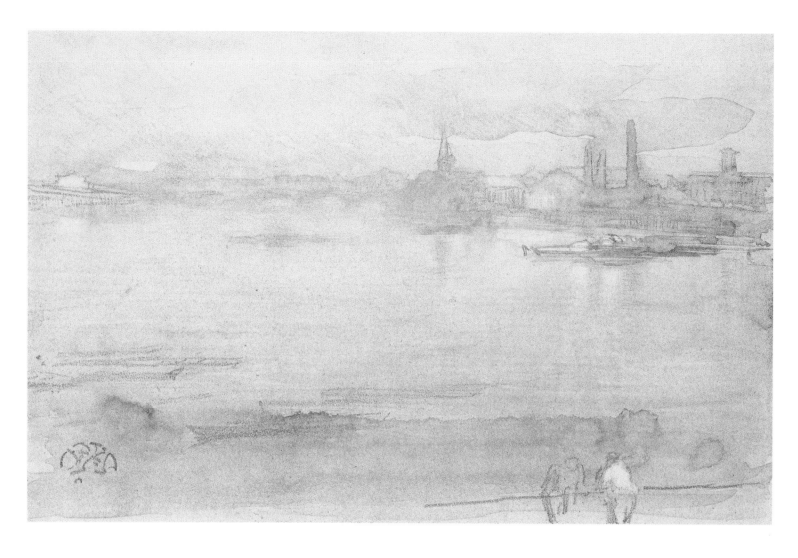

Lithotint, printed on wove paper

W. 7

Image: 16.4 x 25.8 cm. (6 3/8 x 10 1/16 in.)
Sheet: 25.5 x 36.4 cm. (9 15/16 x 14 3/16 in.)

Signed on the stone, l.l.: butterfly
Letterpress, on the sheet, upper margin:
SUPPLEMENT TO PICCADILLY JULY 18th,
1878
Letterpress, on the sheet, l.r.: Imp. T. Way. Lond.

Purchased from Obach & Co., London, 1907

Bequest of Margaret Watson Parker, 1954/1.416

Like *Nocturne: The River at Battersea* (cat. no. 24), *Early Morning* exploits the fluid qualities of the lithotint medium to represent a watery view along the Thames. The site depicted is roughly identical to that of the *Nocturne*, although we are now looking farther up the river with a more sweeping vantage that takes in the West London Extension Railway Bridge, its arched span faintly indicated at the left background.

Whistler never intended "Nocturne" as a precise term, and that category of his work embraces a surprisingly wide range of atmospheric and temporal obscurity beyond that of simple darkness. Indeed, T.R. Way recounts that the first rich proofs of *Early Morning* could have been called Nocturnes, and the lithographic stone was subsequently scraped and re-etched several times in order to obtain the "most silvery delicacy" of morning that Whistler had originally intended.[1] Lithotint is itself a technique of delicacy, and many areas of the drawing on the stone eventually clogged with ink and lost their subtle definition as the printing progressed. This is probably a later proof, the image having been lightened most apparently in the arches of the bridge and the water. There is also evidence of scraping and redrawing in the white shirt of the figure at the right foreground.

Dilute washes brushed onto a prepared area of half-tint, and heightened with a few crayon lines, create silver-grey tonalities handled with a freedom reminiscent of watercolor. A monochromatic watercolor study of the Battersea side of the river (fig. 27a) probably dates from around the same time as the lithotint, and may have been something of a trial, not only of the general composition, but also of the technique Whistler would employ on the stone. The greasy component of the lithotint wash registers the image on the limestone and, if it is too heavily worked, the diluted solution prints as a muddy, undifferentiated dark, hardly the effect sought in *Early Morning*. The medium thus permits an artist little room for maneuver once initial strokes of the brush have been made, and Whistler probably would have wanted some assurance of his proficiency in laying down washes before committing himself to such an unforgiving process.

Early Morning was produced for Theodore Watts-Dunton's *Piccadilly*, but it was never published due to the financial failure of the periodical. The stone was printed by machine in the "many hundreds" such publication called for, and Way notes that he set aside a "small selection" of the finest impressions of the riverscape.[2] This particular proof bears the "T. Way" imprint that appears on all the machine-produced prints. The Museum's Whistler collection also includes another *Early Morning* (app. no. 67), its trimmed margins suggesting that it, too, originally bore the letterpress of the Way printing firm.

JS

1 Way, *Memories*, 18-19.
2 *Ibid.*, 20.

27a *Battersea*, watercolor, Trustees of the British Museum, London

28 The Tall Bridge
1878

Lithotint, printed on white wove paper

W. 9

35.5 x 25.8 cm. (13 7/8 x 10 1/16 in.)

Signed on the stone, at center right between piers: butterfly
Letterpress, on the sheet, l.r.: Imp. T. Way Lond.

Purchased from Obach & Co., London, 1906

Bequest of Margaret Watson Parker, 1954/1.418

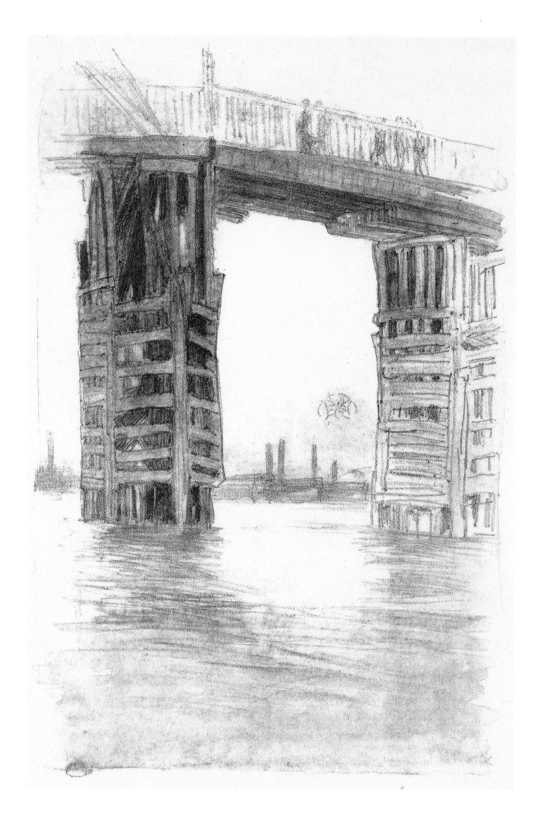

As Katharine Lochnan has observed, Whistler's concentration on the working class and industrial areas of the Thames was in part motivated by a desire to immortalize a portion of the city that was disappearing.[1] Factories and wharves were being torn down to make way for the construction of the Embankment, and this expansion and gentrification of London included razing several old bridges, among them Old Battersea Bridge seen here, and replacing them with modern bridges that could better serve the burgeoning metropolis. Whistler depicted the old bridge a number of times and in various media before it was torn down.[2] Among these images, three are included in the Museum's collections: *The Tall Bridge, The Broad Bridge* (cat. no. 29), and *Old Battersea Bridge* (cat. no. 30).

The compositions for all of these views of the Old Battersea Bridge reflect a knowledge of Japanese prints. Beginning in the 1860s Whistler, like a number of artists, began to incorporate into his paintings and prints principles of visual construction which he admired in works by artists such as Hokusai and Hiroshige. His use of Oriental design features, such as the low vantage point and flattening of space, in his own works is also clear (figs. 28a, 28b).[3]

The Tall Bridge, along with *The Toilet* (cat. no. 26), *Early Morning* (cat. no. 27), and *The Broad Bridge*, were all commissioned by *Piccadilly* for inclusion in their publication, but the periodical went bankrupt before *The Tall Bridge* and *Early Morning* could be published. Thomas Way remarked that "*The Tall Bridges* were all destroyed, except the very few hand-pulled proofs."[4]

CM

1 Lochnan, *Etchings*, 82-83.
2 The Battersea Bridge was featured in a number of Whistler's works. Two paintings have the bridge as a subject: *Nocturne: Blue and Gold—Old Battersea* (YMSM 140) and the two-part folding screen painted for Frederick Leyland, *Blue and Silver: Screen with Old Battersea Bridge* (YMSM 139). Five prints also feature the bridge as subject (W. 8, W. 9, W. 12, K. 176, K. 177), as do several preparatory drawings.
3 At the same time that Whistler was painting the Battersea Bridge, Claude Monet was also painting bridges employing the same Japanese sources; see Tucker, Paul, *Monet at Argenteuil*, (New Haven and London: Yale University Press, 1982), fig. 57. However, as Tucker describes, Monet's images of Argenteuil are more a celebration of France's revitalization following the destruction of the Franco-Prussian War and an embracing of the new technology embodied in the Industrial Revolution. Despite their differences in intent and technique—in Whistler's case, the artist was looking at a changing London, while Monet was anticipating the benefits of a new society—both men subjected their bridges to a simplification which goes far beyond straightforward observation and demonstrates how thoroughly, albeit differently, Whistler and Monet assimilated Japanese spatial construction into their art.
4 Way, *Memories*, 20.

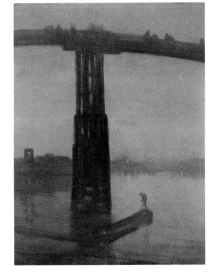

28a *Nocturne: Blue and Gold—Old Battersea Bridge*, ca. 1872-5, oil on canvas, Tate Gallery

28b Hiroshige, *Okazaki, Bridge over the Yahagi River*, from "Illustrations of the 53 Stages of the Tokaido" (*Gojusan-tsugi no uchi*), no. 38, published 1847-54, color woodblock print, Bequest of Margaret Watson Parker, 1948/1.132

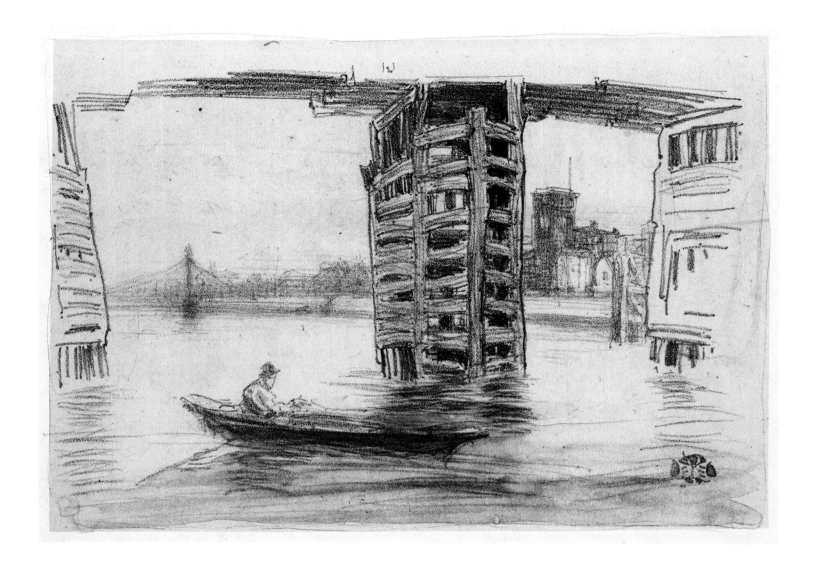

Lithotint, printed in brown ink on Japan paper,
laid down on heavy wove paper

W. 8

Image sheet: 18.4 x 27.9 cm. (7 1/4 x 11 in.)
Support sheet: 28.4 x 43.4 cm. (11 3/16 x 17 1/16 in.)

Signed on the stone: butterfly

Collection: Thomas R. Way (Lugt 2456)
Purchased from P. & D. Colnaghi & Co.,
London, 1913

Bequest of Margaret Watson Parker, 1954/1.417

The Broad Bridge was the first of Whistler's two lithotints to appear in *Piccadilly* before the magazine ceased publication. The looming height of the bridge drawn at low tide[1] and the figure of the boater in the foreground reveal the image's Japanese origins (see fig. 28b). Through the piers Whistler frames a view of the distant cityscape, which includes the clocktower of Old Chelsea Church, the new suspension bridge and the Embankment in the distance. Experiments with Japanese compositional forms can be seen in the artist's cropping of the bridge and his concentration on sections of its span as seen from a low vantage point (figs. 29a, 29b).

This lithograph of the bridge is more freely drawn than the other view executed at the same time and on the same stone, *The Tall Bridge* (cat. no. 28).[2] Printed in brown ink on chine collé, *The Broad Bridge* has a freedom of line and broadness of modeling that differ from the handling of the crayons in *The Tall Bridge*. Whistler experimented with lithography and its possibilities to portray a wooden structure full of picturesque irregularities. His ability to utilize the full range of the lithographic medium is evident in the smoky softness of the distant view under the span, in contrast to the vibrant and more linear drawing of the pier. The faint washes of lithographic ink, known as lithotint, reinforce the shadows in the foreground near the boat. This same effect on the surface of the water will be created in the Venice etchings a year later by retaining a faint layer of ink on the plate. Thomas R. Way noted that the edition for *The Broad Bridge* was very small and that "There are a few very fine proofs on Japanese paper mounted."[3]

CM

1 Way, *Mr. Whistler's Lithographs*, 24.
2 *Ibid.*, p. 24.
3 *Ibid.*, p. 24.

29a *Old Battersea Bridge*, ca. 1871, charcoal with touches of white chalk and watercolor on paper, Albright-Knox Art Gallery, Buffalo, New York, Gift of George F. Goodyear, 1958

29b *The New Albert Bridge seen through Old Battersea Bridge*, 1873, chalk on brown paper, Hunterian Art Gallery, University of Glasgow, Birnie Philip Bequest

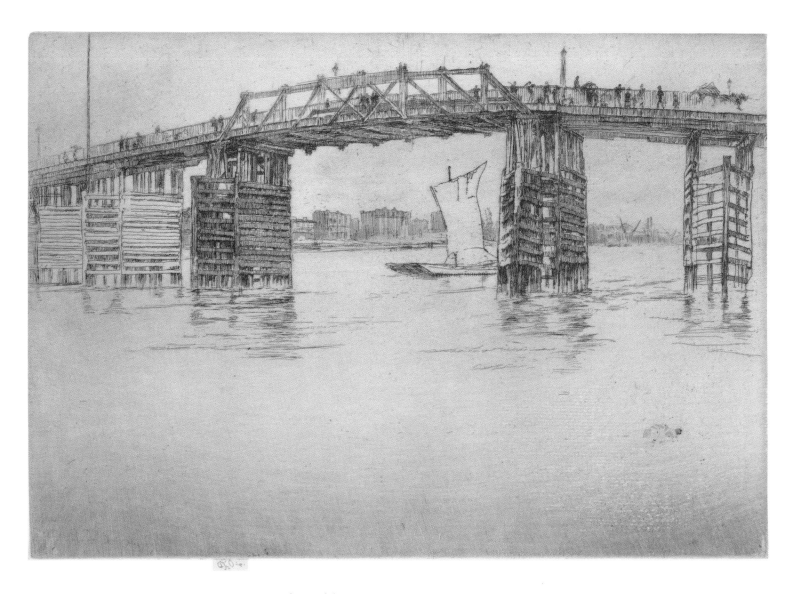

Etching and drypoint, printed in dark brown
ink on laid paper, trimmed to platemark

K. 177 iv/v

20.2 x 29.4 cm. (7 7/8 x 11 7/16 in.)

Signed in pencil, on tab: butterfly and imp.
Signed on the plate, l.r.: butterfly

Purchased from Obach & Co., London, 1905

Bequest of Margaret Watson Parker, 1954/1.371

Two major professional debacles in the late 1870s contributed to the personal financial difficulties that eventually resulted in Whistler's declaration of bankruptcy in 1879. He was unable in 1877 to recover the considerable payment he expected for his remarkable redecoration of the dining room at Frederick Leyland's London residence, a project that resulted in the celebrated Peacock Room, now in the Freer Gallery of Art. To compound his distress, his suit for libel against the English critic, John Ruskin, had gone to trial in November 1878 and had ended in only a token award of damages to the artist, who was left to bear the legal costs.[1] Faced with a pressing need for money, Whistler returned to the idea of marketing his prints. In the last several years of the seventies he reprinted a number of plates he had executed earlier, and he created new works calculated to appeal to the same London audience that had shown such enthusiasm for his "Thames Set" imagery.

Among the new etchings Whistler produced with the hope of improving his financial situation were a number of views of London's more picturesque bridges, such as *Old Putney Bridge* (K. 178) and *The Little Putney, No. 1* (see fig. 30a). The closely related plate of *Old Battersea Bridge* represents the distinctive wooden structure spanning Chelsea and Battersea that was only steps away from the artist's home. In this image of the familiar landmark, however, Whistler did not experiment with the daring compositional possibilities of an isolated segment of the structure, as he had in *The Tall Bridge* and *The Broad Bridge* (cat. nos. 28, 29). Rather, the more conventional choice to represent much of the whole span underscores his determination to create a broadly marketable print. That conviction is further expressed in the relative definition and detailed treatment of the wooden piers of the bridge and the pedestrian traffic shown upon it. Nonetheless, Whistler did allow room for more eclectic tastes to be drawn to this work, as well; the barge in full sail passing through the central span of the bridge adds a touch that connoisseurs conversant with Japanese woodblock prints could appreciate, a subtle element that lets the etching speak Japanese while retaining a pronounced English accent.

The Fine Art Society, which had issued a second edition of the original "Thames Set" in 1879, bought impressions of *Old Battersea Bridge* in the summer of that same year and later purchased the copper plate itself, signs that the artist's hopes to reach the print-buying public had met with some success.[2] The plate tone in the water, the margins trimmed to the platemark, and the projecting tab left for Whistler's butterfly signature all indicate that the Museum's impression of the etching must have been printed after the artist had returned from Venice in 1880.

JS

1 The definitive account of the Whistler-Ruskin trial is given in Merrill, *A Pot of Paint*.
2 Lochnan, *Etchings*, 179.

30a *The Little Putney, No. 1*, app. no. 74

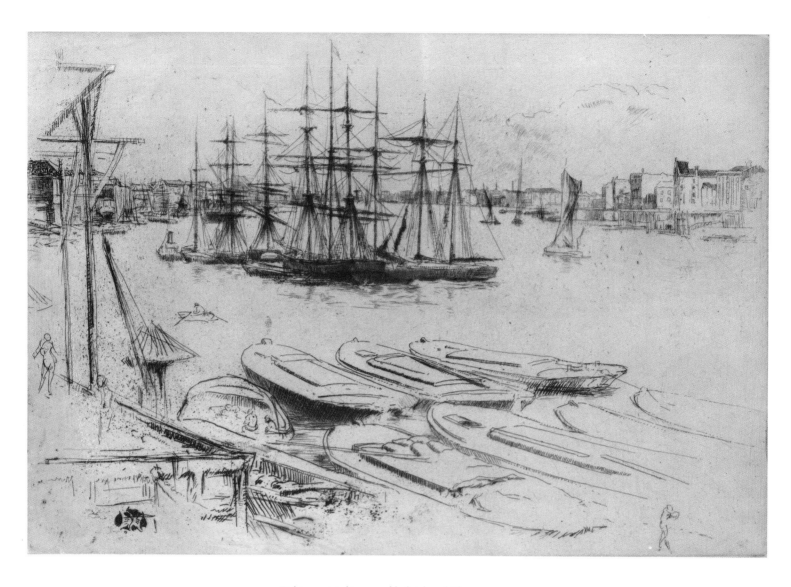

Etching, printed in warm black ink on laid
paper; watermark: crowned coat of arms with
fleur-de-lis

K. 174 iv/vii

Plate: 18.7 x 27.6 cm. (7 5/16 x 10 3/4 in.)
Sheet: 24.8 x 35.4 cm. (9 3/4 x 13 7/8 in.)

Signed in pencil, on the sheet, l.r.: butterfly
Signed on the plate, l.r. butterfly
Inscribed in pencil [in Whistler's hand],
l.l.: "Wapping—The Pool"

Purchased from Obach & Co., London, 1906

Bequest of Margaret Watson Parker, 1954/1.370

With *The Large Pool*, Whistler returned to the
very site that had inspired many of his "Thames
Set" etchings twenty years earlier. Wapping
and the Pool of London are again the subjects
in this effort to reprise the success he had
enjoyed with the publication of those previous
prints. Even more so than in *Old Battersea
Bridge* (cat. no. 30), Whistler reverts to the
descriptive style and the picturesque composition
that served him so well in the late fifties. As
he did in the earlier etchings, he once again
allows sections of the composition to fall into
abeyance while other portions of the plate
receive greater attention. The foreground boats
indicated in precise contours are aligned to
point toward the dark ships in the middle
ground, where complicated masts and rigging
form a screen before the greyed tonalities of
the distant riverbank.

 In contrast to the specific rendering of
boats and ships, a lone rower on the river and
several figures standing on the near bank are
sketched in the most gestural of calligraphic
lines that subordinate the human element to
the riverside setting. The artist portrays the
Pool now as a much more subdued place
than the cluttered locus of constant activity,
conspicuously peopled with rough-edged
workers, that he had depicted in many of the
"Thames Set" plates (see cat. no. 13). The
tranquility of the Thames and its traffic at
places as varied as Chelsea and Wapping is the
dominant theme in Whistler's riverscape etchings
of the late seventies. The central group of tall
ships, their majesty flanked by the solitary,
modest rowboat and several small barges, clearly
stars in his production here, a performance
that he anticipated would still find an audience
receptive to new versions of his "portraits
of place."

 JS

32 Reading
1879

Lithograph, printed on china paper, laid down on white wove paper

W. 13

Image sheet: 21.4 x 16.5 cm. (8 3/8 x 6 7/16 in.)
Support sheet: 54.9 x 38 cm. (21 7/16 x 14 13/16 in.)

Signed in pencil, on the support: Whistler and butterfly
Signed on the stone, to right of figure: butterfly

Bequest of Margaret Watson Parker, 1954/1.422

Whistler often depicted models quietly contemplating a book or journal, an activity that permitted him to study his subject uninterrupted and at some length. *Reading* represents just such an absorptive theme. An image of Maud Franklin, who succeeded Joanna Hiffernan as the artist's model and mistress, this lithograph also embodies the important element of the domestic in Whistler's art.[1] He turned frequently to his immediate family and a small circle of friends for available and relatively compliant subjects.[2] One early example of this kind of domestic genre scene in Whistler's graphic work is *The Music Room* (see fig. 32a), an etching of the Haden household, in which Seymour and Deborah Haden are shown engaged in separate, introspective pursuits.

32a *The Music Room*, app. no. 20

In *Reading*, Whistler has drawn his mistress in profile, as he had one year earlier in the lithotint *Study* (W. 2), another image of Maud seated and perusing a newspaper or periodical. In *Reading* itself, regular, diagonal strokes of the lithographic crayon suggest that the artist was familiarizing himself with the effects he could obtain with a greasy drawing material on a smooth stone, interested as much in studying the medium as the figure before him. An earlier state of *Reading* reinforces this notion of technical experimentation. In that version of the lithograph, Whistler drew three variations of the seated model on the same stone, one of which turned a featureless face to the viewer, while a sketch of a standing male figure appeared at the far left. *Reading* was part of the set of six lithographic *Notes* issued in 1887 by Boussod, Valadon & Co.

JS

1 Maud's role in Whistler's work and life is discussed most fully in Margaret F. MacDonald, "Maud Franklin," in Fine, ed., *Whistler: A Reexamination*, 13-26.
2 See, for example, *Maud Reading*, ca. 1878 (Freer Gallery of Art; repro. Curry, pl. 243), a chalk drawing closely related to this lithographic image of Maud.

33 Little Venice

from the "Twelve Etchings," or the "First Venice Set"
1879-80

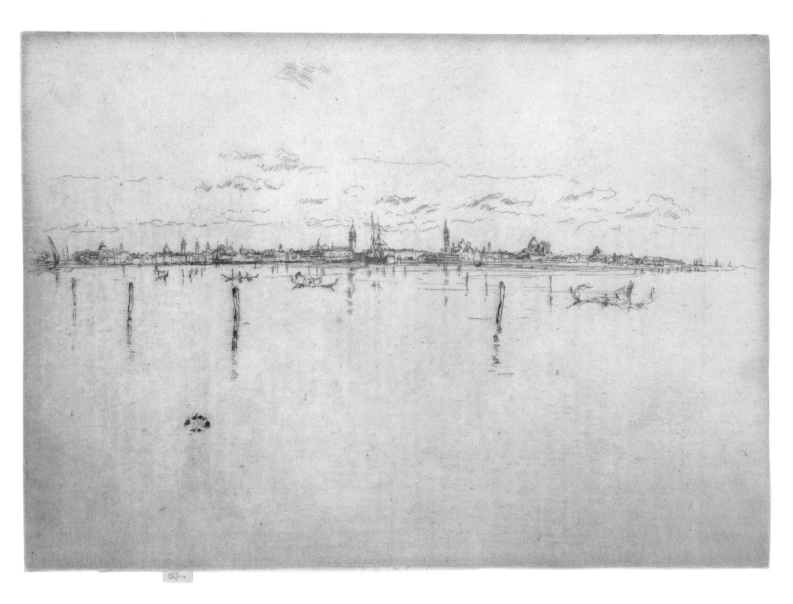

Etching, printed in dark brown ink on laid paper,
trimmed to platemark; watermark: WW

K. 183 (only state)

18.4 x 26.7 cm. (7 3/16 x 10 7/16 in.)

Signed in pencil, on tab: butterfly and imp.
Signed on the plate, l.l.: butterfly
Inscribed in pencil, on verso: Little Venice / W
149. / Fine impression

Purchased from Frederick Keppel, Chicago, 1894

Bequest of Margaret Watson Parker, 1955/1.122

For a number of years, Whistler had entertained the idea of traveling to Venice when, late in 1879, the Fine Art Society commissioned him to make the trip in order to produce a set of twelve etched views of the famous city. The opportunity was timely, for it allowed the artist to escape the creditors descending upon him in London while it also provided him with the prospect of returning to England with a commercially viable body of work whose sale might offset his recent financial losses and declaration of bankruptcy. He left for Venice in September, intending to return in December. Once there, however, his ambition grew, and he remained until October of 1880, having produced some fifty etchings, more than ninety pastels, and at least a dozen paintings. Back in London, he exhibited the twelve commissioned etchings in 1880 under the title *Venice, Whistler. Twelve Etchings*, popularly known as the "First Venice Set." The sojourn provided him with enough material to show the balance of the etchings (supplemented by an assortment of London views) in 1883, and to publish an additional portfolio of twenty-six plates in 1886.

The Venetian landscape presented something of an artistic challenge, for its monuments were well known to generations of travelers. Taking note of its purported ubiquity, Henry James wryly observed of Venice that "There is notoriously nothing more to be said on the subject There is nothing left to discover or describe and originality of attitude is completely impossible."[1] If his views were to attract attention, the artist had to uncover a side of Venice unknown to most of his audience, a task Whistler came to believe he had fulfilled with great imagination. Once established in Italy, he wrote to the director of the Fine Art Society, announcing that he had come "to know a Venice in Venice that the others never seem to have perceived"[2] Indeed, his unexpected imagery of small side canals and anonymous corners offers an alternative to more predictable tourist scenes.

Even ostensibly panoramic conventions are revised to make an original statement in *Little Venice*. Catalogued as the initial image in the "First Venice Set," this distant view of the city across the lagoon actually was one of the last plates Whistler worked on during his stay and was printed only upon his return to London.[3] The etching, done from a site near the Lido, depicts Venice stretching from the Public Gardens to Santa Maria della Salute on the right. The campanile and dome of San Giorgio Maggiore appear in the center of the composition. But these architectural landmarks emerge as little more than incidental vertical marks along a narrow horizontal strip, recognizable but with scarcely more visual significance than the posts which punctuate the open expanse of water filling the lower half of the print.

The relatively untouched character of the foreground suggests that Whistler may have been thinking of reserving this part of the plate as a foundation for different inking effects. In a unique proof (fig. 33a), he experimented with plate tone in both the water and sky. Inking along the sides and in the corners of this impression indicates that he might have contemplated printing the plate as if it were a view framed in a window. The plate tone in the Michigan proof is more uniform and subtle, conveying the luminosity of reflected sunlight. Frederick Wedmore compared the "artistic motive" of Whistler's print to Rembrandt's *View of Amsterdam* (fig. 33b), while reserving his final favor for the *Little Venice*.[4] In Rembrandt's landscape etching, the upper two-thirds of the composition is largely left blank, an emphasis Whistler inverts by indicating light clouds in his sky and leaving the area of the water virtually unmarked.

Whistler began in 1880 to print impressions for the publication of the "First Venice Set," his obligation to the Fine Art Society stipulating that 100 sets were to be produced. But printing editions of such size had never been part of etching's appeal to Whistler. As he commented later in life:

. . . this great over refinement and anxiety for the perfection of quantity is dead loss & vexation—for my own reputation, the complete beauty of one proof is enough—& the production of scores of the same plate is really a madness![5]

Yet the "First Venice Set" etchings sold well enough for the artist to begin to realize some of the profits he had desired. Against his own inclination, he persevered with printing the plates, albeit slowly. Although the 100 sets were mostly complete by 1891, he continued as late as 1901 to tie up the loose ends of the project.[6]

With the printing of the Venice etchings in London Whistler implemented innovations that came to define his unique approach to the print as an independent art object. After pulling a satisfactory impression he trimmed the margins of the paper to the edges of the platemark, leaving only a small projecting tab for his penciled butterfly signature and the abbreviation "imp." to signify that he had printed the plate. He considered the placement of the tab and signature to be integral elements of his composition, and the trimming itself contributed to the tenor of the individual work. Mortimer Menpes, who assisted Whistler with his printing at the time, records that the artist placed the paper on a sheet of glass and with a knife carefully cut along the platemark without the aid of a ruler "because," Whistler said, "I wish the knife to follow sympathetically the edge of the proof." His singular methods, he explained, produced a print that was "vibrated and full of colour."[7]

JS

1 Henry James, "Venice" [1882], in *Italian Hours*, ed. John Auchard (University Park: Pennsylvania State University Press, 1992), 7, 10.
2 Whistler to Marcus Huish, n.d. [1880], GUL Whistler LB3/8.
3 Getscher, *Whistler and Venice*, 74-75.
4 Wedmore, *Whistler's Etchings*, 70.
5 Whistler to Ernest Brown, n.d. [August 1894], GUL Whistler LB9/20.
6 Lochnan, *Etchings*, 221. Even then, however, full editions of *The Beggars* (K. 194) and *The Doorway* (cat. nos. 40, 41) remained incomplete, and were finished after Whistler's death by Frederick Goulding.
7 Quoted in Menpes, *Whistler as I Knew Him*, 94-95.

33a *Little Venice*, K. 83, undescribed state, Hunterian Art Gallery, University of Glasgow, Birnie Philip Bequest

33b Rembrandt, *View of Amsterdam*, ca. 1640, B. 210, etching, The Metropolitan Museum of Art, New York, Bequest of Mrs. H.O. Havemeyer, 1929, The H.O. Havemeyer Collection (29.107.16)

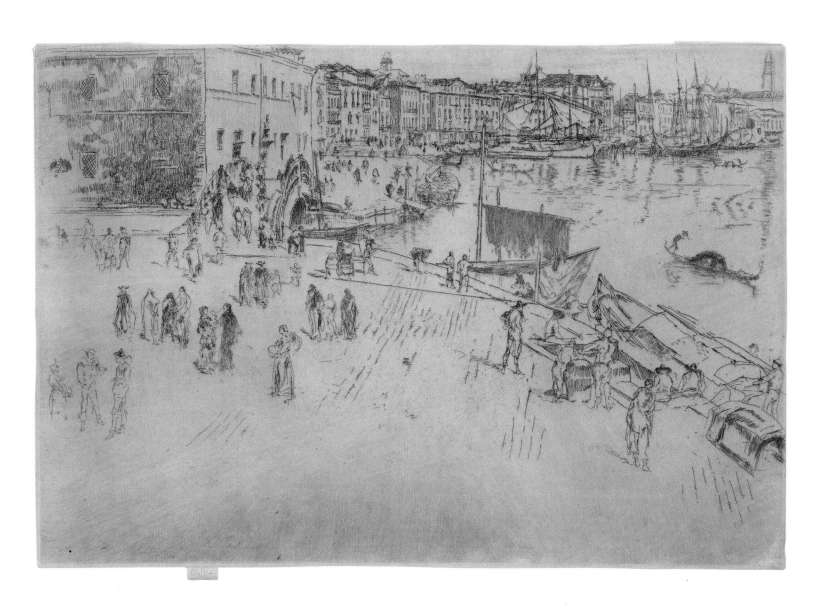

Etching and drypoint, printed in dark brown
ink on laid paper, trimmed to platemark;
watermark: S Wise & Co. with heart

K. 192 iii/iiia

20.1 x 29.6 cm. (7 13/16 x 11 9/16 in.)

Signed in pencil, on tab: butterfly and imp.
Signed on the plate, u.l.: butterfly
Inscribed in pencil, on verso: S / CI

Bequest of Margaret Watson Parker, 1955/1.125

In two very similar views, Whistler represents
the expansive arc of the Riva degli Schiavoni as
it extends to the west from the Riva San Biagio,
whose broad quay constitutes the foreground
in each image. The sweeping, presentational
curve of the Riva affords an overview of
architecture relatively rare in Whistler's Venetian
etchings, as if he were providing a kind of
context for his subject before taking a gondola
and slipping into a side canal to find the
fragments of facades he so often isolates from
the larger whole depicted here. Its value as a
contextual reference may, in part, have prompted
the artist to include versions of *The Riva* in
each of his two Venice sets.

The Riva is seen in both instances from
an elevated vantage, perhaps from a window
of the Casa Jankovitz, where Whistler and
Maud Franklin were staying with a group of
younger American artists working in the city.
The point of view from above nearly negates
the horizon and flattens the foreground. Previous
scholars have speculated that the compositions
may have been compiled from two or more

different viewpoints on either side of the bridge
crossing the Rio d'Arsenale.[1] The view
represented in *The Riva, No. 1* ends at the far
right with a bare suggestion of San Marco's
domes and campanile. In *The Riva, No. 2*, the
domes remain but the campanile is deleted
and several dark ship's masts are allowed to
close off the far side of the composition. The
difference may imply that Whistler slightly
shifted his position when making the second
version of the scene. It is possible, however,
that the first rendition of the view provided
him with a kind of template for his later variant,
and that the erasure of a faint but prominent
vertical at the right edge was primarily an
aesthetic decision.

Further subtle differences distinguish the
treatment of subject in this pair of prints. *The
Riva, No. 2* may well depict a warmer day or
season than its counterpart, for an awning has
been raised at the center to create a dark point
of interest previously performed by a tattered
sail in *The Riva, No. 1*. The space of the
second *Riva* also appears to curve more
coherently, leading the viewer convincingly to
the bridge and thus onto the Riva degli Schiavoni

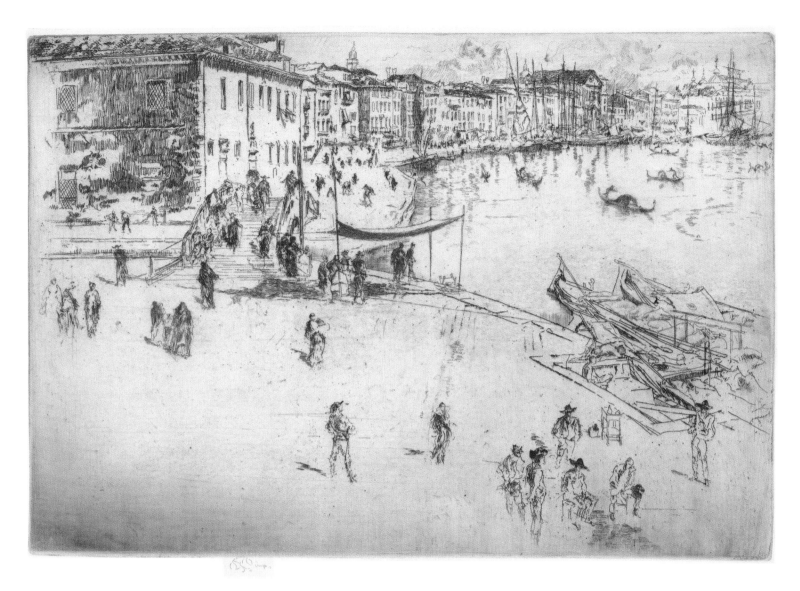

itself as it develops into the distance. As has been observed, the treatment of the building at the left assumes greater solidity in the second plate, producing a visual anchor from which the rest of the Riva continues.[2] Whistler furthers this greater sense of movement in the foreground by minimizing the paving stones which, in *The Riva, No. 1*, work against the tendency of the viewer's gaze to follow the diagonal of the quay. Most significantly, perhaps, the numerous figures that animate both compositions arrange themselves more deliberately into groups in the second version, reinforcing the recession toward the bridge. Like the awning at the center of the composition, the figures in *The Riva, No. 2*, some wearing black, broad-brimmed hats, provide darker accents against the open expanse of the pavement and lead back into depth.

But the two compositions allow both the flatness of the foreground space and the receding curve of the Riva itself to coexist on the same sheet. Despite the relative elaboration of the image, Whistler's work here remains founded on the productive tension between description and suggestion, and the untouched

space of the page in prints such as the *Little Venice* (cat. no. 33) or the Riva pair can either confound or transport the viewer. Charles Caffin, an Anglo-American art critic writing earlier in this century, responded to the latter possibility as he traced the development of Whistler's graphic vision:

Having learned to put in, he became learned in leaving out; and in his later series of Venetian etchings confined himself to a few lines contrasted with large spaces of white paper. . . . These cease to be mere paper; they convey the impression of water or sky under the diverse effects of atmosphere and luminousness, and by their vague suggestiveness stimulate the imagination.[3]

JS

1 Getscher, *Whistler and Venice*, 92; MacDonald, *Graphic Work*, 41.
2 Lovell, *Venice: The American View*, 164.
3 Charles H. Caffin, *How to Study Pictures*, rev. ed. (New York: Appleton Century, 1941), 451.

Etching and drypoint, printed in warm black ink on laid paper, trimmed to platemark; watermark: coat of arms, WR

K. 206 i/ii

21.2 x 30.7 cm. (8 1/4 x 12 in.)

Signed in pencil, on tab: butterfly and imp. Signed on the plate, u.l.: butterfly

Collections: unidentified (Lugt Suppl. 2921h); Royal Library, Windsor (Lugt 2535)

Bequest of Margaret Watson Parker, 1954/1.389

36 The Traghetto, No. 1
1879-80

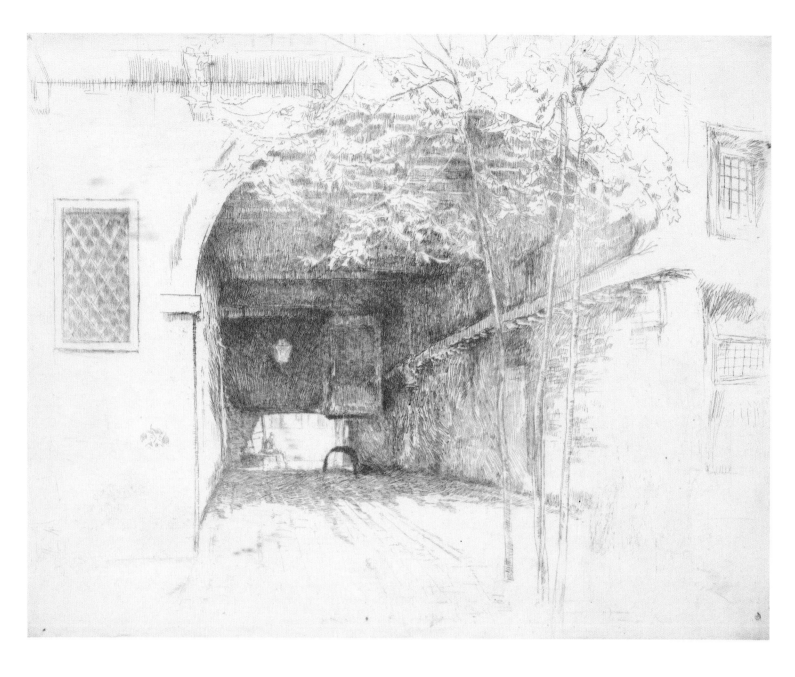

Etching, printed in warm black ink on laid
Japan paper

K. 190 ii/iii

Plate: 23.8 x 30.4 cm. (9 3/8 x 12 in.)
Sheet: 29 x 44.3 cm. (11 7/16 x 17 7/16 in.)

Signed on the plate, l.l.: butterfly

Collection: H.S. Theobald (no mark)

Bequest of Margaret Watson Parker, 1954/1.376

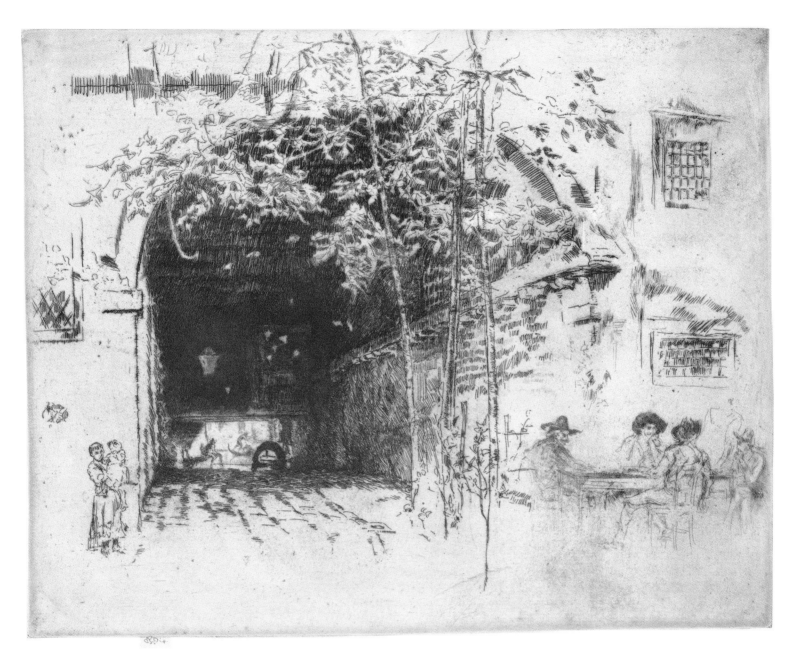

Etching, printed in dark brown ink on laid paper,
trimmed to platemark; watermark: J WHATMAN

K. 191 v/vi

23.6 x 30.4 cm. (9 1/4 x 12 in.)

Signed in pencil, on tab: butterfly and imp.
Signed on the plate, l.l.: butterfly

Purchased from P. & D. Colnaghi & Co., London, 1927

Bequest of Margaret Watson Parker, 1954/1.377

Whistler completed many of his Venetian etchings while he was still in Venice, taking working proofs of the plate on Otto Bacher's press to check the progress of the image. He worked extensively on other plates, such as *The Beggars* (app. no. 81), after returning to London, as has been observed by Mortimer Menpes and Thomas R. Way. Both men were close to Whistler at the time the Venice impressions were printed, first in the room above the gallery at the Fine Art Society, then in the space provided for him in Air Street. One print had a uniquely difficult passage from the first drawing of the needle to the finished image. The *Traghetto* went through two incarnations: *The Traghetto, No. 1*, a work which Bacher admired when he saw an impression of the first state in Venice, and *The Traghetto, No. 2*, a second plate in which Whistler painstakingly and selectively salvaged what remained from the ruined first plate.

Bacher had seen the early impression of *The Traghetto, No. 1*, which Whistler had pinned to the wall of his room so that he could use it as a benchmark against which to compare subsequent impressions. Seeing Bacher's admiration of this proof impression, Whistler brought out an impression of the second state taken from the same plate. Bacher was dumbstruck. He later recalled:
At the first glance I noticed that he had added many new lines, thereby losing much of the life and charm of the first beautiful proof. By comparing the two prints, it seemed that he was losing his grip on that plate. Divining that I perceived this, a shadow of disappointment crossed his face as he brought me the third proof of the same plate. This last one represented the actual, sad condition of the copperplate as it was then. Horrors! What a shock ran through me! The plate was ruined! I was stunned for a moment, and falteringly questioned him for the reasons that had influenced him to dare to add another line to the finished state of the copperplate which had yielded such a glorious proof as I had before me on the wall.

'I changed it because a duffer—a—duffer—a painter—thought it was incomplete.' This was all he said, but he seemed very bitter.[1]

As terrible a loss as it was, Whistler realized that the composition had wonderful possibilities and was clearly built upon spatial themes which he had explored in works such as *The Lime-burner* (cat. no. 14), and even earlier works such as the *Marchand de Moutard* (cat. no. 5) from the "French Set." Whistler's use of doorways to provide glimpses of distant vistas had become a familiar device in his pictorial construction, and one that he employed with great variety and success. In a number of the Venetian plates he returned to this motif as a means of creating space and including a smaller, distant vignette of an entirely different subject. This can be seen in the *Doorway and Vine* (app. no. 99), where a dark passageway ending in a distant scene is closely related to the *Traghetto*, as well as in *Nocturne: Furnace* (cat. no. 47), a work in which the dark doorway is handled quite differently. Whistler's evident conviction that the essential composition of *The Traghetto, No. 1* was worth attempting again led the artist to come up with an ingenious way to transfer the image onto a clean plate which could be redrawn and then re-etched. Whistler inked the damaged *Traghetto, No. 1* with white paint rather than printers' ink and pulled an impression on Dutch paper. He then took a new copperplate with a ground covering it and ran both it and the impression printed in white paint through the press. In this way, the image of *Traghetto, No. 1* would be transferred to a new plate, the etched lines of the first plate now appearing in white ink on top of the dark ground of the second plate. Whistler then took several weeks to carefully etch the lines that he wanted to retain from the first plate, always keeping at hand for reference that silvery first state impression which had so dazzled Bacher. The plate was bitten with nitric acid and the great moment arrived for proving the second plate. They anxiously compared the proof of the new plate against the early *Traghetto, No. 1*. Although the images are not duplicates, Whistler was quite satisfied; he had successfully recaptured the effect of the first plate.

Even with the work transferred to the new plate, Whistler continued to be haunted by the recriminating first state of *The Traghetto, No. 1.* Thomas R. Way, whose close association with Whistler dated from just prior to the trip to Venice, states that *The Traghetto, No. 2* was the last of the plates to be proved, and was subjected to continued modification before the final image was considered satisfactory:

The first plate having been spoiled, he redrew it, but could not get the same quality that he had obtained in a certain early proof of the first plate, and he was greatly troubled with it. Again and again he took the charcoal and lightened it, only to rebite the whole again. It was the last of the [First Venice] set he had to prove, and as the invitations had been sent out I was very anxious lest he should fail to get it ready in time. This made him dub me "Croaker," but at last all came right; he obtained the silvery quality he wanted, and the lantern with its reflected light at the end of the dark archway, and the leaves falling from the little trees in front—just in time.[2]

In looking at the two versions of the *Traghetto*, one can see the subtle shifts in the composition which occurred between the two plates, and how Whistler has taken one step further the evolution of the framing doorway or passageway in his visual construction. The positions of elements around the deep passageway are slightly varied between the two prints. The addition of figures at the entrance, the group of men seated at a table to the right, and the young girl and baby in the place of the butterfly give more local color to the foreground. The cropping and angle of the windows upon the end walls have been altered as well.

Whistler's assimilation of the lessons of Japanese spatial construction was more complete than that of many other late-nineteenth-century artists, and his ability to integrate these principles into his core is demonstrated in this print. The "floating world" of *ukiyo-e* prints, with its flattened spatial relationships, became a major influence on Whistler's work. In *The Traghetto, No. 2,* he creates a dynamic tension between the traditional handling of space, provided by the distant passageway with its implied recession, and the *tour de force* of an element which denies that deep spatial perspective. Way refers in passing to the falling leaves that are present in *The Traghetto, No. 2* but absent in the first plate. The leaves, which occur just in front of the entrance to the deep traghetto, or passageway, flutter as bright accents of light before the deep tunnel behind, visually eroding the mass of the shadowy vault. In this way they bring the viewer's eye back to the plane of the passageway entrance, creating a sort of foliate curtain which is suspended before the dark void. Thus Whistler achieves visual tension by creating a compelling spatial depth and simultaneously denying that depth by superimposing a flat surface pattern in the form of the leaves. Only an adroit posing of such forces can keep them in balance and prevent both the passage and leaves from rending the spatial tension into disunity. Whistler has truly labored to incorporate the best of the Japanese and Occidental ways of constructing space, and has integrated both traditions into his visual vocabulary.

CM

1 Bacher, *With Whistler in Venice*, 166-169.
2 Way, *Memories*, 46.

38 The Palaces
from the "Twelve Etchings," or the "First Venice Set"
1879-80

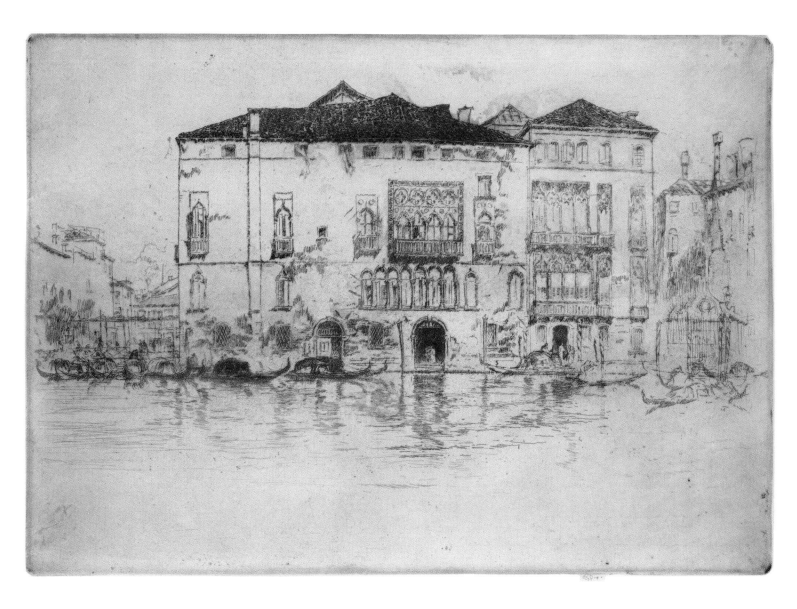

Etching, printed in black ink on heavy laid
paper, trimmed to platemark; watermark: crown
surmounting a fleur-de-lis and 1814

K. 187 iii/iii

25.1 x 35.9 cm. (9 7/8 x 14 1/8 in.)

Signed in pencil, on tab: butterfly and imp.

Purchased from Frederick Keppel, Chicago, 1894

Bequest of Margaret Watson Parker, 1955/1.123

Among the Venetian etchings *The Palaces* appears to be something of an anomaly. Of the many views of Venice, this is Whistler's largest plate, and the only etching that stands as a topographical view of a particular building or group of buildings, the Palazzo Sagredo and the Palazzo Pesaro.[1] Furthermore, it is a view along the Grand Canal instead of the back waterways of the city, and one in which the artist's poetical and personal evocations do not dominate. Thus *The Palaces* serves as one of the artist's only "portraits" of a building in a city known for its beautiful architecture. In this etching of the Palazzo Sagredo, Whistler has selected a building that dates from the late 1300s and is a notable, if somewhat dilapidated, Venetian Gothic structure.[2]

Of the works Whistler executed in Venice, *The Palaces* seems to come closest to fulfilling the expectations for conventional imagery of this most unconventional city, yet it is full of subtle mastery. The Palazzo Sagredo stands immediately next to one of the most famous of the Venetian palaces, the Ca' d'Oro. Whistler does not include any of this more famous building, however, other than an oblique look at the unfamiliar and undecorated side of the Ca' d'Oro at the right of the composition. He chooses instead to focus on two smaller palaces standing in the shadow of their more celebrated neighbor. This penchant for discovering hidden beauty in the city's decaying splendors is in fact perfectly in keeping with Whistler's preferences as to subject matter and his endeavor to create a vision of Venice uniquely his. In his depiction of a palace from Venice's graceful Gothic past, he elected to omit an immediately recognizable palace adjacent to it.

The Palaces belongs to a long tradition of *vedute* in Venetian painting going back to Canaletto and Guardi, in which important individual buildings, as well as sweeping views on the Grand Canal or the Piazza San Marco, record the details of the city and its inhabitants. Whistler was aware of photography and seems to have utilized it in his "Thames Set"; *The Palaces* may also reflect the artist's response to the emerging role of photography as a means of recording architectural monuments in Italy.

Working from a vantage point directly opposite the palaces on the Grand Canal, Whistler presents the structures frontally and in full sunlight; a relatively large portion of the plate remains unetched, depicting water, sky, and stuccoed walls. His use of line in this image is lively and relishes the details of the Gothic windows, grillwork, and the gondolas hugging the waterline. There are, however, problematic passages in *The Palaces*. In the sky above the tile roof, in the water, and between the windows and fluttering curtains trailing below the eaves, exist passages which appear to be false biting of the plate, or possibly a sulphur tint, as Ruth Fine has suggested.[3] Whether there by accident or design, these areas of tonal shading in the plate have been used by Whistler to heighten shadows in a work that does not utilize the plate tone that characterized many of the Venetian etchings. In the reflections to the left of the central doorway, in the shadows under the roof line, and in the wall of the smaller of the palaces to the right, Whistler appears to have used stop-out varnish to sculpt these tonal areas into a usable "color." Even the suggestion of clouds above the Palazzo Sagredo consists of shading controlled with stop-out varnish. Although at first glance *The Palaces* appears to be a straightforward rendition of one of Venice's architectural gems, bathed in sunlight and full of lively nuance, Whistler has in fact created a gossamer tribute to the city's faded glory.

CM

1 The Pennells identified the buildings as those situated opposite the Palazzo Rezzonico, Whistler's first residence during the fall and winter of 1879-80, which stands on the Grand Canal very near the Academia. More recently, Margaretta Lovell has identified them as the Palazzi Sagredo and Pesaro; see *Venice, The American View*, 151.
2 Ruskin, *Stones of Venice*, 1900, 3:347.
3 Fine, *Drawing Near*, 123.

39 Nocturne

from the "Twelve Etchings," or the "First Venice Set"
1879-80

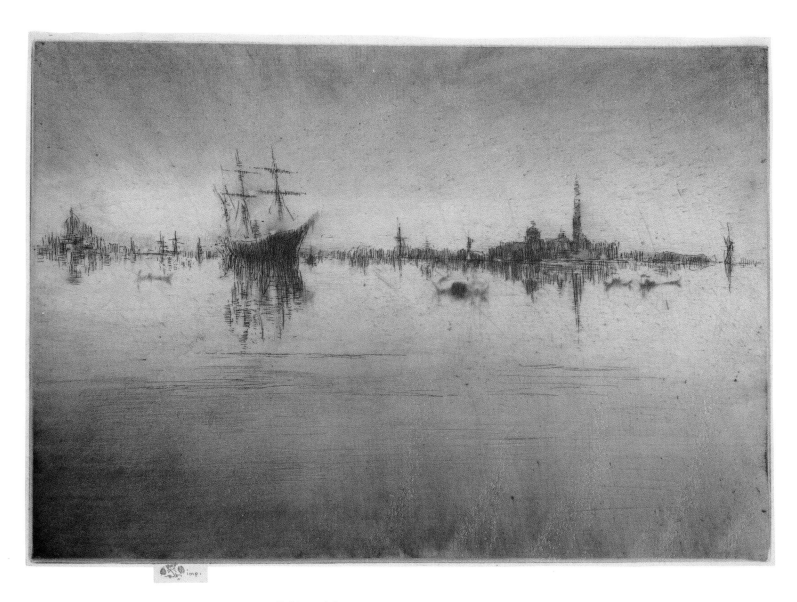

Etching and drypoint, printed in warm black
ink on heavy laid paper, trimmed to platemark

K. 184 iv/v

20.5 x 29.3 cm. (8 1/16 x 11 9/16 in.)

Signed in pencil, on tab: butterfly

Collection: J.H.L. LeSecq (Lugt 1336)
Purchased from M. Knoedler & Co., New York,
1906

Bequest of Margaret Watson Parker, 1954/1.372

Of all the Venetian etchings, one of the largest and best known is the *Nocturne*. Printed in warm black ink, it most closely approximates the effects of the artist's painted Nocturnes and may have been a subject Whistler had in mind as early as 1878 when writing to Alfred Chapman of his plans to visit Venice: "If I go to Venice would you like to go in for a Nocturne of the Gondola kind?"[1] Like the painted Nocturnes, the subject in this work is enveloped in a rich darkness composed of overall tonal harmonies.[2] The major elements of the etching are seen from the Riva degli Schiavoni: a ship at anchor in the Basin of San Marco, the dome of Santa Maria della Salute flanking it at the left, and the campanile and basilica of San Giorgio Maggiore at the right. These elements float and hover along the ribbon-like horizon line, and we see in the *Nocturne* and related pastels (fig. 39a) how Whistler so effectively evokes the undulating rhythms and dark mysteries of this magical city at night.

Of the etchings in the "First Venice Set," the *Nocturne* depends most on the inking of each impression. Whistler's printer of the "French" and "Thames" sets, Auguste Delâtre, introduced the artist to the possibilities of enhancing the atmospheric qualities of his image through manipulation of the inking of the plate. In the *Nocturne* we see perhaps the most successful example of Whistler's use of plate tone to evoke the palpable humidity of nighttime in Venice. In order to understand how simple a construction the *Nocturne* is, it is useful to compare the Museum's impression with the first impression that Whistler took primarily as a working proof against which to check the line work (fig. 39b). The image is composed of very few etched lines; these consist largely of vertical hatching along the horizon line which obviates the distinction between the objects themselves and their reflections. The Museum's later state includes the addition of extremely fine drypoint lines used both to describe the gondolas and to evoke the ethereal luminosity of the lights in the rigging of the ship at the center of the composition. The few, very lightly etched horizontal lines in the foreground suggest the undulating movement of the water and help establish the distance between the viewer and the buildings and shipping. Compared with the impression of the first state from the Hunterian, Whistler's mastery of the printing process here becomes obvious. The depth of space and atmosphere are greatly heightened by the film of ink that lies on the plate at both the top and bottom edges. Further augmenting the sense of depth, Whistler has employed a directional sweep to the wiping of the ink, radiating the ink film outward and towards the edges from the center of the plate.[3]

39a *Nocturne: San Giorgio*, 1879-80, pastel on brown paper, Courtesy of the Freer Gallery of Art, Smithsonian Institution, Washington, D.C. (17.6)

39b *Nocturne*, K. 184 i/iv, Hunterian Art Gallery, University of Glasgow, Birnie Philip Bequest. This impression carries Whistler's pencil inscription, "1st State — 1st Proof."

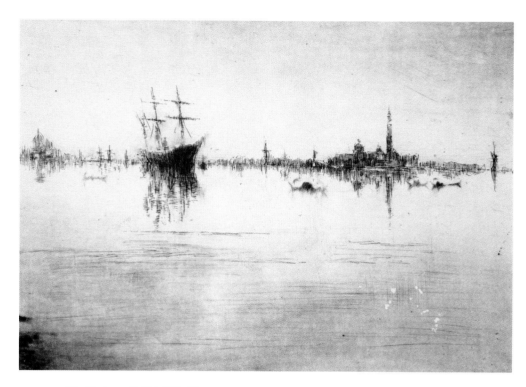

39c *Nocturne*, K. 184, iii/iv, The
Metropolitan Museum of Art, Gift of Felix
M. Warburg and his family, 1941 (41.1.200)

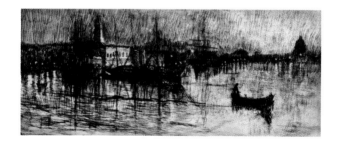

39d Otto Henry Bacher, *Harbor*, etching
and drypoint, The Fine Arts Museums of
San Francisco, Gift of A.S. MacDonald to
the De Young Museum (1916)

As atmospheric and evocative as the Museum's impression is, it is interesting to note how varied the impressions of the *Nocturne* can be. One can see tremendous variety in the use of brown or warm black ink and the individual wiping of the plate to explore differences in time; effects range from twilight to full nighttime. The Museum's impression emphasizes the lights of the city and the swell of the water. In other impressions Whistler very subtly evokes the effect of a moonlit night (fig. 39c). By wiping a pale halo in the water below the ship at anchor, he has conjured, with only changes in the manipulation of the plate tone, the effect of still water with moonlight reflected on its surface.

In order to appreciate how innovative the *Nocturne* is in its use of minimal line etching and evocative wiping of the plate, one can compare it with a work done at the same time by an artist with whom Whistler was acquainted while in Venice, the American painter and printmaker Otto Bacher. Although the *Nocturne* is considered one of the earliest prints that Whistler executed in Venice, Bacher's etching of a similar subject, *Harbor* (fig. 39d), shows several of the same techniques employed with less finesse than in the *Nocturne*. With the exception in the Bacher of the brightly lit Doges Palace and campanile, the evocation of a nocturnal atmosphere and the silhouetting of the ships and buildings along the horizon line are common to both Bacher's print and the *Nocturne*. The sureness and delicacy of Whistler's understated use of line distinguish it from Bacher's etching. Whereas in the *Nocturne* the lights in the rigging are indicated by the most delicate of drypoint lines, Bacher's lights in both the rigging and along the embankment of the Riva degli Schiavoni are more heavily worked. The rain in *Harbor* is described by the loosely organized vertical hatching in the sky and does not have the suggestive atmospheric presence created by the plate tone of the *Nocturne*. As Katharine Lochnan observes, however, the rich atmospheric effect in Whistler's Venice works, most notably the *Nocturne*, could well have been inspired by Bacher's improvisations with monotypes in Venice (fig. 39e).[4]

When the "First Venice Set" was shown in London in 1882, the *Nocturne* was reviewed by London critics, who deplored the understated qualities of the print and found it sadly lacking in the finish that had characterized the "Thames Set":

"Nocturne" is different in treatment to the rest of the prints, and can hardly be called, as it stands, an etching; the bones as it were of the picture have been etched, which bones consists of some shipping and distant objects, and then over the whole of the plate ink has apparently been smeared. We have seen a great many representations of Venetian skies, but never saw one before consisting of brown smoke with clots of ink in diagonal lines.[5]

Although the Venetian etchings were unappreciated by some of the British public when they were displayed at the Fine Art Society, they contributed a new component to Whistler's etching style. The artist, however, had pursued this interest in atmospheric effects prior to his Venice trip. Regardless of any immediate influences, in the *Nocturne*'s harmonic and tonal vision of Venice Whistler is referring to his own lithotints of London done two years before, as well as to those ethereal renditions of Venice executed earlier in the century by Joseph M.W. Turner.

CM

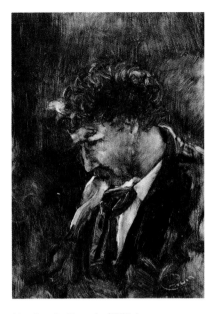

39e Corwin, *Portrait of Whistler*, monotype, The Metropolitan Museum of Art, The Elisha Whittelsey Collection, The Elisha Whittelsey Fund, 1960 (60.611.134)

1 Getscher, *Whistler and Venice*, 16.
2 There is a painted Nocturne of the same scene at the Museum of Fine Arts, Boston, *Nocturne in Blue and Silver: The Lagoon, Venice* (YMSM 212).
3 The "secret of drawing" is here employed in an almost abstract capacity. The vignetting of the composition which was common for Whistler and used widely in reproductive etching and wood engraving in the later nineteenth century was characteristic in Whistler's Venetian compositions.
4 Bacher describes how he and other artists created monotypes, called "Bachertypes," which he printed on his press, and he sums up the effect that these monotypes had on Whistler's printing technique: "I believe Whistler saw in their beauty the possibilities of their further use as a tonal form in the printing of etchings, for the Venetian etchings which were printed at this time reveal a more definite use of this form of printing" (Bacher, *With Whistler in Venice*, 118). Lochnan connects these experiments with Whistler's knowledge of "artistic printing" and suggests that his use of plate tone to create dramatic atmospheric effects may have been inspired by Bacher's evening entertainments (Lochnan, *Etchings*, 206).
5 Fine, *Drawing Near*, 133.

40 **The Doorway**
from the "Twelve Etchings," or the "First Venice Set"
1879-80

Etching and drypoint, printed in warm black
ink on laid paper, trimmed to platemark

K. 188 iv/vii

29.4 x 20.2 cm. (11 7/16 x 7 7/8 in.)

Signed in pencil, on tab: butterfly and imp.
Signed on the plate, on the facade, u.l.: butterfly

Bequest of Margaret Watson Parker, 1954/1.375

Etching and drypoint, printed in dark brown
ink on laid paper, trimmed to platemark

K. 188 vii/vii

29.4 x 20.2 cm. (11 7/16 x 7 7/8 in.)

Signed in pencil, on tab: butterfly
Signed on the plate, on the facade, u.l.: butterfly

Bequest of Margaret Watson Parker, 1955/1.124

Opposite page

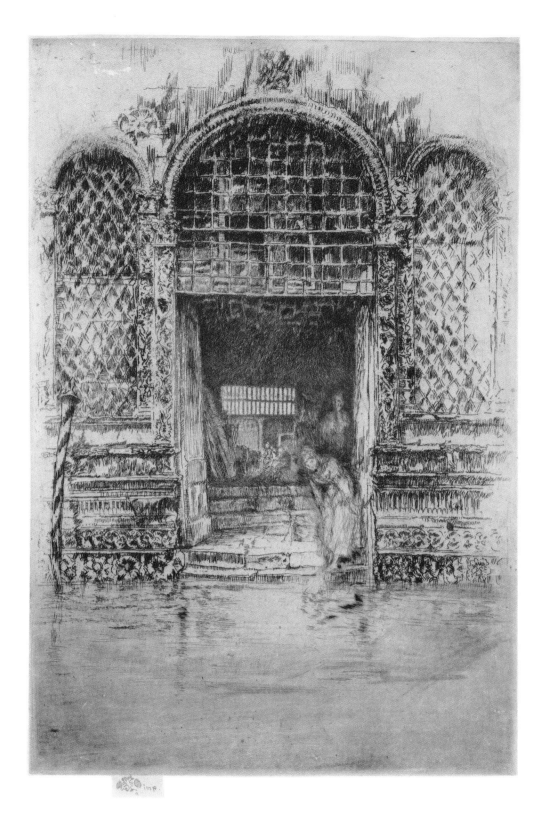

41 The Doorway

from the "Twelve Etchings," or the "First Venice Set"
1879-80

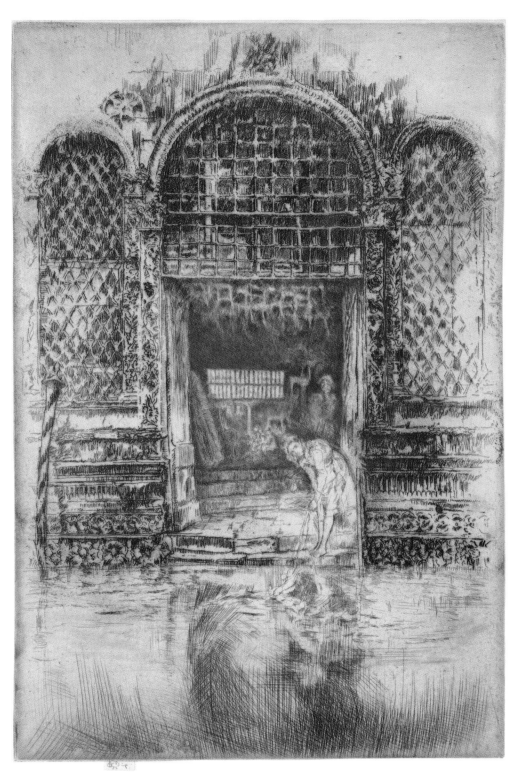

The motif of figures framed in a doorway, which Whistler had made a part of his visual repertoire as early as the "French Set" (see cat. no. 5), reappears in various guises throughout the Venetian etchings. Here the subject is the portal of a Renaissance facade located on the Rio della Fava near the Doge's palace.[1] Whistler worked on the plate from a gondola moored fifteen or twenty feet across the canal, according to Otto Bacher, who reproduces a photograph of the very doorway that attracted the artist's attention.[2] The suggestion of direct

sunlight on the elaborately worked grills above and on either side of the central aperture counters the heavy shadows within the interior. What might at first appear to be the effect of flickering sunshine filtered through the doorway's grillwork is, in fact, an indication of the structure's use at the time. The building was then the shop of a chairmaker or caner, and the mysterious forms, seen most clearly in the impression of the seventh state, are his merchandise suspended from the ceiling.

The two impressions of *The Doorway* from the Parker Bequest demonstrate most of the significant changes Whistler continued to make to the plate for years after he had returned from Venice.[3] In its initial state, a young woman stands and stoops at the doorstep to rinse a cloth in the canal. By the fourth state in the Museum's collection, the gesture that helps to account for her posture has been effaced, and the figure has been turned more toward the viewer. In the seventh and final state the drapery she originally held has been restored. Alterations have also been made to the figure standing behind the girl. Most dramatically, Whistler has added fine drypoint lines to the canal in the seventh state to create reflections that he achieved in other impressions through the use of plate tone.[4] These passages in the final state, including the reflection of the girl herself, are intricately traced on the insubstantial, watery surface of the canal and are played against the more solidly carved and assembled tracery and screens of the facade above, a contrast between the evanescent and the enduring brought together under the sign of art. In a final authorial conceit, as if to signal his ultimate responsibility for all the effects pictured in the etching, Whistler signed the plate with his butterfly positioned to the left of the central arch, where it presides as both part of the print and an element of the ornamented facade recorded and constructed within it.

JS

1 Lovell, *Venice: The American View*, 153.
2 Bacher, *With Whistler in Venice*, 194-95.
3 Whistler complained as late as 1894 about the need to keep producing impressions of *The Doorway* (Lochnan, *Etchings*, 266; MacDonald, *Graphic Work*, 44).
4 In previous states he had experimented with the roulette (a tool with a sharp-toothed wheel that leaves a grained pattern when run across the plate) to obtain these shadows and reflections; see, for example, three impressions of the third state in the Freer Gallery of Art (98.385, 02.45, 05.181).

42 Two Doorways

from the "Twelve Etchings," or the "First Venice Set"
1879-80

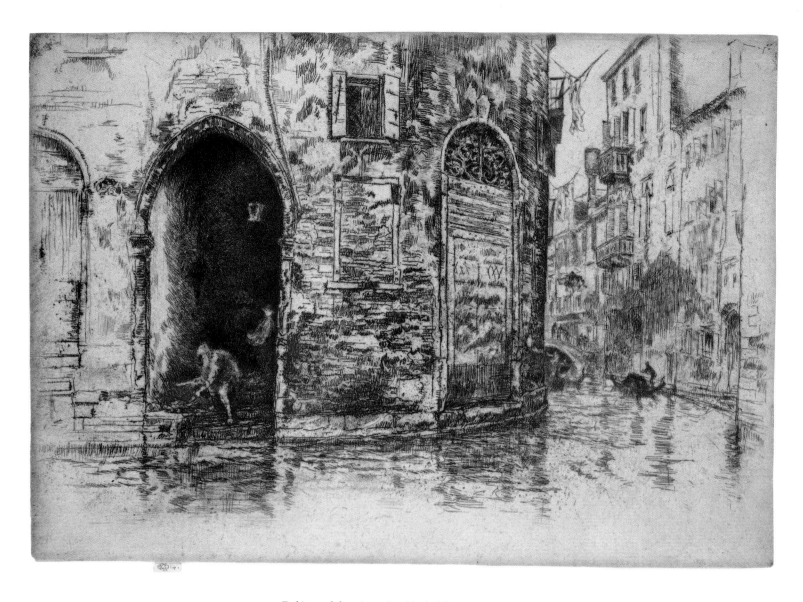

Etching and drypoint, printed in dark brown
ink on laid paper, trimmed to platemark

K. 193 v/vi

20.2 x 29.3 cm. (7 7/8 x 11 7/16 in.)

Signed in pencil, on tab: butterfly and imp.
Signed in pencil, on verso: butterfly
Signed on the plate, u.l.: butterfly
Inscribed in pencil [in Whistler's hand], on verso:
Before last State

Bequest of Margaret Watson Parker, 1954/1.381

Whistler found in the constant visual stimulus of Venice an embarrassment of riches. "He used to say," a contemporary recalled, "Venice was an impossible place to sit down and sketch in—he always felt 'there was something still better round the corner.'"[1] Those words could provide a caption for *Two Doorways*. Where the theme of *The Doorway* (cat. nos. 40, 41) was the focus and symmetry of a single, centralized motif rendered on the page as something of a well-ordered, decorative design, *Two Doorways* revels in multiplicity and the interaction of opposites.[2]

A pair of doors, one open and in shadow and the other closed, is presented as part of a larger architectural fabric whose crumbling textures Whistler conveys with short strokes of his etching needle, as if attempting to note as much detail as possible before being compelled to move on to what was "round the corner." As we progress from one doorway to the next, the facade suddenly ends and the canal that curves past it joins our gaze to the dark silhouette of a gondolier traveling toward a distant bridge. The foreground building establishes a formal foundation for the rest of the scene. Positioned parallel to the page, it opens up as a descriptive surface that simultaneously closes off a full view beyond. Within the facade itself, variations on the theme of open-and-closed play out not only in the dialogue of the two doors, but also in the pairing of an unshuttered window with a bricked-in counterpart below.

In its later states, *Two Doorways* offers an elaborately worked image, and much of the carefully descriptive hatching throughout must have been the product of the studio. The earliest proof taken from the plate reveals Whistler's procedure (fig. 42a). Annotated "1st State 1st Impression," and "Printed in Venice," this proof demonstrates the value Whistler placed on periodically checking the progress of his line work and his developing composition. The trial proof also shows that he was concentrating from the beginning on the crucial passage where the edge of the flattened facade and the oblique view down the canal abruptly meet.

Whistler seems to have been attracted to the motif of the doorway not only for the play of form it afforded, but also as a kind of metaphor for visual perception and artistic representation. A girl holding a basket peers out from behind an old man whose stooped shape is enclosed by the darkened portal. This open door offers only a partial view within and hints at unseen, and unknowable, elements beyond its threshold. In *Two Doorways*, that threshold awareness extends beyond the doors themselves, and we are left to wonder about what, precisely, might unfold were we able to follow the movement of the gondola along the canal.[3] In his many doorway images, his sustained interest in the composition of the fragment and the vignette, and even the duality of presentation and withholding hinted at in certain of his portraits (see cat. no. 23), Whistler suggests art's incapacity to represent anything other than the partially seen or experienced. Yet within that limitation, these visual structures seem to say, lies the dynamic possibility of perpetually uncovering what may be just around the corner.

JS

42a *Two Doorways*, K. 196 i/vi, Courtesy of the Freer Gallery of Art, Smithsonian Institution, Washington, D.C. (03.148)

1 Pennell and Pennell, *Life* (1908), 1:263.
2 These juxtapositions—of light and dark, open and closed, surface and recession—are noted in Lovell, *Venice: The American View*, 157.
3 On the thematics of thresholds, see Mary Ann Caws, *A Metapoetics of the Passage* (Hanover, N.H.: The University Press of New England, 1981), 13-15, 49-51; and *The Eye in the Text* (Princeton: Princeton University Press, 1981), 15-19, 189-99.

43 Nocturne: Salute
1879-80

Etching and drypoint, printed in dark brown
ink on laid paper, trimmed to platemark;
watermark: GR surmounted by a crown

K. 226 ii/v

15.2 x 22.7 cm. (5 15/16 x 8 7/8 in.)

Signed in pencil, on tab: butterfly and imp.
Signed on the plate, l.l.: butterfly

Collection: Royal Library, Windsor (Lugt 2535)
Purchased from Obach & Co., London, 1906

Bequest of Margaret Watson Parker, 1954/1.393

Arguably one of the most abstract of Whistler's Venice views, *Nocturne: Salute* was probably among the first etchings he made after his arrival in the city.[1] Nocturnes naturally would have been much on his mind in the aftermath of the recently concluded Ruskin libel suit of November 1878. That trial had centered around Ruskin's scathing commentary on a controversial Nocturne painting, and several of Whistler's finest Nocturne canvases were introduced into the proceedings as evidence. The lingering financial effects of the affair in part prompted the artist's Venetian sojourn. Not surprisingly, then, he began to picture Venice in his prints by seeing the city nocturnally. His view here is taken from the Molo, in front of the Piazzetta, looking toward the recognizable outline of the church of the Santa Maria della Salute at the mouth of the Grand Canal. At the left, a few lines indicate what is probably a corner of Sansovino's Library on the Piazzetta itself.[2] To the right of the Salute is the gilt orb of the Dogana along with several ships' masts visible from the Giudecca. An ever-present gondola floats in the middle distance, complementing Whistler's butterfly signature which alights at the opposite edge of the plate.

Whistler did not include *Nocturne: Salute* in either of his "Venice" sets, perhaps because its minimally etched lines could not bear the repeated pressure of the printing press. Like *Nocturne* (cat. no. 39), those lines define the image less than does the manipulation of ink upon the surface of the plate. In the impression at the Museum of Art, the ink is wiped with even, horizontal strokes that suggest a uniform light, and comparatively equal amounts of plate tone are left in both the sky and the water. The printing in other impressions, however, varies widely. Another proof, for example (fig. 43a), exhibits stronger contrasts between the bands of space on either side of the horizon, and a radial pattern of wiping in the sky implies the refracted light of sundown.

From their first appearance in the early 1870s, Whistler's subtly reductive Nocturnes had been associated in many viewers' minds with the later, densely atmospheric paintings of J.M.W. Turner.[3] Now, with the American artist's presence in Venice, a city immortalized by Turner most recently during his third visit in 1840, the connections suggested by the two artists' imagery were all but inescapable. Despite his many critical comments about Turner, Whistler sustained a lifelong interest in the English painter's work. That interest had begun as early as 1855 with a watercolor copy made from a chromolithograph of *Rockets and Blue Lights (Close at Hand) to Warn Steam-Boats of Shoal-Water*, a Turner oil painting exhibited in 1840 (Butlin and Joll 387; Sterling and Francine Clark Art Institute, Williamstown, Mass.).[4] Yet Whistler's dismissal of the eminent landscaper painter was often vocal, and he condemned Turner as well as Ruskin, his chief defender (and, of course, Whistler's own courtroom nemesis) for lacking "the brains to carry on tradition."[5]

Whatever Whistler may have actually thought of Turner's work, *Nocturne: Salute* sets a visual tone only superficially similar to the English artist's vision of Venice. In *Venice: S. Maria della Salute and the Dogana* (fig. 43b), a watercolor done around 1840, Turner depicts much the same view as in Whistler's etching. Both images delight in the silhouette of the Salute and its reflection hovering as if suspended between sky and water. Even at its most quiescent, however, Turner's Venice is a drama enacted by and about the elements, and the pulsating sunlight of his watercolor illuminates his active, epic engagement of nature's potency. By contrast, Whistler's nocturnal ambience stands as a metaphor for his aesthetic distance from a natural world he seeks to contain and "arrange" in a subdued dynamic of darkness and limited light.[6] The personal vision of both artists responds to forces of nature that dematerialize the objects of their attention. But perhaps Otto Bacher, Whistler's Boswell in Venice, best captured the deliberately tenuous essence of *Nocturne: Salute* and its ambition to express a dark fragility as vivid as Turner's luminous depths. Whistler's etching, Bacher observes, is redolent with a certain "tentativeness of feeling," a quality that compares, he favorably concludes, to "a breath in its delicate elusiveness. . . ."[7]

JS

1 Getscher, *Whistler and Venice*, 63.
2 Mark Evans, *Impressions of Venice from Turner to Monet*, exh. cat. (Cardiff: National Museum of Wales, 1992), 44.
3 Turner's name also was invoked pointedly during the course of *Whistler v. Ruskin*; see Merrill, *A Pot of Paint*, 178, 265-66.
4 Whistler's copy, listed in the *catalogue raisonné* of his oil paintings (YMSM 5), is now known to be a watercolor, executed before he departed America for France. I am grateful to Margaret F. MacDonald for clarifying this matter for me in conversation.
5 Pennell and Pennell, *Journal*, 248. On another occasion, Whistler referred to the Turners hanging in the National Gallery as "a series of accidents" (Menpes, *Whistler as I Knew Him*, 82).
6 In a number of Turner's own Venetian night scenes done in watercolor and bodycolor on brown paper, it is the dramatic and energetic *contrast* between dark and light that defines the image. See Lindsay Stainton, *Turner's Venice* (London: British Museum, 1985), nos. 8-13, 26-29.
7 Bacher, *With Whistler in Venice*, 200.

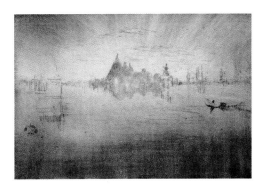

43a *Nocturne: Salute*, K. 226 ii/v, Courtesy of the Freer Gallery of Art, Smithsonian Institution, Washington, D.C. (05.198)

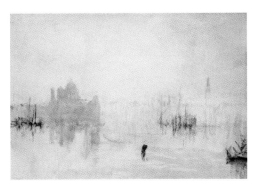

43b J.M.W. Turner, *Venice: S. Maria della Salute and the Dogana*, ca. 1840, watercolor, Tate Gallery, London, Bequeathed by the artist, 1856 TB CCCXV-14

44 San Biagio

from the "Twenty-six Etchings," or the "Second Venice Set"
1879-80

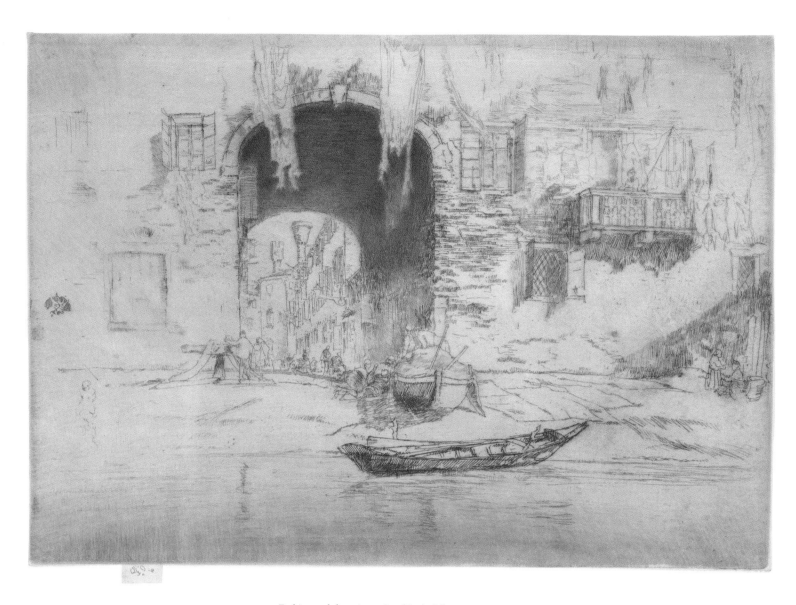

Etching and drypoint, printed in dark brown
ink on laid paper, trimmed to platemark

K. 197 ix/ix

21 x 30.2 cm. (8 1/4 x 12 11/16 in.)

Signed in pencil, on tab: butterfly and imp.
Signed on the plate, left center: butterfly

Purchased from Obach & Co., London, 1906

Bequest of Margaret Watson Parker, 1954/1.385

Whistler's first residence in Venice during the late fall of 1879 and winter of 1880 was the Palazzo Rezzonico on the Grand Canal. Staying in such an expensive part of town became increasingly difficult for Whistler and Maud, and Whistler wrote back to Marcus Huish requesting an advance of funds in order to continue working. In the summer of 1880, after visiting Otto Bacher in his rooms at the Casa Jankovitz, located close to the church of San Biagio, Whistler moved into rooms next door. In addition to the economy that it represented, the move also provided Whistler with an array of possible subjects. The views from his room at the Casa Jankovitz encompassed the dramatic vistas up the Riva degli Schiavoni which included the Doges Palace, Santa Maria della Salute and the Dogana, and San Giorgio Maggiore—most of the recognizable tourist haunts of the city. Yet despite the availability of these celebrated buildings outside his windows, many of the images Whistler executed in etchings and pastels while in Venice are of more anonymous, intimate views of the city—views of back canals and piazzas that tourists would have overlooked as they passed from monument to monument. Even when portraying recognizable buildings, Whistler consciously departed from the tradition of the *veduta* and presented a different Venice from that which typically records the Grand Tour of the continent. He found his Venetian ideal in the colorful back streets of the city. In a letter to his mother he describes the attractions of these quiet canals off the beaten tourist track:

... *this evening the weather softened slightly and perhaps tomorrow may be fine—and then Venice will be simply glorious, as now and then I have seen it—after the wet, the colours upon the walls and their reflections in the canals are more gorgeous than ever—and with sun shining upon the polished marble mingled with rich toned bricks and plaster, amazing city of palaces becomes really a fairy land—created one would think especially for the painter. The people with their gay gowns and handkerchiefs—and the many tinted buildings for them to lounge against or pose before, seem to exist especially for one's pictures and to have no other reason for being! One could certainly spend years here and never lose the freshness that pervades the place!* [1]

The less-fashionable district in which the Casa Jankovitz was located provides the subject for *San Biagio*. Whistler frequently canvassed the city for these out-of-the-way scenes which stood in contrast to Venice's grand public canals and buildings. Bacher records some of the sights Whistler encountered in the Castello quarter near their residence. Bacher's account could almost serve as a description of the image in *San Biagio*:

On clear, sunlight days, we often watched the fishermen coloring the sails of their boats which were moored in picturesque groups, near the Riva below our windows. Spreading the triangular canvas on the smooth, marble walks, they covered them with a mixture of dry paint and salt water, using a sponge with the dexterity of a brush. After both sides of the sail were covered, it was dried in the sun and dipped in the canal to remove the surplus paint. [2]

The "secret of drawing" is used here to explore this area in Whistler's immediate neighborhood. The edge of the canal meets the enclosing wall of the building, with the figures in the foreground attending to daily needs, inspecting the boats, talking in groups. In *San Biagio* the wall, with its penetrating archway leading back to a busy *calle* and its arrangement of windows and balconies, as well as the boats in the foreground, are of principal interest to the artist. As with other Venetian etchings with water in the foreground, the bottom of the plate retains the greatest amount of plate tone, thus darkening the water at the lower edge of the print. Whistler carefully describes the textures of the walls, with their thin rows of bricks, as light passes over them. He must have been delighted with the theme and variation presented by the projecting balconies and shutters of the windows; their interplay contrasts sharply with the recession of the immense barrel vault of the archway leading back to the street. Whistler prevents the entrance to the *calle* from overwhelming the composition by suspending the apparition-like laundry before it, effectively breaking up the dark mass of the archway and returning the viewer's attention to the plane of the wall instead of back into the distant street. Many incidentals at the periphery of the composition are only summarily indicated, and this manner of working, concentrating on the main feature of the work while giving less focus to other components, is indicative of the "secret of drawing" that Whistler used to create his Venetian works. Despite the relatively large scale of the print itself and the imposing archway, in *San Biagio* Whistler has created one of his quietest and most private images from the "Venice" sets.

CM

1 Lochnan, *Etchings*, 187.
2 Bacher, *With Whistler in Venice*, 18.

45 Upright Venice

from the "Twenty-six Etchings," or the "Second Venice Set"
1879-80

Etching and drypoint, printed in black ink on
laid paper, trimmed to platemark

K. 205 ii/iv

25.5 x 17.9 cm. (10 x 7 in.)

Signed in pencil, on tab: butterfly and imp.
Signed on the plate, l.l.: butterfly

Purchased from Obach & Co., London, 1905

Bequest of Margaret Watson Parker, 1954/1.388

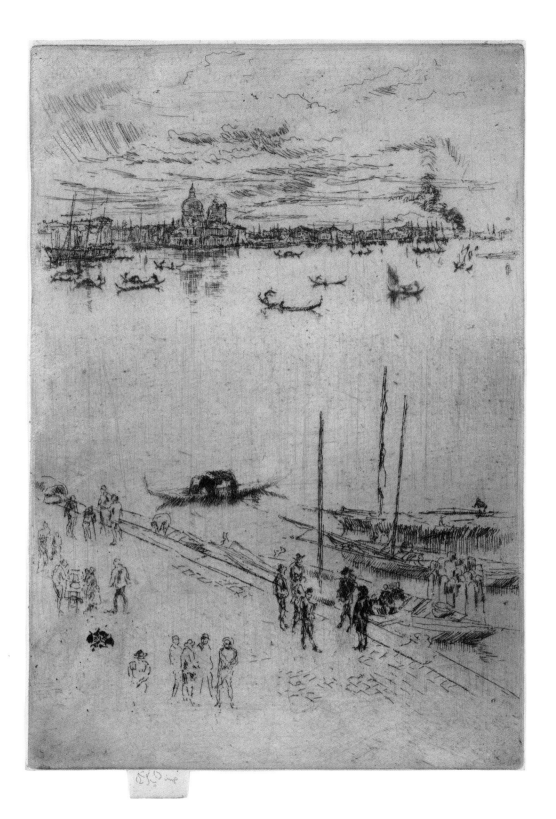

Several years after the publication of the "First Venice Set," Whistler decided to exhibit another group of the fifty or so plates that resulted from his visit to Venice in 1879-80. After the successful exhibition of the etchings published in the "First Venice Set," followed by that of the pastels executed on the trip, Whistler arranged with the Fine Art Society to exhibit the remaining Venetian plates along with a handful of London etchings begun after his return from Venice. On February 17, 1883, an exhibition of the Venetian etchings opened at the Society gallery. The exhibition included the twelve etchings from the "First Venice Set," plus numerous others.

Whistler orchestrated the entire event. The galleries were painted in yellow and white; a servant dressed in yellow handed out copies of the catalogue; Whistler drew barbed butterflies for his supporters to wear; and, lastly, the artist produced a catalogue calculated to provoke comment. Availing himself of the opportunity to pillory his detractors in print, Whistler finally settled the score with a handful of critics whose comments on the "First Venice Set" had struck him as especially ludicrous. Scattering their remarks throughout the catalogue, Whistler delighted in underscoring their absurdity. He described the catalogue to Waldo Story:

And such a catalogue! The last inspiration—sublime simply—never such a thing thought of. I take, my dear Waldo, all that I have collected of the silly drivel of the wise fools who write, and I pepper and salt it about the catalogue . . . in short I put their nose to the grindstone and turn the wheel with a whir![1]

However, as Robert Getscher has pointed out, Whistler freely interpreted his critics' earlier comments, taking them out of context and applying them to works other than the ones originally described. He even consciously misquoted some remarks in order to heighten the sense of the ridiculous. Whistler considered the event a complete success, although his enjoyment was tempered by disputes with the Fine Art Society about the escalating costs for the adventure.

When Whistler finally decided to publish the "Second Venice Set," it was published not by the Fine Art Society, which was still awaiting the final printing of the set of twelve etchings originally commissioned by them, but by the firm of Dowdeswell and Dowdeswell. The prospectus described twenty-six etchings to be published in thirty sets, with twelve additional impressions from fifteen of the plates. As usual, the final proofs were delayed, in part because Whistler had undertaken a sheet to accompany the set. The sheet, known as "Propositions," was to outline the artist's beliefs regarding the principles of etching. The germ of the "Propositions" was contained in a letter Whistler had originally sent from Venice to Marcus Huish at the Fine Art Society. In the "Propositions," however, he elaborated his ideas into something of a manifesto. Among the points Whistler made were that etching, being on a small scale and made with fine tools, should itself be small; that a large scale indicated an artist who was neither in sympathy nor control of his medium; and

. . . that the huge plate, therefore is an offense—its undertaking an unbecoming display of determination and ignorance—its accomplishment a triumph of unthinking earnestness and uncontrolled energy—endowments of the 'duffer'.[2]

In further comments, Whistler chastened artists who elaborated upon and emphasized the margins of the paper around the plate. He found the presence of a printed "remarque," a marginal decoration outside the central image, and the excessive display of large margins to be an indication of false connoisseurship in both artists and collectors, and he maintained that the value of a print was not to be determined in any part by the amount of paper extending beyond the platemark but by the image itself. He compared this to a situation that would never be found in painting:

That wit of this kind should leave six inches of raw canvas between the painting and its gold frame, to delight the purchaser with the quality of the cloth.[3]

Satisfied with this elucidation of his philosophy on printmaking, he returned to the task of printing the remaining plates, completing the project by July 1887.

While Whistler's Venetian prints and pastels exhibit his discovery of the "secret of drawing," *Upright Venice* is unique among the etchings in that it integrates two separate

45a *Upright Venice*, 1880, K. 205 i/iv, Rosenwald Collection, © 1993 National Gallery of Art, Washington

vignettes drawn roughly six months apart. Otto Bacher described the process Whistler followed in the creation of this image. The upper portion, depicting the church of Santa Maria della Salute, floats in the distance and was the part of the composition completed in the first state (fig. 45a), executed not long after Whistler arrived in Venice during the late fall or early winter of 1879-80. The first winter Whistler spent in Venice was an exceptionally difficult one, and the artist wrote back to Huish complaining of the cold and continual illness he experienced during that initial period in Venice.[4] Getscher has noted the relation of the upper portion of the image to pastels which date from the early months of Whistler's stay, and it is presumed therefore that the distant vista of the upper portion was drawn during the winter months.[5] In contrast, the Riva degli Schiavoni, represented in the foreground, was executed before Bacher departed from Venice in August of 1880. It shows the Riva filled with groups of figures talking. It has been observed that the two halves of the etching have a slightly different feeling: the upper portion with its leaden sky and distant crispness stands in contrast to the bottom portion, with its more relaxed and comfortable figures who seem unaffected by any inclement weather. Whistler probably drew these figures in the warmer weather of spring or early summer. The work is therefore a synthesis of the same view taken at different times of year.

Whistler has deftly woven the two portions of the image together, using the placement of the gondolas to integrate the center portion of the plate which remains unetched. The gondolas in the distance are mostly rendered in drypoint, and the one gondola in the foreground is also drawn in drypoint, connecting the two halves through the textural richness of the medium's burr. Another way Whistler unites the composition is through the implied continuation of the sweep of the lagoon at the left of the composition. Although the embankment of the Riva is cropped in this print, Whistler frequently uses the Riva's large sweeping curve in the pastels and etchings (cat. nos. 34, 35) as a means of enlivening the composition and allowing him to adjust the placement of the shipping.

CM

1 Getscher, *Whistler and Venice*, 223.
2 Lochnan, *Etchings*, 234.
3 Lochnan, *Etchings*, 235.
4 Whistler wrote to Huish at the Fine Art Society complaining how difficult the winter had been and how it had hampered his work on the commission for the Venetian etchings (Getscher, *Whistler and Venice*, 116).
5 Getscher, *Whistler and Venice*, 40-41.

46 Long Venice

from the "Twenty-six Etchings," or the "Second Venice Set"
1879-80

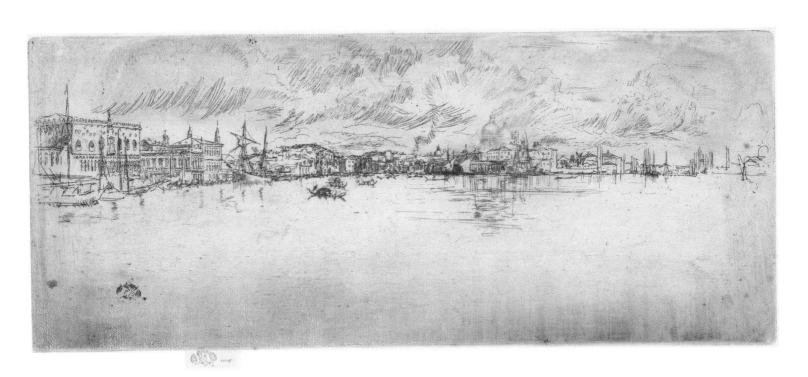

In one of his few traditional views of Venice, Whistler has shown us, in reverse, as was his custom, the spectacular vista from his room at the Casa Jankovitz. This sweep of the Venetian panorama, recalling both Canaletto and Turner, inspired a number of the artist's works in various media (fig. 46a). Here the artist has concentrated his attention on the area where the Grand Canal empties into the basin in front of the Doge's Palace. The domes of Santa Maria della Salute float in shimmering drypoint above the old customs house known as the Dogana near the center of the composition. This pair of domes must have presented continual problems for the artist. In each of the five states he has reworked them, sometimes burnishing them out and completely redrawing them, changing the profile of the domes in the process. The focus on the architecture dissolves as the composition is read to the right: the important Church of the Redeemer, Il Redentore, is only barely suggested at the far right of the plate. Fleeing above the meticulously rendered mouth of the Grand Canal are the blustery clouds, which are much more freely drawn than the buildings and ships below. As with most of his watery Venetian images, Whistler has elected to retain some plate tone at the bottom of the image, thus enhancing the breadth of distance and reinforcing the sense of a dark cloudy day.

CM

Etching and drypoint, printed in dark brown ink on laid paper, trimmed to platemark

K. 212 ii/v

12.9 x 31.1 cm. (5 1/16 x 12 1/4 in.)

Signed in pencil, on tab: butterfly and imp. Signed on the plate, l.l.: butterfly

Purchased from Obach & Co., London, 1906

Bequest of Margaret Watson Parker, 1954/1.391

46a *Venice Harbor*, 1879-80, watercolor on paper, Courtesy of the Freer Gallery of Art, Smithsonian Institution, Washington, D.C. (05.118)

47 **Nocturne: Furnace**

from the "Twenty-six Etchings," or the "Second Venice Set"
1879-80

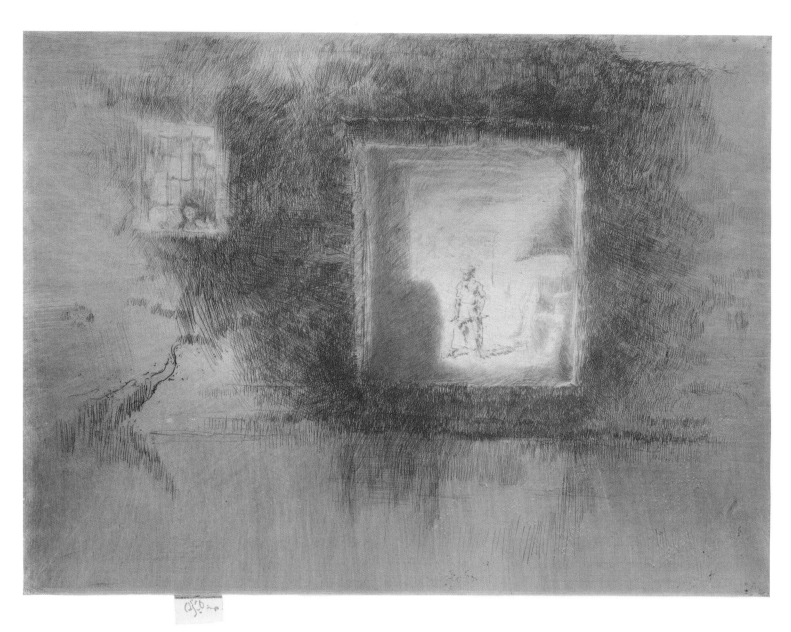

Etching, printed in brown ink on laid paper,
trimmed to platemark

K. 213 iv/vii

16.4 x 22.7 cm. (6 3/8 x 8 7/8 in.)

Signed in pencil, on tab: butterfly and imp.
Signed on the plate, left center: butterfly

Collections: H.S. Theobald (H S T in pencil;
not in Lugt in this form); C.W. Dowdeswell
(no mark)
Purchased from M. Knoedler & Co., New York,
1907

Bequest of Margaret Watson Parker, 1954/1.392

In his approach to the images of Venice, Whistler continued to bring together a number of themes and concerns which he had explored prior to his arrival in Italy. *Nocturne: Furnace* combines several of these earlier motifs in a new way. His appreciation of the subtle splendors of a city at night, his past use of figures framed in doorways, and his depictions of labor in a smithy or forge have all been brought together in this enigmatic and mysterious image of a figure at work in a back canal glass works. Whistler's art is highly synthetic, and he has combined these elements into a cohesive whole united by the pools of darkness punctuated by two hidden light sources, the blast of heat and light from the furnace itself, and the unseen source at the left of the image, whose presence is further suggested by the curving tip of a gondola. Like the other image of buildings on a canal seen by lamplight, *Nocturne: Palaces* (cat. no. 48), the effects of the luminosity create a spectral loneliness which in *Nocturne: Furnace* is underscored by the isolation of the two figures relative to one another, and the sense that there are unseen factors at work. For instance, what has brought the woman at the upper left to come to the window? Is she observing us, or is she drawn by the sound of the passing gondola?

Nocturne: Furnace underwent major modification through the states, especially in the figure of the glassblower standing in the pool of bright light. Bacher identified it as one of the plates that required rebiting. Whistler even had to hammer out from the back of the plate those passages to be modified.[1] Despite the technical difficulties, Whistler's efforts were well rewarded; he achieved the effect he sought. In Bacher's words, "he made his etched lines feel like air against solids; this is the impression some of his rich doorways of Venice gave me."[2] The *Nocturne: Furnace* has all the evocative mystery and palpable atmosphere discovered by Whistler in the back canals of the Venetian night.

CM

1 Bacher, *With Whistler in Venice*, 121.
2 *Ibid.*, 101.

48 **Nocturne: Palaces**

from the "Twenty-six Etchings," or the "Second Venice Set"
1879-80

Etching and drypoint, printed in dark brown
ink on laid paper, trimmed to platemark

K. 202 vii/ix

29.2 x 19.9 cm. (11 3/8 x 7 3/4 in.)

Signed in pencil, on tab: butterfly and imp.
Inscribed in pencil [in Whistler's hand], on
verso: superb proof

Purchased from Frederick Keppel, Chicago, 1904

Bequest of Margaret Watson Parker, 1954/1.387

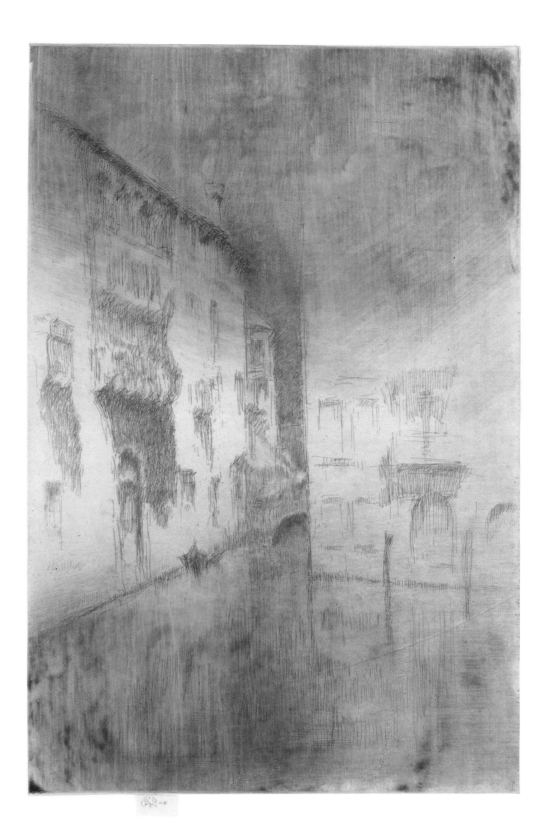

One of the two Nocturne oil paintings extant from Whistler's Venetian period depicts the grand facade of the basilica of San Marco. When he showed his *Nocturne: Blue and Gold — St. Mark's, Venice* (YMSM 213; National Museum of Wales, Cardiff) to a studio visitor in London later in the eighties, the artist sardonically asked his guest if, based on the pictorial evidence, "Ruskin would admit he could draw architecture."[1] John Ruskin's *Stones of Venice* (1851-53), a prose study as embellished with multiple clauses and adjectives as St. Mark's itself is adorned with mosaics, and Ruskin's own, meticulous drawings of Venetian buildings and their decorative details, could hardly seem more remote from the suggestive nocturnal structures Whistler fabricated in both paintings and prints. In *Nocturne: Palaces*, the role of drawing is made an almost irrelevant part of the etching process, and architectural solidity characteristically dissolves under a mantle of printer's ink.

Although it has recently been proposed that *Nocturne: Palaces* represents a view along the Rio di San Severo,[2] the image effaces identity nearly as much as it inscribes it. Whistler reduces the incisive, graphic line of his etching to a skeletal foundation for the creative application of "artistic printing." A trial proof of the plate (fig. 48a), annotated as the first impression pulled while he was still in Venice, reveals a network of mostly parallel, vertical strokes of the etching needle. The palazzo at the right is defined only in its lowest two stories, and it seems to evaporate as it ascends. A cursory series of marks closes it off at the top, and three curved lines at the upper right corner suggest an experiment with other ways to frame this inconclusive passage. When printed, these parts of the composition were most heavily inked with plate tone, which settles onto the top of the palazzo like a veil. The linear basis of the trial proof thus indicates that, from the inception of this particular print, Whistler regarded what he accomplished in Venice as only a beginning. It was always his intention to elaborate upon his etching later, completing it only with the addition of the ink that paradoxically obscures his forms still further.

Whistler's handling of the graphic medium in *Nocturne: Palaces* has been compared to the techniques of monotype.[3] The manipulation of ink over the surface of the plate to create a unique image may also suggest his awareness of and interest in photographic processes. In 1877, several years before his departure for Venice, a friend recorded Whistler's presence at dinner in the company of Joseph Norman Lockyer (1836-1920), an astronomer and solar physicist. According to their host, Whistler and Lockyer spent the evening discussing "the Spectrum, the action of certain rays on sensitive media like silver in photography."[4] In Whistler's etching, however, the photographic process is reordered, and it is the agency of darkness, not light, that registers the visual representation.

The inking of *Nocturne: Palaces* from one impression to the next is fairly consistent and varies mainly in the degree of mystery Whistler obtained. In another proof (fig. 48b) the darkness deepens with bright light from the lantern above the bridge, itself obscured, set in contrast against the surrounding gloom. In the impression from the Parker Bequest, plate tone is distributed evenly in the areas of the sky and the canal, so that the composition would read nearly the same if the print were inverted. That potential visual reciprocity recalls one of Ruskin's most memorable perceptions from the introductory paragraphs to *The Stones of Venice*. In a frequently quoted passage for which *Nocturne: Palaces* could serve as the illustration, Ruskin spoke of the mystique of Venice, "so weak — so quiet, — so bereft of all but her loveliness, that we might well doubt, as we watched her faint reflections in the mirage of the lagoon, which was the City, and which the Shadow."[5]

JS

48a *Nocturne: Palaces*, K. 202 i/ix, Courtesy of the Freer Gallery of Art, Smithsonian Institution, Washington, D.C. (06.39)

48b *Nocturne: Palaces*, K. 202 ix/ix, The Metropolitan Museum of Art, Gift of Harold K. Hochschild, 1940 (40.63.8)

1 Pennell and Pennell, *Life* (1908), 2:28. At about the same time, one reviewer called the St. Mark's Nocturne "a libel on that exquisitely beautiful basilica," a choice of words perhaps intentionally ironic in the aftermath of the Whistler-Ruskin lawsuit (*The Daily Chronicle*, n.d. [November 1886-February 1887], GUL Whistler press-cuttings, 3:57).
2 Martin Hopkinson, *Whistler in Europe*, exh. cat. (Glasgow: Hunterian Art Gallery, 1991), n. pag. [no. 23].
3 See, for example, Lochnan, *Etchings*, 206-07.
4 Alan Cole, diary extracts, 4 December 1877, PWC 281. Cole was the son of Sir Henry Cole (1808-82), the first director of the South Kensington Museum (now the Victoria and Albert Museum) in London, where Norman Lockyer worked in the Department of Science and Art in the mid-seventies.
5 John Ruskin, *The Stones of Venice*, vol. 1, in *The Works of John Ruskin*, ed. E.T. Cook and Alexander Wedderburn, Library Edition, 39 vols. (London: George Allen, 1903-12), 9:17.

49 The Rialto

from the "Twenty-six Etchings," or the "Second Venice Set"
1879-80

Etching, printed in warm black ink on old laid
paper, trimmed to platemark

K. 211 i/ii

22.8 x 20.9 cm. (11 3/8 x 7 7/8 in.)

Signed in pencil, on tab: butterfly and imp

Purchased from David Tunick & Company, Inc.,
New York, 1993

Gift of the Friends of the Museum on the
Occasion of their Twenty-fifth Anniversary,
1993/2.3

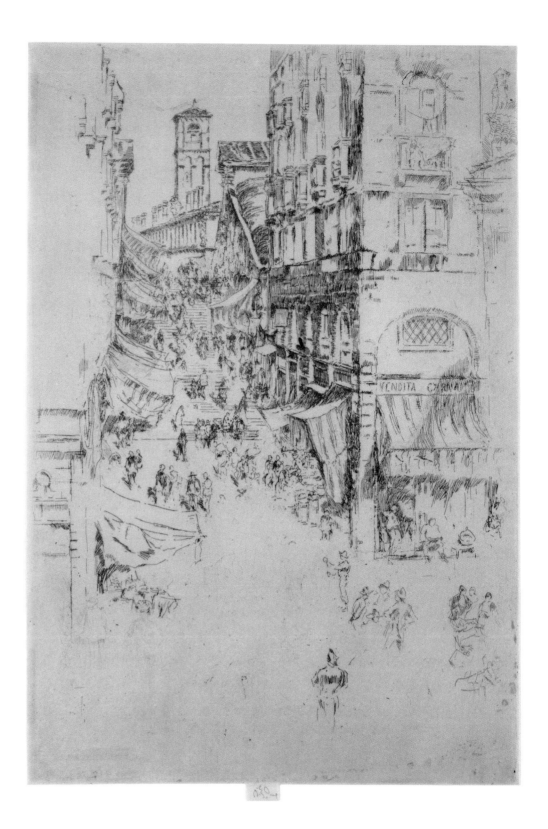

Here, again, in his etching depicting the city's most famous bridge, the Rialto, Whistler has followed his custom of depicting monuments from unfamiliar vantage points. Instead of presenting the more traditional view of the bridge as seen from the Grand Canal, as Canaletto had done, Whistler chose to portray the bridge from the perspective of a walker in Venice. Foregoing the familiar span of the bridge across the Grand Canal (fig. 49a),[1] Whistler has established his vantage point from a nearby building and depicts instead the stairway ascending this Venetian landmark.

In this impression the work has minimal plate tone, and the clean wiping of the plate results in a flatter reading of space than is found in those impressions which retain more ink on the surface of the plate. The flattening creates a vertical stacking of elements in the composition; the resultant compression of space provides a lively decorative surface patterning as well as a spatial reading more closely related to Japanese prints than would be the case if the plate tone at the bottom had been retained.

Margaret MacDonald has noted that Whistler occasionally made initial sketches on the protective brown paper which had been wrapped around the prepared grounded plates he carried on his excursions on foot or in a gondola (fig. 49b). There exists such a drawing of *The Rialto* which is also a view of the pedestrian approach to the bridge. This drawing, which was not a preparatory sketch for the print, shows many of the same lively details that appear in the etching.[2] The drawing shows a greater emphasis on the awnings and close placement of the buildings, while in the etching Whistler concentrates on the more expansive sweep of the stairs as seen from a greater distance.

CM

1 Nineteenth-century photographers were aware of and employed the work of earlier artists. This photograph of the Rialto Bridge shows the same view of the structure that was depicted by Canaletto and other Venetian painters.
2 MacDonald, *The Graphic Work*, 42.

49a Unknown (Carlo Ponti?), *Rialto Bridge, Venice,* albumen print, Gift of Mr. & Mrs. W. Howard Bond, 1987/1.343

49b *The Rialto*, pencil on brown paper, Hunterian Art Gallery, University of Glasgow, Birnie Philip Bequest

50 **Street Scene, Paris [Rue Laffitte (?)]**
ca. 1883-85

Watercolor on brown prepared board

21.6 x 12.7 cm. (8 1/2 x 5 in.)

Signed, center right: butterfly

Purchased from W. Scott & Sons, Montreal, 1906

Bequest of Margaret Watson Parker, 1955/1.91

Whistler had worked in watercolor in his youth (see, for example, fig. 6a), but it was not until after his Venetian sojourn that he took up the medium in earnest. In the 1880s and 1890s he increasingly embraced watercolor's spontaneity and portability to create hundreds of small sheets.[1] Among Whistler's watercolors are a number of cityscapes that place the viewer at a high vantage point looking over rooftops into the plunging perspective of a street framed on either side by buildings. This type of composition appears less frequently in his work than the ubiquitous front views of shop facades. One of Whistler's most influential etchings, *St. James's Street, London* (K. 169), done in 1878, is perhaps the best-known example of the kind of streetscape shown in perspective that again appears in this watercolor of the mid-1880s.

The location of the particular street represented in the watercolor is unknown, and it may even have been painted in London.[2] When Margaret Watson Parker purchased the work it bore the title *Rouen*, but it had been published three years before in *The Art Journal* as *Rue Lafitte [sic]*.[3] That fact would not preclude a setting in Rouen, but a Parisian street of the same name, properly spelled "Laffitte," parallels the rue Le Peletier, northwest of the Opéra, in an area of the city home to a number of prominent art dealers and galleries.[4] One of these, the famous Durand-Ruel gallery, had entrances on both the rue Laffitte and the rue Le Peletier. Whistler occasionally showed his work with Durand-Ruel, first in an important but mostly unnoticed one-man exhibition in January 1873, and again in 1888. Perhaps he was in the vicinity at some point during the mid-eighties and executed this view.

Wherever he may have painted it, Whistler used the warm brown paper as a middle value around which he constructed the rest of his *Street Scene*. Broad, transparent washes of greys and brown provide a basis for details added with a smaller brush in black, grey, and brown. Touches of opaque white highlight the buildings at the left, and the same color floats above the rooflines to imply an urban haze. Whistler's calligraphic brush indicates a number of pedestrians, some of which were painted while the wash underneath was still wet. The blurred forms resulting from this wet-on-wet technique suggest something of the perpetual activity of the city in a way that recalls the contemporaneous street photography that interested the artist and many of his friends among the Impressionist painters. The butterfly signature at the right is of a type Whistler employed most often between 1883 and 1885, and it provides an approximate date for the work.

JS

1 For an overview of these works, see Ruth E. Fine, "Notes and Notices: Whistler's Watercolors," in John Wilmerding, ed., *In Honor of Paul Mellon: Collector and Benefactor* (Washington, D.C.: National Gallery of Art, 1986), 111-33.
2 Spink and Holmes, "Whistler: The Later Years," no. 21.
3 See D. Croal Thomson, "James Abbott McNeill Whistler: Some Personal Recollections," *The Art Journal* 65 (September 1903): 266.
4 Hilarie Faberman, *Modern Master Drawings*, exh. cat. (Ann Arbor: University of Michigan Museum of Art, 1986), 102.

51 **Cottage Door**
ca. 1884-86

Etching, printed in dark brown ink on laid
paper, trimmed to platemark

K. 250 ii/ii

6.7 x 9.9 cm. (2 5/8 x 3 7/8 in.)

Signed in pencil, on tab: butterfly and imp.
Signed on the plate, u.l.: butterfly

Collection: Royal Library, Windsor (Lugt 2535)
Purchased from Obach & Co., London, 1908

Bequest of Margaret Watson Parker, 1954/1.395

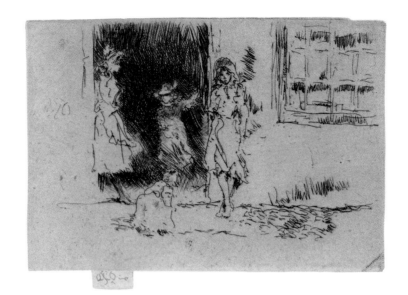

Despite his peripatetic tendencies, Whistler often claimed that only one landscape held real interest for him, and that was the landscape of London.[1] From Venice he wrote to his sister-in-law about his homesickness: "I begin rather to wish myself back in my own lovely London fogs!... I am bored to death after a certain time away from Piccadilly!—I pine for Pall Mall and I long for a hansom!"[2] Immersed again in his favorite setting at the end of 1880, he turned his attention once more to the streetscapes of "his" city. Rather than depicting a bustling panoply of cabs and well-traveled metropolitan squares, however, many of the etchings he produced from around 1884 to 1888 take as their subject the fragments of London shop facades and residences he would happen upon while walking quieter streets. Although Whistler actually may have executed *Cottage Door* outside London, perhaps in the Lake District during a trip to Cumberland,[3] the image embodies the continuing appeal he found in the apparently modest details of the life around him.

Above all, *Cottage Door* exemplifies the artist's concentration at this particular time on an aesthetic of the miniature. Not quite four inches square, the tiny etching fits into the pattern that emerges in Whistler's art in the mid-eighties. Among his most significant oil paintings of the period were a group of small panel pictures he referred to as "Notes," a term that carries the obvious connotations of a visual nature, but which also suggests musical fragments from a larger "Symphony" or "Nocturne."[4] In his "Ten O'Clock" lecture, delivered in 1885, Whistler spoke of art as "a goddess of dainty thought—reticent of habit, abjuring all obtrusiveness...."[5] Indeed, it is striking to note the frequent emphasis he gave to the diminutive in the titles of graphic works created at all phases of his career: *The Little Putney, Little Venice, The Little Balcony, Little London* (app. nos. 73, 74; cat. nos. 33, 74, 78).

In *Cottage Door*, Whistler revisits the familiar convention of figures posed before an open doorway. His line is lively and light, even casual, appropriate to the dimensions with which he was working. Absent now are the added subtleties of drypoint and plate tone, and the cleanly printed marks take on all the spontaneity of sketchbook memoranda. In the etching's calculated charm, undiminished by its small size, Whistler creates one more variation on the theme of understatement that runs throughout his art. "In all that is dainty and lovable," his "Ten O'Clock" observes about the activity of the artist, "he finds hints for his own combinations...."[6]

JS

1 Pennell and Pennell, *Life* (1908), 2:258.
2 Whistler to Helen Ionides Whistler, n.d. [1880], GUL Whistler W680.
3 Wedmore, *Whistler's Etchings*, 85.
4 For a representative selection of Whistler's "Notes," see Curry, pls. 34-38.
5 Whistler, *"Ten O'Clock"*, 8.
6 *Ibid.*, 16.

52 Gran' Place, Brussels
1887

Etching, printed in dark brown ink on old laid paper, trimmed to platemark; watermark: (small)

K. 362 (only state)

22.1 x 14.2 cm. (8 3/4 x 5 5/8 in.)

Signed in pencil, on tab: butterfly and imp.
Signed on the plate, right center: butterfly
Notation on verso, in pencil [not in Whistler's hand]:
K. 362 only state / The Grande [*sic*] Place, Brussels

Purchased from Colnaghi & Co., London, 1927

Bequest of Margaret Watson Parker, 1954/1.401

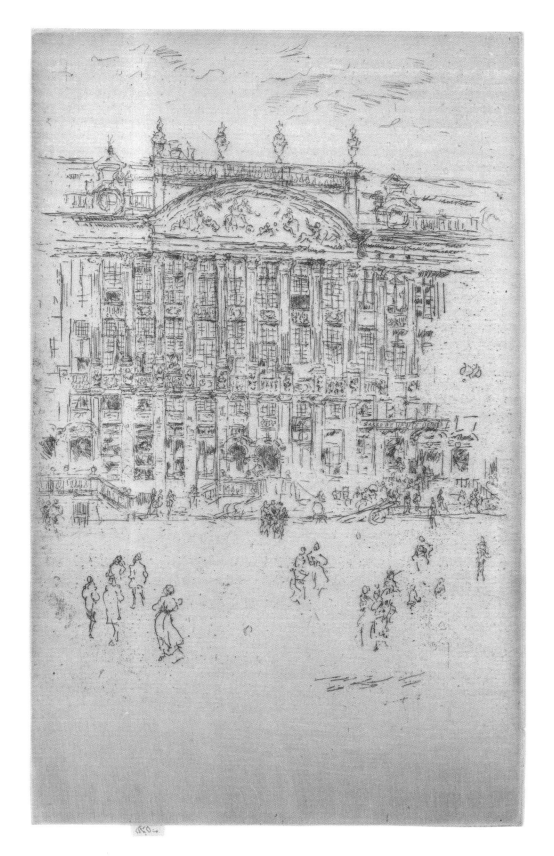

The Low Countries held an attraction for Whistler dating back to the artist's early years in Paris. Whistler considered Rembrandt, Vermeer and de Hooch to be artists of the first rank, and throughout his career he made a number of visits to the Netherlands. In 1887 he traveled to Belgium with his brother and sister-in-law, Dr. and Mrs. William Whistler. Here, as usually happened with Whistler, his drawing expeditions often attracted the notice of passersby, and he found himself fending off the overly-curious by holding his etching needle out at them, as though to keep them at bay.

Of the etchings executed in Brussels, the *Gran' Place* depicts one of the noted older buildings that face onto the picturesque city center, the Maison des Ducs de Brabant. Its facade, a Flemish-Italianate work designed by Willem de Bruyn (1649-1719) in the late seventeenth-early eighteenth century, fills the central portion of the plate. The intricate detailing of the architecture is contrasted against those portions of the plate which remain untouched; the few figures are seen floating on the sheet in the busy square in the foreground. However notational the style, the quick strokes of the needle effectively capture the movement and attitude of the figures. As with other buildings in the series of Brussels etchings, Whistler continues to use the "secret of drawing" to focus the viewer's attention on the salient features of the work, in this case the grandiose architecture of one of the city's monuments. The light and airy treatment of this Brussels palace will be replaced by the more densely worked surfaces of the plates executed in and around Amsterdam in 1889.

Although Whistler may have hoped to assemble a set on the Belgian etchings as he had done for Venice, a formal offering of the works was never issued. The plates were handled by Dowdeswell & Dowdeswell and were not printed in a large edition.

CM

53 Steps, Amsterdam
1889

Etching and drypoint, printed in dark brown
ink on laid paper, trimmed to platemark

K. 403 ii/iv

24.2 x 16.5 cm. (9 1/2 x 6 1/2 in.)

Signed in pencil, on tab: butterfly and imp.
Signed on the plate, top center: butterfly

Collection: Sir John Day (Lugt 526, embossed)
Purchased from Obach & Co., London, 1908

Bequest of Margaret Watson Parker, 1954/1.403

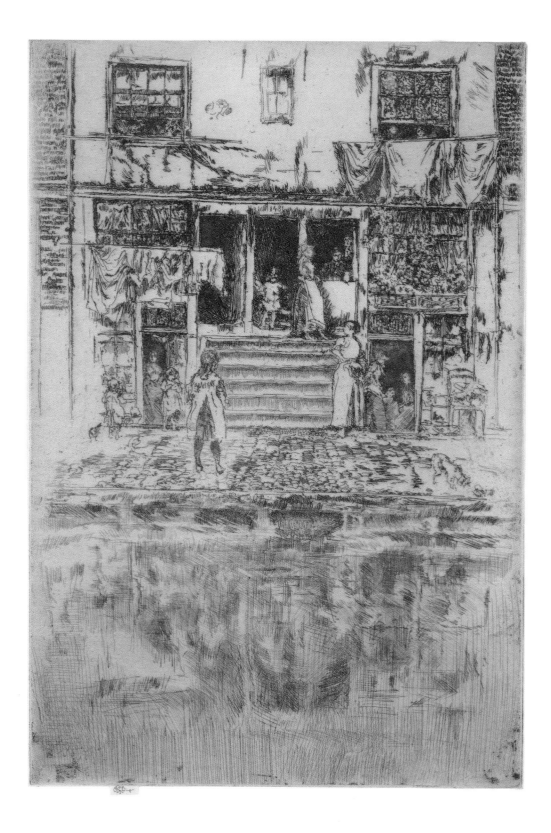

In August of 1888 Whistler finally married and proved to be a devoted husband. The bride, Beatrix Godwin, was the wealthy widow of the architect who had built Whistler's famous White House in 1877, E.W. Godwin. The following August Whistler and Beatrix traveled to the Netherlands, where the artist produced fourteen etchings of Amsterdam and its environs as well as a number of paintings and watercolors that are closely related to the prints. Whistler intended to publish a set of these prints, as he had of Venice and London, and he wrote to Marcus Huish at the Fine Arts Society offering to produce a set of ten etchings in an edition of thirty to be sold for 1,000 guineas. He promised to print the plates himself and assured Huish that the quality of these new Amsterdam etchings would surpass his previous prints:

I find myself doing far finer work than anything I have hitherto produced—and the subjects appeal to me most sympathetically—which is all important. . . . Meanwhile I may say that what I have already begun, is of far finer quality than all that has gone before—combining a minuteness of detail, always referred to with sadness by the Critics, who hark back to the Thames etchings (forgetting that they wrote foolishly about those when they first appeared!) and with greater freedom and more beauty of execution than even the Venice set, or the last Renaissance lot can pretend to.[1]

Whistler also wrote to Edward Kennedy at Wunderlich's offering to send impressions to New York. The artist thought that New Yorkers' traditional links to the Netherlands would create a natural interest in Dutch subjects.

Once Whistler returned to London he printed the plates. In anticipation of exhibitions in New York and London in April of 1890, he was interviewed by a critic from the *Pall Mall Gazette*. Whistler, using the interview to underscore the importance of his recent prints, described the Amsterdam images to the critic, placing them within the evolution of his etching style:

First you see me at work on the Thames. Now, there you see the crude and hard detail of the beginner. So far, so good. There, you see, all is sacrificed to exactitude of outline. Presently and almost unconsciously I begin to criticise myself and to feel the craving of the artist for form and colour. The result was the second stage, which my enemies call inchoate, and I call Impressionism. The third state I have shown you. In that I have endeavored to combine stages one and two. You have the elaboration of the first stage, and the quality of the second.[2]

Whistler's Amsterdam etchings build upon many of the themes he had earlier explored in the Thames and Venice images. As he had in Venice, Whistler frequently worked from a boat on the Amsterdam canals, depicting the poorer neighborhoods away from tourist centers. His pictorial construction has changed, however. Buildings are seen more closely in the Amsterdam etchings, and the rectilinear grid of the structures fills the upper portions of the prints, thus flattening out space and lending them a quality of increasing abstraction. His use of line and plate tone is also different. No longer relying primarily on films of ink to convey atmosphere and the quality of light on water as he did in images such as the *Nocturne* (cat. no. 39) and *Nocturne: Palaces* (cat. no. 48), Whistler fills his Amsterdam images with delicately bitten networks of lines. Similarly, the watery foregrounds of the Venetian images which were evoked with a film of ink are now conveyed through intricate line work.

The Amsterdam etchings were never published as a set, and only about a dozen impressions were pulled from the plates. George Bernard Shaw saw a selection of the etchings when they were exhibited in London in 1890 and described them as "eight of the most exquisite renderings by the most independent man of the century." He went on to compare them to Rembrandt's work, concluding, "Had Mr. Whistler never put brush to canvas, he has done enough in these plates to be able to say that he will not altogether die."[3]

In *Steps, Amsterdam*, Whistler has expanded the motif of figures in doorways reflected in canals. He captures the incidentals of these working class neighborhoods of Amsterdam with a vibrancy that will characterize all of his Amsterdam etchings. The complex patterning of cobbled embankment, bricks, and curtains is softened by the irregular forms of the hanging laundry and the figures standing in doorways. The serenity of the Venetian back canal with its few figures and monumental archway as portrayed in *San Biagio* (cat. no. 44) has evolved into a more contemporary scene conveyed through the dense construction of fine lines. In his rendering of these Amsterdam steps, identified as 148 Lijnbaansgracht,[4] Whistler has returned to the land of Rembrandt and devised a chiaroscuro technique which conveys "colour" as well as form in his images.

CM

1 Letter of September 3, 1889, GUL BP, quoted in Lochnan, *Etchings*, 251-3.
2 Pennell and Pennell, *Life* (1911), 274-5.
3 *Ibid.*, 275.
4 Heijbroek, "Holland vanaf het water," 240.

54 **Pierrot**
1889

Etching and drypoint, printed in dark brown
ink on wove paper, trimmed to platemark

K. 407 v/v

23.1 x 16 cm. (9 x 6 1/4 in.)

Signed in pencil, on tab: butterfly and imp.
Signed on the plate, u.l.: butterfly

Purchased from Obach & Co., London, 1905

Bequest of Margaret Watson Parker, 1954/1.406

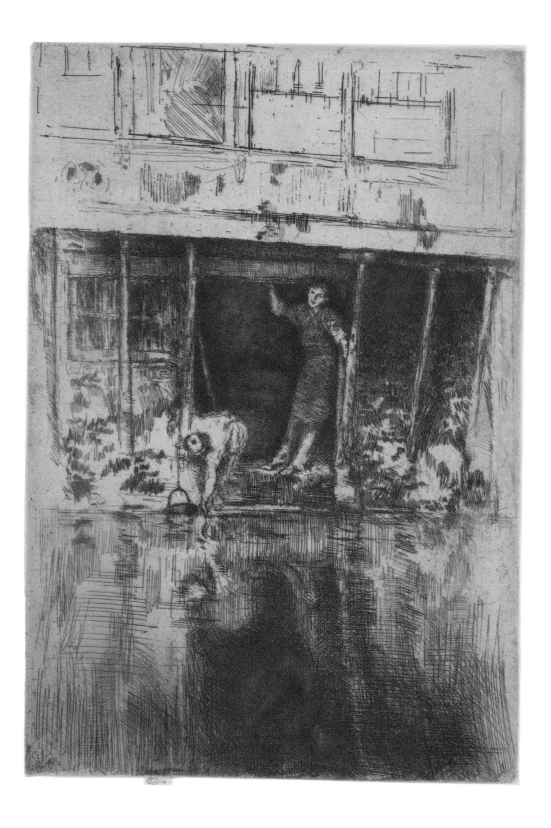

Whistler's fondness for Dutch art and society led him to make numerous trips to the Netherlands throughout his life. The 1858 walking tour of northern France and the Rhineland that yielded the images for his "French Set" was meant to end in Amsterdam in front of Rembrandt's illustrious *Night Watch* painting. Whistler finally made that pilgrimage in 1863. He returned to the country the following year, and then again in consecutive years from 1882 to 1885. When he stayed in Holland for nearly two months in 1889, the famous portrait of his mother was on exhibition in Amsterdam along with two other oil paintings, and a selection of his etchings was being shown in The Hague.[1] Whistler's clear delight in his Dutch surroundings and the renown he enjoyed there seem to have produced a sense of security that during his 1889 visit inspired some of his finest late etchings.

According to Howard Mansfield, *Pierrot* is "probably a study of dyers standing in the doorway of a dilapidated building opening on a canal. . . ."[2] The subject and its setting recall etchings of Venetian scenes such as *The Dyer* (K. 219) or *The Doorway* (cat. nos. 40, 41). Indeed, Amsterdam frequently was called the "Venice of the North," and the physical and social personalities of the two cities were often equated in nineteenth-century travel literature, perhaps nowhere more systematically than in Henry Havard's comparative study of *Amsterdam et Venise*, published in 1876. In Amsterdam, as in Venice, narrow canals and alleyways offered perfect opportunities for the artist to continue his investigations of the fragmented and the partial view.

The facade depicted in *Pierrot* has been identified as the back of a house at 52 Zeedijk, then as now located in Amsterdam's infamous red-light district, the city's oldest quarter.[3] Less convincing attention, however, has been given to the possible significance of the etching's quizzical title. The worker standing at the center of the composition is typically framed by the architectural setting. Perhaps the preponderance of figure to frame struck Whistler—or was intended by him—as theatrical, the main character presented as if on a stage. The print's title, referring to a stock figure of the *commedia dell'arte*, may be meant as a tongue-in-cheek allusion to the model as "actor." The young man's slightly bemused expression could further reflect a flippant exchange that may have passed between subject and artist, who often encountered comment and worse when he ventured into the streets and canals of Amsterdam to work.[4] Pierrot, the clown of the *commedia*, might have seemed an appropriate identity to give to the personality portrayed. Whatever the source of its title, *Pierrot*, like the other Amsterdam etchings of 1889, demonstrates Whistler's continuing attraction to the singularly unexceptional, a street theater of the ordinary made remarkable by its representation.

JS

1 On Whistler's growing European fame in the eighties and nineties, see Joy Newton and Margaret F. MacDonald, "Whistler: Search for a European Reputation," *Zeitschrift für Kunstgeschichte* 41 (1978): 148-59.
2 Howard Mansfield, "Whistler in Belgium and Holland," *The Print-Collector's Quarterly*, 6 (December 1916): 384.
3 Heijbroek, "Holland vanaf het water," 243.
4 The Pennells note the difficulties Whistler endured. "The little Dutch boys are the worst in the world," they helpfully inform us, "and the grown people can be as bad" (Pennell and Pennell, *Life* [1908], 2:83).

55 Balcony, Amsterdam
1889

Etching and drypoint, printed in warm black
ink on laid paper, trimmed to platemark;
watermark: Arms of Amsterdam

K. 405 iii/iii

27 x 16.7 cm. (10 5/8 x 6 9/16 in.)

Signed in pencil, on tab: butterfly and imp.
Signed in pencil on the mount: butterfly
Signed on the plate, on window at right center:
butterfly
Inscribed in pencil on mount, l.l.: To Thomas Croft

Collection: Thomas Croft (no mark)
Purchased from Obach & Co., London, 1905

Bequest of Margaret Watson Parker, 1954/1.405

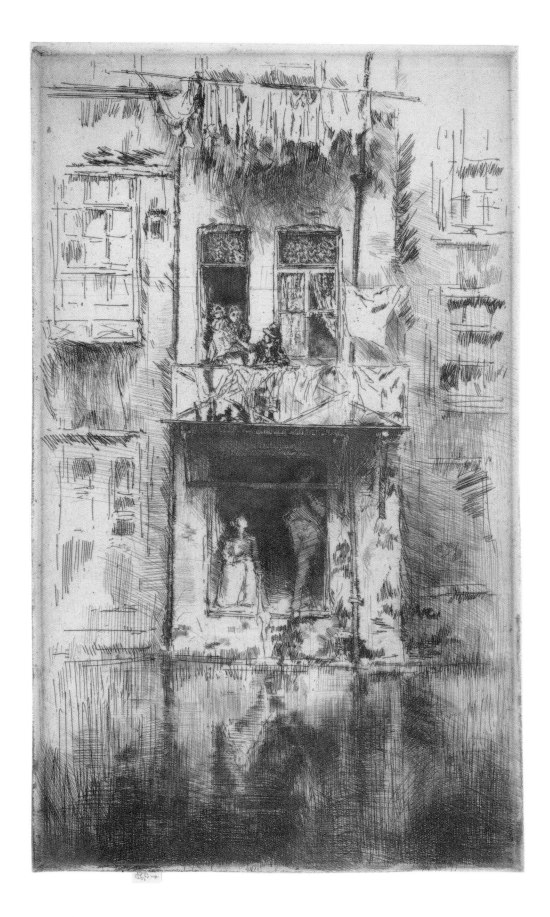

Of all the Amsterdam etchings perhaps none is more evocative of mood, palpable atmosphere, and the confining closeness of the back canals than *Balcony, Amsterdam*. Here Whistler's use of line to convey the half-light shadows of the Oudezijds Achterburgwal recalls that artist whose work is most closely associated with Amsterdam: Rembrandt. Whistler's chiaroscuro effects and the tiered construction of the balcony, with figures above braced by immense darkness below, have been compared to Rembrandt's *Christ Presented to the People* (fig. 55a).[1] Whistler has again employed the subject so familiar in his Venetian etchings, that of a figure seated, stooping or standing in a canal doorway. The intriguing relationship between the woman seated in light and the man standing in shadow contributes to the dark moodiness of the image. Even the familiar figures of the women and child on the balcony seem somehow oppressed by the shadows of the laundry hanging above them. In his review of the Amsterdam etchings for the *Star*, George Bernard Shaw aptly described an image such as this:

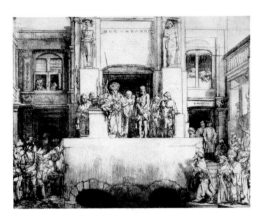

55a Rembrandt, *Christ Presented to the People*, etching, The Metropolitan Museum of Art, Gift of Felix M. Warburg and his family, 1941 (41.1.36)

With two exceptions they are only studies of very undesirable lodgings and tenements on canal banks, old crumbling brick houses reflected in sluggish canals, balconies with figures leaning over them, clothes hanging in decorative lines, a marvellously graceful figure carelessly standing in the great water-door of an overhanging house, every figure filled with life and movement, and all its character expressed in half a dozen lines.[2]

Whistler has been able to imbue these scenes with a grandeur that belies their humble appearance. Both in his etching technique and his ability to transform and elevate the meanest of subjects, he demonstrates his kinship with Rembrandt. The tonal richness of a work like *Balcony, Amsterdam* is evidence of how, like Rembrandt, Whistler can create from the darkness of this poor district a richness of vision which transcends the tenements.

CM

1 Lochnan, *Etchings*, 251.
2 Pennell and Pennell, *Life* (1911), 275.

Etching and drypoint, printed in brown ink
on laid paper, trimmed to platemark

K. 404 ii/ii

23.1 x 17.7 cm. (9 x 6 7/8 in.)

Signed on the plate, u.r.: butterfly

Collection: Royal Library, Windsor (Lugt 2535)
Purchased from Obach & Co., London, 1906

Bequest of Margaret Watson Parker, 1954/1.404

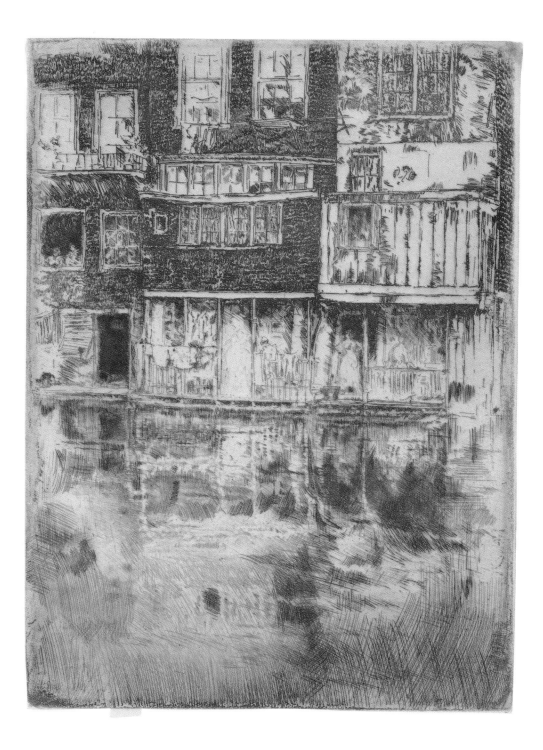

Next to the London he loved, Whistler professed a particular enthusiasm for the scenery of Holland: ". . . everything neat and trim, and the trunks of the trees painted white, and the cows wear quilts, and it is all arranged and charming."[1] For Whistler, a quintessentially urban and urbane artist, a nation that of necessity managed its limited spaces as so many tasteful tableaux provided a welcome relief from the "great, full-blown, shapeless trees" he deplored in the English landscape outside the capital city.[2]

Square House, the image of an edifice along Amsterdam's Oudezijdskolk,[3] juxtaposes geometric order and its softened echoes in the water below, a display of contrasting surfaces and their rendering that Whistler had explored in many of his Venice compositions. Now, however, the tonal emphasis of the Venice plates gives way to a graphic form that is contained and compartmentalized in the description of the building, and which is unbound in a free play of lines set down in parallel and interlaced patches to render reflections in the space of the canal. Almost lost in the artist's concentration on these linear patterns that create dark and light counterpoint are the several figures standing by the water's edge, reduced here to the barest of outlines against the light strip of the building's lowest story.

As if in defiance of the crowded canals that limited his perspective, Whistler gave the composition of *Square House, Amsterdam* a decidedly vertical orientation. In a related oil painting on panel (fig. 56a) he treated the same site in the horizontal format more often dictated by his subject, an architectural arrangement evocative in a general way of the low horizons in the Dutch countryside that Whistler readily endorsed but only rarely depicted.

JS

1 Pennell and Pennell, *Life* (1908), 2:258.
2 *Ibid.*
3 Heijbroek, "Holland vanaf het water," 243.

56a *The Canal, Amsterdam*, oil on panel, Hunterian Art Gallery, University of Glasgow, Birnie Philip Gift

57 **The Embroidered Curtain**
1889

Etching and drypoint, printed in dark brown
ink on laid paper, trimmed to platemark

K. 410 vii/vii

23.8 x 16 cm. (9 5/16 x 6 1/4 in.)

Signed in pencil, on tab: butterfly and imp.
Signed on the plate, u.r.: butterfly

Purchased from Obach & Co., London, 1908

Bequest of Margaret Watson Parker, 1954/1.407

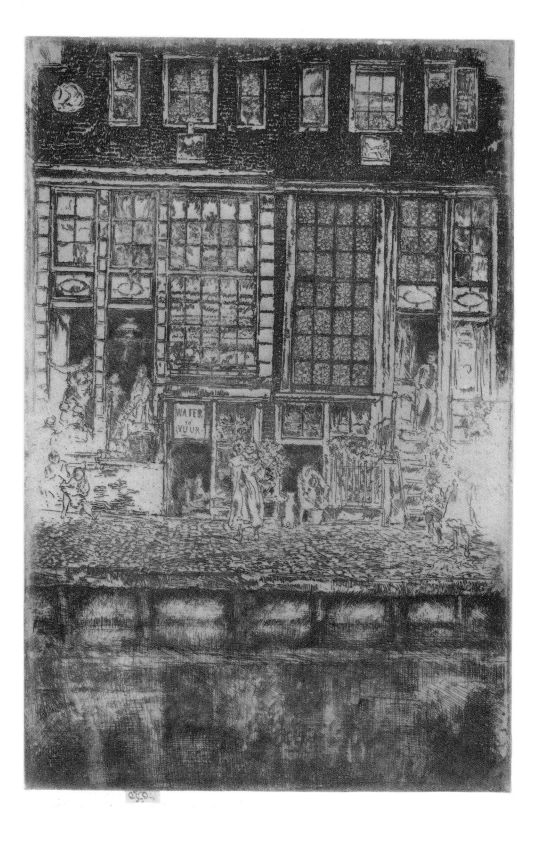

The technical process Whistler employed in the Amsterdam etchings differs from any procedure he had previously used. No longer reliant on the "artistic printing" techniques of *retroussage* and plate tone, the artist's construction of form through dense, but delicate, arrangements of lines results in a richly textured surface. Whistler is aiming for "color" in his lines in a new way. The Pennells recount his manner of working up the surface of the plates, describing how he drew with "such minuteness that hardly any of the ground, the varnish, was left on the plates, and when he bit them, he could only bite slightly to prevent the modelling from being lost."[1] After each plate was bitten, Whistler would go over it again with drypoint. As a result, the lines in the plates were so lightly etched into the copper that very few impressions could be taken from the plates; there are only two dozen or so impressions of *The Embroidered Curtain*.

This scene, identified as Palmgracht 52-54,[2] shows the edge of a busy canal. As in Whistler's depictions of London and Chelsea shopfronts, figures lounge in doorways, peer out of windows, and engage in the chatter of the neighborhood. Whistler has divided his plate into horizontal zones, the central one comprising the quay up through the first floor window treatment. The pairing of elements of doors and windows effectively breaks the pictorial space into a grid construction and gives the work a subtly balanced geometry.

The Embroidered Curtain, also known as *The Lace Curtain*, is perhaps the most satisfying of the Amsterdam etchings. Whistler portrays his chosen vignette through a complex webbing of etched lines, rich with lively detail. This view of contemporary Dutch life, combined with the frontal placement of the buildings, recalls the quietly eloquent representations of Dutch architecture portrayed by seventeenth-century artists. Whistler creates a timeless image, paying direct homage to the satisfying geometry he had admired in the streetfronts and interiors of Vermeer and de Hooch.

CM

1 Pennell and Pennell, *Life* (1911), 274.
2 Heijbroek, "Holland vanaf het water," 240.

Lithograph, printed on laid Japan tissue

W. 28

31.8 x 20 cm. (12 1/2 x 7 7/8 in.)

Signed in pencil, l.r.: butterfly
Signed on the stone at center: butterfly

Collection: Rosalind Birnie Philip (Lugt 406)
Purchased from Pia Gallo, New York, 1993

Gift in memory of John Holmes, 1993/2.5

Whistler's Amsterdam paintings and etchings explore a facet of his art that was to become increasingly central: his reductive distillation of buildings to a geometry bordering on abstraction. Maunder's Fish Shop in the Chelsea area of London was a subject to which he returned over the course of a decade. Two works show the establishment with its awning extended, shading patrons and clerks. The first is a painting in Boston depicting Maunder's as one of many vendors along an entire street full of busy shops (fig. 58a); the second is an etching, in reverse, executed several years later showing the same awning shading the window and shoppers (fig. 58b). When Whistler returned to depict Maunder's Fish Shop for the third time, in this lithograph, he eliminated the peripheral buildings and focused on the figures gathered around the fish arrayed on the open-air counter. Whistler carefully balances the elements of the composition, giving the work a delicately poised harmony. The placement of windows, doorframes, and downspout complement the rhythm established by the arrangement of the figures; even the awning is rolled up so that its diagonal projection in space will not disturb the arrangement of elements along the picture plane. Both this flattening of the picture plane and the use of architecture to create a flowing linear foil for his figures are constant concerns in Whistler's work, and *Maunder's Fish Shop* is an excellent example of how carefully the artist arranges his figures and architecture into a balanced and harmonious whole. In this intimate view of a familiar shop in Chelsea, Whistler has shown how beautifully lithography can capture a scene. Whistler sought pale, "blond" tonalities in his lithographs, and *Maunder's Fish Shop* achieves that delicacy in its balance of line and shading.

Maunder's Fish Shop, The Tyresmith (app. no. 135), and the portrait of his sister-in-law, Ethel Birnie Philip, known as *The Winged Hat*, were published in the eclectic weekly *The Whirlwind*, edited by Herbert Vivian and Stuart Erskine. Each of the three lithographs was executed on *papier viennois* with its mechanical grain of dots. Thomas R. Way wrote, "I remember Whistler's disgust and anger when he learned that packets of these prints had been flung out of the publisher's window in the Strand, on a Lord Mayor's Show day, as an advertisement."[1]

CM

1 Way, *Memories*, 89.

58a *A Street in Old Chelsea*, 1880/5, oil on panel, Gift of Denman Waldo Ross, Courtesy, Museum of Fine Arts, Boston

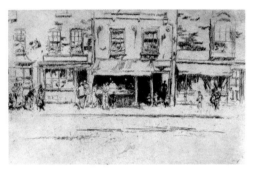

58b *The Fish Shop, Busy Chelsea*, 1886, K. 264, Hunterian Art Gallery, University of Glasgow, Birnie Philip Bequest

59 Gants de Suède
1890

Lithograph, printed on laid paper; watermark:
PRO PATRIA

W. 26

33.2 x 21.2 cm. (12 15/16 x 8 1/4 in.)

Signed in pencil, on the sheet, l.l.: butterfly
Signed on the stone, center right: butterfly

Collection: Rosalind Birnie Philip (Lugt 406)
Purchased from Colnaghi & Co., London, 1927

Bequest of Margaret Watson Parker, 1954/1.426

When Whistler married Beatrix Birnie Philip Godwin in 1888 it almost seems as if he had wed the rest of her close-knit family as well. Each of the Birnie Philip sisters made crucial contributions to his later life and work, especially Rosalind (1873-1958), Beatrix's youngest sister, who became Whistler's ward upon his wife's death in 1896 and ultimately the executrix of his estate. Rosalind Birnie Philip worked zealously, sometimes in concert with Charles Freer, to safeguard the artist's legacy much as she had attended to his affairs during his last years. Like her sisters, Ethel Birnie Philip (1861-1920) assisted Whistler in both personal and professional matters, acting briefly as his secretary in the early 1890s and posing for him repeatedly. She modeled for at least eight oil paintings and numerous smaller works, including the lithograph entitled *Gants de Suède*.[1]

Whistler abandoned lithography in 1879, returning to it in 1887, the year Boussod, Valadon & Co. issued their set of lithographic *Notes*. Whistler had executed the images for that portfolio in the late seventies, directly on the lithographic stone. When he took up the medium again in the eighties, he began to work almost exclusively on specially coated sheets of paper, drawing upon them with crayon and giving them to Thomas R. Way, who transferred the drawings to the stone.[2] The counterproofed image printed not in reverse but precisely as it was drawn, and the transfer papers freed Whistler from the necessity of working on an unwieldy stone. After their marriage the Whistlers traveled frequently, spending much of their time in France, and it was a simple matter to send transfer drawings across the Channel to Way, who posted proofs in return for the artist's approval. Lithography thus took on most of the immediacy of drawing itself.

Gants de Suède is closely related, like a preparatory drawing, to a portrait painting of Ethel Birnie Philip. Whistler probably began *Harmony in Brown: The Felt Hat* (fig. 59a) in 1891, the year after he produced the lithograph of his sister-in-law in virtually the same pose. Ethel's figure appears more attenuated, and her face and features narrower, in the unfinished painting. The long vertical established in each image is broken by the hands that hold a pair of gloves stretched between them. Neither the print nor the painting names the identity of the person portrayed; their titles point instead to the suede gloves and a felt hat. This indirection is part of the larger aesthetic emphasis Whistler intended by calling a painting an "Arrangement" or a "Harmony," ostensibly displacing interest from the subject pictured to the artistic means by which it is represented.

Gants de Suède was published in *The Studio* in April 1894. The journal's editor, Gleeson White, entreated Whistler to supply fifty proofs in addition to the number required for publication, a request the artist flatly refused. He wrote to T.R. Way to make clear the conditions of edition size and financial compensation under which he would allow his lithograph to appear, asking Way to show his explicit terms to White. "Make him give you back the letter afterwards Tom," Whistler added; "you might like to keep it as a rare instance of business perception in an artist!"[3]

When producing lithographs in quantity for publication, Way transferred Whistler's drawing to one or more supplemental stones, the principal stone being reserved for the artist's personal proofs. Mrs. Parker's impression of *Gants de Suède* lacks the blind stamp denoting a proof printed for *The Studio*. Its verso bears instead the collector's mark Rosalind Birnie Philip employed to designate the prints she inherited as part of Whistler's estate. The stamp of her initials in a square border (Lugt 406) is distinguished from the device ("RBP" in a round border, Lugt 405) which usually signifies an impression posthumously printed by Frederick Goulding. Its collector's mark thus would suggest that the Museum's *Gants de Suède* was part of the edition of twenty-eight proofs, separate from the number produced for publication, printed during Whistler's lifetime by Thomas R. Way.

JS

1 For full-length oil paintings, see YMSM 378, 386, 388, 395, 418, and 419. In addition, Whistler painted a bust-length likeness of Ethel (YMSM 387) and a portrait of her seated (YMSM 417).
2 Way, "Mr. Whistler's Lithographs" (1896), 223. Way claims that Whistler was attracted to transfer paper as he was "desirous of working out of doors. . . ."
3 Whistler to T.R. Way, from 110 rue du Bac, Paris, 11 January 1894, Freer Gallery of Art Archives.

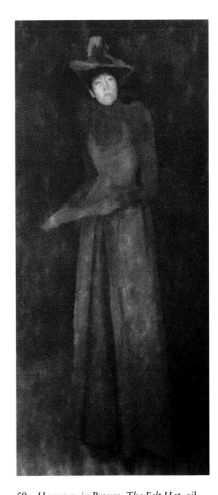

59a *Harmony in Brown: The Felt Hat*, oil on canvas, Hunterian Art Gallery, University of Glasgow, Birnie Philip Bequest

60 The Dancing Girl
1890

Lithograph, printed on laid paper; watermark:
Van der Ley

W. 30

32 x 20.5 cm. (12 1/2 x 8 in.)

Signed in pencil, on the sheet, l.l.: butterfly
Signed on the stone, to left of figure: butterfly

Collection: Rosalind Birnie Philip (Lugt 406)
Purchased from M. Knoedler & Co., New York,
1919

Bequest of Margaret Watson Parker, 1954/1.430

The art of the dance offered richly textured metaphors to the artists and writers of the French Symbolist circle with whom Whistler became closely associated in the 1890s. To the poet Stéphane Mallarmé (see app. no. 162), Whistler's friend since 1888, the ballerina symbolized "some elemental aspect of earthly form" whose movement "*suggests* things which the written work could *express* only in several paragraphs of dialogue or descriptive prose."[1] The imagery of dance was immediate yet mysterious, and ideally suited to the aesthetic of implication that Mallarmé and Whistler shared.

The Dancing Girl is part of a series of works Whistler created in the nineties that study a lightly clothed model who does not seem to dance so much as she strikes and holds a pose that Whistler worked to capture on a sheet of transfer paper. In this respect the lithograph is quite different from a page of pen-and-ink drawings he made around 1893 of the American dancer Loïe Fuller (1862-1928). Those drawings (fig. 60a) convey the drama of the dancer's drapery in kinetic motion as Fuller performed her famous "Dance of the Butterfly" at the Folies-Bergère in Paris, a presentation with obvious appeal to an artist who had adopted the butterfly as his personal emblem. The movement of *The Dancing Girl*, by contrast, is stately and serene, a diaphanous garment falling from her arm to create a diagonal that counters the inclination of her body and anchors her to the ground, yet permits the potential for her movement in the next instant.

According to Way, Whistler was dissatisfied with the proofs of *The Dancing Girl* and asked to have it erased from the stone. Way, however, left the drawing intact, thinking the black and white image "infinitely tender in colour"[2] Indeed, in addition to his lithographic representations, Whistler frequently rendered the theme of the "dancing" model in the medium of pastel, selectively adding small touches of color to the folds of the figure's drapery.[3] Whistler obviously amended his initially unfavorable opinion about his lithograph, for in 1890 he sent a proof of the print to a friend who was especially well-placed to appreciate its intimations. Stéphane Mallarmé wrote to the artist to express his appreciation for the gift: "Quelle merveille!" the poet responded with delight, adding that *The Dancing Girl* now occupied a place of honor on the walls of his Paris apartment.[4]

JS

1 Stéphane Mallarmé, "Ballets" [1886], in *Mallarmé: Selected Prose Poems, Essays, and Letters*, trans. Bradford Cook (Baltimore: The Johns Hopkins Press, 1956), 52.
2 Way, *Memories*, 89-91.
3 For a color reproduction of a closely related pastel study, *A Woman Holding a Black Fan* (ca. 1890, Hunterian Art Gallery), see MacDonald, *Whistler Pastels*, 40.
4 Mallarmé to Whistler, 5 January 1890; see *Correspondance Mallarmé-Whistler*, ed. Carl Paul Barbier (Paris: Nizet, 1964), 47.

60a *Studies of Loïe Fuller Dancing*, ink, Hunterian Art Gallery, University of Glasgow, Birnie Philip Bequest

61 **Cameo, No. 1 (Mother and Child)**
1891

Etching, printed in dark brown ink on laid
paper, trimmed to platemark

K. 347 (only state)

17.7 x 12.9 cm. (6 7/8 x 5 in.)

Signed in pencil, on tab: butterfly and imp.
Signed on the plate, l.r.: butterfly

Purchased from M. Knoedler & Co., New York,
1927

Bequest of Margaret Watson Parker, 1954/1.400

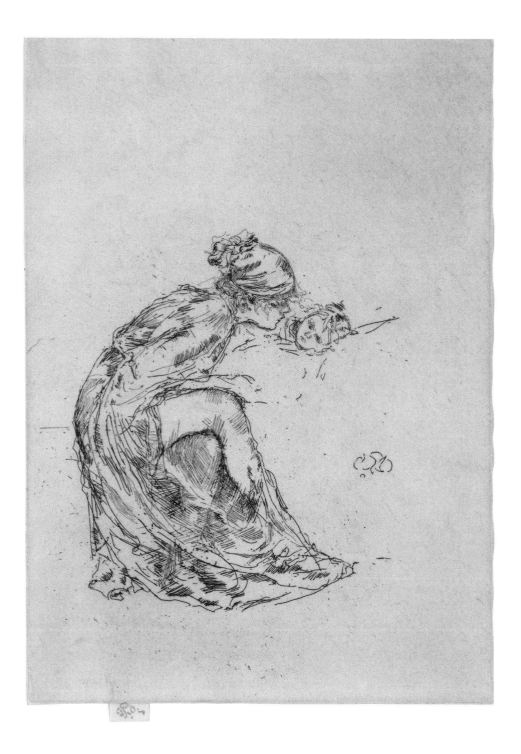

Whistler only rarely attempted to paint the subject that stands near the center of the Western visual tradition, the female nude. Two canvases called *Venus* (YMSM 82, 93), both painted in the 1860s and both now in the Freer Gallery of Art, are marked with signs of the struggle the artist seems to have had with the theme. But in numerous small drawings, pastels, and prints done especially in the 1890s, Whistler explored the image of the nude or lightly draped female figure with more confidence. *Cameo, No. 1* embodies the delicacy and the directness with which he treated the study of the female form once he had removed the subject from its grandiose mythological and academic contexts.

If *Cameo* does not embrace the fiction of the studio model as Greek deity, it nevertheless reflects Whistler's ongoing enthusiasm for one aspect of classical antiquity. He had been interested since the early 1860s in the Hellenistic "Tanagras" in the collection of Alexander Ionides, an Anglo-Greek merchant and one of Whistler's first patrons.[1] The artist's fascination with the Ionides Tanagra collection, of which he owned a photographic album, informed his intense study during the mid- and late-sixties of the studio models he began to draw regularly. Those drawings ultimately provided the impetus for an ensemble of six oil studies, sketches for a decorative project commissioned by Frederick Leyland. The "Six Projects" (YMSM 82-87; Freer Gallery of Art, repro. Curry, pls. 7-12) sum up Whistler's artistic attachments at the time to Greece and Japan: separately studied figures of classically draped models combine to create groups that resemble compositions from Japanese prints.

Cameo, No. 1 dispenses with the elaborate assemblage of the sixties "Projects" and focuses instead on a single female figure with a child. As Katharine Lochnan has observed, that subject often takes on connotations of Aphrodite and Eros when represented in Tanagra figurines.[2] Margaret MacDonald identifies the model in the etching as Rose Pettigrew, one of several sisters Whistler frequently drew in the nineties (see also cat. no. 63), shown in this instance with her young niece.[3] Whether it is read within a classicizing framework or given a more purely domestic "narrative," the artist presented the subject of woman with a child numerous times in his late graphic work. A similarly costumed woman with an infant reappears, for example, in his *Mother and Child, No. 2* (fig. 61a), a lithograph drawn around the same time as the etching but not transferred to stone until 1896.

Although the later figural prints are difficult to date with precision, *Cameo, No. 1* must have been executed in 1891. That summer, Whistler's secretary sent Charles Freer a specially inscribed impression of *Cameo*, the artist's "first new etching," as one of the first of the hundreds of prints the Detroit patron would acquire directly from his friend.[4] The intimate image clearly was one of Whistler's personal favorites; he included it among the list of etchings he drew up to submit to the World's Columbian Exposition held in Chicago in 1893, and he selected it again for exhibition at the Paris Exposition Universelle of 1900.[5]

JS

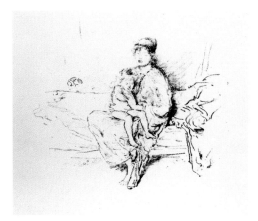

61a *Mother and Child, No. 2*, app. no. 139

1 Whistler had known Alexander's sons since the late 1850s, and their cousin, Helen Ionides, would marry the artist's younger brother, William, in 1877.
2 Lochnan, *Etchings*, 259.
3 MacDonald, *Whistler Pastels*, 10.
4 William Bell (Whistler's private secretary) to Freer, 6 June 1891, Freer Gallery of Art Archives.
5 Howard Mansfield, "Whistler as a Critic of His Own Prints," *The Print-Collector's Quarterly* 3 (December 1913): 382, 389.

Lithograph, printed on laid paper; watermark:
F I PRO PATRIA

W. 39

33.2 x 21.1 cm. (13 1/16 x 8 5/16 in.)

Signed in pencil, at bottom: butterfly
Signed on the stone, on building at right: butterfly

Collection: Rosalind Birnie Philip (Lugt 406)
Purchased from Maggs Bros., London, 1931

Bequest of Margaret Watson Parker, 1954/1.435

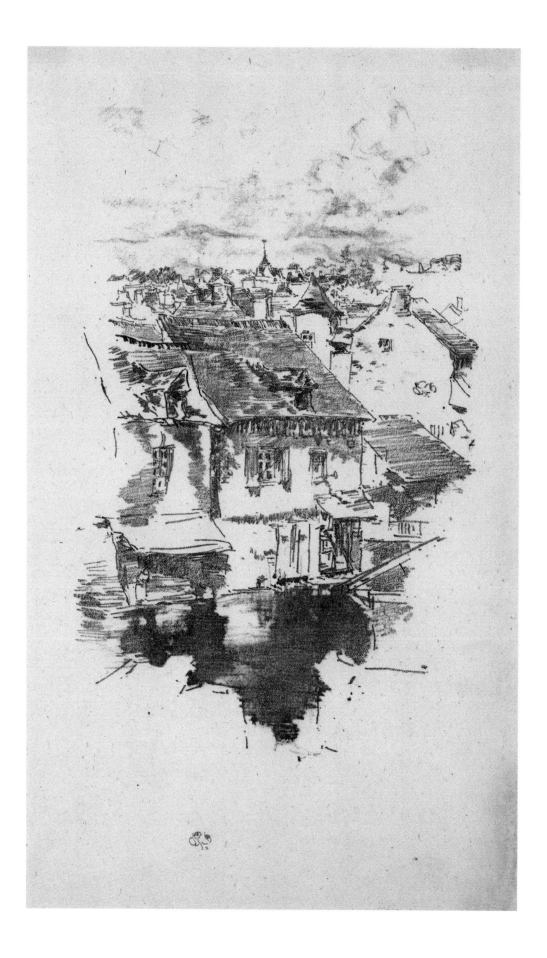

Not long after Whistler and Beatrix arrived in France, Whistler executed *Vitré—The Canal*, his first lithograph employing the use of the stump. The stump, a cigar-shaped roll of paper, is used in lithography to soften contours and create tonal values without hatching, much as smudged chalk creates a similar effect in drawings. Whistler followed what was to become his regular practice for most of the lithographs he drew in France: he carefully packaged them and sent them across the Channel to have them proved by Thomas R. Way in London. Way describes the tremendous effort he went to in order to achieve in printing the effect intended by Whistler:

He sent first the subject known as "Vitré—the Canal." The drawing was made with chalk and finished with stump, the sky and watery foreground being almost entirely so drawn. Now, if this had been drawn upon stone, it would have been a simple matter for the printer; but it was done on transfer paper, and was new to us, and one dared not risk such a charming drawing without learning how to treat it. So I made some little drawings in the same manner, and had them put on stone, and worked out the proper treatment, and I was well rewarded by the successful result when the "Canal" was proved, and the confidence it gave him to follow this line of work with the perfect little group of lithographs of the Luxembourg Gardens and "The Nude Model Reclining" (cat. no. 65).[1]

From this period on, Whistler added stump to his lithographic technique, thereby enabling him to achieve passages of tremendous softness and nuance. In *Vitré—The Canal*, Whistler gives us a view of this town on the northwest coast of France from a high vantage point looking across its roofs and towers. He leaves the foreground empty, putting the buildings at some distance from the viewer. Whistler's drawing technique with the lithographic crayon captures the complex shadings of light and dark, carefully describing the deep shadows on the canal, the more light-permeated shadows cast on buildings by the overhanging roofs, and the overall patterning of light and dark as bright gable walls alternate with darker shadows. This wonderfully subtle handling of light, as well as the use of stump and different drawing techniques, will be explored more fully in a color lithograph executed in the nearby town of Lannion. In *Yellow House, Lannion* (cat. no. 72), the various gradations of shadow are conveyed through manipulation of color as well as drawing, resulting in one of Whistler's richest explorations of light in a lithograph.

CM

1 Way, *Memories*, 92.

63 Draped Figure Reclining
1893-94

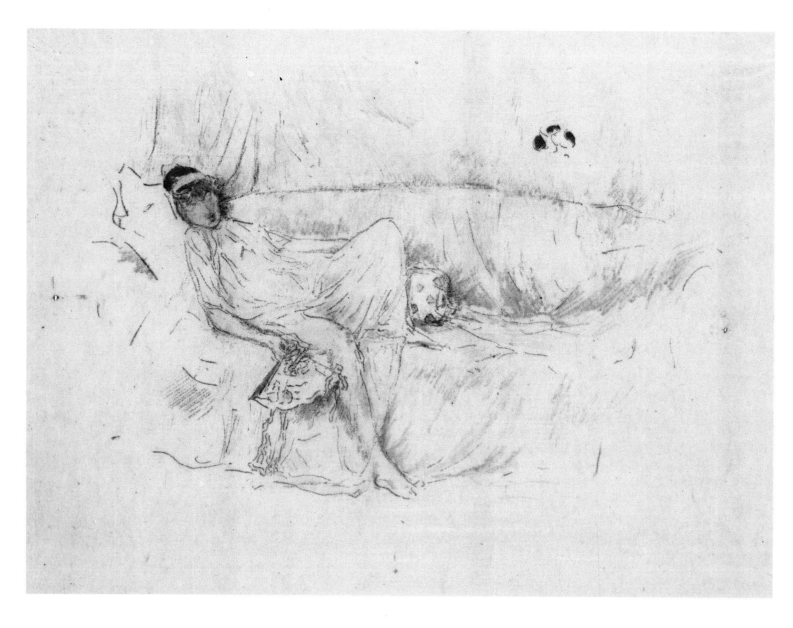

Lithograph, printed in six colors on laid
Japan tissue

W. 156

24.6 x 34.5 cm. (9 5/8 x 13 7/16 in.)

Signed on the stone, u.r.: butterfly

Purchased from M. Knoedler & Co., New York,
1919

Bequest of Margaret Watson Parker, 1954/1.468

Color plate 3

Whistler created the first of his seven, exceedingly rare color lithographs in 1890, with the assistance of the Ways. *Figure Study in Colours* (W. 99) depicted the kind of lightly draped studio model he was portraying at the time in many of his black and white transfer lithographs. He developed an idiosyncratic procedure for working with color printing, first drawing the image on transfer paper, which was printed in the usual manner. Transparent overlays keyed to the master impression were then made, a separate sheet of transfer paper for each of the five colors he wished to print. According to Way, however, two of the sheets had been drawn upon the wrong side of the paper, and the print was never completed.[1] Despite this abandoned effort, Whistler remained interested in exploring the color process. In the early nineties he planned to collaborate with William Heinemann, a friend and publisher, to issue a set of color lithographs lyrically titled "Songs on Stone." That project, too, never came to fruition.[2] Once he was comfortably settled at 110 rue du Bac, however, Whistler wrote to the younger Way about his plans to return to the medium. "One of these days," he said, "I daresay I shall come and have another go with colour in Wellington Street."[3] Although he never realized his intention to work again in color at the Way shop, he finally did see several such prints through to completion in Paris.

Draped Figure Reclining is one of the color lithographs Whistler produced with the help of the printer Belfond, who worked for the large Paris firm of Lemercier.[4] The artist and his printer followed much the same process as had been used in London. Whistler again made a master drawing, from which proofs for each color planned were printed onto separate sheets of transfer paper. He then scraped away all but the part of the image he required to print in that single color, transferring these sheets to individual stones. Colors were precisely registered by placing four marks in the center of each side of the sheet to be printed.[5] Such care was taken to avoid the overlapping and the juxtaposition of large, flat areas of color that Whistler abhorred in the lithographs then enjoying great popularity in France.

Draped Figure Reclining, "that most exquisite print," as Way noted with envy and admiration,[6] is one of Whistler's most complex color lithographs. It was printed in grey, green, pink, yellow, blue, and purple, and no two proofs are exactly alike. Whistler worked closely with Belfond, mixing inks and experimenting with different color combinations. The colors of the proof in the Parker Bequest appear quite vibrant, with deep purple accents in the model's head scarf and in the wings of the artist's butterfly signature. The comparably restrained hues in the pink couch and the blue drapery backdrop seem floated onto the paper like watercolor or dusted onto the page like chalk, while the touches of blue in the fan held by the model and the vase beside her recall the more abbreviated strokes of pigment that were also a part of his pastel technique. Both kinds of color complement but do not compete with the keystone drawing, which in this instance was printed in grey and resembles a graphite line drawing. In certain other impressions the color harmonies are more muted.[7] Always sensitive to the nuances of his materials, Whistler printed his lithograph on the thinnest of tissue paper, and the image seems to merge with its support into a single physical entity. Joseph Pennell compared the final effect to the handling of color in a mosaic or a Japanese woodcut, "so that, as in Japanese prints, the colours would remain fresh and pure, and the surface of the paper not be disturbed."[8]

The model for *Draped Figure*, probably Hetty Pettigrew,[9] poses in a studio setting that subtly invokes Greece and Japan, the twin poles of Whistler's hybrid aesthetic. Her gauzy garments recall the classical Tanagra figurines that so appealed to the artist, and her accessories of fan and blue-and-white porcelain allude to East Asia. Whistler's subdued use of color in *Draped Figure Reclining* may have derived in part from his ongoing interest in Tanagras, which bore powdery traces of paint as faint reminders of their originally polychromed surfaces, a delicate colorism that is echoed in the tranquil tones of the artist's print.

JS

Shown in Ann Arbor only

1 Way, *Memories*, 90.
2 Pennell and Pennell, *Life* (1908), 2:87, 159. Whistler did publish *Chelsea Rags* (W. 22), a black and white transfer lithograph created in 1888, as a "Song on Stone" in the first number of an English monthly review; see *The Albemarle* 1 (January 1892): n. pag.
3 Whistler to T.R. Way, 3 October 1893, Freer Gallery of Art Archives.
4 Belfond, also spelled Belfont, is rarely identified with a first name. Pat Gilmour calls him Henry Belfond; see "Cher Monsieur Clot . . . : Auguste Clot and his Role as a Colour Lithographer," in *Lasting Impressions: Lithography as Art*, ed. Pat Gilmour (Philadelphia: University of Pennsylvania Press, 1988), 369 (n.13).
5 Lochnan, "Whistler and the Transfer Lithograph," 136.
6 Way, *Memories*, 91.
7 See, for example, proofs in the Steven Block Collection (color repro. Hobbs, *Lithographs of Whistler*, front cover); the Hunterian Art Gallery (color repro. Hopkinson, *Whistler at the Hunterian*, 39); and the Freer Gallery of Art (06.202).
8 Pennell and Pennell, *Life* (1908), 2:136.
9 Hopkinson, *Whistler at the Hunterian*, 38.

64 The Draped Figure Seated
1893

Lithograph, printed on laid paper

W. 46

36.8 x 24.4 cm. (14 1/2 x 9 5/8 in.)

Signed in pencil, l.r.: butterfly
Signed on the stone, to right of figure: butterfly
Notation in ink, l.l.: 60.

Purchased from Obach & Co., London, 1907

Bequest of Margaret Watson Parker, 1954/1.441

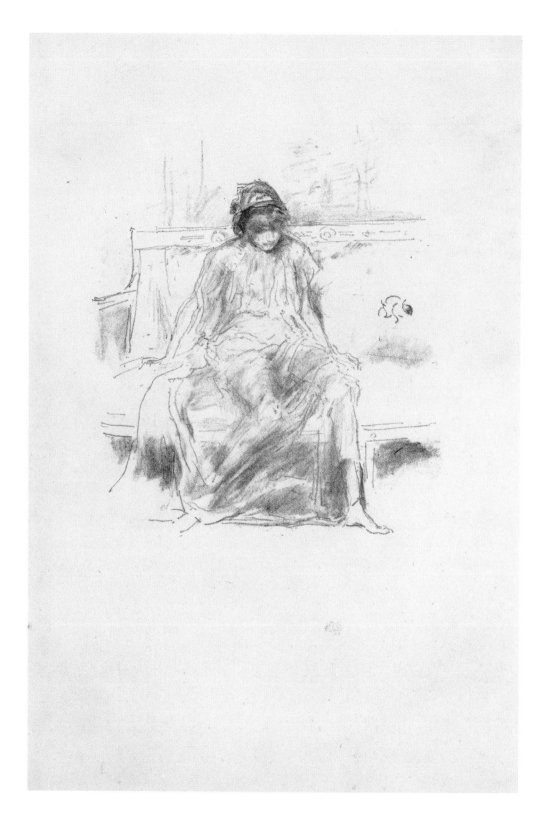

In the 1860s Whistler had executed a group of drawings and pastels which he called Tanagras, after the polychrome terracotta figures from Greek antiquity that enjoyed great popularity at that time. During this period he developed a great friendship with the painter Albert Moore, whose classically draped figures, together with the Tanagra figurines, influenced Whistler's draped figures of the 1860s. Concerned, however, that his work might be mistaken for Moore's, Whistler distanced himself stylistically from Moore in 1870 and abandoned his studies of draped models that had so closely corresponded to Moore's work. Whistler did return to the subject in the 1890s, and out of those works came some of his most poetical figure studies. *The Draped Figure Seated* is one of those lithographs. It is also one of the first of these figural lithographs to employ use of the stump.

Building on the success of *Vitré—The Canal* (cat. no. 62), Whistler applied the softness of the stump which had worked so well in his view of that French town to two figure studies, *The Draped Figure Seated* and the *Nude Model Reclining* (cat. no. 65). Whistler has here vignetted the figure, eliminating the background, except for portions of the Empire settee upon which she sits, and concentrating on the model and her filmy drapery. The model's features are obscured by her downward glance and the shadows cast over her face. Although posed awkwardly upon the settee, the figure is planted firmly in space and is given an overall grace through the arrangement of the drapery. Through the use of both the lightly drawn contour lines and the application of the stump, Whistler has created a transparent cascade of drapery that reveals the model's body and at the same time obfuscates the angles of her legs. The result has a grandeur and an Ionian softness and grace which, while harkening back to the artist's earlier, antique-inspired figure studies, go beyond the drawings of the 1860s in complexity and delicacy.

Whistler sent the drawing for this print, as well as that for the *Nude Model Reclining*, to London to be printed by the Ways. Pleased with the results, the artist wrote to Thomas Way of his growing confidence in use of the stump: *The little sitting figure in drapery I am immensely pleased with . . . Do you see I am getting to use the stump just like a brush and the work is beginning to have the mystery in execution of a painting.*[1]

On behalf of the French publication *L'Estampe Originale*, André Marty asked Whistler for a print of his to be included in the periodical. Whistler, realizing that he was part of a group of major artists to publish in *L'Estampe Originale*—including Bonnard, Toulouse-Lautrec and other prominent French printmakers, picked the *Draped Figure Seated* for inclusion in the periodical. Whistler was sent Japanese paper to be used in the edition of 107 prints, and he forwarded it to Thomas Way in London for printing. After Way had completed the edition, he wrote to Whistler that the stone was in such good condition that "another hundred" could have been printed.[2]

CM

1 Hobbes, *Lithographs of Whistler*, 21-22.
2 Nesta R. Spink, Supplementary Technical Notes, *The Lithographs of James McNeill Whistler from the Collection of Steven Block*, 9.

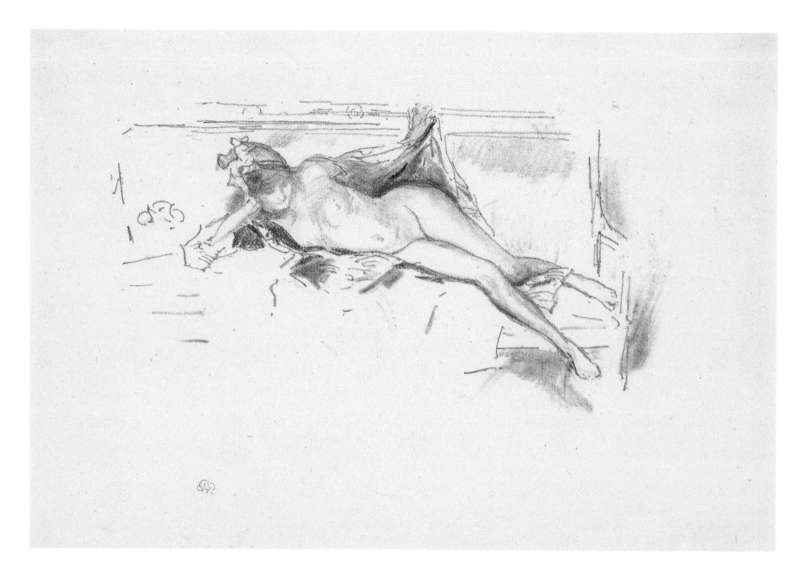

Lithograph, printed on old laid paper;
watermark: crown and GR

W. 47

20.8 x 33.1 cm. (8 1/8 x 12 15/16 in.)

Signed in pencil, l.l.: butterfly
Signed on the stone, to left of figure: butterfly
Inscribed in pencil, l.l.: Way 47 Little Nude model
reclining [not in Whistler's hand]

Purchased from Obach & Co., London, 1927

Bequest of Margaret Watson Parker, 1954/1.442

Drawn at the same time, and probably from the same model, as the *Draped Figure Seated* (cat. no. 64), this image of a reclining figure stems from a long tradition within Whistler's own work, beginning with the early Rembrandtesque etching *Venus*, which dates from around 1859 (fig. 65a). More closely related in time and mood are the pastels in the Freer that date from Whistler's residence in Paris, *Pour le Pastel: Rose and Opal* and *Sleeping*, as well as the color lithograph printed in Paris by Belfond, the *Draped Figure Reclining* (cat. no. 63). Unlike the languorous woman in the color lithograph, the figure in the *Nude Model Reclining* has a more lilting and animated pose, achieved in part by the way the curving form of the body is set off by the same settee seen in *The Draped Figure Seated*, and by the peak of drapery held in the figure's left hand. The dark accents and contour of her hip are softened by the use of the stump, giving her form a graceful swinging line which differs from the more sinuous, but heavier, outline in an etching such as the *Nude Figure Reclining* (fig. 65b). In the *Nude Model Reclining*, Whistler's handling of the figure is lighter, and, as in the *Draped Figure Seated*, the model's features are partly hidden. The soft internal modeling of the figure achieved through the use of the stump gives the forms the softness and texture of pastels from the period.

Whistler sent the drawing for this lithograph, executed on the newly discovered untextured transfer paper *papier végétal*, along with the *Draped Figure Seated*, to London to be printed by T. R. Way.[1]

CM

1 Way, *Memories*, 93.

65a *Venus*, 1859, K. 59, Courtesy of the Freer Gallery of Art, Smithsonian Institution, Washington, D.C. (98.295)

65b *Nude Figure Reclining*, K. 343 (only state), Hunterian Art Gallery, University of Glasgow, Birnie Philip Bequest

66 Rue Vauvilliers
ca. 1892-93

Etching, printed in black ink on laid Japan tissue

K. 439 (only state)

Plate: 22.2 x 13.3 cm. (8 3/4 x 5 1/4 in.)
Sheet: 30.9 x 16.3 cm. (12 1/8 x 6 3/8 in.)

Signed on the plate, left center: butterfly

Purchased from P. & D. Colnaghi & Co.,
London, 1932

Bequest of Margaret Watson Parker, 1954/1.410

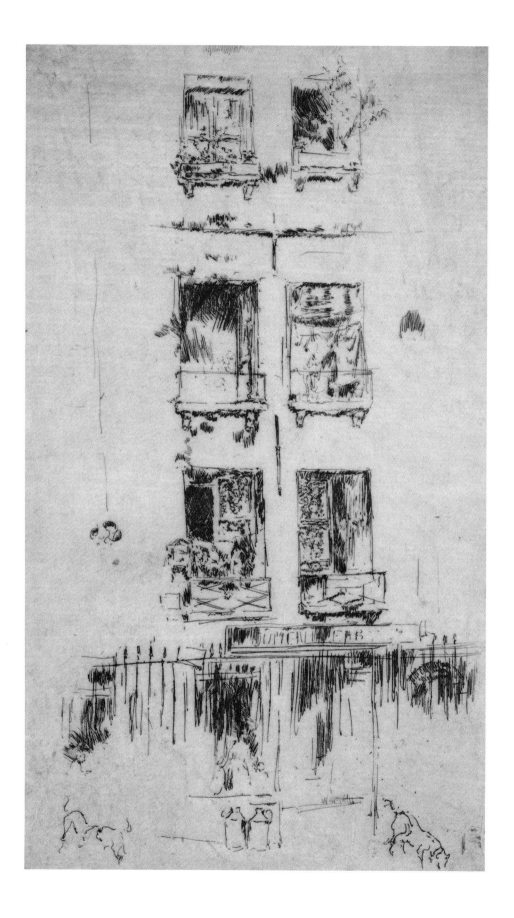

The majority of Whistler's Parisian prints of 1892-93 are lithographs rather than etchings. For the etchings Whistler would carry the plates wrapped in brown paper, but often the paper would rub through the ground, exposing the plate and resulting in some false biting in the image. In addition, Whistler seems not to have printed the etchings immediately, but to have waited as long as six months, increasing the likelihood that the ground would have further deteriorated.[1] When he came to print the Parisian etchings he initially sought out the assistance of Joseph Pennell in Paris, climbing to the top of Notre Dame where Pennell was sketching in order to enlist Pennell's help. Later, in London, Whistler approached Frank Short for assistance in printing the etchings. When asked by Short how he wanted the plates wiped, Whistler replied, "Wipe them as clean as you can—what was good enough for Rembrandt is good enough for me."[2] Whistler's cleanly wiped Parisian prints may have resulted from the difficulty in properly biting the plates, and also from not wanting to risk losing the legibility of their delicate lines in an obscuring layer of plate tone. The etchings dating from these years, with their absence of plate tone, are more closely related in look to his preferred medium for this trip, lithography. Because of his concentration on the lithographs, the etchings executed in Paris are quite rare.

In *Rue Vauvilliers*, Whistler has taken his "secret of drawing" to a more extreme—in fact abstract—degree than he had previously done. His vignetting of the building has dissolved the structure to its skeletal essentials: powerful massings of vertical and horizontal elements. The resulting composition is a blending of Whistler's characteristically astute observation of the minutiae of urban life—lace curtains, half-seen figures glancing out of upper windows, the expressive pose of a dog investigating an interesting scent—with a flattened arrangement of windows and doorways which only just read as a single structure. What Whistler has done is to concentrate on one Parisian building on a small street near Les Halles, eliminating the end walls so that the windows float on the sheet. He has also established a fugal interplay of paired elements. Floating above the fretwork of the high iron grille facing the street, the windows, each a vignette in its own right, form a set of variations as the viewer's eye rises between the floors. The full balcony of the *premier étage* has been transposed at the top floor into mere window boxes. The different views each of these vignettes provides— figures, open versus closed windows, and different types of flowers and plants—give the image a playful quality which is continued on the street level with the dogs and paired cans at the center. The components of the building that help bind the composition together are very faintly indicated; the string course between the second and third floors, and the implied downspouts to either side of the windows only just suggest to the viewer the flat plane of the facade wall. Even the joint in the downspout on the right is really used as a decorative counterpoint to the butterfly signature at the lower left side.

Rue Vauvilliers is a daring exercise in determining the minimal amount of information needed to evoke a complete urban dwelling. Building on his flair for evocative understatement, Whistler has provided us with a vividly rendered fragment of life in contemporary Paris.

CM

1 Lochnan, *Etchings*, 261.
2 Pennell and Pennell, *Journal*, 81.

67 Café Corazza, Palais Royal
ca. 1892-93

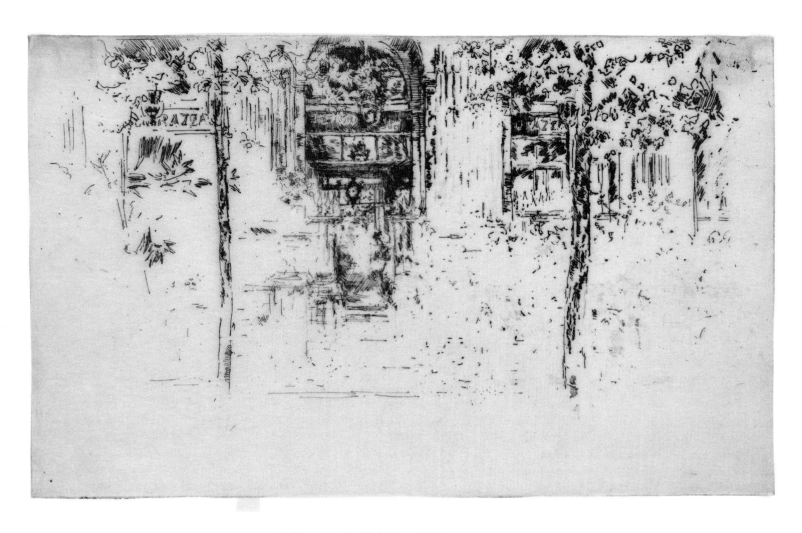

Etching, printed in black ink on laid Japan
tissue, trimmed to platemark

K. 436 (only state)

13.1 x 22 cm. (5 1/8 x 8 5/8 in.)

Purchased from P. & D. Colnaghi & Co.,
London, 1932

Bequest of Margaret Watson Parker, 1954/1.409

In an approach similar to that in the *Rue Vauvilliers* (cat. no. 66), Whistler conveys, in this image of a Parisian cafe, the whole of a scene through its partial representation. The doorway, whose arch is echoed by the windows on either side, is seen through a screen of foliage from two young trees. Whistler positions the viewer close to the building, which he sets parallel to the picture plane. Here the artist has taken the reductive process a step further: the summary rendering of the building has lost even the human activity which animated the Amsterdam etchings and the Chelsea shop fronts. The image floats on the sheet; the tree trunks are not drawn to the street level, and the patterning of their leafy branches contrasts with the regular geometry of the windows. Rather than choosing to depict complete trees anchored solidly in a concrete world, the artist has allowed the suspended trunks to dematerialize into flat, decorative dividers of the pictorial space, creating their own geometric rhythm, much like the partitions of a folding screen.

As with many of the late etchings, the *Café Corazza* exists in only one state and is considered very rare. An impression of the print was included in the Paris retrospective held in the Palais de l'Ecole des Beaux-Arts in 1905, the Exposition des Oeuvres de James McNeill Whistler.

CM

Shown in Ann Arbor only

68 Carpet-Menders

ca. 1892-93

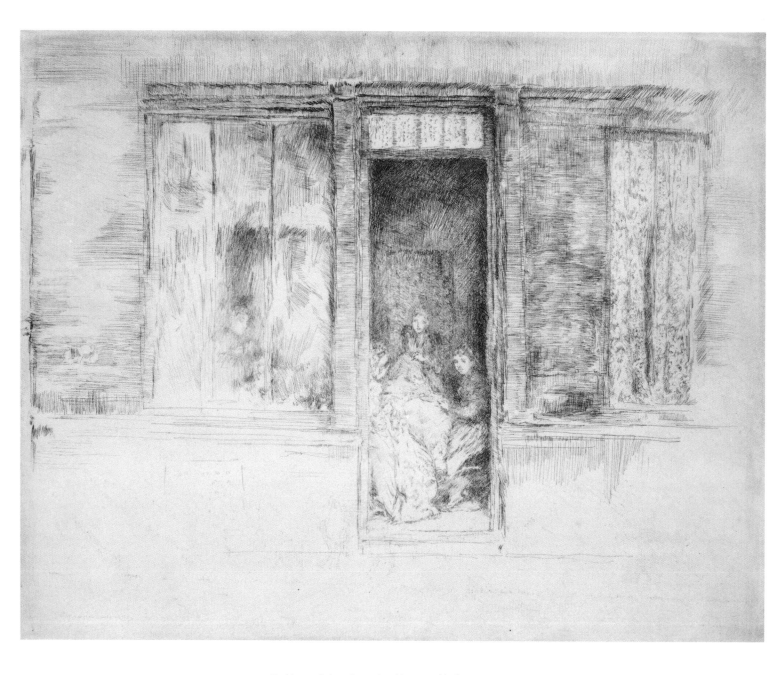

Etching and drypoint, printed in warm black
ink on laid paper, trimmed to platemark

K. 420 (only state)

20.2 x 25.1 cm. (7 7/8 x 9 13/16 in.)

Signed in pencil, on tab [partially trimmed]:
butterfly
Signed on the plate, center left: butterfly

Purchased from P. & D. Colnaghi & Co.,
London, 1932

Bequest of Margaret Watson Parker, 1954/1.408

Whistler often remarked that his work was to be seen as a seamless continuation, not a progression of changes so much as a process of refinement; "always," his biographers note, "he insisted, his work was the same, in the beginning as in the end."[1] Accordingly, his pictorial repertoire revolved around a small number of favorite motifs. When Whistler went to live in Paris in 1892, the same artistic concerns he had shaped in previous years accompanied him, and his eyes were open to familiar sights that might present themselves in his new surroundings. Perhaps no single subject appears more consistently at different times in Whistler's oeuvre than the image of the open doorway and figures gathered at its threshold. *Carpet-Menders* restates his interest in the doorway theme, embodying the artist's notion of his work as a structure grounded in continuity. At the same time, this late etching demonstrates Whistler's capacity for discovering new ways of looking at a well-established theme.

The facade of a residence-cum-shop in Paris is, as usual, represented frontally, the doorway providing a central spine to the image as it develops on either side of its axis. The subject is a French variation on the kind of scene Whistler had depicted in Venetian plates such as *Bead Stringers* (K. 198), which shows workers engaged in the same kind of piece work undertaken in *Carpet-Menders* by their Parisian counterparts. The symmetrical presentation of the composition recalls the centralized design of another Venice etching, *The Doorway* (cat. nos. 40, 41).

In the Paris image, however, Whistler's etched line acquires a new inflection. Developing from the kinds of linear effects he had begun to explore in his Amsterdam plates, the marks made by the etching needle in *Carpet-Menders* are short and feathery, laid down in tight patches that achieve a gossamer vibrancy particularly well-suited to the variety of translucent surfaces Whistler describes. At the right, a lacy curtain is delicately traced upon the plate. That passage is answered on the opposite side of the doorway by a glimpse of a woman shown within the shop, her head bowed as her activity demands her full attention. The subtlety of Whistler's touch is abundantly displayed in this brief, restrained portion of the plate, the woman's form seeming to disappear and reemerge from behind the slight lines that establish the window's reflective plane. Isolated in its own right, this section of the print could stand for the finely calibrated interplay of surfaces and depths that define the etched image in its entirety.

JS

1 Pennell and Pennell, *Journal*, 31.

69 **The Pantheon, from the Terrace of the Luxembourg Gardens**
1893

Lithograph, printed on laid paper

W. 45

30.1 x 20.6 cm. (11 7/8 x 8 1/8 in.)

Signed on the stone, bottom center: butterfly

Collection: Thomas R. Way (Lugt 2456)
Purchased from Frederick Keppel, New York, 1913

Bequest of Margaret Watson Parker, 1954/1.440

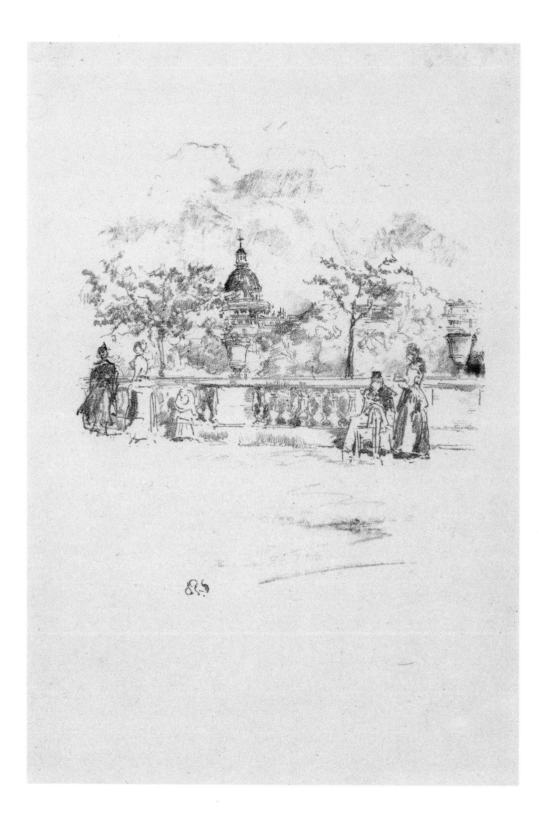

While the Whistlers maintained a residence in Paris at 110 rue du Bac, Whistler also had established a studio near the Luxembourg Gardens at 86 rue Notre-Dame-des-Champs, a street located between Les Invalides and St. Germain-des-Prés. Whistler frequently walked the few blocks to the Luxembourg Gardens to draw groups of people strolling, sitting, and tending young children. The portability of the lithographic transfer paper made it the preferred medium for the artist, but it is interesting to compare where he has depicted closely related scenes in lithography and etching (fig. 69a).

69a *Pantheon, Luxembourg Gardens,* K.429, Courtesy of the Freer Gallery of Art, Smithsonian Institution, Washington, D.C. (02.118)

The image of the terrace overlooking the Luxembourg Gardens appears frequently in the Parisian prints. In this view looking east towards the neo-classical dome of the Pantheon, one can see how Whistler has used the site to explore the different textures of line obtainable with lithographic crayons. Initially Whistler used a transfer paper with a mechanically grained dot pattern supplied to him by Thomas R. Way. The artist considered this paper, known as *papier viennois*, to be excellent for capturing tonal contrasts; the dark figure of the woman at the left, the shadows on the dome and the accents of shadows on the terrace all contrast with the velvety softness of the foliage, clouds, and summary indication of the foreground. In addition to his exploration of the limits of his medium, Whistler has created a subtle geometry, composing the image in a rough triangle, the base of which is formed by the terrace railing anchored at either end by pairs of figures. The dome of the church is echoed, albeit in an inverted fashion, in the urns which embellish the balustrade.

Eventually Whistler found a different transfer paper which he acquired locally through the Paris printer Belfond. This second type of paper, *papier végétal*, had a coating on one side which did not transmit the dot pattern of the *papier viennois*. Using both types of paper, Whistler created images of great nuance and softness. These drawings, executed on transfer paper, were sent through the mails to T.R. Way in London, who transferred the image from the paper to a prepared stone. Way then printed the stone like any other lithograph. Way's records show that about fifteen proofs were taken from the stone during Whistler's lifetime, some additional impressions being printed by Frederick Goulding after Whistler's death.

CM

70 **Conversation Under the Statue,**
 Luxembourg Gardens
 1893

Lithograph, printed on laid paper

W. 44

29 x 23.5 cm. (11 3/8 x 9 1/4 in.)

Signed in pencil, l.l.: butterfly
Signed on the stone, l.r.: butterfly

Collection: Royal Library, Windsor (Lugt 2535)
Purchased from Obach & Co., London, 1906

Bequest of Margaret Watson Parker, 1954/1.438

In this image of women conversing in the Luxembourg Gardens, Whistler has focused his attention on the *tête-à-tête* in the foreground. The statue and foliage beyond them act as a foil for the more darkly drawn figures of the women. This lithograph can be related to an etching of a similar subject, *Polichinelle, Luxembourg Gardens* (fig. 70a). There are many similarities between the two prints, as well as some important differences. Both depict figures seated in a lush setting near sculpture raised on a high pedestal. Also common to both images is the use of large passages of blank paper to convey distance between elements in the composition, especially in the foreground. But whereas in *Conversation Under the Statue* Whistler depicts women seated in the foreground with their backs to the viewer, in *Polichinelle* he concentrates on the flickering quality of light on the trees. The screen of figures watching a Punch and Judy show in the distance of the etching, as well as the seated figures at the base of the statue, are subordinated to the overall accents of light and dark in the upper half of the sheet. In the lithograph the artist has chosen the application of the stump to model the environment surrounding the women, allowing its softness to convey the intimacy of their conversation and creating an updated *fête galante*.

Thomas R. Way, in his catalogue of the lithographs, notes that Whistler never printed editions of these late lithographs, preferring to keep a few impressions on hand and to order additional proofs as his stock ran out. Consequently these lithographs, like the late etchings, are quite rare. Only around fifteen impressions of this lithograph were printed during Whistler's association with the Ways; Frederick Goulding, however, did reprint them after the artist's death, under the direction of Whistler's sister-in-law and executrix, Rosalind Birnie Philip.

CM

70a *Polichinelle, Luxembourg Gardens*, K.430, Courtesy of the Freer Gallery of Art, Smithsonian Institution, Washington, D.C. (04.155)

71 **The Steps, Luxembourg Gardens**
1893

Lithograph, printed on wove paper

W. 43

29.9 x 20.8 cm. (11 3/4 x 8 3/8 in.)

Signed on the stone, l.r.: butterfly

Collection: Thomas R. Way (Lugt 2456)
Purchased from Frederick Keppel, New York,
1913

Bequest of Margaret Watson Parker, 1954/1.437

During Whistler's visit to Paris in 1892-93, he produced a group of lithographs which offer a different view of Paris than the etchings derived from the shop fronts of the 1880s, the *Café Corazza* (cat. no. 67), the *Rue Vauvilliers* (cat. no. 66), and the *Carpet-Menders* (cat. no. 68). Whistler's favored print medium during the Parisian visit was lithography, and his views of the Luxembourg Gardens explore a different set of concerns than the geometry of urban settings. They depict groupings of figures in the gardens, casual strollers on the terrace, nursemaids with their young charges, groups of figures engaged in conversation — in fact all of the types of urban figures that inhabit the prints and paintings of Degas, Forain, Manet, Bracquemond and others.

Whistler's lithographs of the Luxembourg Gardens share many of those aspects of *la vie moderne* that characterize the works of Manet and Degas. Whistler's familiarity with trends in late-nineteenth-century French art, however, may not be the only source of inspiration for the Luxembourg lithographs. Figures engaged in conversation in small groups within a large, park-like setting recall the *fête galante* of the previous century.[1] By depicting figures within an environment that combines the manmade elements of architecture, sculpture, and fountains with the lush and irregular forms of nature, a work such as *The Steps, Luxembourg Gardens* is reminiscent of the graceful lyrical pastimes of the rococo *fête galante*. The idyllic world of the eighteenth-century form, however, has passed through the crucible of the Industrial Revolution; both Whistler's more casually grouped arrangement of the figures and the elimination of the aura of sentiment and romance in the *fête galante* have updated this earlier genre to reflect the pursuits of contemporary denizens in a modern Parisian setting.

Whistler presents a seemingly casual arrangement of figures high upon the sun-dappled terrace of the Luxembourg Gardens, while on the staircase a mother and daughter ascend to the terrace. Executed on *papier viennois*, this lithograph demonstrates the great range of line and texture that could be captured by the lithographic crayons. The dark figure of the woman on the stairs and some of the details of the figures and the trees in the background are drawn in firm, dark contour lines. In the trees and surrounding the figures Whistler has used different techniques to create textural contrasts. Simple delicate shading is mixed with passages of stump to further soften shadows. The resulting image is filled with subtle tonal modulations, enveloping the figures in a rich atmospheric setting. Employing the full range of the lithographic medium, the artist has recorded a scene from contemporary life that is full of nuance and delicate gradations of light.

CM

1 Other scholars have suggested a connection between Whistler's early figural painting and Watteau's work (see Curry, "Artist and Model," from *Whistler at the Freer*).

72 Yellow House, Lannion

1893

Lithograph, printed in black and five colors
on laid Japan paper

W. 101

31.9 x 20.6 cm. (12 7/16 x 8 1/16 in.)

Signed in pencil, on the sheet, l.l.: butterfly
Signed on the stone, on second story of the
facade: butterfly

Collection: Royal Library, Windsor (Lugt 2535)
Purchased from Obach & Co., London, 1906

Bequest of Margaret Watson Parker, 1954/1.453

Color plate 4

On their travels outside Paris in July 1893, the Whistlers visited the coastal towns of Paimpol and Lannion in Brittany. By autumn they were back at 110 rue du Bac, and the artist set to work on two color lithographs made from drawings he produced during his trip. The frontally viewed facades of picturesque Breton buildings provided Whistler with a matrix for a study of colors in *Red House, Paimpol* (W. 100) and *Yellow House, Lannion*. The two lithographs probably evolved simultaneously in Belfond's shop, but the more complex structure of the *Yellow House, Lannion* must have taken longer to create than the relatively simple three-color statement of *Red House*.

Whistler developed *Yellow House, Lannion* in a number of different states, and the limited proofs of the print vary subtly but noticeably in combinations and intensities of their color. The Michigan proof appears to have been printed with a black keystone, and colors were added with a selective touch that prompted T.R. Way to compare the print to one of Whistler's Venice pastels.[1] Within the linear foundation of the keystone drawing yellow-ochre accents the roof, the lower portion of the facade, and, most conspicuously, the costume of the woman standing at the left foreground. Greyed greens consistently highlight the window surrounds and shutters, and combine with the ochre in the roof to suggest the overgrowth of lichens and moss. Two different greys create shadows across the facade; a soft, silvery hue darkens the interior of the doorway, and a richer grey that in various other impressions tends toward purple shades the area directly beneath the roof line. Isolated passages of brown in the masonry on either side of the central house complete this construction of color.

Belfond went bankrupt by 1894, and Whistler's short-lived experimentation with color lithography came to an end.[2] For several brief, productive years, however, his collaboration with a master printer produced a body of work limited in number yet expansive in its ambition and originality.

JS

1 Way, "Mr. Whistler's Lithographs" (1896), 227.
2 The Pennells suggest that Belfond had been producing proofs for Whistler's projected "Songs on Stone" and that the failure of the printer's business ended the planned publication (*Life* [1908], 2:159).

73 The Terrace, Luxembourg
1894

Lithograph, printed on laid paper; watermark: foolscap

W. 55

20.8 x 31.2 cm. (8 1/4 x 12 1/4 in.)

Signed on the stone, to left of image: butterfly

Collection: Rosalind Birnie Philip (Lugt 405)
Purchased from Rosalind Birnie Philip, 1905

Bequest of Margaret Watson Parker, 1954/1.448

The years of Whistler's marriage (1888 until Beatrix's death in 1896) were among the happiest of his life. His extended family included his wife's sisters and his mother-in-law, all of whom posed for him in what became some of his most intimate and touching lithographs. This feeling of congenial family association is found in some of the Luxembourg Garden lithographs such as *The Terrace, Luxembourg*. This print, which Whistler constructed by placing the balustrade parallel to the picture plane and then arranging his figures before it, has a disarming simplicity that is in accordance with the appealing, naive subject. Many of the Luxembourg etchings and lithographs continue the motif of mothers and nannies attending to their children. Varied but quiet activities — reading, strolling, talking — all connote a satisfaction with the surroundings that must have been similar to what Whistler enjoyed in his family circle.

73a *Balustrade, Luxembourg Gardens*, K.427, Courtesy of the Freer Gallery of Art, Smithsonian Institution, Washington, D.C. (06.123)

The Terrace, Luxembourg is clearly related to both *The Pantheon, from the Terrace of the Luxembourg Gardens* (cat. no. 69), and to etchings drawn from the same site (fig. 73a). In this print Whistler has simplified the scene, providing a charming vision of these figures at their leisure in the heart of Paris.

CM

74 The Little Balcony
1894

Lithograph, printed on laid paper; watermark:
lily or fleur-de-lis surrounded by heraldic shields

W. 50

32.3 x 20.6 cm. (12 3/4 x 8 1/8 in.)

Signed in pencil, l.l.: butterfly
Signed on the stone, l.r.: butterfly

Collection: Rosalind Birnie Philip (Lugt 406)
Purchased from P. & D. Colnaghi & Co.,
London, 1927

Bequest of Margaret Watson Parker, 1954/1.444

In this image of figures gathered on a balcony, Whistler has again employed the severe grid-like composition seen in *Rue Vauvilliers* (cat. no. 66). The scene was drawn during the funeral procession of the president of the French Republic, Marie François Sadi Carnot, a member of a distinguished family of French statesmen, who was assassinated by an Italian anarchist on June 24, 1894.[1] As the procession passed beneath him on the rue de Rivoli, Whistler, posed at a vantage point on the opposite side of the boulevard, recorded the event in two lithographs, *The Little Balcony* and *The Long Balcony* (fig. 74a). The structural arrangement of horizontals and verticals in *The Little Balcony* presents a foil for the figures, who are arranged in smaller groups as they engage in quiet conversation while the spectacle passes below.

Images of figures gazing out from balconies in Paris are part of the urban context of French art in the late nineteenth century. Manet's *Balcony*, as well as works by Caillebotte, Cassatt, Degas and Tissot, are evidence of how the modern city provided an appropriate setting for the depiction of contemporary society. Whistler's quiet funeral observance, however, is much less an examination of modern urban mores than an introspective and personal recording of a nation in grief. The women, with their irregular accents of parasols and fans, remain anonymous, and their sun-dappled figures become expressive of those private thoughts which often accompany an observance of death. In both *The Little Balcony* and *The Long Balcony*, Whistler's drawing of these sympathetic mourners is light and expressive in quality. The artist captured the essentials of the figures in a few sure strokes.

CM

74a *The Long Balcony*, app. no. 160

1 Carnot was stabbed during a political function in Lyon. The assassin was a native of Lombardy, twenty-one-year-old Santo Caserio.

Lithograph, printed on laid paper; watermark:
crown surmounted by GR

W. 62

31.3 x 20.2 cm. (12 3/16 x 7 7/8 in.)

Signed in pencil, l.l.: butterfly
Signed on the stone, center right: butterfly
Notation in pencil, on verso: (F.)

Bequest of Margaret Watson Parker, 1954/1.449

Late in 1894 Whistler's domestic happiness was shattered as Beatrix's health began a steady decline. It soon became apparent that she had cancer, but the artist refused to accept the diagnosis, even from his younger brother, Dr. William Whistler. From the time he learned of Beatrix's condition until her death in 1896, life for Whistler was a series of efforts to find the best medical care and the most sympathetic environment possible for her comfort. In the meantime, he carried on with his art, which now was often informed by the personal anguish he was experiencing. *La Belle Dame Paresseuse*, a portrait of his wife, is an image both of the life that continued and the darker shadings it had acquired.

By the end of 1894 Whistler was experimenting with a newer, thinner, transparent tracing paper which lacked the sometimes obtrusive mechanical grain of the papers he had previously employed. The effects he obtained with the new product pleased him greatly, as he wrote to a representative of his American dealer:

. . . *the* newest *and most beautiful quality I have reached, is in "La Belle Dame Paresseuse"* . . . *fair and silvery, and beautiful in the* quality of *blacks! Indeed far away more like the charcoal* drawing *itself of the painter than anything that had ever been printed! — It is really also quite* velvety, *like, in effect, the burr in a drypoint!*[1] Whistler habitually viewed one medium in terms of another. He spoke of drypoint's "soft velvety effect most painter like and beautiful," and on another occasion he expressed pleasure that his work in lithography was "beginning to have the mystery in execution of a painting"[2] His color lithographs, too, often seem to strive for the appearance of watercolors or pastel drawings (see cat. nos. 63, 72).

La Belle Dame is in some respects a lithographic reprise of the drypoint *Weary* (cat. no. 18), created thirty years earlier. In each instance the artist's intimacy with his subject yields an image of great tenderness, a mood whose poignancy is heightened in the lithograph by the undercurrent of Beatrix's deteriorating health. Whistler's representation of his wife may have been a way, perhaps the only means available to him, of distancing himself from the reality of her illness. "Paresseuse" generally translates as "idle" or "lazy," but "The Beautiful Languid Lady" might be a more appropriate label for this print. Leaning against a sofa, her head supported in her hand, Beatrix seems to exhibit no visible signs of ill health. Whistler's title, in the act of indirection he so often applied, further mediates grim fact, removing cancer to the less threatening, aesthetic realm of languour. The artist was pleased with the visual impression he had wrought. So, too, was the husband acutely sensitive to the fact that he could perpetuate in his art an image of his cherished partner. "For me," Whistler simply but revealingly observed, "the very *finest qualities* are in 'La Belle Dame Paresseuse.'"[3]

JS

1 Whistler to E.G. Kennedy, 14 September 1894, quoted in MacDonald, *Whistler Pastels*, 9.
2 Whistler to Charles Sissler, n.d., quoted in Lochnan, *Etchings*, 101; Whistler to T.R. Way, 21 November 1893, Freer Gallery of Art Archives.
3 Whistler to T.R. Way, 12 December 1894, Freer Gallery of Art Archives.

76 **Sunday, Lyme Regis**
1895

Lithograph, printed on laid paper; watermark: (partial)

W. 96

25 x 18.3 cm. (9 3/4 x 7 1/8 in.)

Signed in pencil, on the sheet, l.l. of image: butterfly
Signed on the stone, above doorway, u.r.: butterfly

Collection: Rosalind Birnie Philip (Lugt 406)
Purchased from Maggs Bros., London, 1932

Bequest of Margaret Watson Parker, 1954/1.452

The Whistlers went to Lyme Regis in September 1895, hoping that the air of the resort town on the southern coast of England in Dorset would lessen Beatrix's discomfort. Although Beatrix left town in October, Whistler remained to paint and to draw upon the block of transfer paper he carried like a sketchbook. T.R. Way was encountering difficulties in transferring Whistler's drawings from the thin, transparent lithographic paper the artist had brought from France, and he encouraged Whistler to experiment with alternatives. *Sunday, Lyme Regis* was drawn upon this newer paper, Way records, which gave "crisp, clear lines, delicate or strong, as he wished"[1]

Whistler's anxiety over Beatrix's health seems to have engendered a temporary lapse in his creative self-confidence. After she returned to London the artist wrote almost daily to her of the artistic struggles he was experiencing. But he quickly regained his equilibrium and continued with his work. He painted several portraits of local residents and continued to study his favorite shop front subjects, producing a tiny panel picture entitled *Rose and Red: The Barber's Shop, Lyme Regis* (YMSM 444; Georgia Museum of Art, Athens). While in Lyme Whistler stayed at the Royal Lion Hotel, and his lithograph depicts the view available from the hotel lobby, looking out to a steeply sloped street lined with houses and sprinkled with pedestrian traffic. The print forsakes the artist's usual frontal approach to such motifs in favor of a plunging perspective that recalls his watercolor of *Street Scene, Paris* (cat. no. 50), although now it is the view itself, and not his vantage point, that is elevated as the composition seems to climb the page. The buildings on either side of the center serve to frame his focus on animated weekend activities casually but carefully noted with minimal strokes of crayon.

At the bottom of the sheet, a dog pauses in the middle of the road to watch the scene unfolding before him. Whistler's paintings and prints of street life and shop facades are often punctuated by these unobtrusive yet incisively observed animal presences. For Thomas Way, such renderings revealed "yet another side to the artist's amazing versatility, for who would have imagined that he would now show himself as an accomplished animal draughtsman?"[2]

JS

1 Way, *Memories*, 118.
2 Way, "Mr. Whistler's Lithographs" (1896), 224.

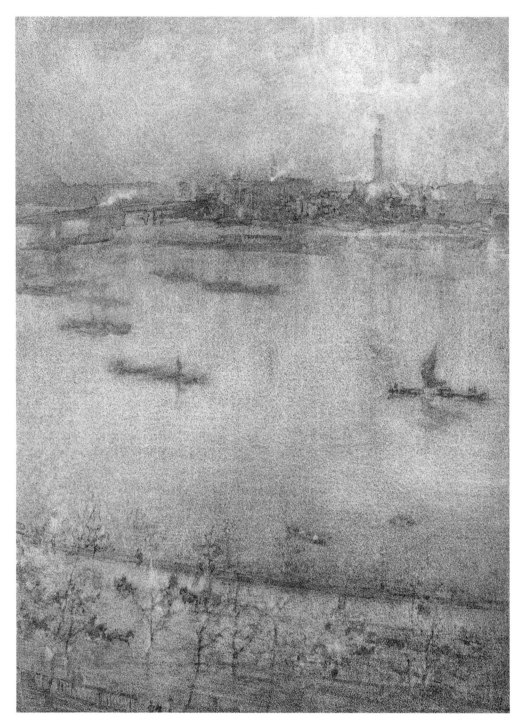

Lithotint, printed on heavy wove paper;
watermark: O.W.P. & A.C.L. (partial)

W. 125

Image: 26.5 x 19.4 cm. (10 5/16 x 7 9/16 in.)
Sheet: 27.5 x 27.4 cm. (10 3/4 x 10 11/16 in.)

Signed on the stone, in the water, l.r.: butterfly

Collection: Rosalind Birnie Philip (Lugt 405)
Purchased from Rosalind Birnie Philip, 1905

Bequest of Margaret Watson Parker, 1954/1.463

Whistler's first works in the lithographic
medium were the lithotints he created in 1878-79
(see cat. nos. 22, 24, 26-29). Fourteen years later
he wrote to the younger Way from 110 rue du
Bac in Paris to inquire anew about the lithotint
process: "I want you to send me the exact
formula for the liquid your Father gave me to
use for the *wash* on stone," he requested.
"There is of course the English Chemist where
I can have any thing made up if you send the
prescription in English measures."[1] But the
Ways refused to impart their trade secrets to
the artist who was busily working with Parisian
printers. Consequently, Whistler did no further
lithotints until he was once more in London,
and staying at the Savoy Hotel on The Strand,
virtually next door to the Ways' printshop on
Wellington Street.

In January of 1896 the Whistlers moved
into the Savoy, the grand London hotel opened
in 1889 by the Victorian impresario and
entrepreneur Richard D'Oyly Carte. The artist
and his wife, whose cancer was rapidly
advancing, took rooms on an upper floor that
provided a commanding view of the great
presentational curve of the Thames as it shifts
from a northerly direction to flow once again
toward the east. From his elevated vantage
Whistler could take in the Victoria Embankment
and its activity, the numerous bridges spanning
the river, and the sights on the Surrey side of
the Thames opposite the hotel, the same views
that his friend Claude Monet would seek to
capture in multiple canvases painted from the
almost precise Savoy viewpoint around the
turn of the century.[2] As Whistler kept vigil
over the ailing Beatrix, he continued to make
lithographs, including six drawings on transfer
paper and a large lithotint, *The Thames*.

The Thames was worked directly on a stone prepared with the half-tint Whistler had used so effectively in his earlier lithotint imagery of the river (see cat. nos. 24, 27). The view from his hotel vantage is resolutely across the river to the South Bank. A puff of smoke or steam signals the presence and purpose of Charing Cross Railway Bridge on the left, while the Shot Tower rises to the right on the Surrey side of the river.[3] A number of barges travel the Thames, and a hansom cab ("gondolas of London," Way calls them)[4] appears at the left of the broad Embankment screened by trees still bare in the winter months of Whistler's stay at the Savoy.

According to Way, the artist prepared to work on the stone by making an oil study of the scene.[5] A painting, *Grey and Silver: The Thames* (fig. 77a), does appear remarkably close to the composition and tonality of the lithotint. But Whistler produced the canvas around 1872, in the midst of working on some of his finest Nocturnes. *Grey and Silver* seems not to have left his possession—it was in his studio at the time of his death—and he could have made reference to this earlier work when attempting to achieve similar effects in another medium. His steady presence at the Savoy, however, guaranteed him ample opportunity to study the scene itself, and the print has a liveliness that speaks of a dialogue engaged with nature as much as with other art.

Whistler encountered difficulties while trying to maintain the tonalities of the half-tint, and the first proofs of *The Thames* did not satisfy him. He carried the stone between the Savoy and the Ways' premises several times in order to scrape and re-etch the image until he obtained the effects he sought.[6] Way immediately recognized the results as one of the artist's most exceptional prints. Several months after Beatrix Whistler's death in May of 1896, the printer sought permission to have additional proofs of *The Thames* made. Whistler's despondence, coupled with his growing animosity toward Way, led him to refuse the request. The stone eventually was printed posthumously by Frederick Goulding under Rosalind Birnie Philip's supervision, with lifetime impressions lent by Charles Freer for comparison. Forty-six proofs were pulled in October 1903, and thirty-three a month later.[7] Not long thereafter, Margaret Watson Parker acquired one of the proofs printed by Goulding directly from Rosalind Birnie Philip.

The half-tint ground of *The Thames* convincingly conveys the haze and transient light of nocturnal London. "A sort of steam," the French critic Duret called the effect, "a twilight mist of wonderful fluidity . . ." [*Une sorte de buée, de brouillard crépusculaire d'une fluidité extraordinaire . . .*].[8] A writer for a Glasgow newspaper later related the print's pictorial expression to Whistler's concern at the time for Beatrix's health, recognizing that he may have found in the moody river a scene "that touched his soul and gave it peace."[9] The atmospheric veil that softened the contours of his favorite city at his preferred time of day seems also to have muted momentarily the harsher coloring of the artist's own emotional landscape, inspiring one of his most striking interpretations of a beloved subject.

JS

1 Whistler to T.R. Way, 16 November 1893, Freer Gallery of Art Archives.
2 Robin Spencer points to evidence suggesting that Whistler may have assisted Monet by informing him about changes in the notoriously fickle London weather the Impressionist artist found a delight and a challenge to paint ("The Aesthetics of Change: London as Seen by James McNeill Whistler," in *The Image of London: Views by Travellers and Emigrés, 1550-1920*, exh. cat. [London: Trefoil, in association with the Barbican Art Gallery, 1987], 69).
3 The Shot Tower was built in 1826 and used as a height from which molten lead was poured and dropped from various levels to make small and large shot.
4 Way, *Memories*, 128.
5 Way, "Whistler's Lithographs" (1913), 289.
6 Way, *Memories*, 127.
7 MacDonald, "Whistler's Lithographs," 34.
8 Duret, *Histoire de Whistler*, 122.
9 *The Glasgow Herald*, 1 June 1915, quoted in Hopkinson, *Whistler at the Hunterian*, 44.

77a *Grey and Silver: The Thames*, oil on canvas, Hunterian Art Gallery, University of Glasgow, Birnie Philip Gift

78 **Little London**
1896

Lithograph, printed on wove paper

W. 121

28.6 x 22.2 cm. (11 1/8 x 8 11/16 in.)

Signed on the stone, bottom center: butterfly

Collection: Thomas R. Way (Lugt 2456)
Purchased from Colnaghi & Obach, London,
 1913

Bequest of Margaret Watson Parker, 1954/1.460

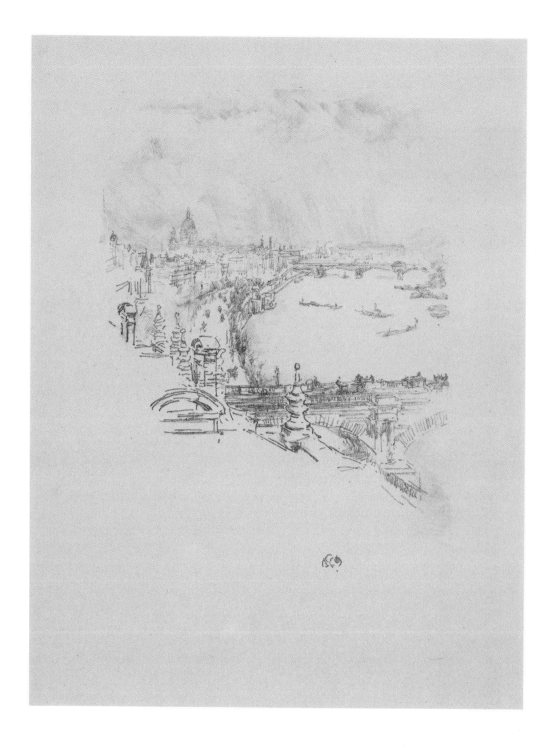

79 Savoy Pigeons
1896

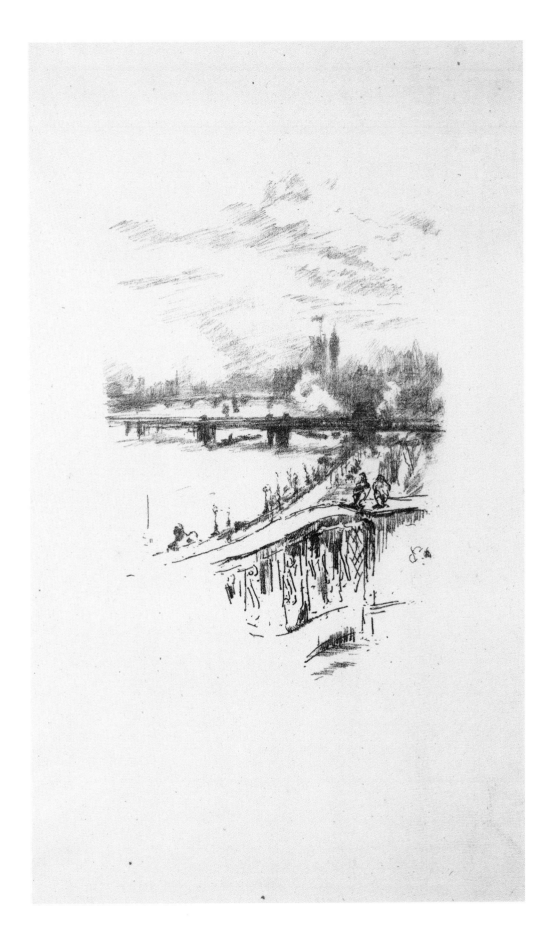

Lithograph, printed on laid paper; watermark: D & C BLAUW

W. 118

37.4 x 23.2 cm. (14 9/16 x 9 1/16 in.)

Signed on the stone, l.r.: butterfly

Collection: Rosalind Birnie Philip (Lugt 405)
Purchased from Rosalind Birnie Philip, 1905

Bequest of Margaret Watson Parker, 1954/1.457

The care of Beatrix and the creation of art reinforced one another during the Whistlers' several months at the Savoy. Simply by looking in either direction from the balcony as he remained with his wife, the artist found satisfying compositions for his work. Drawn on transfer paper, the six Thames lithographs Whistler produced in addition to *The Thames* printed as the scenes would appear in nature, and not with a reversed orientation. *Little London* embraces the view downstream from the hotel. Two arches of Waterloo Bridge form a base from which the Embankment curves away toward Blackfriars Bridge, distant Thames traffic, and the prominent dome of St. Paul's on the far horizon. Delicate use of the stump in the sky and in areas of the Embankment contributes to a sense of London's damp atmosphere.

Even in the midst of his concern over Beatrix's health Whistler's visual wit remained attuned to the pictorial puns he might make from London's landscape. At the extreme foreground of *Little London* several spires and stacks thrust upward. These are the pinnacles of Examination Halls, a structure next to the Savoy used at the time by the Royal Colleges of Physicians and Surgeons.[1] Indeed, T.R. Way originally catalogued the print under the title *The Pinnacles of Examination Hall*. Those pinnacles, isolated from the rest of the building, stand as the foreground counterparts to the dome of St. Paul's crowning the City in the distance. In a similar visual play, Whistler detaches a segmental pediment from one of the Hall's chimney stacks on the left. Viewed from this angle, its shape rhymes visually with the arches of Waterloo Bridge, as if the chimney's element continues the bridge's progress across the page.

Savoy Pigeons looks upstream, in the direction of Charing Cross Railway Bridge, Westminster Bridge beyond it, and the Palace of Westminster — the Houses of Parliament — looming in the background. The balcony of the Whistlers' own hotel room appears in the foreground, with two pigeons noted in the lithograph's title perched upon its railing. Whistler's graphic wit is here more subtle than in the *Little London*. At the far left a vague shape that seems to pose at the edge of the balcony is the statue of a sphinx that accompanies Cleopatra's Needle, a granite obelisk transported from Egypt and installed on the Victoria Embankment in 1878. Whistler reduces the great Needle itself to a mere vertical line, deflating its grandiose presence by barely indicating its edge.

The small transfer lithographs Whistler drew from the Savoy Hotel were, for the most part, quite personal works, although *Savoy Pigeons* was published in *The Studio* in November 1896. But it, *Little London*, and the four other Thames views (see app. nos. 174, 176-78) are in some respects the records of Whistler's watchfulness over Beatrix, and they represent what she could see of the world from the confines of her bed. In addition to his cityscapes, the artist made two almost painfully poignant lithographs of his wife as she rested. "Of the portraits," T.R. Way confessed, "I cannot bring myself to write"[2] The titles of these two works, like that of *La Belle Dame Paresseuse* (cat. no. 75), seem designed to moderate traumatic reality. In *The Siesta* (W. 122), a reclining Beatrix looks out at the viewer, her worn face clearly bearing the strains of her cancer, and her left arm falls from her bedclothes to hang limply at her side. *By the Balcony* (fig. 78/79a) again shows Beatrix resting in bed. But now she has been moved to the window overlooking the river that provided such a stimulating visual environment. In the sky above Waterloo Bridge, presiding over the London landscape and perhaps in the line of Beatrix's vision, hovers Whistler's butterfly, as if to picture in another way his devoted presence.

JS

1 Since 1910 the Hall has belonged to the Institution of Electrical Engineers; it no longer has its pinnacles.
2 Way, *Memories*, 126.

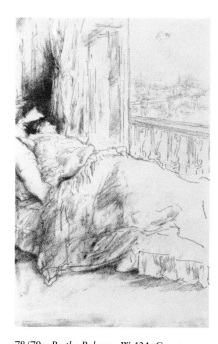

78/79a *By the Balcony*, W. 124, Courtesy of the Freer Gallery of Art, Smithsonian Institution, Washington, D.C. (05.212)

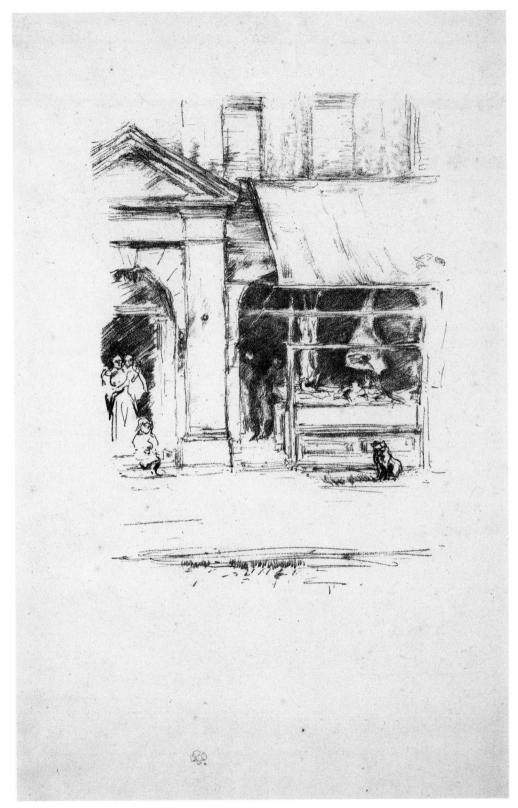

Lithograph, printed on wove paper; watermark: (partial)

W. 128 ii

31.4 x 21.6 cm. (12 3/8 x 8 1/2 in.)

Signed in pencil, l.l.: butterfly
Signed on the stone, on awning, u.r.: butterfly

Collection: Spanish Royal Arms (blind stamp, not in Lugt)
Purchased from P. & D. Colnaghi & Co., London, 1931

Bequest of Margaret Watson Parker, 1954/1.464

Margaret Watson Parker seems not to have cared for the images of shop fronts which occupied Whistler's production in the 1880s; as a result, *The Butcher's Dog* is the only work of this genre that she collected. Whistler has presented the shop and the adjacent establishment's more elaborate doorway with a typical blending of understatement and acute observation. The play of architectural elements, arches, pediments, windows and awning sets off the groups of figures in the composition; the figures themselves stand framed in their respective doorways, and a lone dog stands guard outside the shop. Thomas R. Way, noting that the shop was on Cleveland Street in London, described Whistler's attempt to portray the lamb and beef hanging in the butcher's window, adding that "he was quite amusing in his anxiety to get the right quality into the various joints displayed."[1]

CM

1 Way, *Memories*, 129.

81 St. Giles-in-the-Fields
1896

Lithograph, printed on laid paper

W. 129

28.7 x 22 cm. (11 1/4 x 8 5/8 in.)

Signed on the stone, under cornice at right center: butterfly

Collection: Thomas R. Way (Lugt 2456)
Purchased from Colnaghi & Obach, London, 1913

Bequest of Margaret Watson Parker, 1954/1.465

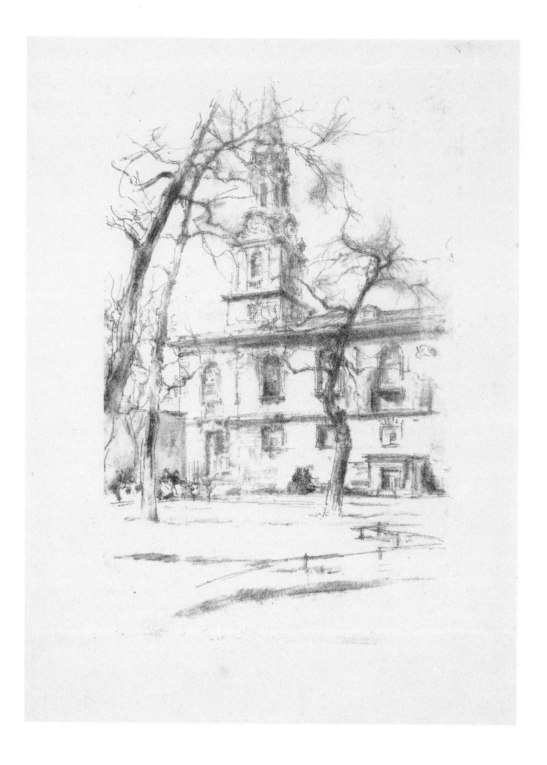

Following Beatrix's death Whistler was disconsolate. He wrote to Edward Kennedy, "The end has come . . . my dear Lady has left us — and I am without further hope."[1] Whistler had difficulty settling down after Beatrix's death. He had hoped to execute a group of six lithographs of London churches, but he realized only two of the images, *St. Giles-in-the-Fields*, a church located between the Royal Opera House and the British Museum, and *St. Anne's Soho* (W. 126). Approximately eight proofs of *St. Giles-in-the-Fields* were printed in Whistler's lifetime.

The church, a structure built in 1731-33 by Henry Flitcroft (1697-1769) in imitation of St. Martin-in-the-Fields, is seen from an oblique view across its lawn, thus emphasizing its pastoral quality. The details of its Palladian-inspired architecture, delicately drawn by Whistler on ungrained transfer paper (*papier végétal*), are softened by the stumping of both the building and the framing trees. Whistler's freely calligraphic drawing of the branches complements the majestic solidity of the church. The low railing in the foreground both divides the foreground space and creates a sinuous line leading the viewer's eye back to the satisfying arches of the church's flank.

By choosing not to depict the formal and frontal aspect of St. Giles' facade, and in rendering the building with such breathtaking softness and delicacy of execution, Whistler has produced a more private, and even melancholy, image of the classically restrained structure.

CM

1 Quoted in Hobbes, *Lithographs of Whistler*, 31.

82 The Shoemaker, Dieppe
ca. 1896-97

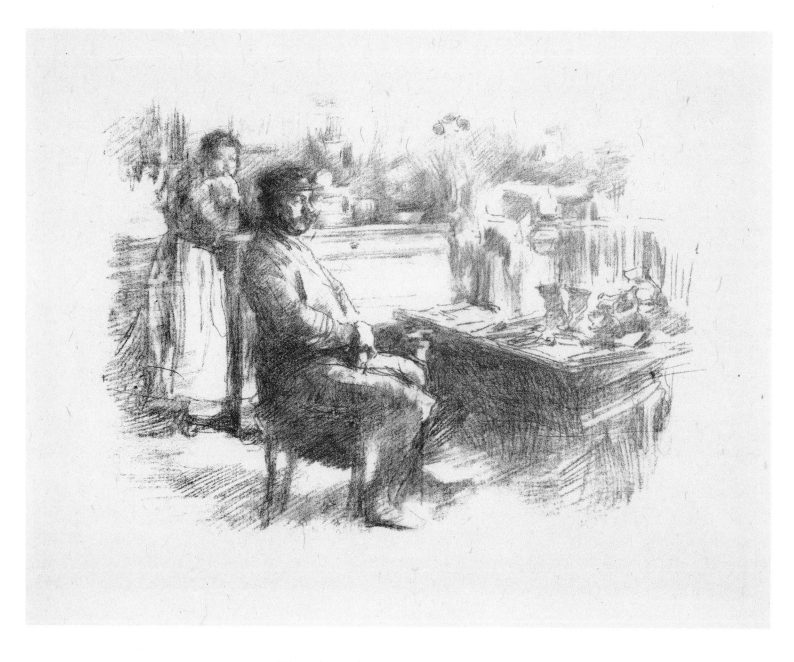

Lithograph, printed on wove paper

W. 151

25.9 x 33.6 cm. (10 1/8 x 13 1/8 in.)

Signed on the stone, u.r.: butterfly

Bequest of Margaret Watson Parker, 1954/1.466

After Beatrix Whistler died in May 1896 the artist did very little further work in lithography, a medium Beatrix had especially enjoyed watching Whistler develop. His heaviness of heart as his wife declined must have contributed to his increasingly testy relationship with the Ways, father and son, who had proven themselves such accommodating and invaluable collaborators in the printmaking process. Whistler's acrimony attached itself ostensibly to the *catalogue raisonné* of his lithographs that T.R. Way was compiling, which was published in 1896. Finally, in the following year, ties between the parties were severed.

Nevertheless, Whistler did execute several more lithographs in the final years of the nineties. *The Shoemaker, Dieppe* was probably drawn on transfer paper sometime during the winter of 1896-97, when the artist made one of his frequent Channel crossings and may have paused in the harbor town he knew well.[1] In a richly studied composition he depicts a craftsman seated in his shop, surrounded by the tools of his trade and watched over by a woman who seems to stand at a respectful distance. The central figure's impassive and impressive presence is communicated through the seated profile in which he is shown, a posture Whistler had reserved in the 1870s for images of such venerable individuals as the philosopher Thomas Carlyle and his own mother.[2]

Whistler treats what is essentially a genre scene with an interest in particular details that recalls some of his early "French Set" etchings of workers and merchants, such as *La Marchande de Moutarde* (cat. no. 5), or the dramatically lit interior of *The Kitchen* (cat. no. 6). In *The Shoemaker*, light enters from the right and strikes the seated figure's face, reserving the rest of his form in soft shadows made softer still by the use of the stump. The dark contour that rims his solid body increases the gravity and the dignity he projects. Indeed, Whistler expresses such empathy with the tradesman-artisan represented here that it is tempting to see the shoemaker as an analogue for the artist himself, a figure similarly engaged in an honorable profession.

Whistler's drawing was transferred to the lithographic stone, which was left with the firm of Lemercier in Paris, whose printing services the artist had occasionally used.[3] Impressions certainly were printed during his lifetime, and Frederick Goulding editioned further, posthumous proofs from the stone.

JS

1 Throughout the 1880s and 1890s his travels regularly took him to Dieppe, where he socialized with Walter Sickert, Degas, and Jacques-Emile Blanche, among others.
2 In addition to the familiar portrait of the artist's mother (YMSM 101), see *Arrangement in Grey and Black, No. 2: Portrait of Thomas Carlyle* (YMSM 137; City Art Gallery, Glasgow).
3 MacDonald, "Whistler's Lithographs," 53. See, for example, cat. no. 63.

83 **Blue and Silver: Morning, Ajaccio** (recto, shown)
Building with Trees (verso)
1901

Watercolor on Japan paper, mounted on board

25.1 x 14.6 cm. (9 7/8 x 5 3/4 in.)

Inscribed and signed with butterfly on backing
label: Blue & Silver— / Morning. / Ajaccio.

Purchased from M. Knoedler & Co., New York,
1914

Bequest of Margaret Watson Parker, 1955/1.90

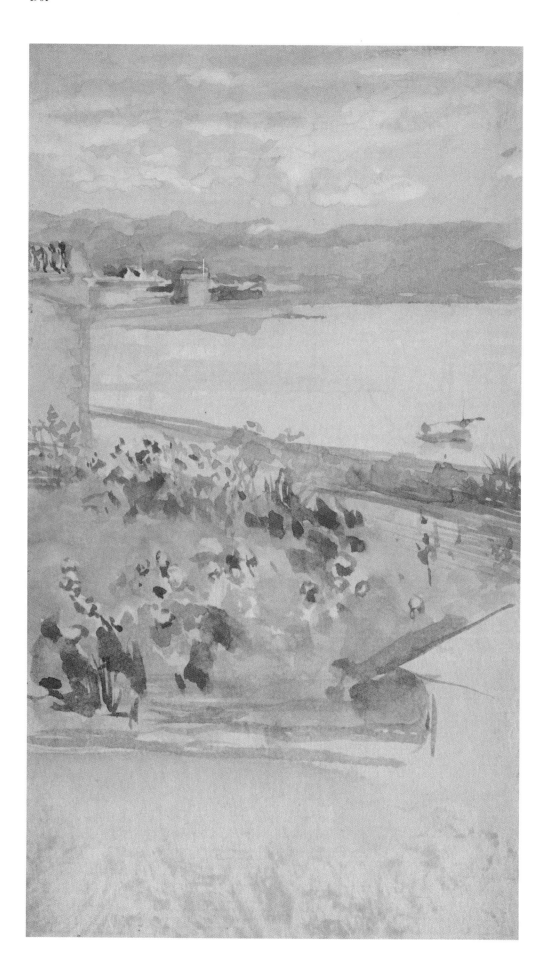

In the last few years of his life, fatigue and persistent illness took their toll on Whistler's physical well-being. "Lowered in tone," was the doctor's diagnosis, Whistler said; "probably the result," the artist added, "of living in the midst of English pictures."[1] Seeking sun as an antidote, Whistler traveled from London to the warmer, brighter climates of Algiers and Corsica in December of 1900. Originally planned to last two weeks, his stay in the Corsican town of Ajaccio continued for several months. "I never went out without a sketch-book or an etching plate," he recalled. "I was always meaning to work, always thinking I must." A sympathetic observer, however, noted Whistler's weariness and counseled rest. "And I put myself down to doing nothing," he noted; "amazing, you know."[2]

Whistler gradually recovered his strength and resumed his work, producing a few oil paintings and prints, many drawings, and some watercolors, among them *Blue and Silver: Morning, Ajaccio*.[3] A number of the images he created at this time express his delight in the view of the Corsican coast seen across the water (fig. 83a). That is the view captured in Michigan's sheet, which may have been taken from the elevated vantage of the artist's hotel window.

A series of broad diagonals structures the watercolor, and a palette of blues and greens is joined intermittently by isolated touches of white and red. The lines of the rooftops and the coastline provide pathways into and across the vertical landscape. A shimmering Mediterranean light from the bright morning sky strikes the buildings and the bay, where a solitary boat appears idly anchored. The blue and silver harmonies and the quick and fluid execution of watercolor washes all combine in Whistler's representation to convey the therapeutic effects and the "higher tone" of a brilliant southern atmosphere.

JS

83a *The Port of Ajaccio*, Corsican Sketchbook, pencil, Hunterian Art Gallery, University of Glasgow, Birnie Philip Gift

1 Pennell and Pennell, *Life* (1908), 2:263.
2 *Ibid.*, 2:266-67.
3 The fullest account of the Corsican stay and work is Margaret F. MacInnes, "Whistler's Last Years: Spring, 1901—Algiers and Corsica," *Gazette des Beaux-Arts* 73 (May-June 1969): 323-42.

The following bibliography is limited to publications used in the preparation of this catalogue. Citations for other sources consulted may be found in the catalogue entry notes. For a more complete Whistler bibliobraphy, see Robert H. Getscher and Paul G. Marks, *James McNeill Whistler and John Singer Sargent: Two Annotated Bibliographies* (New York and London: Garland, 1986).

Bacher, Otto. *With Whistler in Venice.* New York: Century, 1908.

Curry, David Park. *James McNeill Whistler at the Freer Gallery of Art.* Exh. cat. New York: W.W. Norton, in association with the Freer Gallery of Art, 1984.

Duret, Théodore. *Histoire de J. McN. Whistler, et de son Oeuvre.* Paris: Floury, 1904.

_____ . *Whistler.* Trans. Frank Rutter. Philadelphia: J.B. Lippincott; London: Grant Richards, 1917.

Fine, Ruth E. *Drawing Near: Whistler Etchings from the Zelman Collection.* Exh. cat. Los Angeles: Los Angeles County Museum of Art, in association with the University of Washington Press, 1984.

Fine, Ruth E., ed. *James McNeill Whistler: A Reexamination. Studies in the History of Art* 19. Washington, D.C.: National Gallery of Art, 1987.

Fryberger, Betsy G. *Whistler: Themes and Variations.* Exh. cat. Stanford: Stanford University Museum of Art, 1978.

Getscher, Robert H. *The Stamp of Whistler.* Exh. cat. Oberlin: Allen Memorial Art Museum, 1977.

_____ . *Whistler and Venice.* Diss. Case Western Reserve University, 1970. Ann Arbor: UMI, 1970.

Hamerton, Philip Gilbert. *Etching and Etchers.* 3rd ed. London: Macmillan, 1880.

Heijbroek, J.F. "Holland vanaf het water: De bezoeken van James Abbott McNeill Whistler aan Nederland." *Bulletin van het Rijksmuseum* 36 (1988): 225-56.

Hobbs, Susan, and Nesta R. Spink. *Lithographs of James McNeill Whistler from the Collection of Steven Louis Block.* Washington, D.C.: Smithsonian Institution Traveling Exhibition Service, 1982.

Hopkinson, Martin, et al. *Whistler Exhibition in Japan.* Exh. cat. Tokyo: Yomiuri Shimbun, 1987.

_____ . *James McNeill Whistler at the Hunterian Art Gallery.* Glasgow: Hunterian Art Gallery, 1990.

Kennedy, Edward G. *The Etched Work of Whistler.* New York: The Grolier Club, 1910.

_____ . *The Lithographs by Whistler.* New York: Kennedy & Co., 1914.

Lochnan, Katharine A. "Whistler and the Transfer Lithograph: A Lithograph With a Verdict." *The Print Collector's Newsletter* 12 (November-December 1981): 133-37.

_____ . *Whistler's Etchings and the Sources of His Etching Style, 1855-1880.* Diss. Courtauld Institute, University of London, 1982. New York: Garland, 1988.

_____ . *The Etchings of James McNeill Whistler.* New Haven and London: Yale University Press, 1984.

_____ . *Whistler and His Circle: Etchings and Lithographs from the Collection of the Art Gallery of Ontario.* Exh. cat. Toronto: The Art Gallery of Ontario, 1986.

Lovell, Margaretta M., with the assistance of Marc S. Simpson. *Venice: The American View, 1860-1920.* Exh. cat. San Francisco: The Fine Arts Museums of San Francisco, 1985.

MacDonald, Margaret F. *Whistler. The Graphic Work: Amsterdam, Liverpool, London, Venice.* Exh. cat. London: Thos. Agnew & Sons, in association with The Arts Council of Great Britain, 1976.

_____ . *Whistler Pastels and Related Works in the Hunterian Art Gallery.* Exh. cat. Glasgow: Hunterian Art Gallery, 1984.

_____ . "Whistler's Lithographs." *Print Quarterly* 5 (March 1988): 20-55.

Mansfield, Howard. "Whistler as a Critic of His Own Prints." *The Print-Collector's Quarterly* 3 (December 1913): 366-93.

_____. "Whistler in Belgium and Holland." *The Print-Collector's Quarterly* 6 (December 1916): 374-95.

Menpes, Mortimer. *Whistler as I Knew Him.* London: Adam and Charles Black, 1904.

Merrill, Linda. *A Pot of Paint: Aesthetics on Trial in "Whistler v. Ruskin".* Washington, D.C. and London: Smithsonian Institution Press, 1992.

Pennell, Elizabeth Robins, and Joseph Pennell. *The Life of James McNeill Whistler.* 2 vols. London: William Heinemann; Philadelphia: J.B. Lippincott, 1908.

_____. *The Life of James McNeill Whistler.* 5th, rev. ed. London: William Heinemann; Philadelphia: J.B. Lippincott, 1911.

_____. *The Whistler Journal.* Philadelphia: J.B. Lippincott, 1921.

Schwartz, Roberta M. "Whistler's Aestheticism in His Venetian Etchings." *Porticus* 8 (1985): 36-44.

Spencer, Robin, ed. *Whistler: A Retrospective.* New York: Hugh Lauter Levin Associates, 1989.

Spink, Nesta R., and John E. Holmes. "Whistler: The Later Years." Unpub. cat. ms. Ann Arbor, University of Michigan Museum of Art, 1978.

Staley, Allen, and Theodore Reff. *From Realism to Symbolism: Whistler and His World.* Exh. cat. New York: Wildenstein, 1971.

Thomas, Ralph. *A Catalogue of the Etchings and Drypoints of James Abbott MacNeil Whistler,* London: priv. printed, 1874.

Way, T[homas]. R. "Mr. Whistler's Lithographs." *The Studio* 6 (1896): 219-27.

_____. *Mr. Whistler's Lithographs: The Catalogue.* 2nd ed. London: G. Bell and Sons; New York: H. Wunderlich, 1905.

_____. *Memories of James McNeill Whistler: The Artist.* London and New York: John Lane, 1912.

_____. "Whistler's Lithographs." *The Print-Collector's Quarterly* 3 (October 1913): 277-309.

Way, T.R., and G.R. Dennis. *The Art of James McNeill Whistler: An Appreciation.* London: George Bell, 1903.

Wedmore, Frederick. "Mr. Whistler's Theories and Mr. Whistler's Art." *The Nineteenth Century* 6 (August 1879): 334-43.

_____. *Whistler's Etchings: A Study and a Catalogue.* 2nd, rev. ed. London: Colnaghi, 1899.

Whistler, James McNeill. *Mr. Whistler's "Ten O'Clock".* London: Chatto and Windus, 1888.

Young, Andrew McLaren, Margaret F. MacDonald, Robin Spencer, and Hamish Miles. *The Paintings of James McNeill Whistler.* 2 vols. New Haven and London: Yale University Press, 1980.

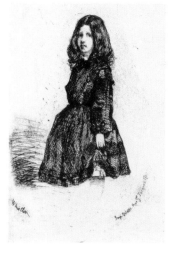

1 The Title to the French Set
from "Twelve Etchings from Nature," or the "French Set"
1858

Etching, printed in black ink on blue wove paper
K. 25 (only state)
Plate: 11.2 x 14.7 cm. (4 3/8 x 5 3/4 in.)
Sheet: 35.2 x 53.6 cm. (13 3/4 x 20 7/8 in.)
Inscribed on the plate, at top (right to left): Douze /
 Eaux Fortes / d'apres Nature / par / James Whistler /
 Imp. Delatre. Rue St. Jacques. 171. Paris. Nov. 1858
Inscribed on the plate, at bottom: À [sic] Mon viel Ami
 Seymour Haden.
Collection: Charles Sydenham Haden (no mark)
Purchased from P. & D. Colnaghi & Co., London,
 1932
Bequest of Margaret Watson Parker, 1954/1.333
Catalogue number 2

2 The Title to the French Set
from "Twelve Etchings from Nature," or the "French Set"
1858

Etching, printed in black ink on Japan paper,
 laid down on white wove paper
K. 25 (only state)
Plate: 11.2 x 14.7 cm. (4 3/8 x 5 3/4 in.)
Sheet: 24.5 x 32.7 cm. (9 9/16 x 12 3/4 in.)
Inscribed on the plate, at top (right to left): Douze /
 Eaux Fortes / d'apres Nature / par / James Whistler /
 Imp. Delatre. Rue St. Jacques. 171. Paris. Nov. 1858
Inscribed on the plate, at bottom: À [sic] Mon viel Ami
 Seymour Haden.
Collection: Charles Sydenham Haden (no mark)
Purchased from P. & D. Colnaghi & Co., London,
 1932
Bequest of Margaret Watson Parker, 1954/1.332

3 Annie
from "Twelve Etchings from Nature," or the "French Set"
1857-1858

Etching, printed in black ink on Japan paper,
 laid down on white wove paper
K. 10 iv/v
Plate: 11.8 x 7.9 cm. (4 5/8 x 3 1/16 in.)
Sheet: 32.6 x 24.6 cm. (12 11/16 x 9 5/8 in.)
Signed on the plate, l.l.: Whistler
Inscribed on the plate, l.r.: Imp. Delatre. Rue St. Jacques.
 171.
Collection: Charles Sydenham Haden (no mark)
Purchased from P. & D. Colnaghi & Co., London,
 1932
Bequest of Margaret Watson Parker, 1954/1.318

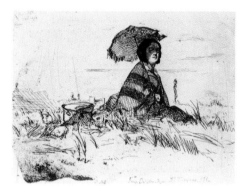

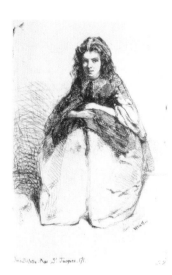

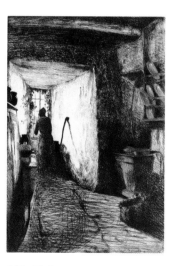

4 En Plein Soleil
from "Twelve Etchings from Nature," or the "French Set"
1858

Etching, printed in black ink on Japan paper,
 laid down on white wove paper
K. 15 ii/ii
Plate: 10.1 x 13.5 cm. (4 x 5 3/8 in.)
Sheet: 24.8 x 32.4 cm. (9 3/4 x 12 3/4 in.)
Signed on the plate, l.l.: Whistler
Inscribed on the plate, bottom right: Imp. Delatre. Rue
 St. Jacques. 171.
Collection: Charles Sydenham Haden (no mark)
Purchased from P. & D. Colnaghi & Co., London,
 1932
Bequest of Margaret Watson Parker, 1954/1.322
Catalogue number 8

5 Fumette
from "Twelve Etchings from Nature," or the "French Set"
1858

Etching and drypoint, printed in black ink on Japan
 paper, laid down on white wove paper
K. 13 iv/iv
Plate: 16.2 x 10.9 cm. (6 3/8 x 4 1/4 in.)
Sheet: 32.6 x 24.9 cm. (12 3/4 x 9 3/4 in.)
Signed on the plate, l.r. of figure: Whistler
Inscribed on the plate, l.l.: Imp. Delatre. Rue St. Jacques.
 171.
Collection: Charles Sydenham Haden (no mark)
Purchased from P. & D. Colnaghi & Co., London,
 1932
Bequest of Margaret Watson Parker, 1954/1.320
Catalogue number 7

6 The Kitchen
from "Twelve Etchings from Nature," or the "French Set"
1858

Etching, printed in black ink on Japan paper,
 laid down on white wove paper
K. 24 ii/iii
Plate: 22.6 x 15.8 cm. (8 13/16 x 6 3/16 in.)
Sheet: 28.5 x 20.4 cm. (11 1/8 x 7 15/16 in.)
Signed on the plate, l.r.: Whistler
Inscribed on the plate, bottom right: Imp. Delatre.
 Rue St. Jacques. 171.
Collection: Charles Sydenham Haden (no mark)
Purchased from P. & D. Colnaghi & Co., London,
 1932
Bequest of Margaret Watson Parker, 1954/1.330

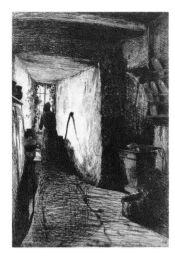

7 The Kitchen
from "Twelve Etchings from Nature," or the "French Set"
1856-1858

Etching, printed in dark brown ink on laid paper
K. 24 ii/iii
Plate: 22.6 x 15.8 cm. (8 13/16 x 6 3/16 in.)
Sheet: 28.5 x 20.4 cm. (11 1/8 x 7 15/16 in.)
Signed on the plate, l.r.: Whistler
Inscribed on the plate, bottom right: Imp. Delatre. Rue
 St. Jacques. 171.
Inscribed in pencil [in Whistler's hand], on the sheet,
 l.l.: Seymour
Inscribed in pencil, on verso: S.H.
Collection: Sir Francis Seymour Haden (not in Lugt in
 this form)
Bequest of Margaret Watson Parker, 1954/1.331
Catalogue number 6

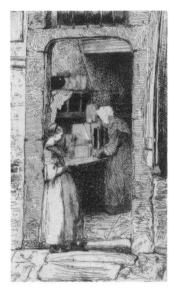

8 La Marchande de Moutarde
from "Twelve Etchings from Nature," or the "French Set"
1858

Etching, printed in black ink on Japan paper,
 laid down on white wove paper
K. 22 ii/v
Plate: 15.7 x 8.9 cm. (6 1/8 x 3 1/2 in.)
Sheet: 32.3 x 24.7 cm. (12 5/8 x 9 5/8 in.)
Signed on the plate, l.l.: Whistler
Inscribed on the plate, bottom left: Imp. Delatre. Rue
 St. Jacques. 171.
Collection: Charles Sydenham Haden (no mark)
Purchased from P. & D. Colnaghi & Co., London,
 1932
Bequest of Margaret Watson Parker, 1954/1.329
Catalogue number 5

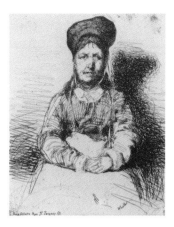

9 La Rétameuse
from "Twelve Etchings from Nature," or the "French Set"
1858

Etching, printed in black ink on Japan paper,
 laid down on white wove paper
K. 14 ii/ii
Plate: 11.2 x 9 cm. (4 3/8 x 3 1/2 in.)
Sheet: 32.6 x 24.9 cm. (12 11/16 x 9 11/16 in.)
Signed on the plate, l.r.: Whistler
Inscribed on the plate, l.l.: Imp. Delatre. Rue St.
 Jacques. 171.
Collection: Charles Sydenham Haden (no mark)
Purchased from P. & D. Colnaghi & Co., London,
 1932
Bequest of Margaret Watson Parker, 1954/1.321

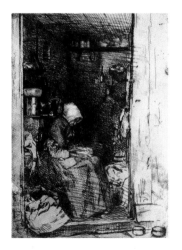

10 La Vieille aux Loques
from "Twelve Etchings from Nature," or the "French Set"
1858

Etching, printed in black ink on Japan paper,
 laid down on white wove paper
K. 21 ii/iii
Plate: 20.8 x 14.8 cm. (8 1/8 x 5 3/4 in.)
Sheet: 32.9 x 24.5 cm. (12 13/16 x 9 9/16 in.)
Signed on the plate, l.r.: Whistler
Inscribed on the plate, l.r.: Imp. Delatre. Rue St. Jacques.
 171.
Collection: Charles Sydenham Haden (no mark)
Purchased from P. & D. Colnaghi & Co., London,
 1932
Bequest of Margaret Watson Parker, 1954/1.327

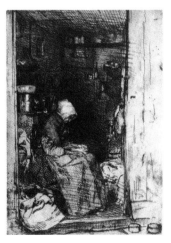

11 La Vieille aux Loques
from "Twelve Etchings from Nature," or the "French Set"
1858

Etching, printed in dark brown ink on green laid paper;
 watermark: Moel Savon
K. 21 ii/iii
Plate: 20.8 x 14.8 cm. (8 1/8 x 5 3/4 in.)
Sheet: 26.1 x 19.1 cm. (10 3/16 x 7 7/16 in.)
Signed in pencil, l.l.: butterfly
Signed on the plate, l.r.: Whistler
Inscribed on the plate, l.r.: Imp. Delatre. Rue St. Jacques.
 171.
Inscribed in pencil, on verso: 69 within circle
Collection: Theodore DeWitt (no mark)
Bequest of Margaret Watson Parker, 1954/1.328

12 La Vieille aux Loques
from "Twelve Etchings from Nature," or the "French Set"
1858

Etching, printed in black ink on laid paper; watermark:
 Moel Savon
K. 21 iii/iii
Plate: 20.8 x 14.8 cm. (8 1/8 x 5 3/4 in.)
Sheet: 21.5 x 15.5 cm. (8 3/8 x 6 1/6 in.)
Signed in pencil: butterfly
Signed on the plate, l.r.: Whistler
Collection: Theodore DeWitt (no mark)
1950/1.202

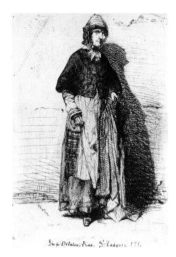

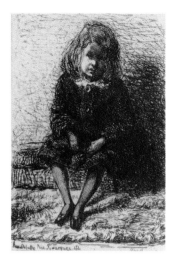

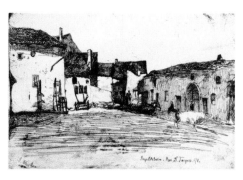

13 La Mère Gérard
from "Twelve Etchings from Nature," or the "French Set"
1858

Etching, printed in black ink on Japan paper,
 laid down on white wove paper
K. 11 iv/iv
Plate: 12.8 x 9 cm. (5 x 3 1/2 in.)
Sheet: 32.6 x 24.7 cm. (12 11/16 x 9 5/8 in.)
Signed on the plate, to left of figure: Whistler.
Inscribed on the plate, bottom: Imp. Delatre. Rue St.
 Jacques. 171.
Collection: Charles Sydenham Haden (no mark)
Purchased from P. & D. Colnaghi & Co., London,
 1932
Bequest of Margaret Watson Parker, 1954/1.319

14 Little Arthur
from "Twelve Etchings from Nature," or the "French Set"
1858

Etching, printed in black ink on Japan paper,
 laid down on white wove paper
K. 9 iii/v
Plate: 8.3 x 5.7 cm. (3 1/4 x 2 1/4 in.)
Sheet: 32.5 x 24.4 cm. (12 11/16 x 9 1/2 in.)
Signed on the plate, l.r.: Whistler
Inscribed on the plate, l.l.: Imp. Delatre. Rue St. Jacques.
 171.
Collection: Charles Sydenham Haden (no mark)
Purchased from P. & D. Colnaghi & Co., London,
 1932
Bequest of Margaret Watson Parker, 1954/1.317

15 Liverdun
from "Twelve Etchings from Nature," or the "French Set"
1858

Etching, printed in black ink on Japan paper,
 laid down on white wove paper
K. 16 ii/ii
Plate: 10.9 x 15.4 cm. (4 1/4 x 6 in.)
Sheet: 24.7 x 32.4 cm. (9 5/8 x 12 5/8 in.)
Signed on the plate, u.r.: Whistler
Signed on the plate, l.l.: J. Whistler
Inscribed on the plate, l.r.: Imp. Delatre. Rue St. Jacques.
 171.
Collection: Charles Sydenham Haden (no mark)
Purchased from P. & D. Colnaghi & Co., London,
 1932
Bequest of Margaret Watson Parker, 1954/1.323

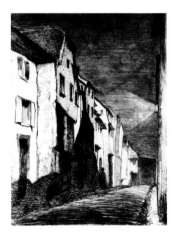

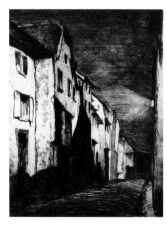

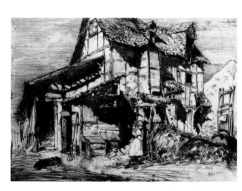

16 Street at Saverne
from "Twelve Etchings from Nature," or the "French Set"
1858

Etching, printed in black ink on Japan paper, laid
 down on white wove paper
K. 19 iv/v
Plate: 20.7 x 16 cm. (8 1/16 x 6 1/4 in.)
Sheet: 32.7 x 24.8 cm. (12 3/4 x 9 11/16 in.)
Signed on the plate, l.l.: Whistler
Inscribed on the plate, l.r.: Imp. Delatre. Rue St. Jacques.
Collection: Charles Sydenham Haden (no mark)
Purchased from P. & D. Colnaghi & Co., London,
 1932
Bequest of Margaret Watson Parker, 1954/1.325
Catalogue number 4

17 Street at Saverne
from "Twelve Etchings from Nature," or the "French Set"
1858

Etching, printed in black ink on Japan paper
K. 19 v/v
Plate: 20.7 x 16 cm. (8 1/16 x 6 1/4 in.)
Sheet: 26.6 x 19.5 cm. (10 3/8 x 7 5/8 in.)
Signed on the plate, l.l: Whistler
Bequest of Margaret Watson Parker, 1954/1.326

18 The Unsafe Tenement
from "Twelve Etchings from Nature," or the "French Set"
1858

Etching, printed in black ink on Japan paper,
 laid down on white wove paper
K. 17 ii/iv
Plate: 15.9 x 22.5 cm. (6 1/4 x 8 7/8 in.)
Sheet: 24.7 x 32.5 cm. (9 3/4 x 12 3/4 in.)
Signed on the plate, l.r.: Whistler
Inscribed on the plate, bottom left: Imp. Delatre. Rue
 St. Jacques. 171.
Collection: Charles Sydenham Haden (no mark)
Purchased from P. & D. Colnaghi & Co., London,
 1932
Bequest of Margaret Watson Parker, 1954/1.324
Catalogue number 3

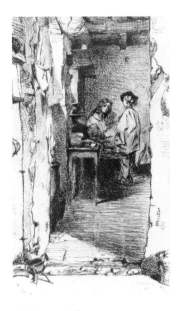

19 The Rag Gatherers
1858

Etching and drypoint, printed in black ink on pale
 green laid paper
K. 23 v/v
Plate: 15.3 x 8.8 cm. (5 15/16 x 3 7/16 in.)
Sheet: 20.1 x 14.3 cm. (7 13/16 x 5 9/16 in.)
Signed and dated on the plate, l.r.: Whistler / 1858
1991/2.1

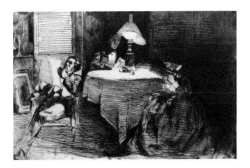

20 The Music Room
1858

Etching, printed in black ink on wove paper;
 watermark: J.F.
K. 33 ii/ii
Plate: 14.2 x 21.6 cm. (5 9/16 x 8 7/16 in.)
Sheet: 19.8 x 27.5 cm. (7 3/4 x 10 3/4 in.)
Bequest of Margaret Watson Parker, 1954/1.334

21 The Wine Glass
1858

Etching, printed in black ink on laid paper;
 watermark: (partial) PRO PATRIA
K. 27 ii/ii
Plate: 8.2 x 5.5 cm. (3 3/16 x 2 1/8 in.)
Sheet: 20.8 x 16.8 cm. (8 1/8 x 6 9/16 in.)
Signed on the plate, l.l.: Whistler
Purchased from C. & J. Goodfriend, New York, 1992
Gift of the Friends of the Museum, 1992/2.4
Catalogue number 9

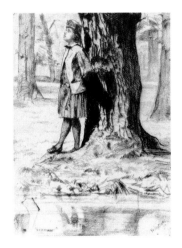

22 Seymour Standing Under a Tree
1859

Etching, printed in black ink on laid paper
K. 31 ii/iii
Plate: 13.4 x 9.6 cm. (5 1/4 x 3 3/4 in.)
Sheet: 21.5 x 14.1 cm. (8 3/8 x 5 1/2 in.)
Signed on the plate, l.r.: Whistler
Inscribed on the plate, l.l.: "Seymour"
Inscribed on the sheet, in pencil, l.l.: W. 23 Seymour
Jean Paul Slusser Memorial Fund, 1988/2.22

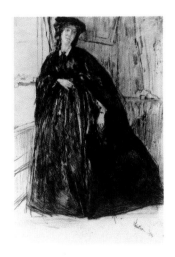

23 Finette
1859

Etching and drypoint, printed in black ink on laid
 Japan tissue
K. 58 iii/x
Plate: 29.1 x 20.1 cm. (11 3/8 x 7 13/16 in.)
Sheet: 35.3 x 23.3 cm. (13 3/4 x 9 1/16 in.)
Signed and dated on the plate, l.r.: Whistler. 1859.
Inscribed in pencil, l.l.: Early state. W.—
Collection: H.S. Theobald (no mark)
Purchased from M. Knoedler & Co., New York, 1907
Bequest of Margaret Watson Parker, 1954/1.342
Catalogue number 10

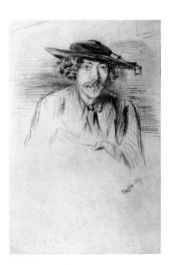

24 Portrait of Whistler
1859

Etching and drypoint, printed in black ink on laid paper
K. 54 ii/ii
Plate: 22.4 x 15.1 cm. (8 3/4 x 5 7/8 in.)
Sheet: 29.6 x 22.1 cm. (11 9/16 x 8 5/8 in.)
Signed and dated on the plate, l.r.: Whistler. 1859.
Inscribed in pencil, l.l., and on verso: J.T.K. [in oval]
 no. 7
Notation in red ink, l.r.: 363
Collection: Sir James Thomas Knowles (Lugt 1546)
Purchased from Obach & Co., London, 1907
Bequest of Margaret Watson Parker, 1954/1.341
Catalogue number 1

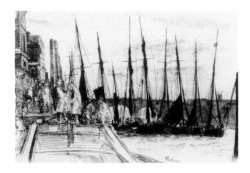

25 Billingsgate
1859

Etching, printed in black ink on laid Japan paper
K. 47 vii/viii
Plate: 15.1 x 22.6 cm. (6 x 8 7/8 in.)
Sheet: 20.7 x 30.9 cm. (8 1/4 x 12 1/8 in.)
Signed and dated on the plate, l.r.: Whistler. 1859.
Bequest of Margaret Watson Parker, 1954/1.339

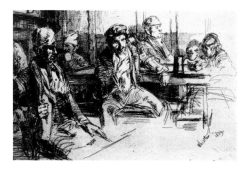

26 Longshoremen
1859

Etching, printed in black ink on laid Japan tissue
K. 45 (only state)
Plate: 15.2 x 22.7 cm. (5 15/16 x 8 7/8 in.)
Sheet: 19.6 x 26.9 cm. (7 5/8 x 10 1/2 in.)
Signed and dated on the plate, l.r.: Whistler. / 1859.
Bequest of Margaret Watson Parker, 1954/1.338

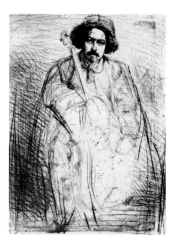

27 Becquet
from "Sixteen Etchings," or the "Thames Set"
1859

Etching and drypoint, printed in black ink on laid paper;
 watermark: (SPAIN ?)
K. 52 iii/iv
Plate: 24.5 x 18.4 cm. (9 9/16 x 7 3/16 in.)
Sheet: 37.1 x 24.1 cm. (14 1/2 x 9 3/8 in.)
Bequest of Margaret Watson Parker, 1954/1.340

28 Eagle Wharf (Tyzac, Whiteley & Co.)
from "Sixteen Etchings," or the "Thames Set"
1859

Etching, printed in black ink on laid tissue
K. 41 (only state)
Plate: 13.9 x 29.5 cm. (5 7/16 x 8 3/8 in.)
Sheet: 23.6 x 34.3 cm. (9 3/16 x 13 3/8 in.)
Signed and dated on the plate, bottom: Whistler. 1859.
Inscribed in pencil, on the sheet, l.r.: K. 41
 Tyzac Whiteley & Co. / only state
Bequest of Margaret Watson Parker, 1954/1.336

29 The Lime-burner
from "Sixteen Etchings," or the "Thames Set"
1859

Etching and drypoint, printed in black ink on laid
 Japan tissue
K. 46 ii/iii
Plate: 25.4 x 17.7 cm. (9 3/4 x 7 in.)
Sheet: 29.9 x 21.3 cm. (11 3/4 x 8 3/8 in.)
Signed and dated on the plate, l.r.: Whistler. 1859.
Signed lightly on the plate, l.l.: Whistler
Purchased from R.M. Light & Co., Inc., Santa Barbara,
 1986
The Alfred E. Pernt Memorial Fund, in honor of Dr. of
 Technical Sciences Max H.J. Pernt and his wife Anna
 Pernt (née Mueller), 1986/2.14
Catalogue number 14

30 The Pool
from "Sixteen Etchings," or the "Thames Set"
1859

Etching, printed in dark brown ink on laid Japan tissue
K. 43 undescribed state between iii and iv/iv
Plate: 13.9 x 21.5 cm. (5 7/16 x 8 3/8 in.)
Sheet: 24.5 x 34.2 cm. (9 9/16 x 13 5/16 in.)
Signed and dated on the plate, l.l: Whistler. / 1859.
Purchased from P. & D. Colnaghi & Co., London,
 1927
Bequest of Margaret Watson Parker, 1954/1.337
Catalogue number 13

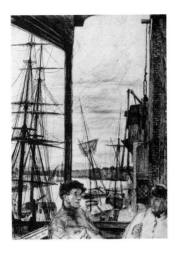

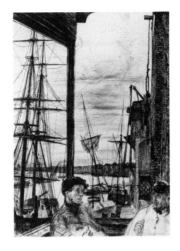

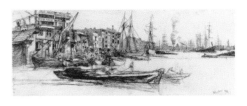

33 Thames Warehouses
from "Sixteen Etchings," or the "Thames Set"
1859

Etching, printed in black ink on laid paper
K. 38 ii/ii
Plate: 7.7 x 20.3 cm. (3 x 7 15/16 in.)
Sheet: 11.6 x 23.5 cm. (4 1/2 x 9 3/16 in.)
Signed and dated on the plate, l.r.: Whistler. 1859.
Bequest of Margaret Watson Parker, 1954/1.335

31 Rotherhithe
from "Sixteen Etchings," or the "Thames Set"
1860

Etching and drypoint, printed in black ink on laid
 Japan paper
K. 66 iii/iii
Plate: 27.8 x 20.1 cm. (10 13/16 x 7 13/16 in.)
Sheet: 36.8 x 28 cm. (14 3/8 x 10 15/16 in.)
Signed and dated on the plate, l.l.: Whistler. 1860.
Bequest of Margaret Watson Parker, 1954/1.345
Catalogue number 16

32 Rotherhithe
from "Sixteen Etchings," or the "Thames Set"
1860

Etching and drypoint, printed in black ink on laid
 Japan paper
K. 66 iii/iii
Plate: 27.8 x 20.1 cm. (10 13/16 x 7 13/16 in.)
Sheet: 38.8 x 26.3 cm. (15 1/8 x 10 1/4 in.)
Signed and dated on the plate, l.l.: Whistler. 1860.
Bequest of Margaret Watson Parker, 1954/1.346

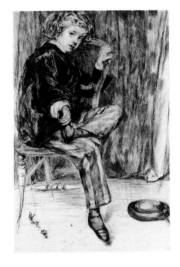

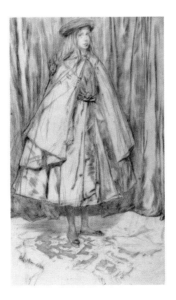

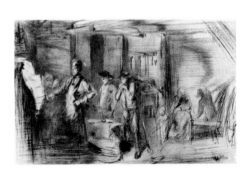

36 The Forge
from "Sixteen Etchings," or the "Thames Set"
1861

Drypoint, printed in black ink on laid Japan tissue
K. 68 iii/iv
Plate: 19.2 x 30.5 cm. (7 1/2 x 11 7/8 in.)
Sheet: 25.9 x 36.5 cm. (10 1/8 x 14 1/4 in.)
Signed in pencil, l.l. margin: butterfly and imp.
Signed and dated on the plate, l.r.: Whistler. / 1861.
Collections: Howard Mansfield (Lugt 1342); H.S.
 Theobald (no mark); B. Bernard McGeorge
 (Lugt Suppl. 394)
Purchased from M. Knoedler & Co., New York, 1907
Bequest of Margaret Watson Parker, 1954/1.347
Catalogue number 15

34 Arthur Haden
1859

Drypoint, printed in black ink on laid Japan tissue
K. 61 iii/iii
Plate: 22.5 x 15.2 cm. (8 7/8 x 6 in.)
Sheet: 38.2 x 26 cm. (15 x 10 1/4 in.)
Signed and dated on the plate, l.l.: Whistler. 1869.
Inscribed in pencil, lower margin: Portrait of Arthur
 Seymour [not in Whistler's hand]
Collection: Sir John Day. (Lugt 526)
Purchased from Obach & Co., London, 1908
Bequest of Margaret Watson Parker, 1954/1.343
Catalogue number 11

35 Annie Haden
1860

Drypoint, printed in black ink on laid paper
K. 62 iii/iii
Plate: 35.1 x 21.5 cm. (13 13/16 x 8 1/2 in.)
Sheet: 47.1 x 32.9 cm. (18 1/2 x 12 15/16 in.)
Signed and dated on the plate, l.l.: Whistler. 1860.
 ("6" is in reverse)
Notation in pencil, lower margin [possibly by Beatrix
 Whistler]
Collection: Royal Library, Windsor (Lugt 2535)
Purchased from Obach & Co., London, 1906
Bequest of Margaret Watson Parker, 1954/1.344
Catalogue number 12

37 Jo's Bent Head
1861

Etching and drypoint, printed in dark brown ink
 on laid paper; watermark: V I
K. 78 ii/iia
Plate: 22.6 x 15 cm. (8 13/16 x 5 7/8 in.)
Sheet: 32 x 19.4 cm. (12 1/2 x 7 9/16 in.)
Collections: C.W. Dowdeswell (Lugt 690); J.H.
 Hutchinson (no mark)
Bequest of Margaret Watson Parker, 1954/1.350

38 Jo's Bent Head
1861

Etching and drypoint, printed in dark brown ink
 on laid paper; watermark: V I
K. 78 ii/iia
Plate: 22.6 x 15 cm. (8 13/16 x 5 7/8 in.)
Sheet: 32 x 19.4 cm. (12 1/2 x 7 9/16 in.)
Collections: Mortimer Menpes (no mark); H.S. Theobald
 (no mark)
Purchased from M. Knoedler & Co., New York, 1907
Bequest of Margaret Watson Parker, 1954/1.349
Catalogue number 17

39 Jo's Bent Head
1861

Etching, and drypoint, printed in black ink on laid
 paper; watermark (elaborate)
K. 78 ii/iia
Plate: 22.6 x 15 cm. (8 13/16 x 5 7/8 in.)
Sheet: 40.7 x 25.6 cm. (15 7/8 x 10 in.)
Bequest of Margaret Watson Parker, 1954/1.348

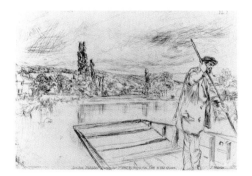

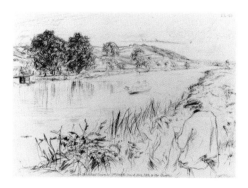

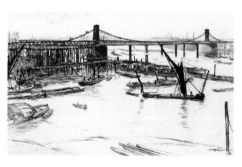

40 The Punt (The Angler)
an illustration for "Passages from Modern English Poets"
1861

Etching, printed in black ink on wove paper
K. 85 undescribed state between iii and iv/iv
Plate: 11.6 x 16.4 cm. (4 1/2 x 6 3/8 in.)
Sheet: 16.4 x 23.5 cm. (6 3/8 x 9 3/16 in.)
Signed and dated on the plate, l.l.: Whistler/1861
Printed on the plate: London, Published December 1st.
 1861, by Day & Son, Lith. to the Queen.
Printed on the plate, l.r.: J. Whistler.
Inscribed on the plate, u.r.: PL. 7
1938.10

41 Sketching, No. 1
an illustration for "Passages from Modern English Poets"
1861

Etching, printed in black ink on wove paper
K. 86 iv/iv
Plate: 12.2 x 16.5 cm. (4 3/4 x 6 7/16 in.)
Sheet: 16.7 x 23.5 cm. (6 1/2 x 9 3/16 in.)
Signed on the plate, l.r.: Whistler
Printed on the plate: London Published Decembe[r]
 1st. 1861 by Day & Son, Lith. to the Queen
Printed on the plate, l.r.: J. Whistler
Inscribed on the plate, u.r.: PL. 45
1938.11

42 Old Hungerford Bridge
from "Sixteen Etchings," or the "Thames Set"
1861

Etching, printed in black ink on laid paper;
 watermark: (partial)
K. 76 iii/iii
Plate: 13.8 x 21.3 cm. (5 3/8 x 8 5/16 in.)
Sheet: 18.4 x 23.9 cm. (7 3/16 x 9 5/16 in.)
Signed on the plate, l.r.: Whistler
Inscribed in pencil, l.l.: Old Hungerford Bridge.
 very fine
Bequest of Margaret Watson Parker, 1955/1.121

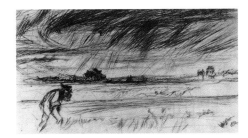

43 The Storm
1861

Drypoint, printed in black ink on laid paper; watermark:
 (elaborate) and R K
K. 81 from cancelled plate
Plate: 15.9 x 28.3 cm. (6 3/16 x 11 1/16 in.)
Sheet: 17.6 x 30.5 cm. (6 7/8 x 11 7/8 in.)
Signed on the plate, l.r.: Whistler / 1861.
Inscribed in pencil, on verso, l.l.: The Storm. W.77.
 "A scarce Drypoint," Wedmore
Inscribed in pencil, on verso, l.r.: Rawlinson collection
Collection: W.G. Rawlinson (no mark)
Bequest of Margaret Watson Parker, 1954/1.351

44 Weary
1863

Drypoint, printed in warm black ink on laid Japan
 tissue, tipped down
K. 92 ii/iii
Plate: 19.7 x 13.1 cm. (7 11/16 x 5 1/8 in.)
Sheet: 27.4 x 19.2 cm. (10 11/16 x 7 1/2 in.)
Signed in pencil, on the sheet, l.r.: Whistler and butterfly
Signed and dated on the plate, l.l.: Whistler. / 63.
Inscribed in pencil, on the sheet, l.l.: A Lady / "Weary"
Notation in pencil, on the sheet, u.r.: 71
Purchased from Obach & Co., London, 1907
Bequest of Margaret Watson Parker, 1954/1.353
Catalogue number 18

45 Amsterdam, from the Tolhuis
1863

Etching, printed in black ink on laid paper; watermark:
 (elaborate)
K. 91 i/iv
Plate: 13.2 x 20.9 cm. (5 1/8 x 8 1/8 in.)
Sheet (irregular): 21 x 33.6 cm. (8 3/16 x 13 1/8 in.)
Signed and dated on the plate, l.r.: Whistler. 1863. /
 à Amsterdam - Tolhuis.—
Bequest of Margaret Watson Parker, 1954/1.352

46 Speke Hall, No. 1
1870

Etching and drypoint, printed in black ink on old laid
 paper; watermark: (elaborate)
K. 96 v/x
Plate: 22.7 x 15 cm. (8 7/8 x 5 7/8 in.)
Sheet: 33 x 21.6 cm. (12 7/8 x 8 7/16 in.)
Signed and dated in pencil, on the sheet, l.l.: butterfly
 and imp.
Signed on the plate, l.r.: Whistler. 1870. / Speke Hall.
Inscribed in brown ink, on verso: Latin notation
Bequest of Margaret Watson Parker, 1954/1.354

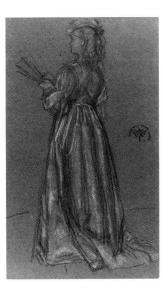

47 Lady with a Fan (recto)
Standing Woman (verso)
ca. 1871-73

Black and white chalk on brown wove paper
21 x 13 cm. (8 1/4 x 5 1/8 in.)
Signed in chalk, center right: butterfly
Purchased from Obach & Co., London, 1905
Bequest of Margaret Watson Parker, 1954/1.266
Catalogue number 23

48 Fanny Leyland
1873

Drypoint, printed in dark brown ink on laid paper;
 watermark: Arms of Amsterdam
K. 108 iv/vi
Plate: 19.5 x 13.2 cm. (7 5/8 x 5 1/8 in.)
Sheet: 33.8 x 21.3 cm. (13 3/16 x 8 5/16 in.)
Signed on the plate, center left: butterfly
Inscribed on the plate, u.l.: Fanny Leyland
Collections: unidentified (Lugt Suppl. 2912h); Royal
 Library, Windsor (Lugt 2535)
Purchased from Obach & Co., London, 1906
Bequest of Margaret Watson Parker, 1954/1.355
Catalogue number 19

49 Florence Leyland
ca. 1873

Drypoint, printed in dark brown ink on laid paper
K. 110 viii/ix
Plate: 21.4 x 13.8 cm. (8 3/8 x 5 3/8 in.)
Sheet: 32.7 x 20 cm. (12 3/4 x 7 13/16 in.)
Signed in pencil, on the sheet, l.l.: Whistler
Signed on the plate, l.r.: butterfly
Inscribed on the plate, u.r.: "I am Flo"
Collections: J.H. Hutchinson (no mark); C.W. Dowdeswell
 (Lugt 690)
Purchased from Obach & Co., London, 1905
Bequest of Margaret Watson Parker, 1954/1.356
Catalogue number 20

50 Maud, Seated
1873

Drypoint, printed in black ink on old laid paper;
 watermark: (partial)
K. 115 ii/iii
Plate: 13.7 x 10 cm. (5 5/8 x 4 in.)
Sheet: 20 x 15.3 cm. (7 7/8 x 6 in.)
Signed on the plate, center left: butterfly
Collection: Watson B. Dickerman
Purchased from Nesta R. Spink, Ann Arbor, 1993
Gift of Alan and Marianne Schwartz, 1993/2.33

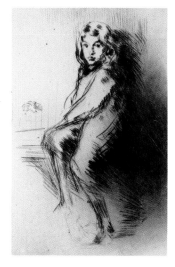

51 The Boy
1873-75

Drypoint, printed in black ink on laid paper; watermark:
 (crown flanked by lions)
K. 135 v/viii
Plate: 22.5 x 14.9 cm. (8 13/16 x 5 13/16 in.)
Sheet (irregular): 33.2 x 21.7 cm. (12 15/16 x 8 7/16 in.)
Signed on the plate, to left of figure: butterfly
Bequest of Margaret Watson Parker, 1954/1.358

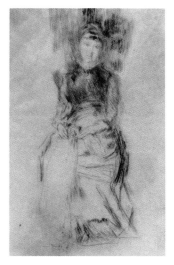

52 Agnes
ca. 1873-75

Etching and drypoint, printed in warm black ink
 on laid Japan tissue
K. 134 ii/ii
Plate: 22.7 x 15.2 cm. (8 7/8 x 5 15/16 in.)
Sheet: 27.5 x 19.9 cm. (10 3/4 x 7 3/4 in.)
Signed in pencil, l.r.: butterfly
Inscribed in pencil, l.r.: Agnes
Collections: Mortimer Menpes; H.S. Theobald (no mark)
Bequest of Margaret Watson Parker, 1954/1.357

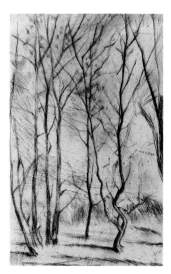

53 The Dam Wood
ca. 1875

Etching and drypoint, printed in black ink on laid paper,
 trimmed to platemark; watermark: (small)
K. 145 i/iii
17.5 x 11.1 cm. (6 13/16 x 4 5/16 in.)
Signed in pencil, on tab: butterfly and imp.
Collection: Royal Library, Windsor (Lugt 2535)
Bequest of Margaret Watson Parker, 1954/1.359

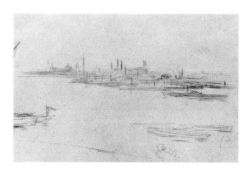

54 Battersea: Dawn
1875

Drypoint, printed in brown ink on laid paper, trimmed
 to platemark; watermark: Arms of Amsterdam
K. 155 i/iv
14.9 x 22.5 cm. (5 13/16 x 8 3/4 in.)
Signed in pencil, on tab and on verso: butterfly
Signed on the plate, u.r.: butterfly
Inscribed in pencil [in Whistler's hand], on verso:
 "Battersea Morn"—1st— / Plate destroyed
Purchased from Obach & Co., London, 1908
Bequest of Margaret Watson Parker, 1954/1.362
Catalogue number 21

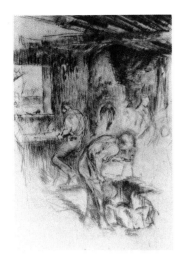

55 The Little Forge
1875

Etching and drypoint, printed in black ink on laid
 paper; watermark: (crown flanked by lions)
K. 147 iii/viii
Plate: 22.5 x 15.1 cm. (8 3/4 x 5 7/8 in.)
Sheet: 38.6 x 30 cm. (15 1/16 x 11 11/16 in.)
Bequest of Margaret Watson Parker, 1954/1.361

56 Shipbuilder's Yard
1875

Drypoint, printed in black ink on old laid paper;
 watermark: B/TH in circular cartouche
K. 146 undescribed state between ii and iii/iii
Plate: 27.7 x 15.2 cm. (10 13/16 x 5 15/16 in.)
Sheet (irregular): 32.8 x 20.4 cm. (12 13/16 x 7 15/16 in.)
Signed on the plate, center left: butterfly
Inscribed in ink, on verso, l.r.: Latin notation
Bequest of Margaret Watson Parker, 1954/1.360

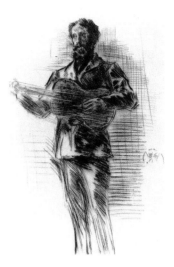

57 The Guitar Player
1875

Drypoint, printed in black ink on old laid paper;
 watermark: Arms of Amsterdam
K. 140 ii/v
Plate: 27.5 x 17.5 cm. (10 7/8 x 6 7/8 in.)
Sheet: 32.3 x 19.7 cm. (12 3/4 x 7 3/4 in.)
Signed on the plate, center right: butterfly
Purchased from R.M. Light & Co., Inc., Santa Barbara,
 1993
Gift of the Friends of the Museum on the Occasion of
 their Twenty-fifth Anniversary, 1993/2.4
Catalogue number 25

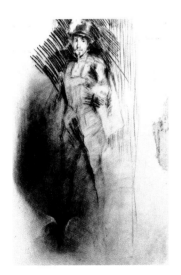

58 Irving as Philip of Spain, No. 1
ca. 1876-77

Etching and drypoint, printed in black ink on laid paper;
 watermark: (elaborate)
K. 170 ii/iii
Plate: 22.6 x 15 cm. (8 13/16 x 5 7/8 in.)
Sheet (irregular): 33.3 x 21.2 cm. (13 x 8 1/4 in.)
Bequest of Margaret Watson Parker, 1954/1.368

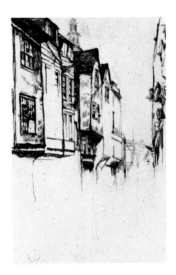

59 Wych Street
1877

Etching and drypoint, printed in black ink on laid paper
K. 159 i/ii
Plate: 21.5 x 13.8 cm. (8 3/8 x 5 3/8 in.)
Sheet (irregular): 32.9 x 21.5 cm. (12 13/16 x 8 3/8 in.)
Bequest of Margaret Watson Parker, 1954/1.363

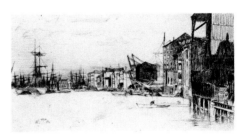

60 Free Trade Wharf
1877

Etching and drypoint, printed in black ink on laid paper;
 watermark: B/TH in circular cartouche
K. 163 iii/v
Plate: 9.8 x 18.8 cm. (3 13/16 x 7 5/16 in.)
Sheet: 20.5 x 29.9 cm. (8 x 11 11/16 in.)
Signed on the plate, l.l.: butterfly
Bequest of Margaret Watson Parker, 1954/1.364

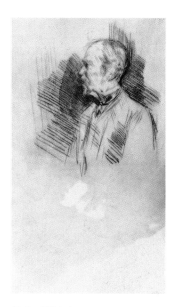

61 Lord Wolseley
ca. 1877

Drypoint, printed in black ink on laid paper with ink
 washes; watermark: (crown flanked by lions)
K. 164 undescribed state between ii and iii/iv
Plate: 30.2 x 17.6 cm. (11 3/4 x 6 7/8 in.)
Sheet: 37.2 x 24.3 cm. (14 1/2 x 9 1/2 in.)
Bequest of Margaret Watson Parker, 1954/1.365

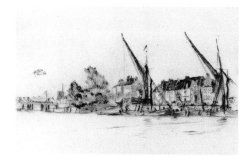

62 From Pickle-Herring Stairs
ca. 1878

Etching and drypoint, printed in black ink on laid paper;
 watermark: De Erven Der Blauw
K. 167 v/vi
Plate: 14.9 x 22.6 cm. (5 13/16 x 8 13/16 in.)
Sheet: 17.6 x 24.7 cm. (6 7/8 x 9 5/8 in.)
Signed on the plate, l.r.: butterfly
Bequest of Margaret Watson Parker, 1954/1.367

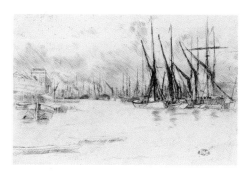

63 Lindsey Houses
ca. 1878

Etching and drypoint, printed in black ink on laid paper;
 watermark: (elaborate)
K. 166 i/iii
Plate: 15.2 x 22.9 cm. (5 15/16 x 8 15/16 in.)
Sheet (irregular): 20.3 x 33.6 cm. (7 15/16 x 13 1/8 in.)
Signed on the plate, left center: butterfly
Inscribed in pencil, on the sheet, l.l.: K. 166I Lindsey
 Houses / (very rare)
Bequest of Margaret Watson Parker, 1954/1.366

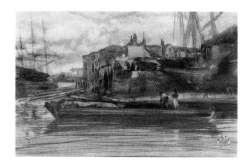

64 Limehouse
1878

Lithotint, printed on heavy wove paper
W. 4
Image: 17.3 x 26.6 cm. (6 7/8 x 10 1/2 in.)
Sheet: 19.1 x 27.9 cm. (7 1/2 x 11 in.)
Signed in pencil, l.l.: butterfly
Signed on the stone, l.r.: butterfly
Purchased from Obach & Co., London, 1905
Bequest of Margaret Watson Parker, 1954/1.412
Catalogue number 22

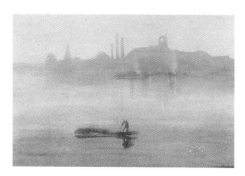

65 Nocturne: The River at Battersea
1878

Lithotint, printed on blue-grey laid paper, laid down
 on white wove paper
W. 5
Image sheet: 17.2 x 25.8 cm. (6 3/4 x 10 1/8 in.)
Support sheet: 37.9 x 54.7 cm. (14 7/8 x 21 1/2 in.)
Signed in pencil, on the support, l.r.: Whistler
Signed on the stone, l.r.: butterfly
Inscribed in pencil [in T.R. Way's hand], on the support,
 l.r.: nocturne no. 5
Inscribed in pencil, on verso, u.l.: Way
Collection: Thomas R. Way (Lugt 2456)
Purchased from Obach & Co., London, 1906
Bequest of Margaret Watson Parker, 1954/1.413
Catalogue number 24

66 The Toilet
1878

Lithotint, heightened with black and white crayon,
 on wove paper
W. 6a
Image: 26 x 16.3 cm. (10 1/4 x 6 1/2 in.)
Sheet: 30 x 20.5 cm. (11 3/4 x 8 1/16 in.)
Signed on the stone, l.l.: butterfly
Notation in pencil, on mat: Touched proof
Purchased from Obach & Co., London, 1906
Bequest of Margaret Watson Parker, 1954/1.414
Catalogue number 26

67 Early Morning
1878

Lithotint, printed on wove paper
W. 7
Image: 16.4 x 25.8 cm. (6 3/8 x 10 1/16 in.)
Sheet: 25.5 x 36.4 cm. (9 15/16 x 14 3/16 in.)
Signed on the stone, l.l.: butterfly
Signed in pencil, on the sheet, bottom left: butterfly
Bequest of Margaret Watson Parker, 1954/1.415

68 Early Morning
1878

Lithotint, printed on wove paper
W. 7
Image: 16.4 x 25.8 cm. (6 3/8 x 10 1/16 in.)
Sheet: 25.5 x 36.4 cm. (9 15/16 x 14 3/16 in.)
Signed on the stone, l.l.: butterfly
Letterpress, on the sheet, upper margin: SUPPLEMENT
 TO PICCADILLY JULY 18th, 1878
Letterpress, on the sheet, l.r.: Imp. T. Way. Lond.
Purchased from Obach & Co., London, 1907
Bequest of Margaret Watson Parker, 1954/1.416
Catalogue number 27

69 The Broad Bridge
1878

Lithotint, printed in brown ink on Japan paper,
 laid down on heavy wove paper
W. 8
Image Sheet: 18.4 x 27.9 cm. (7 1/4 x 11 in.)
Support Sheet: 28.4 x 43.4 cm. (11 3/16 x 17 1/16 in.)
Signed on the stone: butterfly
Collection: Thomas R. Way (Lugt 2456)
Purchased from P. & D. Colnaghi & Co., London, 1913
Bequest of Margaret Watson Parker, 1954/1.417
Catalogue number 29

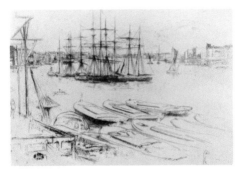

70 The Tall Bridge
1878

Lithotint, printed on white wove paper
W. 9
35.5 x 25.8 cm. (13 7/8 x 10 1/16 in.)
Signed on the stone, at center right between piers:
 butterfly
Letterpress, on the sheet, l.r.: Imp. T. Way Lond.
Purchased from Obach & Co., London, 1906
Bequest of Margaret Watson Parker, 1954/1.418
Catalogue number 28

71 The Large Pool
ca. 1879

Etching, printed in warm black ink on laid paper;
 watermark: crowned coat of arms with fleur-de-lis
K. 174 iv/vii
Plate: 18.7 x 27.6 cm. (7 5/16 x 10 3/4 in.)
Sheet : 24.8 x 35.4 cm. (9 3/4 x 13 7/8 in.)
Signed in pencil, on the sheet, l.r.: butterfly
Signed on the plate, l.r.: butterfly
Inscribed in pencil [in Whistler's hand], l.l.:
 "Wapping—The Pool"
Purchased from Obach & Co., London, 1906
Bequest of Margaret Watson Parker, 1954/1.370
Catalogue number 31

72 Gaiety Stage Door
1879

Lithograph, printed on buff-colored paper, laid down
 on white wove paper
W. 10
Image sheet: 18.2 x 22.7 cm. (7 1/8 x 8 7/8 in.)
Support sheet: 38 x 54.9 cm. (15 x 21 9/16 in.)
Signed in pencil, on the mount, l.l.: Whistler and
 butterfly
Signed on the stone, center left: butterfly
Bequest of Margaret Watson Parker, 1954/1.419

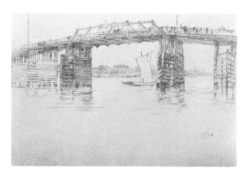

73 The Little Putney, No. 1
1879

Etching, printed in black ink on heavy laid paper;
 watermark: (partial) ENGLAND
K. 179 ii/ii
Plate: 13.4 x 20.5 cm. (5 1/4 x 8 in.)
Sheet: 21.2 x 29.8 cm. (8 1/4 x 11 5/8 in.)
Signed on the plate, l.r.: butterfly
1930.26

74 The Little Putney, No. 1
1879

Etching, printed in black ink on pale green wove paper;
 watermark: ENGLAND
K. 179 ii/ii
Plate: 13.4 x 20.5 cm. (5 1/4 x 8 in.)
Sheet: 23.3 x 29.4 cm. (9 1/16 x 11 7/16 in.)
Signed on the plate, l.r.: butterfly
The Marvin Felheim Collection, 1983/1.226

75 Old Battersea Bridge
1879

Etching and drypoint, printed in dark brown ink
 on laid paper, trimmed to platemark
K. 177 iv/v
20.2 x 29.4 cm. (7 7/8 x 11 7/16 in.)
Signed in pencil, on tab: butterfly and imp.
Signed on the plate, l.r.: butterfly
Purchased from Obach & Co., London, 1905
Bequest of Margaret Watson Parker, 1954/1.371
Catalogue number 30

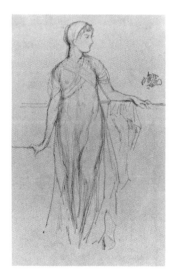

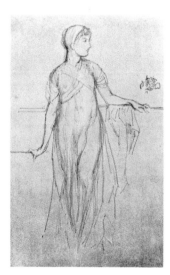

76 Study
1879

Lithograph, printed in brown ink on wove paper
W. 15
Image: 26.1 x 16.5 cm. (10 3/16 x 6 7/16 in.)
Sheet: 33.7 x 25.6 cm. (13 1/8 x 10 in.)
Signed on the stone, to right of figure: butterfly
Collection: Thomas R. Way (Lugt 2456)
Bequest of Margaret Watson Parker, 1954/1.424

77 Study
1879

Lithograph, printed in black ink on laid paper
W. 15
Image: 26.1 x 16.5 cm. (10 3/16 x 6 7/16 in.)
Sheet: 27.5 x 17.3 cm. (10 3/4 x 6 3/4 in.)
Signed on the stone, to right of figure: butterfly
Bequest of Margaret Watson Parker, 1954/1.423

78 Reading
1879

Lithograph, printed on china paper, laid down
 on white wove paper
W. 13
Image sheet: 21.4 x 16.5 cm. (8 3/8 x 6 7/16 in.)
Support sheet: 54.9 x 38 cm. (21 7/16 x 14 13/16 in.)
Signed in pencil, on the support, l.l.: Whistler and
 butterfly
Signed on the stone, to right of figure: butterfly
Bequest of Margaret Watson Parker, 1954/1.422
Catalogue number 32

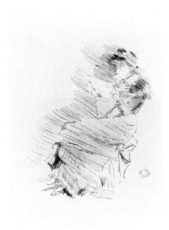

79 Reading
1879

Lithograph, printed on china paper, laid down
 on white wove paper
W. 13
Image sheet: 21.4 x 16.5 cm. (8 3/8 x 6 7/16 in.)
Support sheet: 54.7 x 38 cm. (21 5/16 x 14 13/16 in.)
Signed in pencil, on the support, l.r.: butterfly
Signed on the stone, to right of figure: butterfly
Bequest of Margaret Watson Parker, 1954/1.421

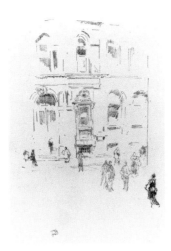

80 Victoria Club
1879

Lithograph, printed on buff-colored paper, laid down
 on white wove paper
W. 11
Image sheet: 23.4 x 15.7 cm. (9 1/8 x 6 1/8 in.)
Support sheet: 47.3 x 34.6 cm. (18 7/16 x 13 1/2 in.)
Signed in pencil, on the mount, l.l.: butterfly
Signed on the stone, l.l.: butterfly
Bequest of Margaret Watson Parker, 1954/1.420

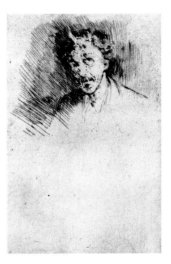

81 Whistler with the White Lock
1879

Etching and drypoint, printed in black ink on pale
 green laid paper
K. 172 (only state)
Plate: 11.9 x 8.2 cm. (4 5/8 x 3 3/16 in.)
Sheet: 20.1 x 14.2 cm. (7 13/16 x 5 9/16 in.)
Bequest of Margaret Watson Parker, 1954/1.369

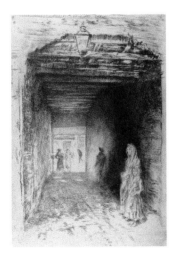

82 The Beggars
from "Twelve Etchings," or the "First Venice Set"
1879-80

Etching and drypoint, printed in dark brown ink
 on laid paper, trimmed to platemark; watermark:
 V C H (?)
K. 194 vii/ix
30.9 x 21.4 cm. (12 1/16 x 8 3/8 in.)
Signed in pencil, on tab, l.l.: butterfly and imp.
Bequest of Margaret Watson Parker, 1954/1.382

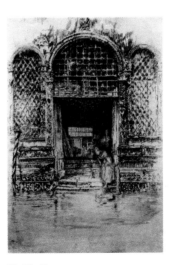

83 The Doorway
from "Twelve Etchings," or the "First Venice Set"
1879-80

Etching and drypoint, printed in warm black ink
 on laid paper, trimmed to platemark
K. 188 iv/vii
29.4 x 20.2 cm. (11 7/16 x 7 7/8 in.)
Signed in pencil, on tab: butterfly and imp.
Signed on the plate, on the facade, u.l.: butterfly
Bequest of Margaret Watson Parker, 1954/1.375
Catalogue number 40

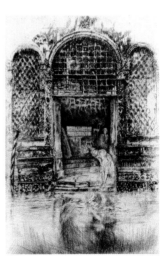

84 The Doorway
from "Twelve Etchings," or the "First Venice Set"
1879-80

Etching and drypoint, printed in dark brown ink
 on laid paper, trimmed to platemark
K. 188 vii/vii
29.4 x 20.2 cm. (11 7/16 x 7 7/8 in.)
Signed in pencil, on tab: butterfly
Signed on the plate, on the facade, u.l.: butterfly
Bequest of Margaret Watson Parker, 1955/1.124
Catalogue number 41

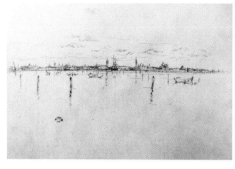

87 Little Venice
from "Twelve Etchings," or the "First Venice Set"
1879-80

Etching, printed in dark brown ink on laid paper,
 trimmed to platemark; watermark: WW
K. 183 (only state)
18.4 x 26.7 cm. (7 3/16 x 10 7/16 in.)
Signed in pencil, on tab: butterfly and imp.
Signed on the plate, l.l.: butterfly
Inscribed in pencil, on verso: Little Venice / W 149. /
 Fine impression
Purchased from Frederick Keppel, Chicago, 1894
Bequest of Margaret Watson Parker, 1955/1.122
Catalogue number 33

85 The Little Lagoon
from "Twelve Etchings," or the "First Venice Set"
1879-80

Etching, printed in black ink on old laid paper;
 watermark: (small, with crown)
K. 186 ii/ii
Plate: 22.7 x 15.2 cm. (8 7/8 x 5 15/16 in.)
Sheet: 34.2 x 22.6 cm. (13 5/16 x 8 13/16 in.)
Signed on the plate, l.r.: butterfly
Inscribed in brown ink, on verso: Latin notation
Bequest of Margaret Watson Parker, 1954/1.374

86 The Little Mast
from "Twelve Etchings," or the "First Venice Set"
1879-80

Etching, printed in brown ink on laid paper, trimmed
 to platemark; watermark: (partial)
K. 185 ii/iv
26.7 x 18.8 cm. (10 7/16 x 7 5/16 in.)
Signed in pencil, on tab: butterfly and imp.
Signed on the plate, u.r.: butterfly
Bequest of Margaret Watson Parker, 1954/1.373

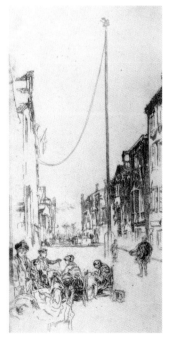

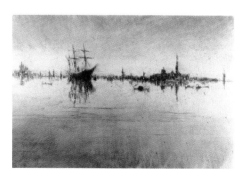

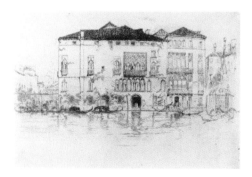

89 Nocturne
from "Twelve Etchings," or the "First Venice Set"
1879-80

Etching and drypoint, printed in warm black ink
 on heavy laid paper, trimmed to platemark
K. 184 iv/v
20.5 x 29.3 cm. (8 1/16 x 11 9/16 in.)
Signed in pencil, on tab: butterfly
Collection: J.H.L. LeSecq (Lugt 1336)
Purchased from M. Knoedler & Co., New York, 1906
Bequest of Margaret Watson Parker, 1954/1.372
Catalogue number 39

90 The Palaces
from "Twelve Etchings," or the "First Venice Set"
1879-80

Etching, printed in black ink on heavy laid paper, trimmed
 to platemark; watermark: crown surmounting a
 fleur-de-lis and 1814
K. 187 iii/iii
25.1 x 35.9 cm. (9 7/8 x 14 1/8 in.)
Signed in pencil, on tab: butterfly and imp.
Purchased from Frederick Keppel, Chicago, 1894
Bequest of Margaret Watson Parker, 1955/1.123
Catalogue number 38

88 The Mast
from "Twelve Etchings," or the "First Venice Set"
1879-80

Etching, printed in warm black ink on laid paper,
 trimmed to platemark; watermark: (partial)
K. 195 vii (undescribed state)
34.1 x 16.5 cm. (13 5/16 x 6 7/16 in.)
Signed in pencil, on tab: butterfly and imp.
Signed on the plate, center left: butterfly
Notation in pencil, on verso: B/ooo
Bequest of Margaret Watson Parker, 1954/1.383

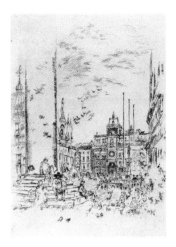

91 The Piazzetta
from "Twelve Etchings," or the "First Venice Set"
1879-80

Etching and drypoint, printed in black ink on heavy
 Japan paper
K. 189 iii/v
Plate: 25.5 x 18.1 cm. (9 15/16 x 7 1/16 in.)
Sheet: 31.7 x 22.5 cm. (12 3/8 x 8 3/4 in.)
Signed in pencil, on the sheet, l.l.: butterfly and imp.
Signed on the plate, on column, l.l.: butterfly
Inscribed in pencil, l.l.: 81793
The Alfred E. Pernt Memorial Fund in honor of Dr. of
 Technical Sciences Max H.J. Pernt and his wife Anna
 Pernt (née Mueller), 1987/2.41

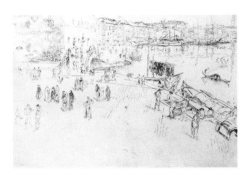

92 The Riva, No. 1
from "Twelve Etchings," or the "First Venice Set"
1879-80

Etching, printed in black ink on wove paper
K. 192 ii/iiia
Plate: 20.1 x 29.6 cm. (7 13/16 x 11 9/16 in.)
Sheet: 22.9 x 33.2 cm. (8 15/16 x 12 15/16 in.)
Signed on the plate, u.l.: butterfly
Bequest of Margaret Watson Parker, 1954/1.378

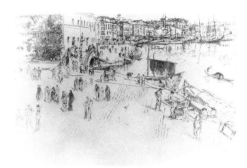

93 The Riva, No. 1
from "Twelve Etchings," or the "First Venice Set"
1879-80

Etching and drypoint, printed in black ink on wove paper
K. 192 iii/iiia
Plate: 20.1 x 29.6 cm. (7 13/16 x 11 9/16 in.)
Sheet: 22.2 x 31.3 cm. (8 11/16 x 12 3/16 in.)
Signed in pencil, on the sheet, l.l.: butterfly and imp.
Signed on the plate, u.l.: butterfly
Collection: J.H. Hutchinson (Lugt 2921)
Bequest of Margaret Watson Parker, 1954/1.379

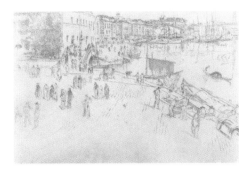

94 The Riva, No. 1
from "Twelve Etchings," or the "First Venice Set"
1879-80

Etching and drypoint, printed in dark brown ink
 on laid paper, trimmed to platemark; watermark:
 S. WISE & Co. with heart
K. 192 iii/iiia
20.1 x 29.6 cm. (7 13/16 x 11 9/16 in.)
Signed in pencil, on tab: butterfly and imp.
Signed on the plate, u.l.: butterfly
Inscribed in pencil, on verso: S / CI
Bequest of Margaret Watson Parker, 1955/1.125
Catalogue number 34

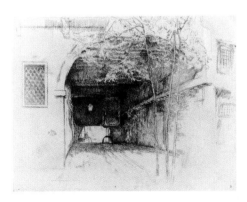

95 The Traghetto, No. 1
1879-80

Etching, printed in warm black ink on laid Japan paper
K. 190 ii/iii
Plate: 23.8 x 30.4 cm. (9 3/8 x 12 in.)
Sheet: 29 x 44.3 cm. (11 7/16 x 17 7/16 in.)
Signed on the plate, l.l.: butterfly
Collection: H.S. Theobald (no mark)
Bequest of Margaret Watson Parker, 1954/1.376
Catalogue number 36

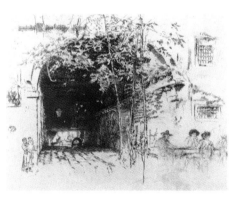

96 The Traghetto, No. 2
from "Twelve Etchings," or the "First Venice Set"
1879-80

Etching, printed in dark brown ink on laid paper,
 trimmed to platemark; watermark: J WHATMAN
K. 191 v/vi
23.6 x 30.4 cm. (9 1/4 x 12 in.)
Signed in pencil, on tab: butterfly and imp.
Signed on the plate, l.l.: butterfly
Purchased from P. & D. Colnaghi & Co., London,
 1927
Bequest of Margaret Watson Parker, 1954/1.377
Catalogue number 37

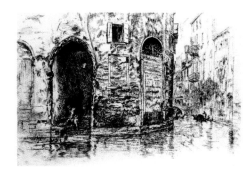

97 Two Doorways
from "Twelve Etchings," or the "First Venice Set"
1879-80

Etching and drypoint, printed in black ink on laid paper;
watermark: (elaborate)
K. 193 iii/vi
Plate: 20.2 x 29.3 cm. (7 7/8 x 11 7/16 in.)
Sheet: 22.5 x 31.4 cm. (8 3/4 x 12 1/4 in.)
Signed on the plate, to left of doorway: butterfly
Inscribed in pencil, on verso, l.l.: The two doorways
Bequest of Margaret Watson Parker, 1954/1.380

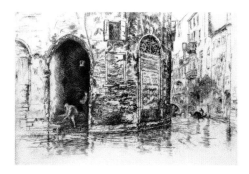

98 Two Doorways
from "Twelve Etchings," or the "First Venice Set"
1879-80

Etching and drypoint, printed in dark brown ink
on laid paper, trimmed to platemark
K. 193 v/vi
20.2 x 29.3 cm. (7 7/8 x 11 7/16 in.)
Signed in pencil, on tab: butterfly and imp.
Signed in pencil, on verso: butterfly
Signed on the plate, u.l.: butterfly
Inscribed in pencil [in Whistler's hand], on verso:
 Before last State
Bequest of Margaret Watson Parker, 1954/1.381
Catalogue number 42

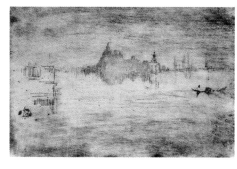

99 Nocturne: Salute
1879-80

Etching and drypoint, printed in dark brown ink on
laid paper, trimmed to platemark; watermark: GR
surmounted by a crown
K. 226 ii/v
15.2 x 22.7 cm. (5 15/16 x 8 7/8 in.)
Signed in pencil, on tab: butterfly and imp.
Signed on the plate, l.l.: butterfly
Collection: Royal Library, Windsor (Lugt 2535)
Purchased from Obach & Co., London, 1906
Bequest of Margaret Watson Parker, 1954/1.393
Catalogue number 43

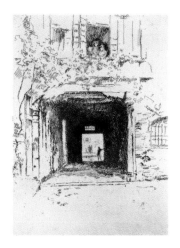

100 Doorway and Vine
from "Twenty-six Etchings," or the "Second Venice Set"
1879-80

Etching, printed in black ink on laid paper, trimmed
 to platemark; watermark: (elaborate)
K. 196 ix/x
23.2 x 16.8 cm. (9 1/16 x 6 9/16 in.)
Signed in pencil, on tab: butterfly and imp.
Signed on the plate, to right of doorway: butterfly
Bequest of Margaret Watson Parker, 1954/1.384

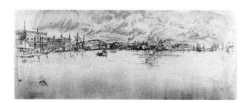

101 Long Venice
from "Twenty-six Etchings," or the "Second Venice Set"
1879-80

Etching and drypoint, printed in dark brown ink
 on laid paper, trimmed to platemark
K. 212 ii/v
12.9 x 31.1 cm. (5 1/16 x 12 1/4 in.)
Signed in pencil, on tab: butterfly and imp.
Signed on the plate, l.l.: butterfly
Purchased from Obach & Co., London, 1906
Bequest of Margaret Watson Parker, 1954/1.391
Catalogue number 46

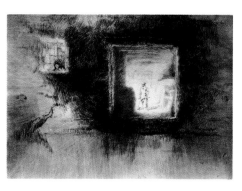

102 Nocturne: Furnace
from "Twenty-six Etchings," or the "Second Venice Set"
1879-1880

Etching, printed in brown ink on laid paper, trimmed
 to platemark
K. 213 iv/vii
16.4 x 22.7 cm. (6 3/8 x 8 7/8 in.)
Signed in pencil, on tab: butterfly and imp.
Signed on the plate, left center: butterfly
Collections: H.S. Theobald (H S T in pencil; not in
 Lugt in this form); C.W. Dowdeswell (no mark)
Purchased from M. Knoedler & Co., New York,
 1907
Bequest of Margaret Watson Parker, 1954/1.392
Catalogue number 47

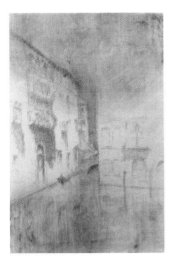

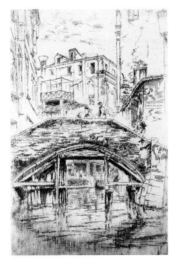

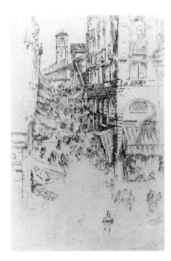

103 Nocturne: Palaces
from "Twenty-six Etchings," or the "Second Venice Set"
1879-80

Etching and drypoint, printed in dark brown ink
 on laid paper, trimmed to platemark
K. 202 vii/ix
29.2 x 19.9 cm. (11 3/8 x 7 3/4 in.)
Signed in pencil, on tab: butterfly and imp.
Inscribed in pencil [in Whistler's hand], on verso:
 superb proof
Purchased from Frederick Keppel, Chicago, 1904
Bequest of Margaret Watson Parker, 1954/1.387
Catalogue number 48

104 Ponte del Piovan
from "Twenty-six Etchings," or the "Second Venice Set"
1879-80

Etching and drypoint, printed in warm black ink
 on laid paper, trimmed to platemark
K. 209 iv/vi
23 x 15.2 cm. (9 x 5 15/16 in.)
Signed in pencil, on tab: butterfly and imp.
Signed on the plate, on bridge, center right: butterfly
Bequest of Margaret Watson Parker, 1954/1.390

105 The Rialto
from "Twenty-six Etchings," or the "Second Venice Set"
1879-80

Etching, printed in warm black ink on old laid paper,
 trimmed to platemark
K. 211 i/ii
22.8 x 20.9 cm. (11 3/8 x 7 7/8 in.)
Signed in pencil, on tab: butterfly and imp.
Purchased from David Tunick & Company, Inc.,
 New York, 1993
Gift of the Friends of the Museum on the Occasion
 of their Twenty-fifth Anniversary, 1993/2.3
Catalogue number 49

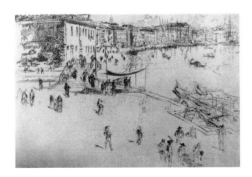

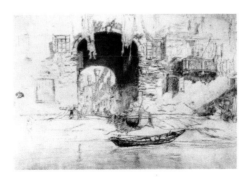

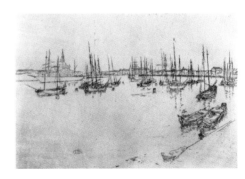

106 The Riva, No. 2
from "Twenty-six Etchings," or the "Second Venice Set"
1879-80

Etching and drypoint, printed in warm black ink on
 laid paper, trimmed to platemark; watermark: coat
 of arms, WR
K. 206 i/ii
21.2 x 30.7 cm. (8 1/4 x 12 in.)
Signed in pencil, on tab, l.l.: butterfly and imp.
Signed on the plate, u.l.: butterfly
Collections: unidentified (Lugt Suppl. 2921h); Royal
 Library, Windsor (Lugt 2535)
Bequest of Margaret Watson Parker, 1954/1.389
Catalogue number 35

107 San Biagio
from "Twenty-six Etchings" or the "Second Venice Set"
1879-80

Etching and drypoint, printed in dark brown ink
 on laid paper, trimmed to platemark
K. 197 ix/ix
21 x 30.2 cm. (8 1/4 x 12 11/16 in.)
Signed in pencil, on tab: butterfly and imp.
Signed on the plate, left center: butterfly
Purchased from Obach & Co., London, 1906
Bequest of Margaret Watson Parker, 1954/1.385
Catalogue number 44

108 San Giorgio
from "Twenty-six Etchings," or the "Second Venice Set"
1879-80

Etching, printed in dark brown ink on laid paper,
 trimmed to platemark
K. 201 iv/iv
20.9 x 30.5 cm. (8 1/8 x 11 7/8 in.)
Signed in pencil, on tab: butterfly and imp.
Signed on the plate, l.l.: butterfly
Bequest of Margaret Watson Parker, 1954/1.386

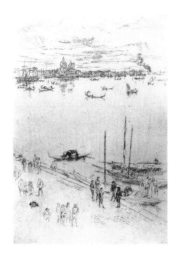

109 Upright Venice
from "Twenty-six Etchings," or the "Second Venice Set"
1879-80

Etching and drypoint, printed in black ink on laid paper,
 trimmed to platemark
K. 205 ii/iv
25.5 x 17.9 cm. (10 x 7 in.)
Signed in pencil, on tab: butterfly and imp.
Signed on the plate, l.l.: butterfly
Purchased from Obach & Co., London, 1905
Bequest of Margaret Watson Parker, 1954/1.388
Catalogue number 45

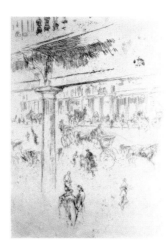

110 Regent's Quadrant
1880-81

Etching, printed in black ink on laid paper, trimmed
 to platemark; watermark: (partial) elaborate
K. 239 iii/iv
16.4 x 11.9 cm. (6 3/8 x 4 5/8 in.)
Signed in pencil, on tab: butterfly and imp.
Signed on the plate, u.r.: butterfly
Bequest of Margaret Watson Parker, 1954/1.394

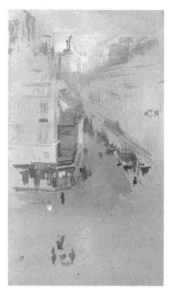

111 Street Scene, Paris [Rue Laffitte (?)]
ca. 1883-85

Watercolor on brown prepared board
21.6 x 12.7 cm. (8 1/2 x 5 in.)
Signed, center right: butterfly
Purchased from W. Scott & Sons, Montreal, 1906
Bequest of Margaret Watson Parker, 1955/1.91
Catalogue number 50

112 Clothes-Exchange, No. 1
1886-88

Etching, printed in dark brown ink on laid paper,
 trimmed to platemark
K. 287 ii/ii
16 x 24 cm. (6 1/4 x 9 3/8 in.)
Signed in pencil, on tab: butterfly and imp.
Signed on the plate, center left: butterfly
Gift of Gilbert M. Frimet, 1985/2.119

113 Cottage Door
ca. 1884-86

Etching, printed in dark brown ink on laid paper,
 trimmed to platemark
K. 250 ii/ii
6.7 x 9.9 cm. (2 5/8 x 3 7/8 in.)
Signed in pencil, on tab: butterfly and imp.
Signed on the plate, u.l.: butterfly
Collection: Royal Library, Windsor (Lugt 2535)
Purchased from Obach & Co., London, 1908
Bequest of Margaret Watson Parker, 1954/1.395
Catalogue number 51

114 Fleur de Lys Passage
ca. 1886-88

Etching, printed in dark brown ink on laid paper,
 trimmed to platemark; watermark: (partial) PRO
 PATRIA
K. 289 ii/iii
18.2 x 8.1 cm. (7 1/8 x 3 3/16 in.)
Signed in pencil, on tab: butterfly and imp.
Signed on the plate, u.l.: butterfly
Collections: C.W. Dowdeswell; H.S. Theobald (no mark)
Bequest of Margaret Watson Parker, 1954/1.396

115 The Young Tree
ca. 1886-88

Etching, printed in warm black ink on laid paper,
 trimmed to platemark
K. 296 (only state)
13.3 x 9.5 cm. (5 3/16 x 3 11/16 in.)
Signed in pencil, on tab: butterfly and imp.
Signed on the plate, to right of tree trunk: butterfly
Bequest of Margaret Watson Parker, 1954/1.397

116 The Cock and the Pump
ca. 1887

Etching, printed in warm black ink on laid paper,
 trimmed to platemark; watermark: PRO PATRIA
K. 304 (only state)
21.9 x 14 cm. (8 9/16 x 5 7/16 in.)
Signed in pencil, on tab: butterfly and imp.
Signed on the plate, l.r.: butterfly
Bequest of Margaret Watson Parker, 1954/1.398

117 Return to Tilbury
from the "Jubilee" or the "Naval Review" series
1887

Etching, printed in dark brown ink on laid paper,
 trimmed to platemark
K. 327 (only state)
13.1 x 9.5 cm. (5 1/8 x 3 11/16 in.)
Signed in pencil, on tab: butterfly and imp.
Signed on the plate, l.l.: butterfly
The Alfred E. Pernt Memorial Fund in honor of Dr. of
 Technical Sciences Max H.J. Pernt and his wife Anna
 Pernt (née Mueller), 1987/1.361

118 The Fur Cloak
late 1880s

Drypoint, printed in warm black ink on laid paper,
 trimmed to platemark
K. 332 i/iii
21.5 x 12.5 cm. (8 3/8 x 4 7/8 in.)
Signed in pencil, on tab: butterfly and imp.
Collection: H.S. Theobald (no mark)
Bequest of Margaret Watson Parker, 1954/1.399

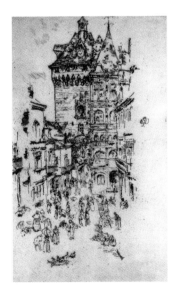

119 Hotel de Ville, Loches
1888

Etching, printed in dark brown ink on laid paper,
 trimmed to platemark
K. 384 (only state)
27 x 16.5 cm. (10 1/2 x 6 7/16 in.)
Signed in pencil, on tab: butterfly and imp.
Signed on the plate, center right: butterfly
Bequest of Margaret Watson Parker, 1954/1.402

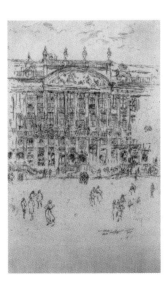

120 Grand' Place, Brussels
1887

Etching, printed in dark brown ink on old laid paper,
 trimmed to platemark; watermark: (small)
K. 362 (only state)
22.1 x 14.2 cm. (8 3/4 x 5 5/8 in.)
Signed in pencil, on tab: butterfly and imp.
Signed on the plate, right center: butterfly
Notation on verso, in pencil [not in Whistler's hand]:
 K.362 only state / The Grande [sic] Place, Brussels
Purchased from Obach & Co., London, 1927
Bequest of Margaret Watson Parker, 1954/1.401
Catalogue number 52

121 Courtyard, Chelsea Hospital
1888

Lithograph, printed on laid paper
W. 23
28.9 x 22.2 cm. (11 1/4 x 8 11/16 in.)
Signed on the stone, u.l.: butterfly
Collection: Thomas R. Way (Lugt 2456)
Bequest of Margaret Watson Parker, 1954/1.425

122 Balcony, Amsterdam
1889

Etching and drypoint, printed in warm black ink on
 laid paper, trimmed to platemark; watermark: Arms
 of Amsterdam
K. 405 iii/iii
27 x 16.7 cm. (10 5/8 x 6 9/16 in.)
Signed in pencil, on tab: butterfly and imp.
Signed in pencil, on mount: butterfly
Signed on the plate, on window, right center: butterfly
Inscribed in pencil, on mount: To Thomas Croft
Collection: Thomas Croft (no mark)
Purchased from Obach & Co., London, 1905
Bequest of Margaret Watson Parker, 1954/1.405
Catalogue number 55

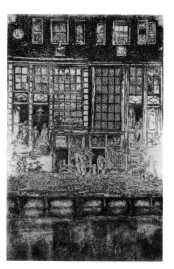

123 The Embroidered Curtain
1889

Etching and drypoint, printed in dark brown ink
 on laid paper, trimmed to platemark
K. 410 vii/vii
23.8 x 16 cm. (9 5/16 x 6 1/4 in.)
Signed in pencil, on tab: butterfly and imp.
Signed on the plate, u.r.: butterfly
Purchased from Obach & Co., London, 1908
Bequest of Margaret Watson Parker, 1954/1.407
Catalogue number 57

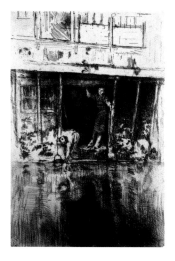

124 Pierrot
1889

Etching and drypoint, printed in dark brown ink
 on wove paper, trimmed to platemark
K. 407 v/v
23.1 x 16 cm. (9 x 6 1/4 in.)
Signed in pencil, on tab: butterfly and imp.
Signed on the plate, u.l.: butterfly
Purchased from Obach & Co., London, 1905
Bequest of Margaret Watson Parker, 1954/1.406
Catalogue number 54

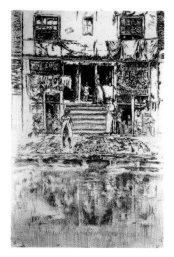

125 Steps, Amsterdam
1889

Etching and drypoint, printed in dark brown ink
 on laid paper, trimmed to platemark
K. 403 ii/iv
24.2 x 16.5 cm. (9 1/2 x 6 1/2 in.)
Signed in pencil, on tab: butterfly and imp.
Signed on the plate, top center: butterfly
Collection: Sir John Day (Lugt 526, embossed)
Purchased from Obach & Co., London, 1908
Bequest of Margaret Watson Parker, 1954/1.403
Catalogue number 53

126 Square House, Amsterdam
1889

Etching and drypoint, printed in brown ink on laid paper,
 trimmed to platemark
K. 404 ii/ii
23.1 x 17.7 cm. (9 x 6 7/8 in.)
Signed on the plate, u.r.: butterfly
Collection: Royal Library, Windsor (Lugt 2535)
Purchased from Obach & Co., London, 1906
Bequest of Margaret Watson Parker, 1954/1.404
Catalogue number 56

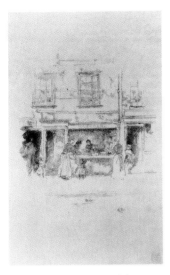

127 Maunder's Fish Shop, Chelsea
1890

Lithograph, printed on laid Japan tissue
W. 28
31.8 x 20 cm. (12 1/2 x 7 7/8 in.)
Signed in pencil, l.r.: butterfly
Signed on the stone at center: butterfly
Collection: Rosalind Birnie Philip (Lugt 406)
Purchased from Pia Gallo, New York, 1993
Gift in memory of John Holmes, 1993/2.5
Catalogue number 58

128 The Novel—Girl Reading
1890

Lithograph, printed in black ink, laid down on heavy
wove paper
W. 33
Image sheet: 22.4 x 10.9 cm. (8 3/4 x 4 1/4 in.)
Support sheet: 32 x 24.9 cm. (12 1/2 x 9 11/16 in.)
Collection: Thomas R. Way (Lugt 2456)
Bequest of Margaret Watson Parker, 1954/1.434

129 Model Draping
1890

Lithograph, printed on laid paper; watermark: PRO
PATRIA F I etc.
W. 31
32.5 x 20.3 cm. (12 11/16 x 7 15/16 in.)
Signed in pencil, l.l.: butterfly
Signed on the stone, to right of figure: butterfly
Bequest of Margaret Watson Parker, 1954/1.432

130 Model Draping
1890

Lithograph, printed on wove paper; watermark:
H. Smith & Son. / 1824
W. 31
31.9 x 20 cm. (12 7/16 x 7 13/16 in.)
Signed on the stone, to right of figure: butterfly
Bequest of Margaret Watson Parker, 1954/1.431

131 The Dancing Girl
1890

Lithograph, printed on laid paper; watermark:
D & C Blauw
W. 30
36.5 x 23.2 cm. (11 1/4 x 9 1/16 in.)
Signed on the stone, to left of figure: butterfly
Collection: Rosalind Birnie Philip (Lugt 405)
Bequest of Margaret Watson Parker, 1955/1.126

132 The Dancing Girl
1890

Lithograph, printed on laid paper; watermark:
Van der Ley
W. 30
32 x 20.5 cm. (12 1/2 x 8 in.)
Signed in pencil, on the sheet, l.l.: butterfly
Signed on the stone, to left of figure: butterfly
Collection: Rosalind Birnie Philip (Lugt 406)
Purchased from M. Knoedler & Co., New York, 1919
Bequest of Margaret Watson Parker, 1954/1.430
Catalogue number 60

133 The Horoscope
1890

Lithograph, printed on laid paper; watermark:
 D & C Blauw
W. 32
36.9 x 22.5 cm. (14 3/8 x 8 3/4 in.)
Signed on the stone, l.r.: butterfly
Collection: Rosalind Birnie Philip (Lugt 405)
Bequest of Margaret Watson Parker, 1954/1.433

134 The Little Nude Model Reading
1890

Lithograph, printed on laid paper
W. 29
28.8 x 22.2 cm. (11 1/4 x 8 11/16 in.)
Signed on the stone, to right of figure: butterfly
Collection: Thomas R. Way (Lugt 2456)
Bequest of Margaret Watson Parker, 1954/1.429

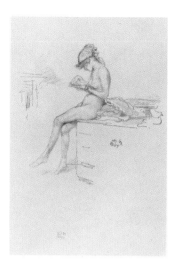

135 The Little Nude Model Reading
1890

Lithograph, printed on laid paper; watermark: IVDL (?)
W. 29
32 x 20.4 cm. (12 1/2 x 7 15/16 in.)
Signed in pencil, l.l.: butterfly
Signed on the stone, to right of figure: butterfly
Bequest of Margaret Watson Parker, 1954/1.428

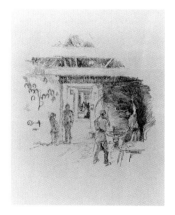

136 The Tyresmith
1890

Lithograph, printed on heavy wove paper
W. 27
28.6 x 22.3 cm. (11 1/8 x 8 11/16 in.)
Signed on the stone, center left: butterfly
Letterpress, at u.r.: Presented with THE WHIRLWIND,
 Nov. 15, 1890.
Bequest of Margaret Watson Parker, 1954/1.427

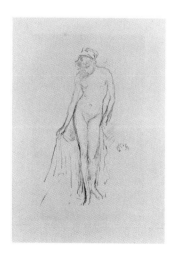

137 Nude Model, Standing
ca. 1890-95

Lithograph, printed on buff-colored laid paper
W. 154
32.9 x 26.5 cm. (12 13/16 x 10 5/16 in.)
Signed on the stone, to right of figure: butterfly
Inscribed in purple (originally blue?) ink, on verso:
 J within an oval
Bequest of Margaret Watson Parker, 1954/1.467

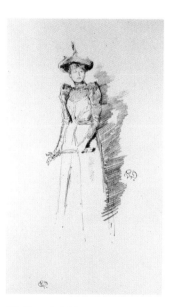

138 Gants de Suède
1890
Lithograph, printed on laid paper; watermark:
 PRO PATRIA
W. 26
33.2 x 21.2 cm. (12 15/16 x 8 1/4 in.)
Signed in pencil, on the sheet, l.l.: butterfly
Signed on the stone, center right: butterfly
Collection: Rosalind Birnie Philip (Lugt 406)
Purchased from Colnaghi & Co., London, 1927
Bequest of Margaret Watson Parker, 1954/1.426
Catalogue number 59

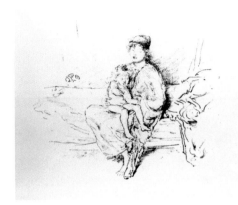

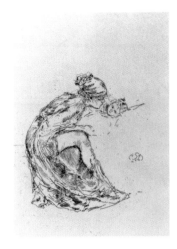

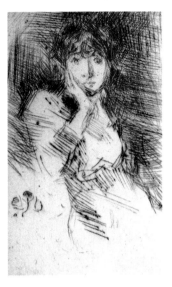

139 Mother and Child, No. 2
1890

Lithograph, printed on laid paper; watermark: (partial)
 Van Gelder Zonen
W. 102
22.5 x 28.3 cm. (8 3/4 x 11 1/16 in.)
Signed on the stone, to left of figures: butterfly
Collection: Thomas R. Way (Lugt 2456)
Bequest of Margaret Watson Parker, 1954/1.454

140 Cameo, No. 1 (Mother and Child)
1891

Etching, printed in dark brown ink on laid paper,
 trimmed to platemark
K. 347 (only state)
17.7 x 12.9 cm. (6 7/8 x 5 in.)
Signed in pencil, on tab: butterfly and imp.
Signed on the plate, l.r.: butterfly
Purchased from M. Knoedler & Co., New York, 1927
Bequest of Margaret Watson Parker, 1954/1.400
Catalogue number 61

141 Mrs. Whibley
ca. 1892-93

Etching and drypoint, printed in dark brown ink
 on laid paper, trimmed to platemark
K. 441 (only state)
8.6 x 5.2 cm. (3 3/8 x 2 in.)
Signed in pencil, on tab: butterfly and imp.
Signed on the plate, center left: butterfly
Inscribed in pencil, on verso, [in Whistler's hand]: 2nd
 Proof / butterfly
Bequest of Margaret Watson Parker, 1954/1.411

142 Rue Vauvilliers
ca. 1892-93

Etching, printed in black ink on laid Japan tissue
K. 439 (only state)
Plate: 22.2 x 13.3 cm. (8 3/4 x 5 1/4 in.)
Sheet: 30.9 x 16.3 cm. (12 1/8 x 6 3/8 in.)
Signed on the plate, center left: butterfly
Purchased from P. & D. Colnaghi & Co., London,
 1932
Bequest of Margaret Watson Parker, 1954/1.410
Catalogue number 66

143 Café Corazza, Palais Royal
ca. 1892-93

Etching, printed in black ink on laid Japan tissue,
 trimmed to platemark
K. 436 (only state)
13.1 x 22 cm. (5 1/8 x 8 5/8 in.)
Purchased from P. & D. Colnaghi & Co., London,
 1932
Bequest of Margaret Watson Parker, 1954/1.409
Catalogue number 67

144 Carpet-Menders
ca. 1892-93

Etching and drypoint, printed in warm black ink
 on laid paper, trimmed to platemark
K. 420 (only state)
20.2 x 25.1 cm. (7 7/8 x 9 13/16 in.)
Signed in pencil, on tab [partially trimmed]: butterfly
Signed on the plate, center left: butterfly
Purchased from P. & D. Colnaghi & Co., London,
 1932
Bequest of Margaret Watson Parker, 1954/1.408
Catalogue number 68

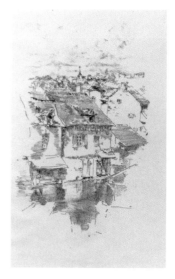

145 Yellow House, Lannion
1893

Lithograph, printed in black and five colors on laid
 Japan paper
W. 101
31.9 x 20.6 cm. (12 7/16 x 8 1/16 in.)
Signed in pencil, on the sheet, l.l.: butterfly
Signed on the stone, on second story of the facade:
 butterfly
Collection: Royal Library, Windsor (Lugt 2535)
Purchased from Obach & Co., London, 1906
Bequest of Margaret Watson Parker, 1954/1.453
Catalogue number 72

146 Vitré — The Canal
1893

Lithograph, printed on laid paper; watermark: F I
 PRO PATRIA
W. 39
33.2 x 21.1 cm. (13 1/16 x 8 5/16 in.)
Signed in pencil, at bottom: butterfly
Signed on the stone, on building at right: butterfly
Purchased from Maggs Bros., London, 1931
Collection: Rosalind Birnie Philip (Lugt 406)
Bequest of Margaret Watson Parker, 1954/1.435
Catalogue number 62

147 Vitré — The Canal
1893

Lithograph, printed on laid paper
W. 39
29.5 x 20.8 cm. (11 1/2 x 8 1/8 in.)
Signed on the stone, on building at right: butterfly
Collection: Thomas R. Way (Lugt 2456)
Bequest of Margaret Watson Parker, 1954/1.436

148 Nude Model Reclining
1893

Lithograph, printed on old laid paper; watermark:
 Crown and GR
W. 47
20.8 x 33.1 cm. (8 1/8 x 12 15/16 in.)
Signed in pencil, l.l.: butterfly
Signed on the stone, to left of figure: butterfly
Inscribed in pencil, l.l.: Way 47 Little Nude model
 reclining [not in Whistler's hand]
Purchased from Obach & Co., London, 1927
Bequest of Margaret Watson Parker, 1954/1.442
Catalogue number 65

149 The Draped Figure Seated
1893

Lithograph, printed on laid paper
W. 46
36.8 x 24.4 cm. (14 1/2 x 9 5/8 in.)
Signed in pencil, l.r.: butterfly
Signed on the stone, to right of figure: butterfly
Notation in ink, l.l.: 60
Purchased from Obach & Co., London, 1907
Bequest of Margaret Watson Parker, 1954/1.441
Catalogue number 64

150 Draped Figure Reclining
1893-94

Lithograph, printed in six colors on laid Japan tissue
W. 156
24.6 x 34.5 cm. (9 5/8 x 13 7/16 in.)
Signed on the stone, u.r.: butterfly
Purchased from M. Knoedler & Co., New York, 1919
Bequest of Margaret Watson Parker, 1954/1.468
Catalogue number 63

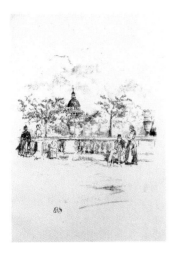

151 The Pantheon, from the Terrace of the Luxembourg Gardens
1893

Lithograph, printed on laid paper
W. 45
28.4 x 19.1 cm. (11 1/16 x 7 7/16 in.)
Signed on the stone, bottom center: butterfly
Bequest of Margaret Watson Parker, 1954/1.439

152 The Pantheon, from the Terrace of the Luxembourg Gardens
1893

Lithograph, printed on laid paper
W. 45
30.1 x 20.6 cm. (11 7/8 x 8 1/8 in.)
Signed on the stone, bottom center: butterfly
Collection: Thomas R. Way (Lugt 2456)
Purchased from Frederick Keppel, New York, 1913
Bequest of Margaret Watson Parker, 1954/1.440
Catalogue number 69

153 Conversation under the Statue, Luxembourg Gardens
1893

Lithograph, printed on laid paper
W. 44
29 x 23.5 cm. (11 3/8 x 9 1/4 in.)
Signed in pencil, l.l.: butterfly
Signed on the stone, l.r.: butterfly
Collection: Royal Library, Windsor (Lugt 2535)
Purchased from Obach & Co., London, 1906
Bequest of Margaret Watson Parker, 1954/1.438
Catalogue number 70

154 The Steps, Luxembourg Gardens
1893

Lithograph, printed on wove paper
W. 43
29.9 x 20.8 cm. (11 3/4 x 8 3/8 in.)
Signed on the stone, l.r.: butterfly
Collection: Thomas R. Way (Lugt 2456)
Purchased from Frederick Keppel, New York, 1913
Bequest of Margaret Watson Parker, 1954/1.437
Catalogue number 71

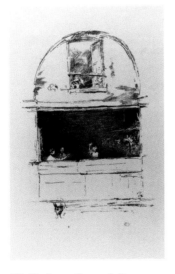

155 The Forge—Passage du Dragon
1894

Lithograph, printed on old laid paper; watermark:
 crown / C R
W. 72 ii
33.1 x 21 cm. (13 x 8 1/4 in.)
Signed on the stone, under arch at u.l.: butterfly
Signed in pencil, l.r.: butterfly
Collections: Rosalind Birnie Philip (Lugt 405);
 Robert Rice
Gift of Mr. and Mrs. David P. Tunick, 1992/1.143

156 La Belle Dame Paresseuse
1894

Lithograph, printed on laid paper; watermark: crown
 surmounted by GR
W. 62
31.3 x 20.2 cm. (12 3/16 x 7 7/8 in.)
Signed in pencil, l.l.: butterfly
Signed on the stone, center right: butterfly
Notation in pencil, on verso: (F.)
Bequest of Margaret Watson Parker, 1954/1.449
Catalogue number 75

157 La Belle Dame Paresseuse
1894

Lithograph, printed on heavy laid paper; watermark:
J H & Zoon etc., with device
W. 62
25.2 x 19.4 cm. (9 13/16 x 7 9/16 in.)
Signed on the stone, center right: butterfly
Bequest of Margaret Watson Parker, 1954/1.450

158 The Long Gallery, Louvre
1894

Lithograph, printed on wove paper
W. 52
29.8 x 21.3 cm. (11 5/8 x 8 5/16 in.)
Signed on the stone, l.r.: butterfly
Collection: Thomas R. Way (no mark)
Bequest of Margaret Watson Parker, 1954/1.446

159 The Little Balcony
1894

Lithograph, printed on laid paper; watermark: lily or
fleur-de-lis surrounded by heraldic shields
W. 50
32.3 x 20.6 cm. (12 3/4 x 8 1/8 in.)
Signed in pencil, l.l.: butterfly
Signed on the stone, l.r.: butterfly
Collection: Rosalind Birnie Philip (Lugt 406)
Purchased from P. & D. Colnaghi & Co., London,
1927
Bequest of Margaret Watson Parker, 1954/1.444
Catalogue number 74

160 The Long Balcony
1894

Lithograph, printed on wove paper
W. 49
31.4 x 23.9 cm. (12 1/4 x 9 5/16 in.)
Signed in pencil, bottom center: butterfly
Signed on the stone, between windows: butterfly
Collection: H.H. Benedict (Lugt 2936)
Gift of Jean Paul Slusser, 1964, 1964/1.109

161 Nursemaids—Les Bonnes du Luxembourg
1894

Lithograph, printed on laid paper; watermark: V / S /
D V I
W. 48
30.8 x 20.2 cm. (12 x 7 7/8 in.)
Signed in pencil, bottom left: butterfly
Signed on the stone, l.r.: butterfly
Bequest of Margaret Watson Parker, 1954/1.443

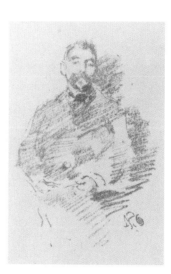

162 Stéphane Mallarmé
1894

Lithograph, printed on china paper, laid down
on heavy white wove paper
W. 66
Signed on the stone, l.r.: butterfly
Blind stamp, to lower left of image: Belfond & Cie.
Image sheet: 12 x 7.9 cm. (4 11/16 x 3 1/8 in.)
Support sheet: 31.9 x 24.6 cm. (12 9/16 x 9 11/16 in.)
Purchased from C. & J. Goodfriend, New York, 1993
Gift of Mildred R. Hartsook, 1993/2.34

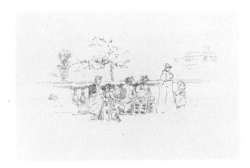

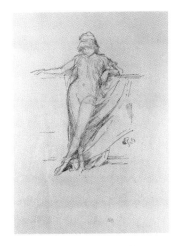

163 The Terrace, Luxembourg
1894

Lithograph, on laid paper; watermark: foolscap
W. 55
20.8 x 31.2 cm. (8 1/4 x 12 1/4 in.)
Signed on the stone, to left of image: butterfly
Collection: Rosalind Birnie Philip (Lugt 405)
Purchased from Rosalind Birnie Philip, 1905
Bequest of Margaret Watson Parker, 1954/1.448
Catalogue number 73

164 Little Draped Figure Leaning
1894

Lithograph, printed on heavy laid paper
W. 51
34.2 x 23.9 cm. (13 5/16 x 9 5/16 in.)
Signed in pencil, at bottom: butterfly
Signed on the stone, to right of figure: butterfly
Inscribed in pencil, on verso: (11.)
Collection: Thomas R. Way (no mark)
Bequest of Margaret Watson Parker, 1954/1.445

165 Sunday, Lyme Regis
1895

Lithograph, printed on laid paper; watermark: (partial)
W. 96
25 x 18.3 cm. (9 3/4 x 7 1/8 in.)
Signed in pencil, on the sheet, l.l. of image: butterfly
Signed on the stone, above doorway, u.r.: butterfly
Collection: Rosalind Birnie Philip (Lugt 406)
Purchased from Maggs Bros., London, 1932
Bequest of Margaret Watson Parker, 1954/1.452
Catalogue number 76

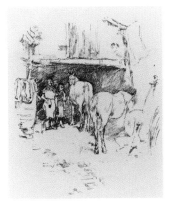

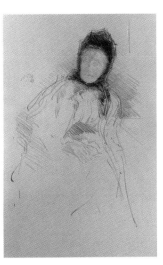

166 The Fair
1895

Lithograph, printed in black ink, laid down on heavy
 wove paper
W. 92
Image sheet: 23.6 x 15.9 cm. (9 3/16 x 6 3/16 in.)
Support sheet: 34.4 x 25.4 cm. (13 7/16 x 9 7/8 in.)
Signed on the stone, u.r.: butterfly
Bequest of Margaret Watson Parker, 1954/1.451

167 Smith's Yard
1895

Lithograph, printed on wove paper
W. 88
29.9 x 21 cm. (11 11/16 x 8 3/16 in.)
Signed on the stone, u.r.: butterfly
Chopmark, l.r.: The Studio
1930.27

168 An Unfinished Sketch of Lady Haden
1895

Lithograph, printed on wove paper
W. 143
40.5 x 26.9 cm. (15 13/16 x 10 1/2 in.)
Signed on the stone, u.l.: butterfly
Gift of the Family of Albert Kahn: through Dr. Edgar
 A. Kahn; Mrs. Barnett Malbin; Mrs. Martin L. Butzel,
 1973/1.735

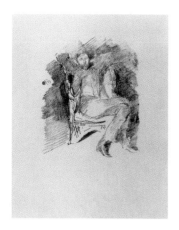

169 Firelight: Joseph Pennell
1896

Lithograph, printed on laid paper; watermark: (elaborate)
W. 104
35.2 x 25.4 cm. (13 3/4 x 9 7/8 in.)
Signed on the stone, u.l.: butterfly
Gift of the Friends of the Museum, 1978/1.166

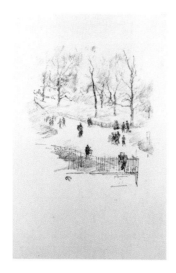

170 Kensington Gardens
1896

Lithograph, printed on laid paper; watermark:
PRO PATRIA
W. 109
31.5 x 20 cm. (12 5/16 x 7 13/16 in.)
Signed on the stone, l.l.: butterfly
Bequest of Margaret Watson Parker, 1954/1.456

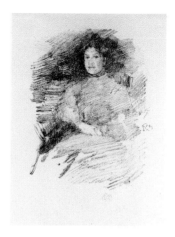

171 Firelight
1896

Lithograph, printed on wove paper
W. 103
28.2 x 21.9 cm. (11 x 8 9/16 in.)
Signed in pencil, at bottom: butterfly
Signed on the stone, center right: butterfly
Bequest of Margaret Watson Parker, 1954/1.455

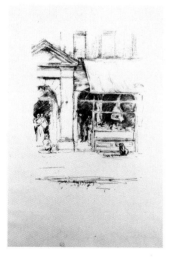

172 The Butcher's Dog
1896

Lithograph, printed on wove paper; watermark: (partial)
W. 128 ii
31.4 x 21.6 cm. (12 3/8 x 8 1/2 in.)
Signed in pencil, l.l.: butterfly
Signed on the stone, on awning, u.r.: butterfly
Collection: Spanish Royal Arms (blind stamp, not in Lugt)
Purchased from P. & D. Colnaghi & Co., London,
1931
Bequest of Margaret Watson Parker, 1954/1.464
Catalogue number 80

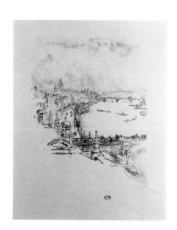

173 Little London
1896

Lithograph, printed on wove paper
W. 121
28.6 x 22.2 cm. (11 1/8 x 8 11/16 in.)
Signed on the stone, bottom center: butterfly
Collection: Thomas R. Way (Lugt 2456)
Purchased from Colnaghi & Obach, London, 1913
Bequest of Margaret Watson Parker, 1954/1.460
Catalogue number 78

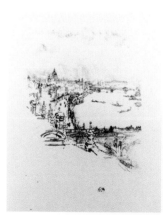

174 Little London
1896

Lithograph, printed on wove paper; watermark:
O.W.P. & A.C.L. / A.C.L. / O.W.P.
W. 121
37.9 x 25.7 cm. (14 3/4 x 10 in.)
Signed on the stone, at bottom: butterfly
Collection: Rosalind Birnie Philip (Lugt 405)
Bequest of Margaret Watson Parker, 1954/1.461

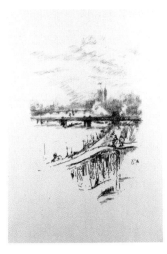

175 Savoy Pigeons
1896

Lithograph, printed on laid paper; watermark:
 D & C BLAUW
W. 118
37.4 x 23.2 cm. (14 9/16 x 9 1/16 in.)
Signed on the stone, l.r.: butterfly
Collection: Rosalind Birnie Philip (Lugt 405)
Purchased from Rosalind Birnie Philip, 1905
Bequest of Margaret Watson Parker, 1954/1.457
Catalogue number 79

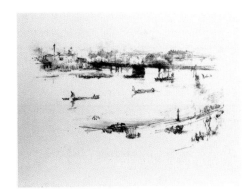

176 Charing Cross Railway Bridge
1896

Lithograph, printed on laid paper; watermark: (partial)
 Van Gelder Zonen
W. 120
23 x 28.3 cm. (9 x 11 1/16 in.)
Signed on the stone, in the water: butterfly
Collection: Thomas R. Way (Lugt 2456)
Bequest of Margaret Watson Parker, 1954/1.459

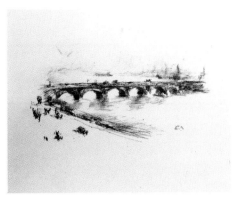

177 Evening—Little Waterloo Bridge
1896

Lithograph, printed on laid paper; watermark: (partial)
 Van Gelder Zonen
W. 119
23.1 x 28 cm. (9 1/16 x 10 15/16 in.)
Signed on the stone, center right: butterfly
Collection: Thomas R. Way (Lugt 2456)
Bequest of Margaret Watson Parker, 1954/1.458

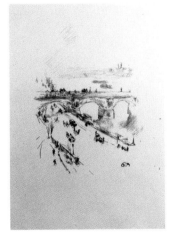

178 Waterloo Bridge
1896

Lithograph, printed on old laid paper; watermark:
 (partial) elaborate
W. 123
34.4 x 24.9 cm. (13 7/16 x 9 11/16 in.)
Signed on the stone, l.r.: butterfly
Collection: Rosalind Birnie Philip (Lugt 405)
Bequest of Margaret Watson Parker, 1954/1.462

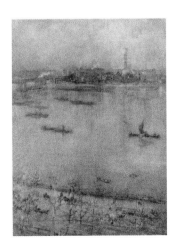

179 The Thames
1896

Lithotint, printed on heavy wove paper; watermark:
 (partial) O.W.P. & A.C.L.
W. 125
Image: 26.5 x 19.4 cm. (10 5/16 x 7 9/16 in.)
Sheet: 27.5 x 27.4 cm. (10 3/4 x 10 11/16 in.)
Signed on the stone, in the water, l.r.: butterfly
Collection: Rosalind Birnie Philip (Lugt 405)
Purchased from Rosalind Birnie Philip, 1905
Bequest of Margaret Watson Parker, 1954/1.463
Catalogue number 77

180 St. Giles-in-the-Fields
1896

Lithograph, printed on laid paper
W. 129
28.7 x 22 cm. (11 1/4 x 8 5/8 in.)
Signed on the stone, under cornice at right center: butterfly
Collection: Thomas R. Way (Lugt 2456)
Purchased from Colnaghi & Obach, London, 1913
Bequest of Margaret Watson Parker, 1954/1.465
Catalogue number 81

181 The Shoemaker, Dieppe
ca. 1896-97

Lithograph, printed on wove paper
W. 151
25.9 x 33.6 cm. (10 1/8 x 13 1/8 in.)
Signed on the stone, u.r.: butterfly
Bequest of Margaret Watson Parker, 1954/1.466
Catalogue number 82

182 Blue and Silver: Morning, Ajaccio (recto)
Building with Trees (verso)
1901

Watercolor, on Japan paper, mounted on board
25.1 x 14.6 cm. (9 13/16 x 5 11/16 in.)
Inscribed and signed with butterfly on backing label:
 Blue & Silver— / Morning. / Ajaccio.
Bequest of Margaret Watson Parker, 1955/1.90
Catalogue number 83

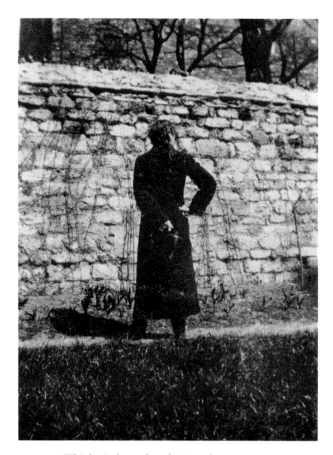

Whistler in the garden of 110 rue du Bac,
Paris, ca. 1895, probably photographed by
Ethel Birnie Philip

Courtesy of the Librarian, Glasgow
University Library